THE QUEST
FOR ETERNITY

○

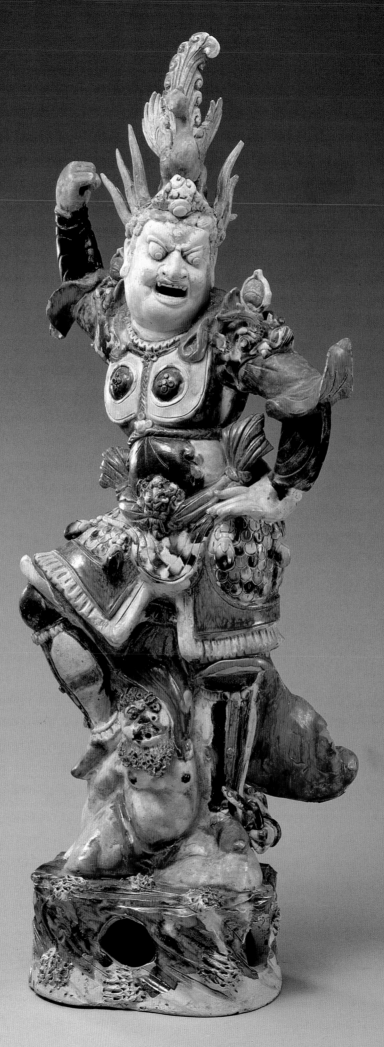

Guardian king
Tang dynasty, cat. no. 80

THE QUEST FOR ETERNITY

CHINESE CERAMIC SCULPTURES
FROM THE PEOPLE'S REPUBLIC OF CHINA

o

Organized by
Los Angeles County Museum of Art
Overseas Archaeological Exhibition Corporation,
The People's Republic of China

Published by
Los Angeles County Museum of Art
Chronicle Books, San Francisco

Copublished by
Los Angeles County Museum of Art
5905 Wilshire Boulevard
Los Angeles, California 90036
and
Chronicle Books
One Hallidie Plaza
San Francisco, California 94102

Exhibition Itinerary:

Philadelphia Museum of Art
March 22–May 24, 1987

The Museum of Fine Arts, Houston
June 28–September 6, 1987

Los Angeles County Museum of Art
October 15, 1987–January 3, 1988

The Cleveland Museum of Art
February 7–April 10, 1988

This exhibition has been made possible in part by a grant
from the National Endowment for the Humanities.

Editor: Susan L. Caroselli

Cover: Woman with a loose chignon, Tang dynasty,
cat. no. 83 (detail)

Library of Congress Cataloging in Publication Data

The Quest for eternity.
Bibliography: p. 159
1. Ceramic sculpture–China–Exhibitions. I. China.
II. Los Angeles County Museum of Art. III. Overseas
Archaeological Exhibition Corporation,
the People's Republic of China.
NK4165.Q4 1987 732'.71'074019494 86–27528
ISBN 0-87587-134-8 (pbk.)
ISBN 0-87701-440-X (Chronicle Books)
ISBN 0-87701-428-0 (Chronicle Books : pbk.)

CONTENTS

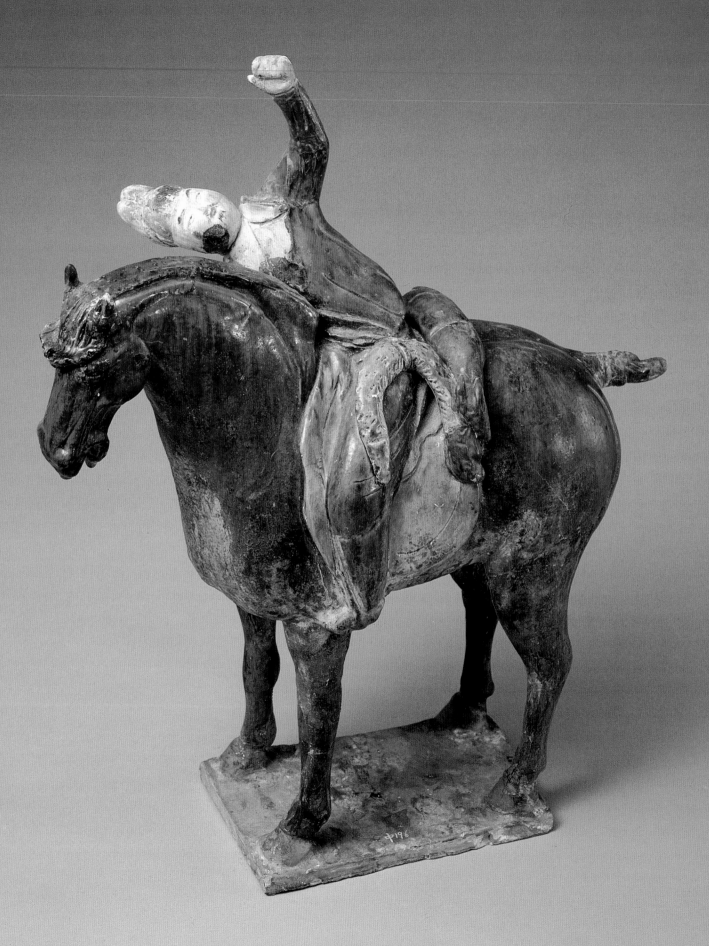

Hunter on horseback
Tang dynasty, cat. no. 70

O

FOREWORD

Our country has always been fascinated by China, the oldest continuous civilization on earth, a land whose cultural accomplishments and technological developments have contributed enormously to our lives.

The Chinese ceramic sculptures selected for the exhibition *The Quest for Eternity* represent one aspect of this ancient culture, its funerary customs. Figures of people, animals, and strange guardian creatures, models of homes, farms, and fields were buried with the deceased to serve and sustain them in the afterlife. These interred objects have also served us by preserving the images of the inhabitants and material culture of China for more than five millennia.

Such objects are obviously of great archaeological and historical significance. This exhibition demonstrates their importance, and their charm, as works of art. Heroic warriors from the terra-cotta army of the First Emperor of Qin, the energetic dancers and singers of the Han and Jin dynasties, and the elegant ladies and handsome horses of Tang are a few of the treasures that grace this exhibition. More than 155 works of art provide an unprecedented comprehensive view of the artistic development of Chinese funerary art from the Neolithic period through the Ming dynasty.

In October of 1984 George Kuwayama, senior curator of Far Eastern Art at the Los Angeles County Museum of Art, returned from Japan with a glowing account of the Chinese ceramic sculpture exhibition he had seen in Nagoya. Soon thereafter, on obtaining the approval and support of our Board of Trustees, we began negotiations with the government of the People's Republic of China. *The Quest for Eternity* is the result of the fruitful collaboration between the Chinese cultural agencies and the Los Angeles County Museum of Art. Our special thanks go to Lu Jimin, director of the Administrative Bureau of Museums and Archaeological Data, Ministry of Culture, for his kind support of this project. Initial negotiations were made possible by the good offices of Wang Zicheng, director, and Yu Huijun, staff assistant, of the China Association for the Advancement of International Friendship. Julia F. Andrews, assistant curator of Far Eastern Art at the museum, and her husband, Han Xin, provided invaluable assistance in the ensuing negotiations with Chinese agencies and officials.

The broad scope of the present exhibition and the choice of works of art of great historical importance and aesthetic quality are due to the cooperation of the Overseas Archaeological Exhibition Corporation of the People's Republic. We are especially appreciative of the unstinting help provided by Zhang Yong, manager, Madame Guo Sen, deputy manager, and Lu Shaochen, in charge of the Manager's Office.

The Quest for Eternity has been made possible in part by a grant from the National Endowment for the Humanities. I also wish to thank my colleagues from the Philadelphia Museum of Art, the Museum of Fine Arts, Houston, and the Cleveland Museum of Art for their collaborative efforts in bringing about this important international cultural exchange.

Earl A. Powell III
Director
Los Angeles County Museum of Art

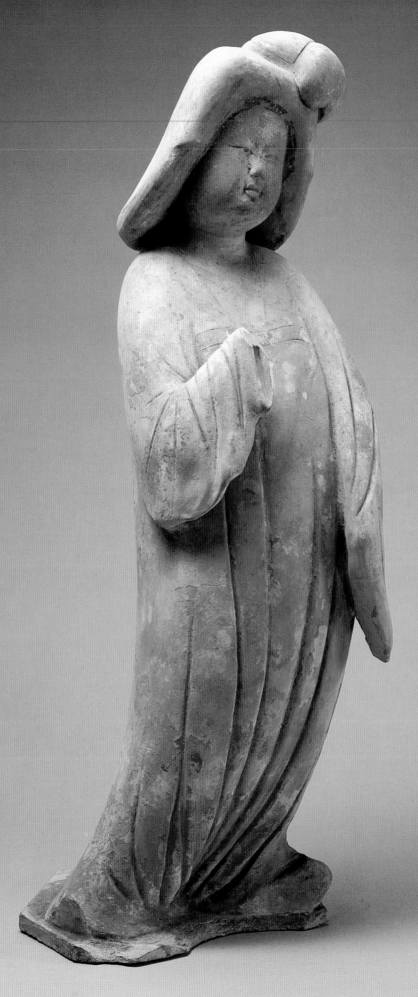

Woman with a loose chignon
Tang dynasty, cat. no. 83

PREFACE

Chinese ceramic sculpture has a history stretching back more than seven thousand years. Among the most important examples of this art form are the many extremely fine pieces of funerary sculpture discovered in the tombs of ancient China.

The custom of producing sculptures as burial objects to substitute for human sacrifices began in the Shang and Zhou periods and flourished in the Qin, Han, and post-Han dynasties. Tens of thousands of tomb figures have been discovered by archaeological workers in the course of excavating tombs in all parts of China. This ancient funerary sculpture, with its rich and diverse subject matter, is inextricably linked to the culture and thought of the society and therefore provides precious material for research in Chinese history, archaeology, and art. Artistically, the lively forms and bright colors of these masterpieces are a legacy of the skill and intelligence of ancient artists.

The 157 objects exhibited in *The Quest for Eternity* were carefully chosen from the holdings of fourteen museums and institutions for the administration of cultural relics. They were excavated in twenty different counties or municipalities in the provinces of Shaanxi, Henan, Shanxi, and Sichuan. Chronologically, they range from the Neolithic period (c. 8000–2000 B.C.) through the Ming dynasty (A.D. 1368–1644). Besides figures of human beings, the exhibition includes replicas of cultivated fields, dwellings, sacrificial animals, and tomb guardian beasts. Among the images are musicians less than two inches tall and life-sized warriors and horses. They range from the naive sculpture of a human head from the Neolithic era to the dazzling artistry of the polychrome *sancai* wares of the Tang period. There are completely realistic depictions of human beings and animals as well as wonderfully imaginative renderings of fierce tomb guardians. Their forms may be animated with an unsophisticated vigor, heroic and powerful, or solemn and awe-inspiring.

These works of art modeled in clay have been buried in the earth for thousands of years. Their reappearance reveals their eternal artistic quality and their profound historical significance.

This is the first time that an exhibition on a theme as specialized as Chinese ceramic sculpture has been held in the United States. We very much hope that this exhibition, by expanding the American public's understanding of the development of this art form, will also increase its understanding of Chinese culture and history and thus contribute to the friendship and cultural exchange between the peoples of our two nations.

Overseas Archaeological Exhibition Corporation,
The People's Republic of China

Shaanxi Provincial Museum

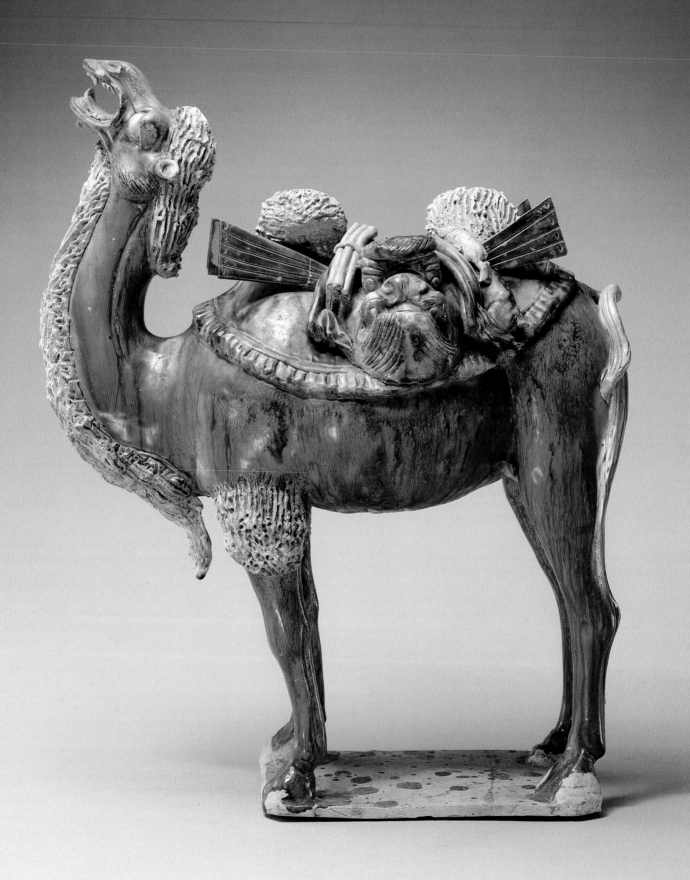

Bactrian camel
Tang dynasty, cat. no. 79

ACKNOWLEDGMENTS

Ceramic funerary sculptures are among the most universally admired works of Chinese art. Their spontaneity and sense of immediacy elicit a sympathetic response from every viewer. In a prancing horse or a haughty courtier the essence of life is captured by an engaging pose or a piquant gesture. One hundred fifty-seven sculptures spanning six millennia are presented in *The Quest for Eternity,* an unprecedented international cultural event.

This exhibition and its accompanying catalogue are the result of a successful collaboration between many people in both China and the United States. The magnificent works of art have been lent under the auspices of the Chinese Ministry of Culture. Arrangements for the loans were made with the generous aid of Guo Sen, deputy manager, and Lu Shaochen, office director, of the Overseas Archaeological Exhibition Corporation of the People's Republic of China. We owe a debt of gratitude to them and their staff for their kind cooperation in all phases of the organization of this exhibition, from contractual matters to the production of this book and the complex logistics of the exhibition.

I would like to express my deepest appreciation to the Board of Trustees of the Los Angeles County Museum of Art and Director Earl A. Powell III for their encouragement of this project. Dr. Powell's unswerving support and consummate diplomatic skills are largely responsible for the successful conclusion of arrangements for the exhibition. Myrna Smoot, former assistant director of Museum Programs, and John Passi, exhibitions coordinator, provided invaluable assistance in contractual and organizational matters. The important details of shipping and insurance were coordinated by Renee Montgomery and June Li of the Registrar's Office, and members of the staff of the museum's Conservation Center watched over matters of environmental control and preservation. Information on the exhibition has been disseminated by Pamela Jenkinson Leavitt and the staff of the Press Office.

This publication is the joint undertaking of authors in China and the United States. It was produced under the direction of Mitch Tuchman, managing editor of the Los Angeles County Museum of Art, with judicious editing by Susan L. Caroselli and a handsome design created by Ed Marquand Book Design. Many of the informative photographs and diagrams were provided through the kind cooperation of the Overseas Archaeological Exhibition Corporation. Julia F. Andrews and Yueh-min Wang supplied the Chinese characters for the Glossary and Character List.

Finally, I would like to thank Karen Nagamoto, secretary of the Far Eastern Art Department, for her cheerful help through all phases of the production of the catalogue and the organization of the exhibition.

George Kuwayama
Senior Curator, Far Eastern Art
Los Angeles County Museum of Art

CHRONOLOGY

Neolithic	c. 8000–2000 B.C.
Xia	c. 2000–1523 B.C.
Shang	1523–1028 B.C.
Zhou	1027–256 B.C.
Spring and Autumn	*770–475 B.C.*
Warring States	*475–221 B.C.*
Qin	221–207 B.C.
Western (Former) Han	206 B.C.–A.D. 8
Xin	8–23
Eastern (Later) Han	25–220
Three Kingdoms	220–265
Shu	*221–264*
Wei	*220–265*
Wu	*222–280*
Western Jin	265–316
Sixteen Kingdoms	301–439
Southern Dynasties	
Eastern Jin	*317–420*
Former Song	*420–479*
Southern Qi	*479–502*
Southern Liang	*502–557*
Southern Chen	*557–589*
Northern Dynasties	
Northern Wei	*386–534*
Eastern Wei	*534–550*
Western Wei	*535–556*
Northern Qi	*550–577*
Northern Zhou	*557–581*
Sui	581–618
Tang	618–907
Five Dynasties	907–960
Later Liang	*907–923*
Later Tang	*923–936*
Later Jin	*936–947*
Later Han	*947–950*
Later Zhou	*951–960*
Liao	907–1125
Northern Song	960–1126
Southern Song	1127–1279
Jin	1115–1234
Yuan	1271–1368
Ming	1368–1644
Qing	1644–1912
Republic	1912–1949
People's Republic of China	1949–

Since there are several chronological systems currently
in use, individual authors have chosen to observe
slightly different chronologies in their essays.

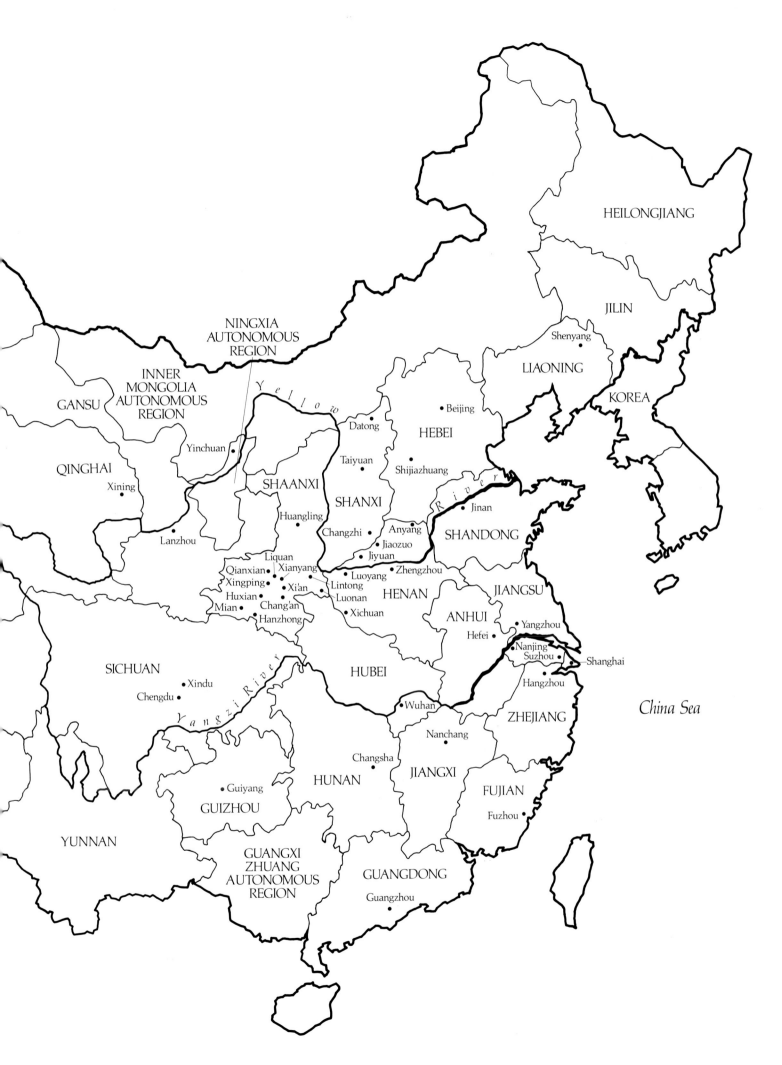

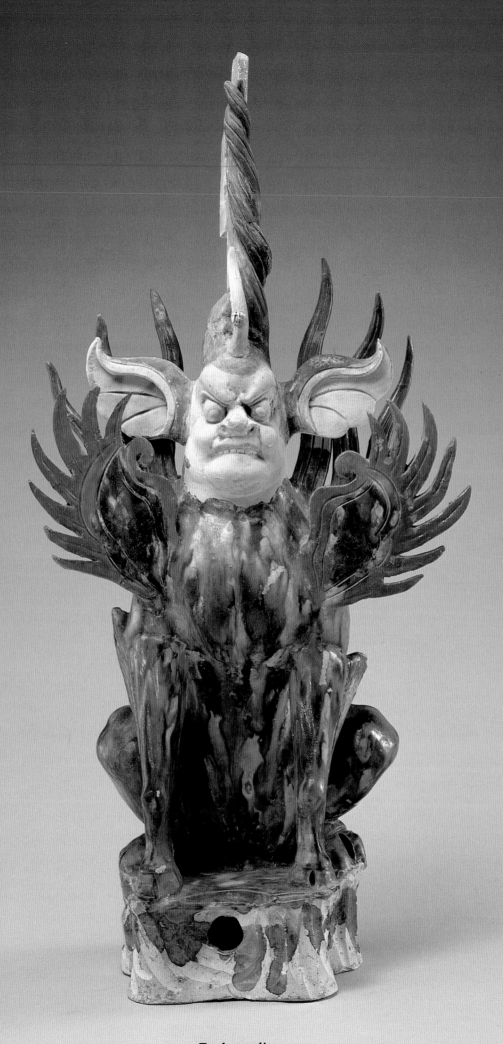

Tomb guardian
Tang dynasty, cat. no. 81

CHINESE BELIEFS IN THE AFTERWORLD

Albert E. Dien
Stanford University

There is a popular perception that China is a country without religion, and that therefore its people can have no belief in or hope for a life after death. On the contrary, the Chinese have been no exception in giving much thought to this universal human concern. Chinese folk religion in the past, and indeed down to our own time, consisted of a large, changing body of beliefs and practices, incorporating a number of sometimes contradictory systems.

The complex and fascinating subject of Chinese religion and beliefs in the afterworld has only recently begun to be studied. Previous attention was almost exclusively focused on philosophical writings, such as those of Confucius (552–479 B.C.), the greatest of Chinese sages, who suggested that speculation about the hereafter served no useful purpose:

Chi-lu asked about serving the spirits [of the dead]. The Master said, "While you are not able to serve man, how can you serve [his spirit]?" [Chi-lu added,] "I venture to ask about death?" He was answered, "While you do not know about life, how can you know about death?"

(*Analects of Confucius* XI.11)[1]

It should be noted that in this passage Confucius does not deny the existence of the hereafter; he simply affirms that the primary concern of the philosopher and intellectual should be life on this earth.

Although there is no systematic exposition of eschatological matters in the sources of the early period, we find evidence of belief in an afterlife in a variety of written materials, primarily by Taoists and Buddhists and usually in the form of miraculous tales. However, perhaps the primary source of information concerning the Chinese views of life after death remains the archaeological evidence, represented by the objects in this exhibition: "In effect, the funeral monuments of a period are generally the concrete expressions of the ideas concerning the human soul and its destiny after death. They materialize the feelings and opinions of an antiquity of which the ancient texts retain only a vague reflection."[2]

Thus, any attempt to understand Chinese beliefs concerning the other world requires a consideration of the material evidence brought to light by archaeologists and students of religion. Taking all of these into account, one may well conclude that matters having to do with funerary practices and life after death have been of crucial importance and integral to the very composition of Chinese society.

One of the enduring elements of Chinese social organization has been the hierarchical principle based on age, which is displayed in the honor rendered by the child to the parent or by the survivor to the deceased. Filial piety, which dictated so much of the behavior within the traditional family, extended beyond the grave to the obligations owed to the spirits of the dead. Confucius taught that parents must be served in death just as they had been served in life:

The Master told [Fan Ch'ih] saying, "Meng-sun asked me what filial piety was, and I answered him, 'not being disobedient.'"

Fan Ch'ih said, "What did you mean?" The Master replied, "That parents, when alive, should be served according to propriety; that, when dead, they should be buried according to propriety; and that they should be sacrificed to according to propriety."

(*Analects of Confucius* II.5)[3]

Thus, filial piety and ancestor worship formed a continuum, with ancestor worship as the basis of the conception of the other world in the Chinese system of values. In effect, the deceased remained the head of the family, and the familial reciprocal responsibilities and duties, those of parent to child as well as of child to parent, were maintained.[4] But underlying that filial and pious sentiment there was in addition a more compelling basis for this worship of ancestors: failure to fulfill obligations to the spirits of the departed could result in malevolent retribution. The Chinese have always believed in the existence of spirits of the dead, and, while there may have been changes in the details, they continue to do so. Developments in philosophy or religion have had to accommodate themselves to that belief in order to gain a hearing.

A concern with the afterworld appears in China as early as the Neolithic period, approximately the eighth to the early second millenium B.C. We have no direct statements from that preliterate period, of course, but the evidence from the graves is abundant. Increasing numbers of grave goods such as pottery, tools and weapons of stone and bone, ornaments of stone, bone, and ceramics, and even ocarina-like musical instruments bear witness to a belief that life continued after death

and that objects used during one's lifetime would continue to be employed beyond the grave. The presence of finely carved jades, often deliberately destroyed before being deposited in the grave (evidently so that they would be of use only to the dead), and of offerings of food and drink clearly indicate that the survivors were concerned about the welfare of the deceased and felt obligated to supply them with sustenance. By the late Neolithic period one begins to find animal bones cracked by the application of heat for the purpose of foretelling the future, a practice known as pyromantic divination. There is also evidence of human sacrifice. One may thus already see in this early period elements of the mortuary practices that continued into subsequent periods, some even down to the present.[5] These have important implications for our understanding of the evolving Chinese conception of the afterworld.

Many of the tendencies that one notes in the late Neolithic era reached a high level of development in the Shang (1722–1050 B.C.). The eleven royal tombs at Anyang, those of the kings who ruled in that last capital of the dynasty, represent an enormous outlay in manpower to build and to "staff." It has been estimated that each of the large, quadrate cross–shaped pits required seven thousand working days to excavate: the mouth of the pit of one of these, tomb 1001, is 19 by 14 meters, with ramps leading to the bottom on all four sides; the longest of these ramps is 30 meters long. A wooden burial chamber was built at the bottom of the pit, and burial goods of stone, jade, shell, bone, antler, tooth, bronze, and pottery were placed both inside the burial chamber and on ledges and ramps outside. These royal tombs had been thoroughly looted by the time they were discovered by archaeologists in the 1920s (all of the bronzes in museums outside China were purchased or otherwise obtained from grave robbers). However, one can get an idea of the wealth that these tombs must have contained from a relatively modest but untouched tomb recently found at Anyang. This tomb, which belonged to the queen Fu Hao, contained over sixteen hundred objects, including 468 bronzes, weighing a total of over one and a half tons, and 755 pieces of jade.

The royal tombs at Anyang also showed that human sacrifice had assumed enormous proportions by the late Shang. It is estimated that tomb 1001 contained the bodies of three hundred or more sacrificial victims. Some of these were guards buried with their weapons or charioteers lying near their chariots and horses; others of higher status were supplied with individual coffins and sets of grave goods: these may have been close attendants or dependents of the deceased. Finally, there were the ordinary victims, slaves or prisoners, who had simply been decapitated and pushed into pits or left to lie on the ramps. Very important ends indeed must have been served to justify such an expenditure of wealth and human life.[6]

It is significant that such quantities of wealth, the treasures that the king or queen had enjoyed while alive, were consigned to the grave along with the royal corpse. Respect and affection may have been contributing factors, but such sentiments could surely have been satisfied at much less cost. One may therefore surmise that it served the purposes of the ruling house to carry out such impressive funerals. If ostentatious display were the only motive, it would seem that building larger palaces or other more visible signs of pomp and power would have been more effective. So it should be no surprise to learn that the Chinese believed the fortunes of state and the welfare of the living to be dependent on the good offices of the spirits of the rulers' ancestors. The Lord on High, Shang Di, ruled the universe and controlled the fate of all; that deity could only be reached through the spirits of the earlier kings who stood at his side where they might intercede on behalf of those still on earth. The impressive interments, therefore, were meant to earn the gratitude and good services of the departed and to establish their credentials so that they might take their rightful position by Shang Di's side.

This was a mutually beneficial arrangement: the living relied on their ancestral spirits to watch out for their welfare, while these spirits were able to occupy such exalted niches in the afterworld precisely because their descendants reigned as kings and maintained the proper sacrifices. Living rulers justified their power by claiming that their ancestral spirits had special access to Shang Di and that only those who were in that line of descent were qualified to offer sacrifices. Of course, if the ruling house lost the favor of Shang Di because of immoral behavior or failure to carry out its duties, the ancestral spirits would be ousted in favor of another set whose descendants would then assume the rule of the state; in this way religion and politics came together to justify a change of dynasty.

It is possible to make such statements with a fair degree of confidence because there are written documents that have survived from the late Shang. These are the so-called oracle bones, the forerunners of which appeared in Neolithic times, but which by the Shang were inscribed, using an early form of script, with questions and sometimes with the replies. The interpretation

of the fire cracks on these bones (usually the scapula of cattle or the plastrons of large turtles) was the means by which the ancient Chinese communicated with the other world, and the inscriptions, cryptic as they are, permit us to tap into that "telephone line." The questions ranged from the trivial (would the king have a good day?) to the very important (would a military campaign be successful?). An enormous amount of time and effort went into the rituals that attended the use of these oracle bones and into the offerings made to the ancestral spirits in order to maintain the good and close relationship necessary for the proper decisions to be made.

It is clear that Shang man was basically optimistic: he believed that it was possible to establish the proper sacrifices through divination and that, if these offerings were made to the proper ancestor at the correct time, a contractual arrangement could be forged that would propitiate any unhappy ancestral spirit and ensure that the spirit would intercede with Shang Di on behalf of those still in the living world. David Keightley has made the insightful observation that it was just these "habits of an optimistic, manipulating and prognosticating religious logic" that underlay the commitment to ranks and hierarchies, contracts and stipulated criteria, by later secular political institutions.[7]

In the following periods, tombs were still supplied with impressive amounts of treasure and sacrificial victims. One example of this is the tomb of Yi, Marquis of Zeng, who died around 433 B.C.[8] The marquis was buried with an enormous treasure, including a set of bells and many other musical instruments, and the bodies of twenty-one women.

In time, there was an increasing tendency to substitute clay or wood figures for the humans who would normally have accompanied their masters in death. Confucius is reported to have condemned the burial of tomb figures to attend the deceased because he thought it would encourage the sacrifice of human attendants, although it would appear that the opposite proved to be the case.[9]

While human sacrifice was eventually abandoned, unstinting efforts to create the best possible setting for the body continued. The tomb of Qin Shihuangdi, or the First Emperor of Qin (d. 210 B.C.), must have been quite impressive, for it is described as having within it depictions of the heavens above as well as the earth below, complete with models of palaces and offices, and rivers simulated in circulating mercury. Harem ladies and workers were buried in the tomb, but their inclusion seems to have been an afterthought; what had been prepared for the burial was the astounding army of over seven thousand life-sized ceramic figures of warriors and horses as well as of female attendants.

The spirits of rulers found a haven in the heavens, but what about those of lesser status? In the period following the Shang there begin to appear references to the Yellow Springs, sometimes called the Nine Springs, which was an underground abode for the spirits of the dead. The earliest reference is contained in an anecdote in the *Zuozhuan*, a chronicle of the period 721 to 463 B.C.[10] According to this account, in 721 B.C., when the mother of Duke Zhuang of Zheng backed his brother, who contested the rule of the state, the duke became enraged and banished her from court, swearing that they would not meet again until they both descended to the Yellow Springs. He later regretted his oath but saw no way out until someone suggested that he dig a deep tunnel and arrange to meet his mother there, after which they could resume their relationship. Interestingly, the duke did not expect to meet the spirit of his mother in Heaven, since he spoke only of the Yellow Springs. This shadowy underground home of the dead would seem not to have been a happy place, for it was also the realm of Hou Tu, the Lord of Earth, who often kept souls as prisoners in his jail.[11] These early accounts do not provide any details about what the dead did or what their state was in this subterranean world, but it was believed that sacrifices would help them to be at peace there.

The Chinese have never doubted that something survives of the person after death, but ideas of what that something is have differed over time. One can find a number of attempts to explain these beliefs, but for the most part these are attempts to correlate a number of disparate and even contradictory views. It would appear that new theories about life after death do not displace the old; they simply take their place among the others. The oldest terms referring to that which survives after death are *gui* and *shen*, followed later by the terms *hun* and *po*. According to the most general formulation, a living man has two souls: the hun, an emanation of the *yang* (the light, active principle) which gives man his intelligence or spark of life — this spark is sometimes referred to as his *qi* or "breath" — and which after death ascends to the heavens as his shen; and the earthier or more material po, derived from the *yin* (the dark, passive principle) which simply animates the body and which, after the death of the individual, returns to the earth as his gui.[12] Although in common usage there does not seem to be a rigorous systematization, some distinc-

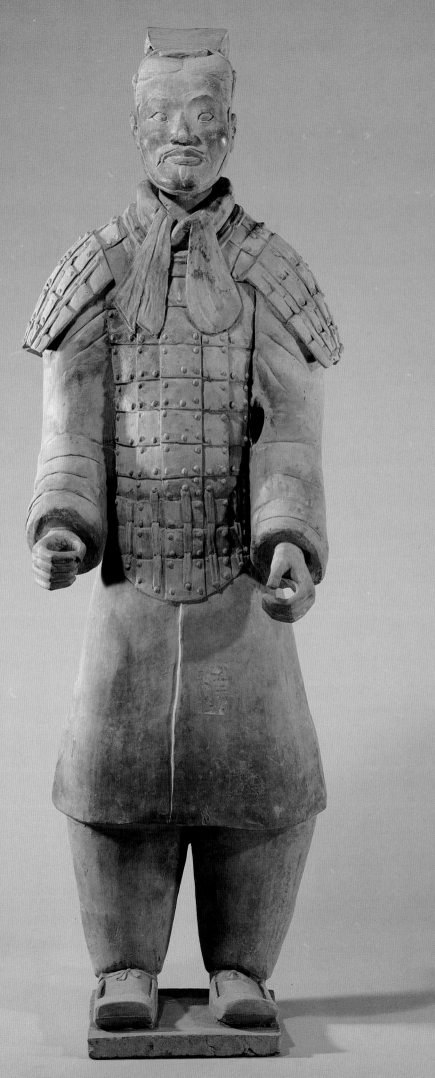

Officer
Qin dynasty, cat. no. 7

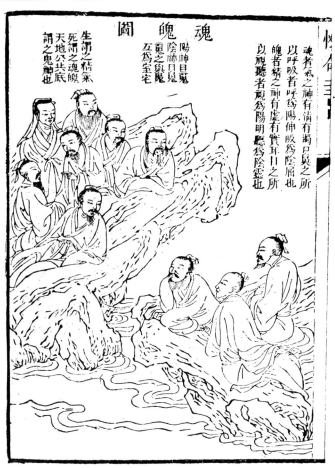

Fig. 1. The seven *po* and three *hun* of the human soul. From *Xing ming gui zhi* (1615).

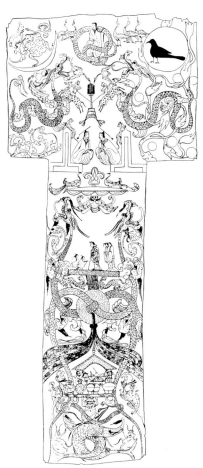

Fig. 2. Banner illustrating the journey of the *hun* to Heaven. From *Changsha Mawangdui I-hao Han mu* (1973).

tions should be noted: malevolent beings are gui, those who seek vengeance are hun; when "the life is frightened out of one," it is by the po; and those mortals who become apotheosized are shen. Later, these souls are even further subdivided, in stark contrast to the Western conception of a unitary, immaterial soul (fig. 1).[13]

One of the more dramatic events that followed the death of an individual was the attempt by the survivors to recall the hun, using a combination of threat and cajolery:

O Soul, go not to the West
Where level wastes of sand stretch on and on;
And demons rage, swine-headed, hairy-skinned,
With bulging eyes;
Who in wild laughter gnash projecting fangs.
O Soul, go not to the West
Where many perils wait!
O Soul, come back to idleness and peace.
In quietude enjoy
The lands of Ching and Ch'u.
There work your will and follow your desire

Till sorrow is forgot,
And carelessness shall bring you length of days.
O Soul, come back to joys beyond all telling![14]

There is an apparent depiction of the journey of the hun to Heaven on an extraordinary T-shaped painted banner, 205 centimeters in length, 92 centimeters wide at the top, and 47.7 centimeters wide below (fig. 2), found in a tomb at Mawangdui containing the perfectly preserved body of a woman who died sometime after 168 B.C. The difficulty in explaining the meaning of the details of this banner stems precisely from the lack of any explicit exposition of the other world and the soul's journey to it.[15]

To Chuang-tzu, or Zhuangzi, a philosopher of the fifth century B.C., earthly existence was simply the result of the conjunction of two spheres, the earthly and the ethereal, and death a result of their separation, a natural occurrence not considered a cause for grief. The implication being that as long as there was life in the body the hun and po would have a place to lodge, the Taoists

began to develop techniques, some alchemical and some holistic, to extend the life of and even to preserve forever the living body. On the other hand, Wang Chong, a tough-minded skeptic of the first century A.D., thought of life merely as a sort of coagulation of the vital fluids, and of death as their dissipation, something like ice forming and then melting into a pool of water. But for the ordinary person life and death were not so simple. The various burial customs and religious practices may be seen as attempts to come to terms with man's mortality and his fear of the harm that the spirits of the other world were capable of inflicting.

The presence of ghosts, the intrusion of the other world into this one, has been a persistent belief in China. One finds an early discussion of ghosts in the *Zuozhuan*. In the entry for 534 B.C., the appearance of a ghost is explained as follows: when a person is born he first possesses the po, or material soul, but this is soon conjoined by the hun. As the body is nurtured, or as the text has it, as the essences of things are ingested, these souls become stronger, developing a liveliness and brightness of spirit. In fact, they are so vital that if a person were cut off in his prime, the po and hun would still be able to linger in the world of the living, but, resentful of their fate, they would take on the form of evil apparitions. A deep-rooted fear of the spirits of the dead and their potential malevolence is evident in incidents reported in the *Zuozhuan* and in later writings, but our knowledge must be inferential since there is no systematic discussion of this topic.[16]

Wang Chong dealt at length with the subject, and although he was primarily interested in debunking what he considered to be superstitions and offering his own explanations for the reports of such phenomena, we can glean something of the common beliefs by looking at the views he felt obliged to attack. According to him, people imagined that the dead were like the living, that they had the same needs and were lonely and hungry. Dreading the possible retribution that the dead might visit on the living, people went to extremes in supplying the dead with whatever they might need. Wang did not deny that there might be such apparitions, but he applied logic to explain what they might represent. For example, ghosts were said to be fully clothed, which would imply that clothing, too, had an afterlife; obviously, he said, this was not so. Rather, Wang believed that these apparitions were all the result of the vital yang fluid that gave man life, but as there was no yin or material essence involved, they had only the semblance of reality.[17] However, it is doubtful that this was of much consolation to someone who believed he was dying from a wound inflicted by a vengeful ghost.[18]

During the Han (206 B.C.–A.D. 220) a new and much more elaborated view of the other world began to develop. The god of Taishan, the sacred mountain in Shandong Province, was considered to be the master of life and death, and the mountain itself became the land of the dead. Mountains had long been considered natural abodes of the dead, and burial mounds were in effect replicas of mountains. There is a statement from the third century A.D., "The Chinese believe that the spirits of the dead return to Taishan," and we find the expression "to go to Taishan" used as a euphemism for death. In a poem from the same period there is a line, "The Eastern Mountain [Taishan] has given me my term of life."[19] Perhaps because Taishan, which had for centuries been considered sacred, was in the East (the traditional locus of the yang potential), the god of Taishan was seen as the arbiter of human destiny. The shades of the dead were thought to return to Taishan where they were warehoused, as it were, their only hope for surcease from that dreary state being promotion into the ranks of the overseers, who formed a bureaucracy that coexisted and, indeed, overlapped with that of the world of the living.

The specific precinct where the spirits of the dead gathered was a small place near Taishan called Haoli, a name that appears in a song sung by a prince of the Han just before he committed suicide on imperial command in 54 B.C.:

> One desires life to be without end,
> But for long it has been without joy, when will it end?
> Having received Heaven's term, there is not a
> moment more.
> The thousand-league horse rushes along the awaited
> road.
> The Yellow Springs below are dark and deep,
> Man is born and will die, what is there about which to
> be embittered?
> Of what is there to take pleasure but in that which the
> heart enjoys,
> I find no joy in my goings and comings, and any
> pleasure is short-lived.
> Haoli now summons me and there is an inspection at
> the gate,
> In death one cannot hire a substitute, one goes
> oneself.[20]

One sees here how such terms as Haoli and Yellow Springs are used quite allusively, and it is difficult to make out how these various elements fit together. As the god of Taishan gained more and more human attributes, he came to be identified with one or another mortal who

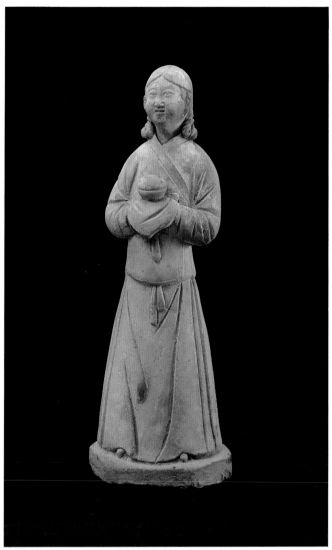

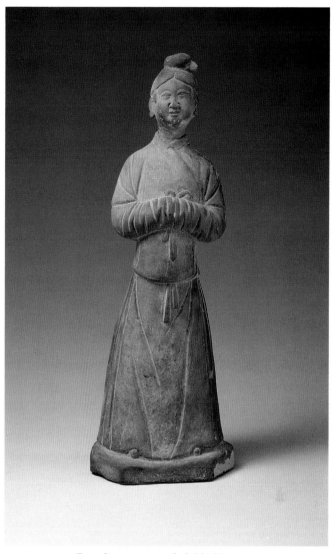

Female servant with a box
Yuan dynasty, cat. no. 100

Female servant with folded hands
Yuan dynasty, cat. no. 101

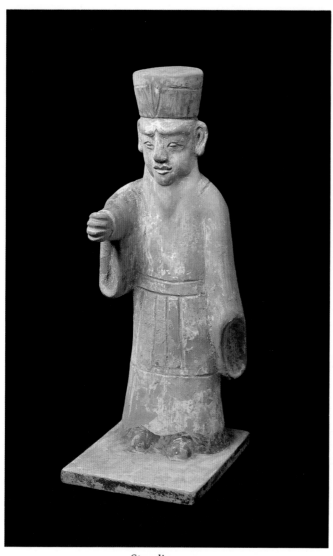

Standing man
Northern Song dynasty, cat. no. 89

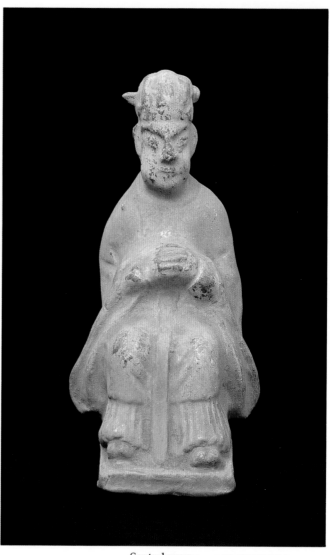

Seated man
Northern Song dynasty, cat. no. 91

during his lifetime had had a reputation as an excellent governor and who, after his death, had been apotheosized and appointed Lord of Taishan. This lord was in charge of the enormous administrative staff needed to record in detail all births and deaths and to serve as police or "runners" to summon the spirits of those who died. These ideas are perhaps spelled out most clearly in stories about Taishan, which, although obviously fiction, must nevertheless reflect to a certain extent the beliefs of the people of the time.

A certain Yin Tingxia was taken by two runners from the underworld; they put a rope around his neck and proceeded to take him away. The local god of the family (tudishen) demanded to see the warrant and, finding an error, he appealed for justice. When a court of appeals was sent from Taishan, the household god testified that he would receive a notice, each time a new family member was born, of the length of life allotted that person; thus he knew that Yin, who was then fifty, was destined to live to be seventy-two. The magistrate discovered that it was a man named Yin Tingzhi who was supposed to die, but that this man's uncle, who was a clerk in the underworld, had changed zhi to xia. The clerk was then punished and Yin was set free.

A man met an old friend, long dead, who claimed to be the runner of the Eastern Peak Bureau and who said that although he had an order to arrest the man, because of their old friendship he would give him another month. The man used the time to carry out three good deeds, in view of which he was given twenty more years of life.[21]

In this second story one may note the intrusion of a new element, that of moral judgment, which, if not a direct result of the coming of Buddhism to China, was to become critically important with the growing popularity of that religion. Original Buddhism denies the survival of souls: karma brings about rebirth, but it is not a specific individual who is reborn. This dogma was not acceptable in China where the belief in an individual soul, an unchanging self, was so ingrained. Thus, in the centuries after the Han, one could find Buddhist laymen arguing for the survival of individual souls, using as evidence anecdotes culled from such Confucian classics as the Zuozhuan, anecdotes which Confucian scholars in turn labeled as superstitions.[22] The revision of the original Indian Buddhist doctrine by native Chinese sects made possible the widespread adoption of that religion and the rise of new attitudes toward the world after death. Most importantly, adherence to moral standards became an important factor in determining the fate of

the soul. Souls now went to Taishan where their lives on earth were judged, and those who had not lived good lives were condemned to the hells of damnation. In other words, we see the emergence of a new system of beliefs, one that still carries much force today.

The present-day conception of the afterworld is fairly systematic, despite the diversity of its sources. Briefly put, there are ten hells, or underground prisons, each governed by a yama-king (Yama being the name of the god of Hell in the Indian Buddhist pantheon) and each specializing in the punishment of specific sins. The entire establishment is under the rule of the Jade Emperor, who assigns responsibility for the hells to his regent on earth, the Emperor of the Eastern Peak (Taishan). The yama-king of the first hell, whose status is higher than that of the other nine kings, performs the initial evaluation of the dead souls. Those whose good deeds outweigh their bad are reborn into the world without undergoing punishment, and the rest are punished in accordance with their particular misdeeds (fig. 3). The types of misconduct range from dishonest marriage brokerage to the practice of cannibalism, and the punishments are described in precise and gory detail: dogs gnawing on limbs, nails driven into heads, brains replaced by porcupines, and so on. Some souls are condemned to remain in the hells forever, but the souls of those who have completed their course of punishment are sent to the tenth hell where they wait to be reborn. The yama-king of this hell assigns to the souls their next place of birth in the world, determines whether it will be in human or animal form and what rank and degree of happiness it will enjoy, all on the basis of past actions. Each soul is made to drink a broth that wipes out the memory of what it has undergone, after which it is thrown into a river of crimson water that carries it to its new birth.

Although the system of hells and judgment of souls was strongly influenced by Buddhism, it was clearly adapted to the needs of those who held fast to the idea of survival of the individual soul. For those who considered themselves real Buddhists, and who saw rebirth on this earth not as a reward but as an extension of suffering, there was an alternative: through the intercession either of the Buddha himself or of the Bodhisattva Ksitigarbha, a person's soul could be extricated from this cycle of transmigration and reborn as a lotus in the Western Paradise of Amitabha Buddha. Those whose records were spotless would bloom immediately; those who had something to account for were required to meditate in the form of a closed bud until purified, after which they

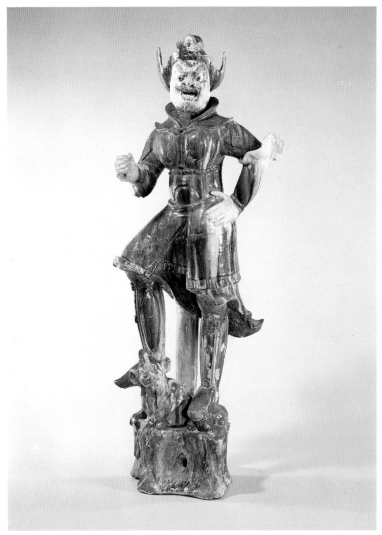

Guardian king
Tang dynasty, cat. no. 63

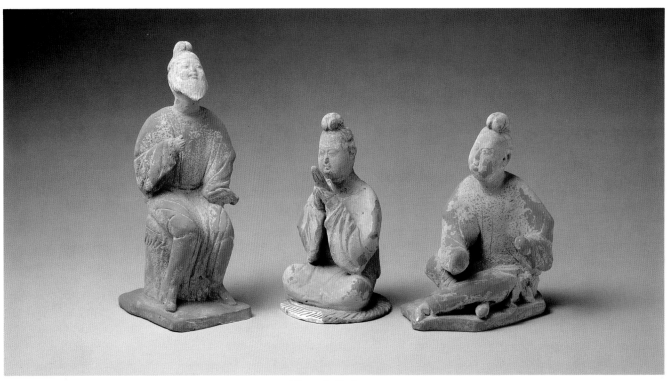

Three balladeers
Tang dynasty, cat. no. 85

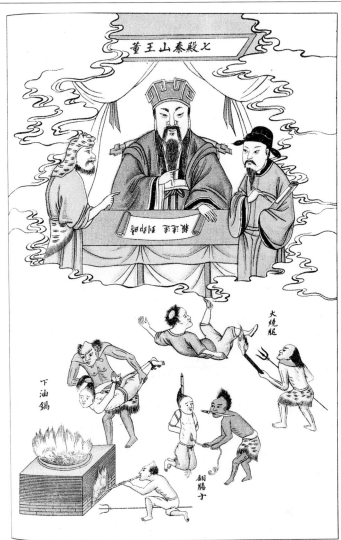

Fig. 3. A yama-king of hell presiding over the tortures of the damned. From Henri Doré, *Recherches sur les superstitions en Chine* (1914).

could flower. Rituals were developed in Taoism that had the same effect of freeing the spirit to permit it to enter the realm of Xiwangmu, the goddess who reigned over the paradise of the immortals. This very short description can only hint at the complexity of detail, the elaborate pantheon of deities involved, and the manner in which Buddhist and Taoist elements are integrated into this system of beliefs.[23]

There would seem to have been a division of responsibilities among the various kinds of souls, some going to Heaven, and others descending to the underworld, perhaps to remain in the tomb, perhaps to be reborn later. It may well be that not all these beliefs were held by any one person at any one time and place and that the apparent welter of beliefs and overlapping systems results from an attempt to compress all these various elements into a single scheme. And yet, as Anna Seidel has pointed out, there are inconsistencies that are hard to explain. For instance, one cannot assume that the hun had no place in the tomb or that the ritual of calling back the hun before the burial indicated that it was believed to have left the body and ascended to Heaven. If this was so, why would the banner that provided a guide for the journey of the hun have been placed within the coffin? There is also evidence that sacrifices were offered to the hun at the tomb. Thus, it is not at all clear that these various catagories of the soul were, in fact, believed to disperse at death.[24]

If people believed in such a dispersal, the tomb would have been seen as simply a place where the soulless material remains rotted away. However, the grave retained its significance during all periods; it was considered to be the meeting place of the two worlds, the portal to the afterlife. The Chinese held the belief that, just as the soul was able to leave the body, it could also return to it as long as the body remained whole. Thus, one finds the use of jade, ranging from pieces placed in the body's orifices to elaborate jade suits, as an attempt to stave off decay. The tomb, then, was treated as a residence, a comfortable and familiar place where people could meet and communicate with the souls of their departed ancestors. The spirit might at times remain in such a tomb furnished with the accoutrements it had used in life, or when duties called, it could depart to the other world with the paraphernalia that would guarantee its being given due recognition.

The very act of constructing the tomb was filled with potential danger since it constituted a trespass on the underworld realm, and the living attempted to obtain the security and comfort of the dead in a variety of ways. From the Han on, land contracts recording the purchase of the grave site were placed in some tombs to certify that the deceased was occupying rightfully gained land and was not an intruder. Yet another type of inscription, sometimes called by modern scholars the grave-quelling document, announced to the underworld officials the arrival of the deceased, so as to facilitate the change of registration. This document also requested that the deceased not be held culpable for digging the grave.[25] A description of burial ceremonies from the pre-Han period tells of a shaman descending into the tomb brandishing a spear and chasing out all malevolent spirits.[26] Figures representing such exorcists were placed in the tomb to provide continuing protection, and often both human and supernatural guards were painted at the tomb's entrance. There were also other apotropaic

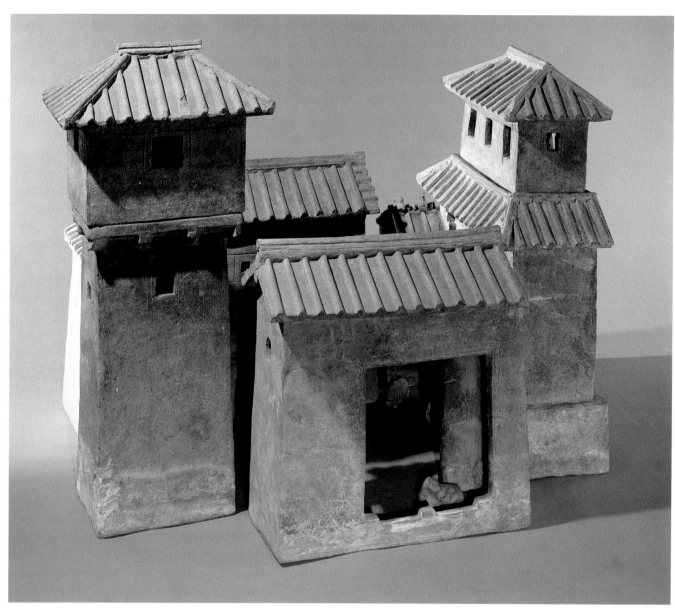

House with a courtyard
Western Han dynasty, cat. no. 24

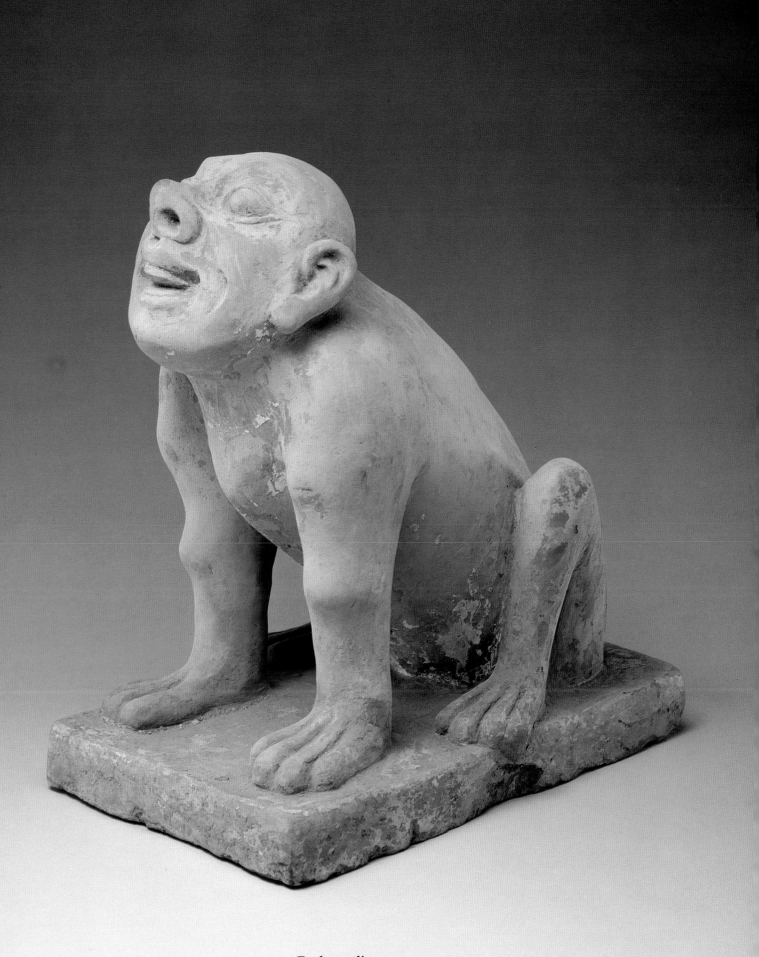

Tomb guardian
Western Wei dynasty, cat. no. 57

devices, such as the models of what are generally called *zhenmu shou,* or "grave-quelling beasts," a representative selection of which is included in this exhibition.[27]

Since death was seen as a transitional stage rather than as a conclusion to existence, and since the tomb was considered to be the new home of the soul, the chamber needed to be furnished with the necessities and even the luxuries that the deceased had enjoyed in life. The fact that the dead seemed satisfied with the mere fragrance of the sacrificial food and drink may have served as a convincing argument that images and models especially made for the tomb, what are termed *mingqi* (literally, "numenous artifacts"), could also take the place of actual objects. At any rate, by the Han one finds in the tombs models of houses, farm equipment, animals, vehicles, and servants and retainers of all sorts. Some objects, such as jewelry and weapons, were never replaced by models, and so the tombs continued to attract grave robbers. However, the use of these mingqi expanded so much that, in time, even ordinary objects such as dishes and jars came to be made especially for burials; these can be recognized by such features as their poor quality, inability to hold stored liquids, and nonfunctional spouts.

To maintain the proper hierarchical distinctions even after death, sumptuary laws were issued specifying the quantities of grave goods that could be interred. Such laws were necessary because, in their filial zeal, families would often go bankrupt and poor sons sell themselves into servitude in order to pay for the funerals. One must note that such expenditures of family resources were also used to augment social status, somewhat akin to the role that large weddings play in our own society.[28]

The use of grave goods continued for centuries, as the objects in this exhibit demonstrate, but parallel to it was the practice of burning paper money, as well as drawings of servants, houses, and animals, these things being carried to the deceased in Heaven by the smoke, the same channel by which sacrificial offerings had been conveyed since the Shang.[29] In time, paper facsimiles came to replace clay models; even today in many Asian countries elaborate models of houses, television sets, and even airplanes are all consigned to the flames during funeral services.

The burning of these paper and bamboo models demonstrates the continuing force of these age-old beliefs concerning the afterworld. The hierarchical structure of the society bridges the worlds of the living and the dead, and people continue to owe support and deference to the spirits of their elders and to depend on them for guidance and protection. These observances are marked by a particular urgency, for the potential malevolence of the spirits is seen as being even greater than the most unreasonable behavior of a living parent (a common saying is that a father's temper is like the weather, because it is always changing).

The ultimate nature of the soul and its fate was, as we have seen, the object of much speculation, and beliefs changed over time to accommodate innovations in religion and society, even as many inherent ambiguities and contradictions remained unresolved.

Fan Ch'ih asked what constituted wisdom. The Master said, "To give one's self earnestly to the duties due to man, and, while respecting spiritual beings, to keep aloof from them, may be called wisdom."

(Analects of Confucius VI.20)[30]

The state in China was concerned only with the state cult and was never identified with a body of religious teaching; China differed in this respect from the West. There was never an organized church that was able to impose a coherent and consistent doctrine on the population. The result has been the redundancy we have noted as well as the coexistence of beliefs in a number of different realms of the spirit, all of which resist efforts at rationalization and consistent explanation. However, given the perennial uncertainty about the afterlife, this approach may in the end be the most reasonable one; Confucius' advice to keep a distance from the gui-shen is not so much agnostic as it is sensible.

Notes

I wish to express my appreciation to Beata Grant for her editorial assistance and to Dr. Donald Harper for his helpful suggestions.

1. James Legge, trans., *Confucian Analects* (Oxford, 1893), 240–41.

2. Fernand Buckens, "Les antiquités funéraires du Honan central et la conception de l'âme dans la Chine primitive," *Mélanges chinois et bouddhiques* 8 (1946–47): 2.

3. Legge, *Confucian Analects*, 147.

4. Paul Pelliot, "Die Jenseitsvorstellung der Chinesen," *Eranos Jahrbuch* 7 (1939): 69–78.

5. For the Neolithic period, see Kwang-chih Chang, *The Archaeology of Ancient China*, 3d rev. ed. (New Haven: Yale University Press, 1977).

6. For the Shang, see Kwang-chih Chang, *Shang Civilization* (New Haven: Yale University Press, 1980).

7. David N. Keightley, "The Religious Commitment: Shang Theology and the Genesis of Chinese Political Culture," *History of Religion* 17, nos. 3–4 (1978): 211–25.

8. Robert L. Thorp, trans., "Brief Excavation Report of the Tomb of Marquis Yi Zeng at Sui Xian, Hubei," *Chinese Studies in Archeology* 1, no. 3 (winter 1979–80): 3–45.

9. Doris Croissant, "Funktion und Wanddekor der Opferschrein von Wu Liang Tz'u," *Monumenta Serica* 23 (1964): 109–110 n. 68. Croissant believes that a direct derivation of these figures from human sacrifices

is questionable. She thinks that figures of warriors, officials, and so forth, were used less as an ersatz of earlier human sacrificial victims than as representations of the retainers who served the deceased while alive. However, the purpose of having people, whether human or figural, accompanying the dead, was the same. According to *Li chi* 9.20a–b, Confucius approved of the use of *mingqi* (that is, objects made specifically to be placed in the tomb) because the use of real objects in a burial might suggest the offering of human victims as well. What Confucius objected to was the use of realistic depictions of humans because, again, it might lead to human sacrifice. This sentiment is also attributed to Confucius by Mencius: "When Confucius said, 'Were there not consequences from beginning to make figurines?' it was that they used them because of their resemblance to humans." The implication here also is that the use of realistic figures led to the use of human victims; see *Meng-tzu* 1A.4. My translation of Mencius' statement above differs from the usual rendition; see, for example, D. C. Lau, *Mencius* (Harmondsworth, Middlesex: Penguin Books, 1970), 52: "The inventor of burial figures in human form deserves not to have any progeny."

10. On the *Zuozhuan*, see Burton Watson, *Early Chinese Literature* (New York: Columbia University Press, 1962), 40–66.

11. Michael Loewe, *Ways to Paradise: The Chinese Quest for Immortality* (London: George Allen and Unwin, 1979), 10–13. See also Joseph Needham, *Chemistry and Chemical Technology,* vol. 5 of *Science and Civilisation in China* (Cambridge: Cambridge University Press, 1974), pt. 2:84–85.

12. Croissant, "Funktion und Wanddekor," 106.

13. For the later division of the *hun* and *po* into multiple souls, see Needham, *Chemistry and Chemical Technology,* pt. 2:88–93.

14. Excerpt from Ch'ü Yuan, "The Great Summons" (third century B.C.?), trans. Arthur Waley, in *Madly Singing in the Mountains: An Appreciation and Anthology of Arthur Waley,* ed. Ivan Morris (New York: Harper Torchbooks, 1970), 166.

15. See Loewe, *Ways to Paradise,* 17–59; Anna Seidel, "Tokens of Immortality in Han Graves," *Numen* 29 (1982): 79–87; and the literature cited on page 87 of the latter.

16. Fear of the shades of the dead was openly admitted. Anna Seidel, in *"Post-Mortem* Immortality; or, The Taoist Resurrection of the Body," unpublished manuscript: 7, cites inscriptions in Han tombs that command the spirit to stay away from the living. Yan Zhitui (531–c. 561), whose writings contain many valuable observations about the society of his time, wrote: "According to unorthodox books, after a man's death there is a day when his soul returns, and on such a day all his sons and grandsons would run away, no one daring to stay at home. Charms are drawn on tiles and plates to prevent the return. On the day for carrying the coffin to burial, fires are lighted and ashes spread on the doorway to repel the family ghost and sever connections with it"; see *Family Instructions for the Yen Clan,* trans. Ssu-yü Teng (Leiden: E. J. Brill, 1968), 36.

17. Alfred Forke, "All About Ghosts," chap. 18 in *Lun-Heng: Philosophical Essays of Wang Ch'ung,* 2d ed. (New York: Paragon, 1962), 1:239–49.

18. For example, see Albert Dien "The *Yuan-hun chih* (Account of Ghosts with Grievances): A Sixth-Century Collection of Stories," in *Wen-lin: Studies in the Chinese Humanities,* ed. Tse-tsung Chou (Madison: University of Wisconsin Press, 1968), 211–28; and Alvin P. Cohen, *Tales of Vengeful Souls,* Variétés Sinologiques, n.s., no. 68 (Taipei, Paris, Hong Kong: Institut Ricci, 1982).

19. Édouard Chavannes, *Le T'ai chan: Essai de monographie d'un culte chinois* (Paris, 1910), 399–400. See also Croissant, "Funktion und Wanddekor," 111–12.

20. *Han shu* (History of the Han) (Beijing: Zhonghua shuju, 1962), 8.268.

21. For these stories and others, see Chavannes, *Le T'ai chan,* 410, 413. A particularly interesting tale has been translated by Donald E. Gjertson in "A Study and Translation of the *Ming-pao-chi:* A T'ang

Dynasty Collection of Buddhist Tales" (Ph.D. diss., Stanford University, 1975), 298–306.

22. Walter Liebenthal, "The Immortality of the Soul in Chinese Thought," *Monumenta Nipponica* 8 (1952): 327–97. See also Henri Maspero, "Chinese Religion in Its Historical Development," in *Taoism and Chinese Religion,* trans. Frank A. Kierman, Jr. (Amherst: University of Massachusetts Press, 1981), 3–74, and especially 47–48; W. Pachow, "The Controversy over the Immortality of the Soul in Chinese Buddhism," *Journal of Oriental Studies* 16 (1978): 12–38; and Whalen Lai, "Beyond the Debate on the 'Immortality of the Soul': Recovering an Essay by Shen Yüeh," *Journal of Oriental Studies* 19 (1981): 138–57.

23. Henri Maspero, "The Mythology of Modern China," in *Asiatic Mythology,* ed. J. Hackin (New York, n.d.), 363–75; reprinted in Maspero, *Taoism and Chinese Religion,* 176–87. For the earlier history of Taoist developments, see Michel Strickmann, "The Mao Shan Revelations: Taoism and the Aristocracy," *T'oung Pao* 63, no. 1 (1977): 12–13; and Laurence G. Thompson, "A Note on the Prehistory of Hell in China," unpublished manuscript. For the Taoist rituals, see Seidel, *"Post-Mortem* Immortality," 10–14.

24. Seidel, "Tokens of Immortality," 106–11. The importance attached to the placement of the tomb and the custom in some areas of a second burial in a different plot to improve the fortunes of the family testify to the remains being significant in themselves. See J. J. M. de Groot, *The Religious System of China* (Leiden, 1892–1910), 2:379–81 and 4:5–6 for discussions of the soul remaining at the grave.

25. See Terry F. Kleeman, "Land Contracts and Related Documents," in *Makio Ryōkai hakasei shōju kinen ronbunshū: Chūgoku no shūkyo-shisō to kagaku* (Collection of essays to mark the sixtieth birthday of Dr. Ryōkai Makio: Chinese religion, thought, and science) (Tokyo, 1984), 1–34.

26. *Chou-li* 31.12a–b. See also Donald Harper, "A Chinese Demonography of the Third Century B.C.," *Harvard Journal of Asiatic Studies* 45, no. 2 (1985): 482.

27. *Zhen,* or "quelling," might better be translated as "garrisoning" or "securing," since what are being quelled are the malevolent beings who threaten to intrude into the tomb.

28. As Martin J. Powers demonstrates in his study, "Pictorial Art and Its Public in Early Imperial China," *Art History* 7, no. 2 (1984): 135–63, the tombs may also have had an important social function, not least being a demonstration of the family's adherence to approved social values, which was helpful in maintaining and improving the family's status. Such observances could easily be carried beyond expressions of natural grief. Yan Zhitui (see note 16) cites the case of a high-ranking person whose reputation for filial piety, gained through his display of deep mourning, was lost when it was revealed that he had used castor beans to raise welts on his face to give the appearance of excessive weeping; see *Family Instructions,* 110.

29. Paper money was burned to reimburse the Celestial Treasure for the emoluments of one's life on earth, which were seen as a loan, to keep the account from being exhausted prematurely, and to accumulate a bankroll that could be drawn upon to make life in the hereafter more comfortable. Statements and receipts were burned along with the paper money to aid in the bookkeeping. In Anna Seidel's review of Hou Ching-lang, *Monnaies d'offrande et la notion de trésorerie dans la religion chinoise,* in *History of Religions* 17, nos. 3–4 (1978): 419–31, she points out that this practice is more characteristic of a bureaucratic structure than of a commercial enterprise; that is, these payments were made by an "administered, registered, taxed, and conscripted subject (or, more precisely, object) of a centralized bureaucracy in which the officially recorded facts determined wealth or poverty, life or death" (p. 429). The burning of such drawings at funerals was reported by Marco Polo, who commented, "This is done in the belief that the deceased will possess in the other world all these conveniences in their natural state of flesh and bones, together with the money and the silks"; see *The Travels of Marco Polo,* ed. Manuel Komroff (New York: Modern Library, 1926), 237–38.

30. Legge, *Confucian Analects,* 191.

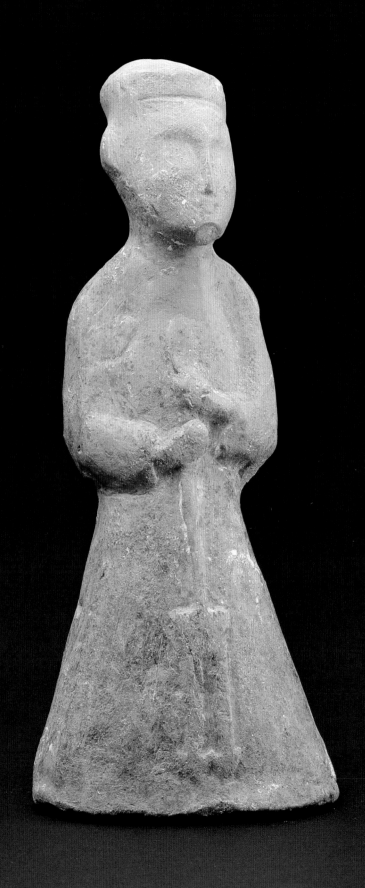

Farmer with spade
Eastern Han dynasty, cat. no. 30

THE QIN AND HAN IMPERIAL TOMBS AND THE DEVELOPMENT OF MORTUARY ARCHITECTURE

Robert L. Thorp
Washington University in St. Louis

To many foreign travelers visiting museums in China it must appear that Chinese archaeologists have been inordinately preoccupied with the excavation of tombs for the last thirty-five years. While this impression does not do justice to Chinese archaeology,[1] it does serve to emphasize the importance of mortuary art and architecture in traditional China and the effects of elaborate burials on Chinese society. As early as the Neolithic period, beginning in the sixth millennium B.C., one finds conspicuous evidence of a concern for the afterlife on the part of the ancestors of the Chinese people. In early historic times, the late Shang period of the twelfth century B.C., lavish burials were already a potent force shaping society. Throughout the imperial era, from the third century B.C. onward, the rites of mourning and burial had a profound impact on society and economy. What a visitor finds in Chinese museums, therefore, are the surviving pieces of a much larger social edifice. This mortuary culture produced not only artifacts but also structures aboveground and below and included the workshops and artisans whose task it was to create the trappings of a proper funeral and burial.

Functions of the Tomb

Certain assumptions underlie the construction of a tomb chamber. Most fundamentally, those committed to such a project must be convinced of its value to them as well as its putative benefit to the deceased, their kin. It may be considered worthwhile to install the deceased in a comfortable underground chamber in order to prevent his spirit from turning into a malevolent ghost that would harass the living. It might be thought desirable to build and furnish a well-designed tomb as a demonstration of filial virtue in order to impress one's peers. Not least, one must assume a basic continuity between life and death and a social order in which what one does for one's parents is, at a later date, done by one's progeny. The ancient injunction to "treat the dead like the living" carries the norms of society across the threshold of death. A mortuary culture cannot flourish without some, if not all, of these assumptions.

A tomb was a safe resting place for the physical corpse, a relic of a much-loved relation. Coffins were the primary equipment with which to protect the corpse, and in some instances the ancient people of China were remarkably successful at preserving mortal remains.[2] The coffins and other appurtenances of burial might be decorated with apotropaic motifs, which carried forward the duties of the exorcist whose task it was to rid the tomb chamber of evil spirits and noxious influences during the funeral.[3]

A tomb chamber also functioned as a support system for the deceased in the Yellow Springs.[4] Many of the gifts offered at the funeral — food, drink, and clothing — were at least symbolically designed to allow a style of life in this netherworld that was as comfortable as that aboveground. It remains to be determined how literally the utility of such gifts was understood by those making the donations. In theory, the earthly soul resided in the tomb, and foodstuffs in particular were "consumed" by it. A "hungry ghost" would be the unhappy consequence of a burial without such offerings. From the writings of Xun Zi (c. 298–238 B.C.) and his followers, however, it seems the real value of such offerings was as a sign of respect and concern:

The rites of the dead can be performed only once for each individual, and never again. They are the last occasion upon which the subject may fully express respect for his ruler, the son express respect for his parents. . . . In the funeral rites, one adorns the dead as though they were still living, and sends them to the grave with forms symbolic of life. They are treated as though dead, and yet as still alive, as though gone, and yet as still present. . . . Articles that had belonged to the dead when he was living are gathered together and taken to the grave with him, symbolizing that he has changed his dwelling. But only token articles are taken, not all that he used, and though they have their regular shape, they are rendered unusable.[5]

Grave goods assumed other roles, the most important being to proclaim and demonstrate the status of the deceased. Indeed, almost every aspect of the tomb, its design, and its furnishings could be related to social or ceremonial rank. The prescriptions on coffins, for example, represent the kind of thinking involved: "Hence the inner and outer coffins of the Son of Heaven consist of seven layers; those of the feudal lords consist of five layers. . . ."[6] Newly excavated documents from southern China suggest that an official, at least, was received by a mirror-image underworld bureaucracy.[7] The son of the Marquis of Dai interred at Mawangdui was sent to the netherworld by his Household Assistant, Fen, with a

wooden tablet addressed to the "Lord Master of the Burials."

Much of the iconography of tomb decor can be interpreted with such concerns in mind. Some tombs became memorials to the deceased and incorporated incised designs or wall paintings that recorded in pictorial form his status, accomplishments, filial piety, or courage. The front chamber of a late Eastern Han tomb at Wangdu, Hebei Province, opened in 1952, was decorated with large painted images of the deceased's official staff, shown in reverent poses facing the rear chamber, which contained the coffin.[8] The decoration of this tomb reflects the heritage of the Bronze Age, when the members of a household were killed and buried at the time of their lord's death. Another late Eastern Han tomb at Holingol, Inner Mongolia, presents the pictorial biography of the deceased on wall panels decorated with key promotions in the man's career, diagrammatic maps of stations to which he was posted, and related details from his dossier.[9] In this instance the tomb chambers memorialize the deceased in literal terms specific to him. Other examples of tomb decor found more widely throughout late Western Han and Eastern Han have a generalized memorial import, suggesting the virtue and courage of the deceased.

A tomb vault also served as the location of ceremonies during the funeral and, later, for further family burials, customs that were a part of the Han reform in burial rites during the second and first centuries B.C. Previously it had been unnecessary to construct a tomb chamber on a scale large enough to accommodate living visitors or to develop a structure and materials appropriate to repeated openings and interments. Structural changes were accompanied by new floor plans that mimicked the homes and estates of the living. Continuity and equivalence underlay architectural expression in the tomb, just as they motivated the furnishings and treatment of the corpse.

The types of figures represented in this exhibition complement several of the roles discussed above. Although there is no evidence that the people of ancient China believed tomb figures to be animated after burial, the creators of these ceramic sculptures invested them with the breath of life, elevating them from the status of expendable artifacts.

Qin and Han Imperial Tombs

The greater portion of the procedures and artifacts of burial in the early imperial age grew directly from norms established during the preceding Bronze Age.[10] Clan burials were sited in a common cemetery plot, marked by mounds whose scale was regulated by social rank. Underground burial chambers designed to contain both the coffin and the investment of grave goods were installed below the tumulus. Wooden coffins, containing not only the corpse but also personal possessions, including mirrors, garment hooks, and jewelry, were carried from the residence of the deceased and interred in the burial chamber during the funeral. Gifts of food and drink were placed in the chamber, as were funeral paraphernalia such as banners used in the cortege and vessels for sacrificial offerings appropriate to the funeral rite and the rank of the deceased. Figures symbolizing some of the staff, servants, or household were provided. Decoration on the coffins or in the chamber embodied the wishes of the living for the protection and good fortune of the deceased.

However, the early imperial period — the Qin (c. 221–210 B.C.) and Han (c. 206 B.C.–A.D. 220) dynasties — saw profound transformations of the established mortuary traditions of the Bronze Age. These revolutionary developments coincided with the unification of "all under Heaven" by the First Emperor of Qin and the succession of the Han house. The transformations had two aspects: the creation of a new canonical system of mourning and burial for the emperor and the more gradual development of new plans, structures, and furnishings for the elite, developments that echoed the new imperial system.[11]

Qin Tradition and the First Emperor's Tomb

Until recently, little archaeological data was available for Qin mortuary customs prior to unification, and thus the Qin contribution to the new imperial system of burials remained obscure. The most promising site for preunification Qin tombs is the extensive tracts of royal burials south of modern Fengxiang, Shaanxi Province, the location of Yong, the Qin capital from about 676 to 362 B.C.[12] Much work remains to be done at this site, but first investigations indicate that the dukes of Qin built exceptionally large tombs unmatched at sites elsewhere. Tomb 1 at tract 1 south of Fengxiang (fig. 1) has been measured at 300 meters in length from the end of its west ramp to the end of its east ramp. At the center of these ramps (156 and 84 meters long, respectively) stands the burial pit, 59 by 38 meters at ground level and 24 meters deep. This is merely one of several tombs, all of large scale, found in this tract; other pits for offerings were also located nearby. A total of thirteen tracts have

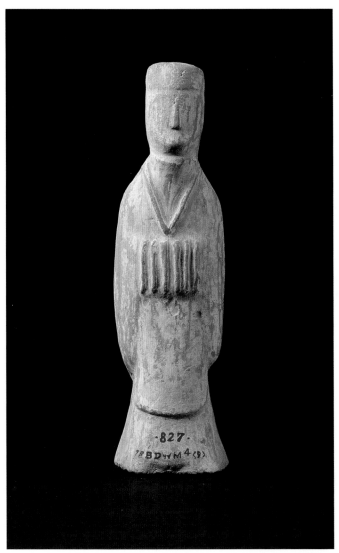

Attendant
Eastern Han dynasty, cat. no. 31

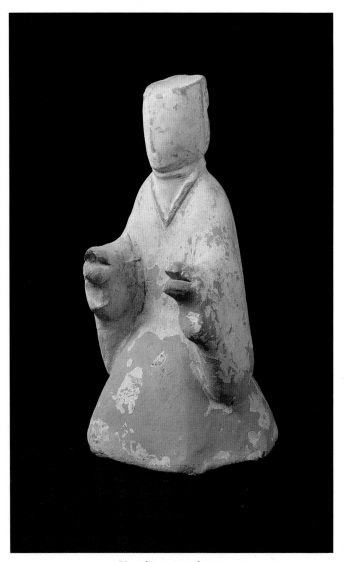

Kneeling attendant
Eastern Han dynasty, cat. no. 32

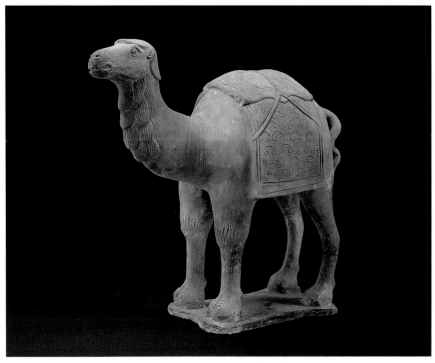

Camel
Yuan dynasty, cat. no. 104

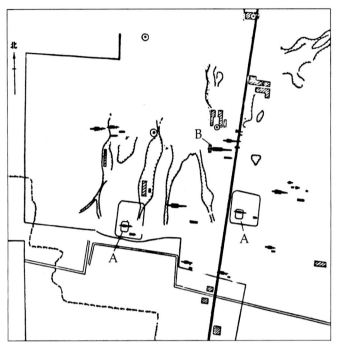

Fig. 1. Map of the Qin royal tomb district near Fengxiang, Shaanxi Province. *A,* tombs with double dry moats; *B,* tomb 1. From *Wenwu,* 1983, no. 7.

been identified through probings; several are defined by double dry moats that segregate the principal tomb and its accompanying components from neighboring zones. At Fengxiang the principal tombs apparently faced east, not south, as was usual in other areas and became the norm after unification. Although the tombs were not surmounted by tumuli, it is likely that there were temple structures above them.

The grandiose scale that characterizes the royal tombs at Fengxiang was to be more than anything else the hallmark of the First Emperor's own designs. A well-defined tomb precinct does not distinguish Qin practice from that of the states on the central plains, but the use of dry moats is unusual. Eastward orientation would seem to be another local trait. The lack of mounds and the likelihood of temple structures over the tombs link Qin mortuary sites to such distant ancestors as the Shang.[13] A system of long ramps leading to deep vertical pits not only continues the Shang model but also parallels practices well established on the central plains, as at Guweicun, in the royal burials of the state of Wei.[14] The dukes of Qin placed smaller tombs of close relations and large pits for chariots and offerings near their own burials, again a custom common among the states of the central plains.

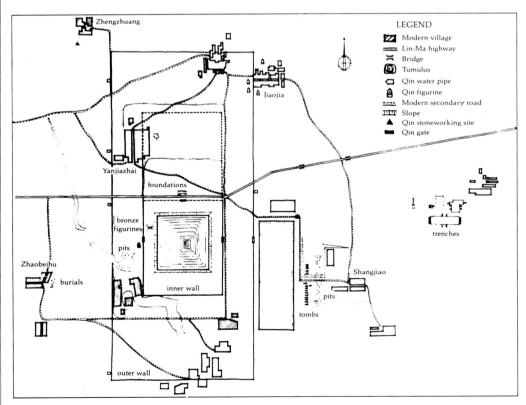

Fig. 2. Plan of the Lishan necropolis of the First Emperor of Qin, Lintong, Shaanxi Province. Rendering by Y. S. Huang.

Recent work at Fengxiang places the accomplishment of the First Emperor in perspective. His necropolis, Lishan (fig. 2), located east of modern Xi'an in Lintong District, Shaanxi,[15] had the following salient features: a site far from the principal residential palaces and oriented to face east, with a double rectangular wall defining the precinct;[16] a massive tumulus of pounded earth placed in the south portion of the precinct, balanced by an architectural complex on the north; pits containing sacrificial offerings both within the precinct and outside its walls; and nearby subsidiary sites for lesser burials and supporting facilities. The architects of the First Emperor utilized both Qin traditions and those of the central plains: a rectangular double wall blends the two systems, while the construction of a tumulus was a conscious adoption of a practice found among the other states of northern and southern China. Some aspects of Lishan, however, were apparently unique to the First Emperor, most notably his decision to place his own tomb alone within a large precinct without regard for his relations. The trenches containing the "underground army" of terra-cotta warriors and horses (cat. nos. 6–9) continued the practices of Qin and the states of the central plains, but for a new, unprecedented purpose.

The underground chambers of the Lishan tomb are as yet unexcavated, but informed speculation is possible.[17] It is likely that the main burial vault was in part a stone structure, perhaps containing a wooden chamber, and that this vault had a central plan so that the coffin was surrounded on all sides by areas in which grave goods were placed.[18] Literary descriptions of the vault of the First Emperor abound with what sounds like hyperbole and fiction, but recent findings of high mercury concentrations under the mound lend some credence to the account of Sima Qian (c. 145–86 B.C.) that the chamber included a topographical map of the world in which mercury was used to represent the movements of the rivers and seas.[19] Where does exaggeration stop and historical reality begin? In the case of the First Emperor, one should probably anticipate more discoveries that will set the boundary of reality closer to "hyperbole."

Other aspects of the Lishan site, such as the "underground army," are no less remarkable.[20] Such a project made great demands on the resources and organizational genius of the new imperial system. The conventional figure of 700,000 convict laborers working on the tomb begins to suggest the magnitude of the project. How were these laborers housed and fed? How was the work itself coordinated? How was so much clay prepared, and how were artisans assigned to the various stages of production required for each type of warrior and horse? How many kilns were constructed, and how was fuel kept in constant supply? The warrior and horse figures were, of course, but one aspect of a much larger project. Consider the amount of earth to be moved, the quantities of architectural stone carving and tiles needed, not to mention timbers and other building materials. Surveying itself was no small matter at a site where the outer precinct wall was more than 2 kilometers in length. The more one considers the challenges of the necropolis in its totality, the greater is the sense of awe it inspires.

The Han Imperial Tombs: Plans and Surface Structures

In defining the features of imperial tombs, the Han court hewed close to the Qin model. The Western Han tombs near modern Xianyang, Shaanxi (northwest of Xi'an), still look much like the Lishan necropolis, and recent surveys and excavations have demonstrated a multiplicity of connections from Qin to Han at the imperial level.[21]

Eleven imperial tombs were constructed during Western Han, nine on the plain above the Wei River to the northwest of the capital, Chang'an, and two to the east of that city. Maoling, the tomb of Han Wudi (r. 141–87 B.C.), the most dynamic and expansive Han sovereign, was built about 40 kilometers northwest of Xi'an. Like the First Emperor, Wudi was confident enough to place his burial well away from the palaces and defenses of the capital proper. The other eight tombs in this region were all closer to the capital and were therefore more accessible when an imperial progress was made to offer sacrifices. Each of these nine tombs is dominated by a four-sided, truncated pyramidal burial mound of pounded earth, the most obvious debt to the First Emperor's Lishan necropolis. The Maoling tumulus (fig. 3) is predictably the largest, fully 230 meters square at the base and 46 meters in height.[22] Its taut profile contrasts markedly with the sagging contour of the Lishan mound. The other imperial mounds vary in size from 150 to 200 meters square; all are about 30 meters high. Two of these mounds have a stepped profile; it has recently been suggested that such shapes symbolize magic mountains and may therefore be linked to cults associated with such sites.[23]

Like Lishan, Maoling and other Han tombs are enclosed by walls, but by only one square wall around the mound rather than a double rectangle. Gates allowed access at each side; the foundations of paired gate towers

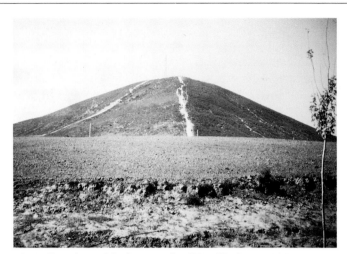

Fig. 3. Tumulus at Maoling, tomb of Han Wudi, near Xingping, Shaanxi Province. Photo courtesy Karen L. Brock.

still survive at several sites. Evidence for surface architecture consists at this point mostly of broken roof tiles and other architectural pottery. The survey conducted at Maoling found pounded earth extending in every direction from the mound to the wall of the precinct, so hard that, even today, local farmers have difficulty cultivating it. Such a firm earth bed would, of course, be a necessity to carry and distribute the immense weight of a burial mound.[24] Textual sources indicate that several establishments were erected at or near the tomb: a formal hall containing the ritual paraphernalia and regalia of the deceased sovereign, a retiring hall used by the sovereigns who visited the site during ritual observances, and a temple dedicated to the deceased emperor. Physical traces of these structures have generally been elusive, but at the Maoling the formal hall may have been located about one kilometer southeast of the mound.[25] Texts also suggest that Wudi's temple was well to the east of the tomb site, rather near the Pingling mausoleum.

The Western Han imperial tombs also added new features not attested at Lishan. All of the sovereigns, from the founder, Gaozu (r. 206–195 B.C.), to Xuandi (r. 74–49 B.C.), established "mausoleum towns" near their tombs, with populations of wealthy families relocated from outside the capital districts, whose taxes would be directed toward maintaining the imperial establishment at their door.[26] The wall enclosing the tomb settlement at Gaozu's tomb, the Changling, measures 2,000 by 1,200 meters.[27] Since the imperial tombs were built over many years and frequently visited during their construction by the Han sovereigns, they represented a real burden on the imperial coffers. One tradition enshrined in historical sources holds that emperors began work on their tombs in the second year of their reigns, and committed to the project one-third of the treasury at their disposal.[28] Mausoleum towns and the income they supplied were therefore a prudent financial measure.

In addition, the Han sovereigns adopted the custom of burying their consorts and favorites nearby, and today some five hundred burial mounds dot the plains surrounding the larger imperial tumuli. Tombs of empresses were smaller than those of their spouses and were placed to the east of the sovereign's mound. Lesser accompanying burials were generally clustered to the east and north of the twin imperial mounds. The walled precincts of those mounds often faced either north or east, suggesting the direction of a formal approach to the site. Smaller mounds were of several shapes, and some had trenches or pits located among them for burial goods. At least 175 accompanying burials have been surveyed. Changling itself has more than 70; Anling, at least 12; Yangling, more than 34; Maoling, 12; Pingling, more than 23; Duling, 58; Weiling, 32; and Yiling, 15.

Even though no Western Han imperial tomb has yet been opened by archaeologists, the artifacts recovered through surveys and random discoveries are truly impressive. Excavations at Anling, the tomb of Huidi (r. 195–188 B.C.), uncovered a long brick-lined trench that contained several hundred figures of warriors and livestock (cat. nos. 21–23). This trench was first partially exposed in 1950, but recent work has revealed it to be square in plan, dug around the base of a small accompanying burial mound.[29] Sixteen mounds still survive in this tract, and more discoveries should be expected.

Wendi (r. 180–157 B.C.) gained the admiration of court scholars by resisting the temptation to erect an ostentatious burial mound. Instead, he used a mountain for his tumulus, the Baling, and took the further unusual step of having ceramic objects made for burial rather than consigning great quantities of palace valuables to the grave.[30] The tomb itself has not been located by archaeologists, but it is reasonable to suppose that it is a rock-cut chamber similar to those known from sites like Mancheng.[31] Several accompanying burial mounds have been investigated in the Baling area. Near one of these, probably that of Empress Dou (d. 135 B.C.), was located a large tract of sacrificial pits with figures (cat. nos. 16–18)[32] that fulfill the same purpose as the many small kneeling servants found along the outer wall of the First Emperor's tomb (cat. no. 10). Such sensitively rendered creations may be products of the imperial workshops, of the sort that might have been used for the sovereign's own burial.

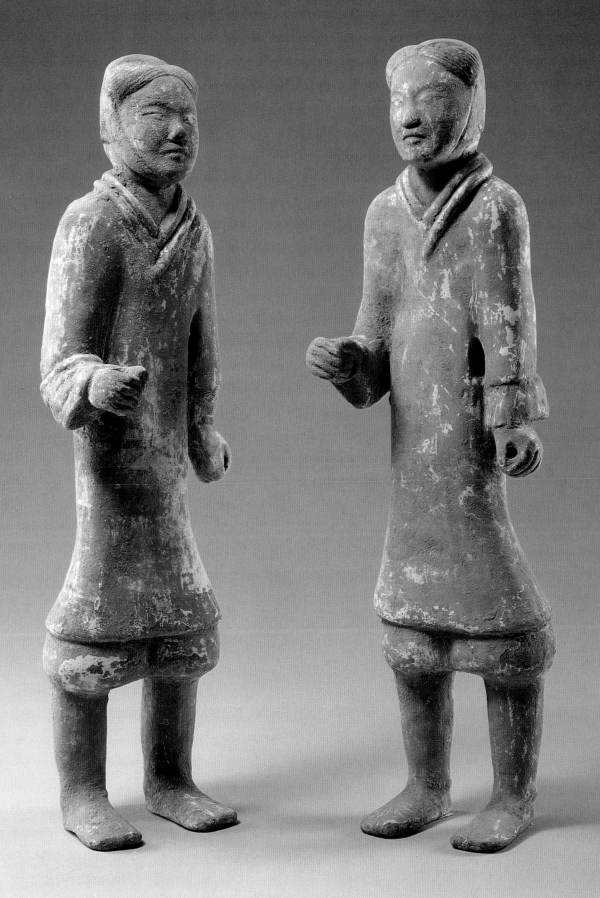

Two warriors
Western Han dynasty, cat. no. 21

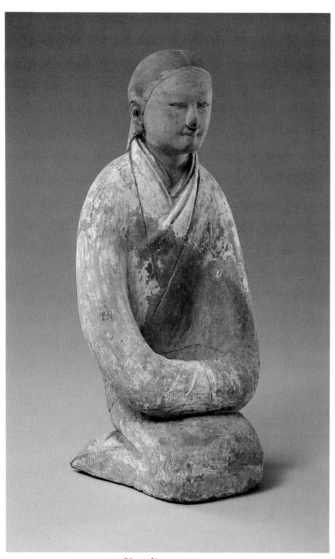

Kneeling woman
Western Han dynasty, cat. no. 16

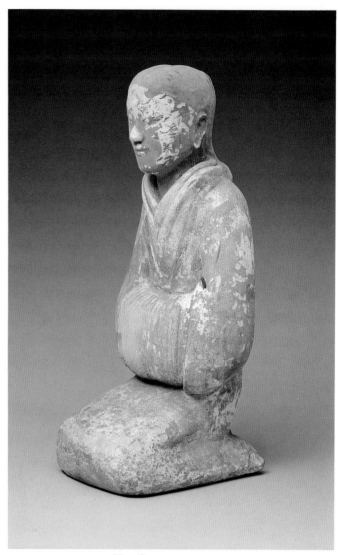

Kneeling woman
Western Han dynasty, cat. no. 17

The greatest of the Western Han funerary establishments was surely the Maoling, the eternal resting place of Wudi (d. 87 B.C.). Construction began in 139 B.C., giving him more than fifty years to finish his tomb. The Maoling settlement had a population of more than 61,000 households (perhaps 275,000 people), while as many as five thousand people, mostly eunuchs and women who had been servants or ladies-in-waiting to the deceased emperor, resided within the necropolis park. Remains of the park wall and gates are relatively well preserved. The wall originally measured about 415 to 430 meters on a side and was 5.8 meters thick at the base. The foundations of the gate towers were 38 by 9 meters and still stand 3 meters high.[33]

A host of discoveries has been made over the years at the Maoling, including such remarkable objects as a large bronze rhinoceros wine container[34] and a nephrite door escutcheon about 35 centimeters square, which suggests the extravagance of the halls erected at Maoling.[35] Such lavish appurtenances are the stuff of the effusive rhapsodies so favored at the Han courts. Again, reality approaches hyperbole.

The discovery of the rhinoceros has been overshadowed recently by the excavation of a pit containing luxurious furnishings located near one of the many accompanying burials at Maoling.[36] The burial is one of five mounds, one of which has traditionally been identified as that of the great Han statesman Huo Guang. This hypothesis cannot be confirmed, but the wealth taken from this pit would be appropriate to such a highly placed and much-favored court official.[37] The pit contained a great variety of furnishings, a total of 230 items, including a remarkable gilt horse and an incense burner on a tall bamboolike stem. Many of the bronze objects were inscribed; some had issued from the imperial family. When one reflects that there are at least thirty-eight other pits and several smaller tombs in this area alone, the total amount of buried wealth must be staggering.

The best-documented architectural survey of a Western Han tomb is that conducted by the Institute of Archaeology at Duling, the tomb of Han Xuandi.[38] This is one of two imperial mausolea situated southeast of Han Chang'an. In addition to the usual pair of walled compounds for the emperor's and empress's tumuli, the survey located fifty-eight accompanying burials. An architectural foundation southeast of the sovereign's mound was carefully excavated, and a good case can be made that this was the formal hall; its pounded-earth foundation measures 51 by 30 meters, and it is surrounded by a gallery about 2 meters wide. Although the interior plan is uncertain, three ramps each on the north and south gave access to the hall, as did large doorways at each end.

A pit excavated at this site is important in its own right: in addition to a variety of furnishings, it held large ceramic figures that were naturalistically painted and unclothed, a type known for some time but never before taken from an excavation. One assumes they were cloaked in garments that have since decayed.[39] The workshop that produced these and other figures, discovered in the northwest corner of Han Chang'an, is the only archaeological trace of the shops and artisans that supplied materials for burial in Western Han times.

These summaries suggest the extraordinary wealth and attention lavished on the mausolea of the Western Han sovereigns. Far less is known about the twelve Eastern Han tombs near Luoyang.[40] Surveys have not yet been published, but tentative locations have been established for five of the tombs in the Mangshan range that shelters the city on the north. Literary sources do, however, describe the interior structures of Eastern Han tombs and will be considered below. Stone sculpture and memorial steles probably started in earnest in Eastern Han, but the lack of careful surveys at the Luoyang imperial Han tombs makes this a tentative statement. Literary sources and Eastern Han tombs in such regions as Sichuan and Shandong attest the use of stone sculpture among the Han elite.[41] An appreciation of the innovations of the Eastern Han imperial tombs awaits a better fund of archaeological evidence.

Han Tomb Chambers

What were the imperial tombs like below ground level? Here archaeological evidence is far less extensive than in the case of aboveground plans and structures. No imperial tombs of either Qin or Han date have yet been opened, and since all are protected Important Cultural Sites, none is in any immediate danger that would necessitate excavation. The best evidence comes from excavations of the tombs of imperial princes and other members of the elite whose status most closely approximated that of the Son of Heaven. Moreover, a focus on imperial burials alone would neglect important developments in mortuary architecture that took place during the Han among the elite as a whole. While their tomb plans and structures were copied from the models established by the imperial family, the considerable range of types developed during the later Western Han and early Eastern Han demonstrates that tomb architecture was a

dynamic aspect of Han mortuary culture in general and not entirely dependent on standards set by the imperial family. Changes in tomb structure were occasioned by new mourning and funeral customs and accompanied by new developments in tomb furnishings and decoration. Those changes, in turn, are reflected in the Han figures in this exhibition (cat. nos. 19–20, 25–38).

Tombs of the Han Imperial Princes

The founder of the Han dynasty, Liu Bang, was a commoner, as was his empress. Having won the throne, he promptly enfeoffed many of his most worthy generals and advisors, as well as setting up the royal sons in kingdoms of their own. After the revolt of the Seven Kingdoms in 154 B.C. the non-royal rulers lost much of their strength, and kingdoms were reserved exclusively for princes of the imperial family. This was still a considerable number of offspring, and with every generation that number increased. It is no wonder that a significant number of princely burials have been discovered since 1949, even without a conscious effort on the part of archaeologists to do so.

Two major plans seem to have been in use during Western Han, and each is now represented by multiple examples from several princely kingdoms.[42] The more elaborate was an axial disposition of linked chambers approached by a lengthy ramp and passage. Major chambers were aligned on axis with the passage, while secondary chambers for storage were placed off axis, usually in balanced left and right pairs. The most famous of all recent Han tomb excavations, the twin burials of the Prince of Zhongshan and his consort at Mancheng, in Hebei, exemplifies this plan.[43] Both tombs were cut into the rock of Lingshan, a small limestone mountain, at a point about 30 meters below its peak. The paired tombs, side by side, perpetuate the notion of burials within a common plot. Eighteen small burial mounds have been surveyed nearby on the slopes of the mountain, evidence that the site was a clan cemetery.

The tomb of Liu Sheng, a prince who died in 113 B.C., is more than 50 meters long from the side of the mountain where the ramp begins to the rear wall of the rear chamber (fig. 4). The passage was sealed with a door of cast iron poured on the spot between two retaining walls; the passage proper was filled with rubble. The man-made cavern widens at the end of the passage, giving access to a pair of side chambers, to the left and right, and to the large central chamber directly ahead. The side chambers were used for storage of goods and victuals and also contained a complement of six chariots

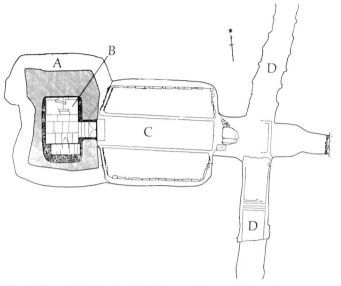

Fig. 4. Plan of the tomb of Liu Sheng, Prince of Zhongshan, at Mancheng, Hebei Province. *A*, rock gallery; *B*, burial chambers; *C*, central chamber; *D*, side chambers. From *Mancheng Han mu fajue baogao* (1980).

and their teams. The central chamber is a grand space 15 by 12.6 meters, almost 7 meters high, refashioned, however, by the erection of a wooden structure with a tile roof, transforming the cavern into a reasonable facsimile of a palace hall. At the end of that hall lies the burial chamber, a stone house installed in another cavelike space. The house is encircled by a gallery carved from the rock.

Two such magnificent burials prepared by hand labor using iron tools would be remarkable at any time. In Han China, however, they were not unusual, since at least half a dozen comparable examples are also known, which must be a small fraction of the original total. Five tombs of like construction have been found on Jiulongshan near modern Qufu, the ancient home of Confucius and during Western Han the seat of the Kingdom of Lu.[44] The largest of these princely tombs was even grander than the Mancheng examples and had a more complicated floor plan featuring additional side rooms, multiple levels, and various types of ceilings. The Qufu tombs cannot be assigned with great precision to individual princes of Lu, but they must date from c. 129–4 B.C. These examples are inferior to the Zhongshan tombs in one particular: they were sealed only with large stone blocks in the corridor leading to the rear section of the tomb. Here, too, tiles were found, a sign that roofed wooden halls were constructed within the chambers.

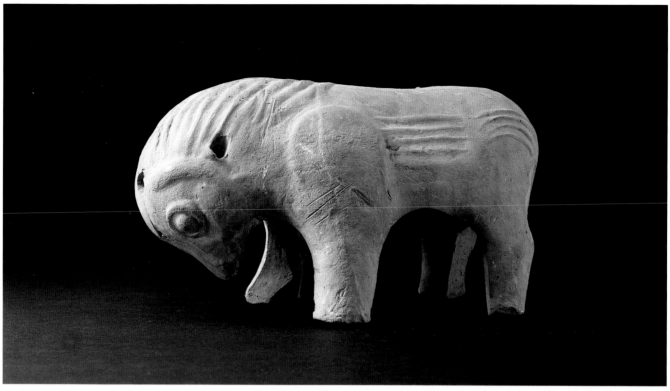

Ram
Eastern Han dynasty, cat. no. 36

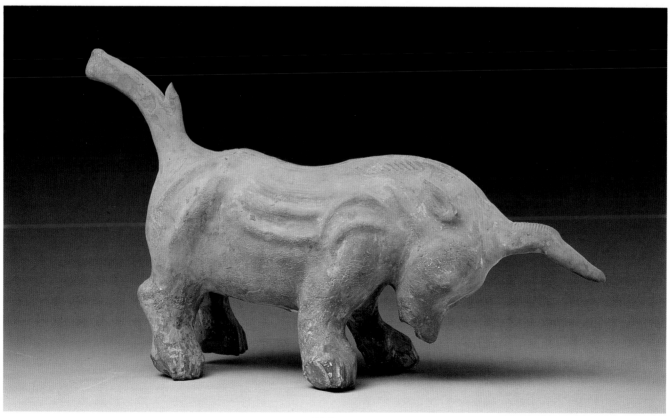

Unicorn
Eastern Han dynasty, cat. no. 37

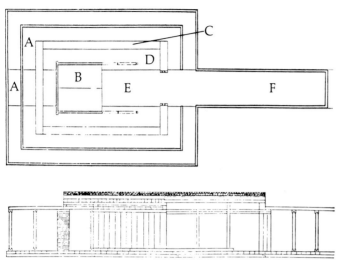

Fig. 5. Plan and cross section of a Western Han tomb at Dabaotai, Beijing. *A*, galleries; *B*, tomb chamber; *C*, stacked timber wall; *D*, inner gallery; *E*, front hall; *F*, corridor. From *Wenwu*, 1977, no. 6.

A central plan was also common among tombs of the Western Han imperial princes. Several examples in both wooden and stone construction are known. The best is the pair of tombs at Dabaotai, just south of Beijing.[45] Only one of the tombs at this site survived intact, and while it probably belonged to a Han prince it remains uncertain whether this was a burial of a prince of Yan or of a somewhat later prince of Guangyang. The possible range of dates is therefore 117 to 45 B.C. The tomb chamber was approached from ground level by a wide ramp and corridor and was set into a large trench, 23 by 18 meters and nearly 4 meters deep (fig. 5). The chamber consisted essentially of a large stack of timbers defining a rectangular interior space 16 by 10.8 meters, with walls 3 meters high, surrounded by a pair of galleries, each about 1.6 meters wide. Within the timbers were an inner gallery and a space divided between a front hall furnished with low wooden couches and a screened rear chamber in which a five-layer coffin was installed. At Dabaotai, therefore, the central space was aligned with the ramp and surrounded on all sides by galleries.

The staggering aspect of the Dabaotai tomb is its walls of stacked cypress timbers, each about 90 centimeters long and planed to a square or rectangular cross section of 10 by 10 or 10 by 20 centimeters. The timbers are aligned with their butt ends facing inward but are not otherwise joined. They stand today like immense stacks of cord wood, their bulk probably once of use in bearing the weight of the ceiling and the earthen burial mound above. In literary sources, this type of wooden chamber is referred to as *huang chang ti zou* (yellow intestines

aligned together), a phrase that must allude to the color of the lumber when freshly cut. It is not unique to Dabaotai: other examples of both earlier and contemporary date are known, both in princely burials and for lesser members of Han society.[46] A brick and stone version of much the same plan was discovered at Beizhuang near Ding Xian, Hebei.[47] This was probably the tomb of a later generation Eastern Han prince of Zhongshan.

It is plausible to connect these princely burials with the underground plans and structures of imperial tombs, but the question of their exact relation remains. From the structure of Han society, especially the graded perquisites of the elite and imperial clan, one might expect that the princely tombs are smaller renderings of plans created for the Han sovereigns. Literary sources are generally vague on the internal construction of the imperial tombs, but two commentaries now appended to the *History of the Later Han* speak to this question. *Huang lan* (Imperial survey, c. A.D. 220) describes the burial shaft of Han imperial tombs as one hundred double paces on a side (approximately 139 meters), with a square wall pierced by doors on each side.[48] *Han jiu yi* (Han old observances) by Wei Hong (c. A.D. 25–57) describes the tomb shaft as 30 meters deep, with a chamber 7 meters high. Wudi's tomb, Wei Hong reports, did not match these dimensions, but did contain a *huang chang ti zou* chamber with four doors. The dimensions given by these texts are not impossible, especially in light of the size of such tombs as Mancheng and Jiulongshan. From these accounts it seems likely that a central plan was typical of the sovereign's tomb, while the axial plan apparently represented an alternative formulation authorized below imperial rank. As yet, however, no tombs with such a square plan and four doors are known from excavations. The recently reported tomb of the second King of Nanyue, in modern Canton, had only one doorway and a modified axial plan.[49]

Western Han Development of Tomb Chambers

Fundamental revisions in funeral and mourning practices during Western Han, although not well documented in literary sources, can be inferred from the pervasive archaeological evidence of changes in all aspects of Han mortuary culture. Ritual behavior at funerals changed, first, with the performance of burial rites within rather than outside the tomb and, secondly, with the burial of husbands and wives in a single chamber. This replaced the tradition of burying spouses side

by side in separate shafts and chambers in the same clan cemetery. The imperial clan clung to the older tradition, as the description of their mausolea plans has made clear. Many early Western Han sites are known in which this practice continued, a good example being the tombs at Mawangdui, near Changsha, dated 186–168 B.C. However, in every region of the Han realm the new custom of joint burial appeared in the middle years of Western Han (c. 140–60 B.C.) and came to dominate by the last third of the period (c. 60 B.C. and after).

These two developments in ritual practice account for many of the changes in tomb plan and structure that took place during the last two-thirds of Western Han and early Eastern Han. Both customs had significant implications for anyone whose task it was to build a tomb. The chamber now had to survive intact for some years after it was first built and the first deceased interred. Moreover, that chamber had now to accommodate two coffins and two ensembles of grave goods. The lid or roof of the structure had to be easily removed and resealed or a proper door structure had to be devised so that the tomb could be entered a second time. In order to accommodate the officiant at the rites and a small company of mourners, the area in front of the coffins had to be enlarged. For ease in installing the second coffin, it would obviously be useful to retain any ramp used in the first excavation and important to be able to locate exactly the underground components from above with a minimum of labor.

Solutions to these new demands were quick in coming. In many parts of China through middle and late Western Han, wooden chambers were simply constructed with wider dimensions and more capacity for grave goods. Examples in Jiangsu, Lelang (North Korea), and Canton perpetuate the older, Bronze Age system of wooden chambers housing coffins and goods, with access through the roof or lid of the outer chamber, but now these chambers contain two, three, or more coffins.[50] However, in northern China, especially modern Henan Province, tomb builders began to experiment with two new components: a cavelike chamber hollowed out from the loessial soil, and ceramic bricks of both large and small size. The chamber had been used earlier, in fact, during the late Zhou period, in tandem with the flexed burial posture typical of the northwest, especially the region of Qin. In these early tombs a cavelike niche had been dug in one wall of the vertical shaft to receive the tightly flexed corpse. These niches were enlarged in early Western Han tombs to contain a coffin in which the body was laid out with legs extended. At much the same

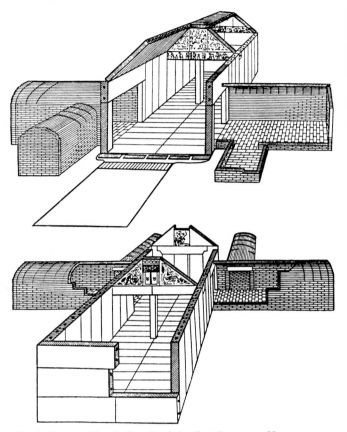

Fig. 6. Western Han hollow brick tomb at Luoyang, Henan Province. From *Kaogu xuebao*, 1964, no. 2.

time large hollow bricks were substituted for wooden timbers as ceiling beams or chamber walls.[51]

With the demands of new funerary ritual came new and better applications of these two components. Within a large cavelike chamber dug from the side of a vertical shaft, tomb artisans could assemble a small room, completely walled and roofed, using hollow bricks. The earliest examples of this new construction date from the last century of Western Han and feature peaked, two-slope roofs with ridges running down the middle (fig. 6). Such a space could easily hold two coffins side by side and allow a front area for the burial rites. Room for the grave goods was created by opening up the side walls of the chamber and building niches with small, solid bricks. The evolution of this structural type, revealed in the important excavations at Shaogou, north of Luoyang, in the 1950s, encapsulates the fundamental shift away from the wooden chambers of the Bronze Age.[52] The new structures were made of the more durable brick, enclosed much larger spaces, had easily opened proper doors, and were likely to survive beyond the lifetime of any members of the deceased's generation.

Similar chambers were created in other regions where stone was an abundant resource, most notably southern Henan, southern Shandong, northern Jiangsu, and the northern portions of Shaanxi.[53] Stone offered many of the structural advantages of brick and could be readily worked in a society that was producing an enormous quantity of iron tools. With the widespread use of brick and stone as building materials, tomb architecture became fundamentally different from structures aboveground. These were normally built of timber, with the exception of city walls, gates, and pagodas, which were constructed of brick or stone.

The new structures generated new plans, and these came, in some cases, from types used by the imperial family and other high-ranking members of the elite. At the Shaogou cemetery the petty bureaucrats in the capital administration adopted simplified versions of the plans already described for Han princes. A common early plan, for example, juxtaposed a transverse front chamber, placed across the axis of the ramp, and a deep main chamber on axis; side chambers were then added at either end of the front chamber. This internal division of space accomplished many of the same functions as the far larger and more costly tomb of Liu Sheng at Mancheng or those of his peers at Qufu. The deceased was ensconced in a modest surrogate of his aboveground abode, with a symbolic front hall and rear retiring chamber, ancillary spaces to represent a kitchen and larder, and perhaps even a stable or farmyard, all in reduced scale. Over time the largest tombs came to resemble the princely axial plans even more closely, linking a series of brick-vaulted chambers with connecting passages. A four-section false vault constructed with the use of corbels became the design of choice for large chambers, and this type of roof was perpetuated well into the Sui and Tang periods, especially for single-chamber tombs.

By the end of Eastern Han large brick and stone tombs with three principal chambers were in use both by the imperial clan and by other high-ranking members of the elite. Some of the best-known excavated Han tombs are of this type, those at Wangdu in Hebei and that at Holingol in Inner Mongolia (fig. 7), for example.[54] The three chambers symbolized the public court, ritual hall, and private quarters of the deceased, while the appended side chambers, in turn, represented subsidiary areas of an estate such as stables and kitchens. Decoration within the tomb followed these plans logically so that the total effect of wall decor and tomb furnishings was a simulacrum of the estate of the deceased.

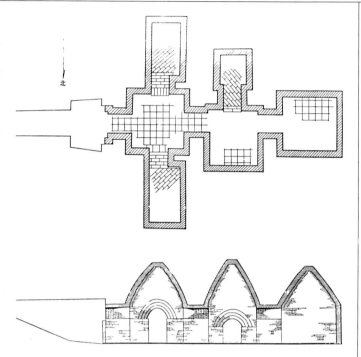

Fig. 7. Plan and cross section of an Eastern Han brick tomb at Holingol, Inner Mongolia. From *Helinge'er Han mu bihua* (1978).

Unlike the contents of the princely tombs of Western Han, most of the furnishings were not usable and were rendered in reduced scale or in inexpensive materials.

Imperial Tombs after the Han

The canonical system developed by the Qin and Han courts served as the basis for later imperial mausolea. Tombs of the Northern and Southern Dynasties, Sui, and Tang followed the patterns established during Western Han, and still later dynasties in turn echoed and elaborated the medieval system. Relatively few innovations in plan or surface components can be assigned entirely to the post-Han period. The greatest variable in imperial tombs appears to have been the relative strength, stability, and wealth of the dynasty, factors that either encouraged or discouraged lavish funerary establishments. On present evidence there was greater innovation in other aspects of post-Han mortuary culture, such as tomb figure types and interior decoration, than in the plan and construction of imperial funerary parks.

Among the regimes that followed the Han, the Wei and Jin eschewed the extravagant burials that had so deeply penetrated all levels of Han society. Cao Cao, the founder of the Wei kingdom (220–265), proscribed such appurtenances of burial as jade shrouds, and both he

and his son, the poet-emperor Cao Pi, were buried in subdued style without any tumuli to mark the sites.[55] Similar frugality seems to have characterized the five sovereigns of the Western Jin (265–316), whose tombs lie east of modern Luoyang.[56] Recent surveys have located the likely remains of two of those imperial tombs on sloping terrain to the south of the Mangshan range. The putative chamber of Jin Wudi's vault measured only 5.5 by 3 meters, with a ramp 36 meters in length leading to it on the south. One of the tomb sites was enclosed by a wall, and both had a number of smaller accompanying burials aligned in rows nearby. The most notable feature of these tombs is their siting on high ground near the sheltering Mangshan hills, a placement that must reflect the growing influence of geomancy.

The sovereigns of the Southern Dynasties — the Eastern Jin, Song, Qi, Liang, and Chen (317–589) — all made their capital at modern Nanjing, in Jiangsu Province, and thereby promoted the penetration of Han culture into new regions south of the Yangzi River. In the districts near Nanjing burials of thirty-one sovereigns and imperial princes have been located, nineteen of which can be identified with specific individuals.[57] All these tombs appear to fall within extensive tracts set aside for the imperial family and its relations. Most occupy both flat and adjacent mountainous terrain; here the geomantic principles of site selection led to locations in which the tomb was backed up against a mountain, facing the level plain below. The Southern Dynasties tombs are distinguished by the first notable arrays of large-scale stone sculpture, usually placed at some distance from the burial chamber.[58] The excavated imperial tombs at Nanjing are severe by Han standards and far more modest in scale.[59] While the interior chambers are reasonably large, there is only one room, with decoration rendered in stamped bricks, sometimes orchestrated into large figural compositions.[60] The most notable features of these underground structures are their stone doors and well-designed drainage systems.

The use of a single brick or stone chamber necessarily involved giving up the full simulation of the different functional and symbolic areas of an estate, even for the Son of Heaven. However, although the half dozen imperial tombs that have been excavated are not especially large, the Southern Dynasties burials represent a return to a more costly and ostentatious style than that of the preceding northern regimes.

During these centuries of disunion the north was controlled by a parade of "barbarian" rulers. The most durable and cultured of these regimes was the Northern Wei

(c. 386–535), which established a capital near modern Datong, Shanxi Province, and relocated at Luoyang about 494. Only one imperial tomb site is known at the former location, the Yongguling of the great Empress Wenming, with the smaller tomb of her consort, Emperor Xiaowen.[61] Here imperial patrons seem to have aspired to the scale and grandeur of the Han. The mound at this site is about 120 meters square at its base and 23 meters high. The chamber itself, which was thoroughly pillaged at the time of excavation, was an extremely sturdy vault made from multiple layers of bricks, following a two-chamber plan. The rear chamber, with its four-slope corbeled ceiling, measured no less than 6.4 by 6.8 meters with a height of 7.3 meters, making it the largest tomb of the period between Han and Tang. The chamber of Wenming's Yongguling mimics the Han formula of ramp, passage, and front and rear chambers, and surely her resting place was not an isolated example.

Even a lesser-ranking personage of this period could be buried in great style. The Prince of Langye, Sima Jinlong, a descendant of the Jin imperial house, was interred near Datong in a sizeable tomb some 17 meters in length, a project that consumed about fifty thousand specially made bricks.[62] While the figures found in this burial are relatively crude by both earlier and later standards (cat. nos. 46–52), they were among such estimable furnishings as a lacquer screen painted with narrative subjects and superbly carved stone sockets.

The Northern Wei imperial tombs at Luoyang have yet to be precisely located, but evidence from their tracts is abundant. To date, at least two hundred epitaphs of the Northern Wei nobility have been recovered near Luoyang, many from a large zone northwest of the capital, again in the Mangshan range.[63] The epitaphs frequently locate the burial of the deceased they extol in relation to a nearby imperial tomb. From the surnames represented among them, it is apparent that the Toba imperial clan and many other elite families were interred in these tracts, an echo of the Han system of accompanying burials. Today these tombs are known almost exclusively from their magnificent stone carvings: the epitaphs, decorated stone coffins, door jambs, lintels, tympana, and even stone coffin beds, many of which now repose in foreign collections. Surface sculpture, however, is rare: a stone warrior figure more than 3 meters high is an exception to the general dearth of monumental carvings at these sites.[64]

The Sui (581–617) and Tang (618–906) dynasties inherited both Han traditions and the innovations of the

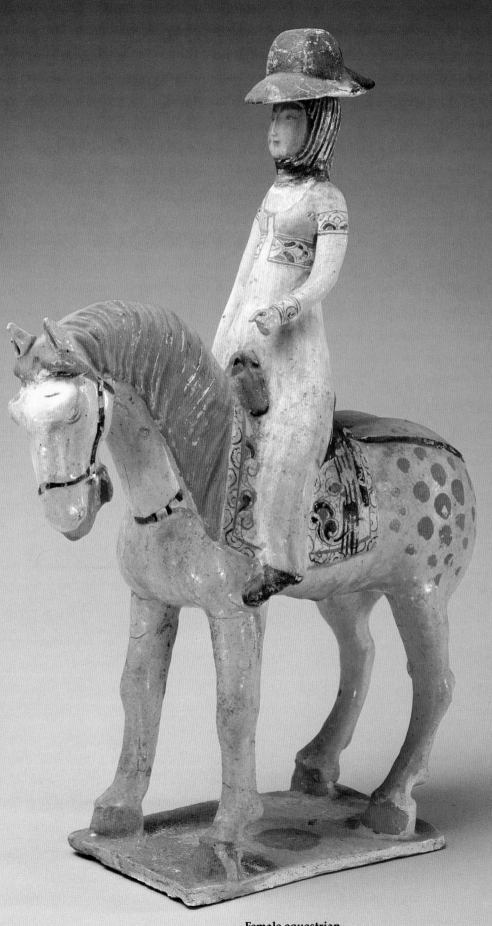

Female equestrian
Tang dynasty, cat. no. 61

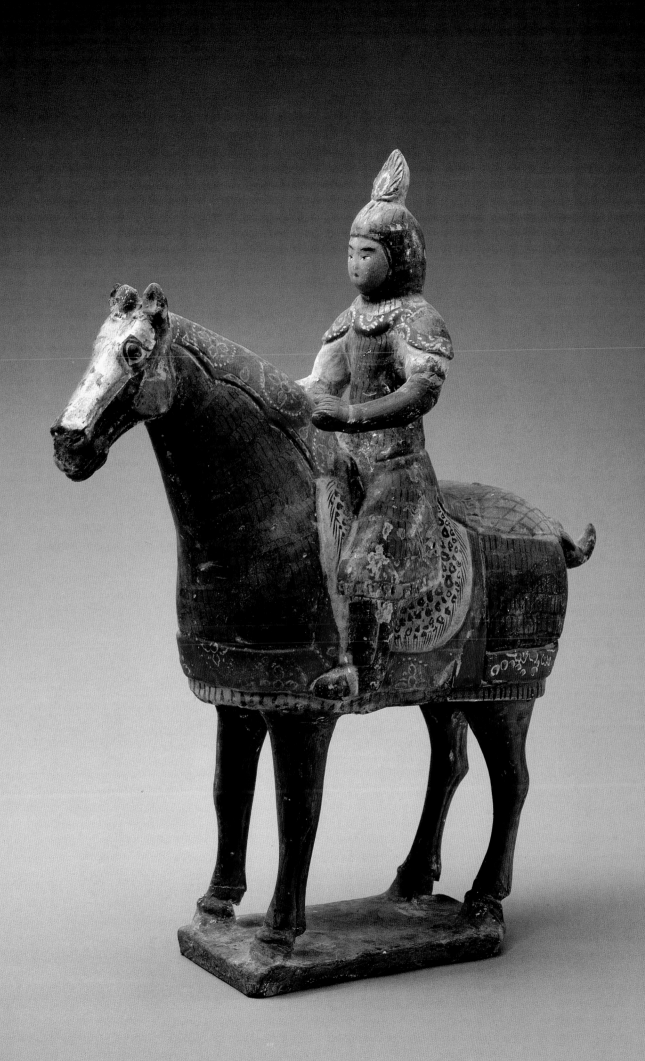

Equestrian figure
Tang dynasty, cat. no. 67

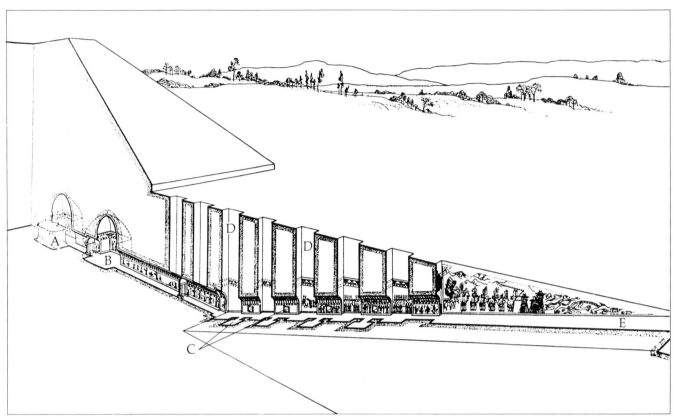

Fig. 8. Cross section of the tomb of Prince Yide, Qian County, Shaanxi Province. *A,* rear (tomb) chamber; *B,* front chamber; *C,* wall niches; *D,* air shafts; *E,* entrance ramp. From *Tang Li Chongrun mu bihua,* 1974.

intervening centuries.[65] The new system that emerged during the seventh century was heavily influenced by recent developments in spite of its general resemblance to the early imperial system. The use of extensive tracts in high terrain outside the capital, epitomized by the Zhaoling of Tang Taizong (r. 626–649), followed the example of the Han and Northern Wei sovereigns. The size of this establishment, however, makes earlier efforts seem modest by comparison: at least 167 tombs are known at the Zhaoling site alone.[66] Several figures in this exhibition come from the accompanying burials of Zheng Rentai (cat. no. 61) and Li Zhen (cat. no. 82).[67] The Zhaoling is but one of eighteen funerary parks constructed north of the Wei River in a zone 100 kilometers long running east to west. It is also one of fourteen Tang tombs that used mountains for burial mounds, another echo of Han precedent. The mountains were similarly made the centers of funerary cities modeled after the imperial capital, Chang'an. Imposing gate towers, long approach paths, monumental sculpture, and magnificent sacrificial halls completed these necropolises.

By the sixth century in the north a long ramp terminating in a passageway leading to a single brick chamber had become the most common tomb plan, a design that endured into Tang times among subimperial burials.[68] Innovations of the seventh century improved the ramp and created new areas for tomb furnishings. Large tombs for imperial relations were built with shafts at intervals along the ramp to supply fresh air and daylight during construction. In addition, niches were added in the walls of the ramp, usually in pairs at points between the air shafts, which became the resting place for the large quantities of figures typical of the richest Tang burials. These improvements had the effect of joining burial trenches to the tomb chamber itself, a departure from Han custom and design, in which the trenches were located near the tomb proper. Whereas the Han warriors from Yangjiawan (cat. nos. 11–15) were buried in pits around the twin tombs at that site, in Tang times a similar army could be a part of the tomb itself.

Several lavishly furnished tombs of Tang imperial princes and princesses have been excavated in recent

years, and the best of them closely follow the plan of an emperor's tomb.[69] That of Prince Yide, for example, was 100 meters in length from the top of the ramp to the back wall of the rear chamber and had seven air shafts, four pairs of wall niches, and lengthy passages leading to its front and rear chambers (fig. 8). The superb mounted warriors included in this exhibition (cat. nos. 67–72) were among hundreds taken from the niches. An extensive program of wall paintings complemented the large number of figures to simulate the palace, personal army, and staff of the eighteen-year-old prince.[70] Tang tombs also perpetuated the use of engraved stone first encountered in Northern Wei. Stone door panels, jambs, tympana, and houselike sarcophagi became standard components of elite tombs.

This exhibition celebrates the art of the ceramic tomb figure, tracing its development from the Neolithic era through the late imperial period. Later tombs and later figures were indebted to the innovations of the early imperial era and often self-consciously took them as models. That is not to say that all aspects of Chinese mortuary culture did not develop in their own way and at their own pace over the centuries following the Han. Taken together, however, the new Han canons of plan, structure, decoration, and furnishings represent the most extensive and long-lasting revision in burial customs ever effected in Chinese society. Within this phenomenon it was the imperial house that led the way in establishing and perfecting new designs. The innovations of this era are the proper starting point for any examination of mortuary culture, as well as the key link between the rites and mores of antiquity and the new world of imperial China.

Notes

1. For a conspectus of recent archaeology, see Institute of Archaeology, *Xin Zhongguo de kaogu faxian he yanjiu* (Archaeological discoveries and research in New China) (Beijing: Wenwu Press, 1984).

2. On coffins in early China, see Robert L. Thorp, "The Mortuary Art and Architecture of Early Imperial China" (Ph.D. diss., University of Kansas, 1979), 79–86, 191–98. At Mawangdui, a site just east of modern Changsha, Hunan Province, an exceedingly well-preserved female corpse was found in a tomb of the second century B.C. This is not unique in modern times nor was it unknown in ancient China. See Hunan Museum, *Changsha Mawangdui I-hao Han mu* (Han tomb 1 at Mawangdui, Changsha) (Beijing: Wenwu Press, 1973), 28–34.

3. On the exorcist, see Derk Bodde, *Festivals in Classical China* (Princeton: Princeton University Press, 1975), 77–80.

4. Joseph Needham, *Science and Civilisation in China* (Cambridge: Cambridge University Press, 1974), vol. 5, *Chemistry and Chemical Technology*, pt. 2, *Spagyrical Discovery and Invention: Magisteries of Gold and Immortality*, 77–85.

5. Burton Watson, trans., *Hsün Tzu* [Xun Zi]: *Basic Writings* (New York: Columbia University Press, 1963), 97–105 *passim*.

6. Watson, *Hsün Tzu*, 97. Similar regulations are found in a variety of pre-Han texts.

7. The documents are from tomb 3 at Mawangdui and tomb 168 at Fenghuangshan, Jiangling, Hubei Province. See Yü Ying-shih, "New Evidence on the Early Chinese Conception of the Afterlife: A Review Article," *Journal of Asian Studies* 41 (1981): 81–85.

8. Beijing Historical Museum, *Wangdu Han mu bihua* (The Han tomb with wall paintings at Wangdu) (Beijing: Chinese Classic Arts Press, 1955).

9. Inner Mongolia Autonomous Region Museum, *Helinge'er Han mu bihua* (The Han tomb with wall paintings at Holingol) (Beijing: Wenwu Press, 1978). The article by A. G. Bulling, "The Eastern Han Tomb at Ho-lin-ko-erh (Holingol)," *Archives of Asian Art* 31 (1977–78): 1–19, should be used with caution since it is based on preliminary reports.

10. For the Bronze Age, see Robert L. Thorp, "Burial Practices of Bronze Age China," in *The Great Bronze Age of China*, ed. Wen Fong (New York: The Metropolitan Museum of Art, 1980), 51–64.

11. In what follows I usually cite the primary excavation report and, when possible, a reliable English-language treatment of the topic. The references adduced are by no means exhaustive. For a general introduction to Han archaeology, see Wang Zhongshu, *Han Civilization* (New Haven: Yale University Press, 1982).

12. Han Wei, "Lue lun Shaanxi chunqiu zhanguo Qin mu" (A brief discussion of Spring and Autumn and Warring States period Qin tombs in Shaanxi), *Kaogu yu wenwu* (Archaeology and cultural relics), 1981, no. 1: 83–93; idem, "Fengxiang Qin gong lingyuan zuantan yu shijue jianbao" (Brief report of probings and exploratory excavations at the royal Qin necropolis at Fengxiang), *Wenwu* (Cultural relics), 1983, no. 7: 30–37.

13. Thorp, "Burial Practices," 53–57. See also Thorp, "Cult Practices and Social Structure: The Evidence from Anyang" (Paper delivered at the conference "Ancient China and Social Science Generalizations," Airlie House, Virginia, June 25, 1986).

14. Institute of Archaeology, *Hui Xian fajue baogao* (Report of excavations at Hui Xian) (Beijing: Kexue Press, 1956), 69–91.

15. On Lishan, see Robert L. Thorp, "An Archaeological Reconstruction of the Lishan Necropolis," in *The Great Bronze Age of China: A Symposium*, ed. George Kuwayama (Los Angeles: Los Angeles County Museum of Art, 1983), 72–83; and *Xin Zhongguo*, 386–89. Work at the site continues to be published in the Chinese journals. Recent finds include more horse pits (*Kaogu yu wenwu*, 1983, no. 5; 1985, no. 2); several kilns (*Kaogu yu wenwu*, 1985, no. 1; 1985, no. 5); a related site at Yuchi (*Kaogu yu wenwu*, 1983, no. 4); and bronze chariots (*Wenwu*, 1983, no. 7).

16. Xu Pingfang, "Zhongguo Qin Han Wei Jin Nanbei chao shidai de lingyuan yingyu" (Chinese imperial necropolises of the Qin, Han, Wei, Jin, and Northern and Southern Dynasties periods), *Kaogu* (Archaeology), 1981, no. 6: 521. Xu reports the discovery that twin ramps approached the chamber under the mound on east and west.

17. Thorp, "Lishan Necropolis," 78–80.

18. One might estimate the size of pre-Han tomb chambers by considering that of the largest chamber at Fengxiang, placed in a shaft 59 by 38 meters and with a putative height of 4 meters. This yields an area about six times larger than any of the known large pre-Qin tombs, such as that of Marquis Yi of Zeng at Sui Xian (now Suizhou), Hubei, which measured about 21 by 16 meters. See Robert L. Thorp, "The Sui Xian Tomb: Re-Thinking the Fifth Century," *Artibus Asiae* 43 (1981–82): 67–110, esp. 72–80.

19. Chang Yong and Li Tong, "Qin Shihuang ling zhong maizang gong de chubu yangjiu" (Preliminary research on the mercury buried in the tumulus of the First Emperor of Qin), *Kaogu*, 1983, no. 7: 659–63, 671. The investigators took nine hundred soil samples from an area of 125,000 square meters, and reported readings of from 70 to 1,500 parts per billion (ppb). At forty-three points, most under the mound, readings were more than 140 ppb; at eleven points, readings were greater than 280 ppb.

20. The best treatment is Yuan Zhongyi, *Qin Shihuang ling bing ma yong* (Terra-cotta warriors and horses at the tomb of the First Emperor of Qin) (Beijing: Wenwu Press, 1983).

21. For a brief introduction to recent work on the Han imperial tombs, see *Xin Zhongguo*, 410–12. The best thorough treatment is Liu Qingzhu and Li Yufang, "Xi Han zhu ling diaocha yu yanjiu" (Investigations and research on the Western Han imperial tombs), *Wenwu ziliao congkan* (Collected materials on cultural relics), 1982, no. 6: 1–15. Thorp, "Mortuary Art and Architecture," 104–21 is sorely out-of-date.

22. Luo Zhongru, "Shaanxi Xingping Xian Maoling kancha" (Investigations of the Maoling in Xingping County, Shaanxi), *Kaogu*, 1964, no. 2: 86–89.

23. Xu, "Zhongguo lingyuan yingyu," 522, citing *Shui jing zhu* (Notes to the Classic of Waters). Compare Sekino Tadashi and Daijo Tokiwa, *Shina bunka shiseki* (Historical monuments of Chinese culture) (Tokyo: Hozokan, 1939–41), text vol. 9, on the Han tombs.

24. On Han architectural practices, see Robert L. Thorp, "Architectural Principles in Early Imperial China: Structural Problems and Their Solution," *Art Bulletin* 68, no. 3 (September 1986), 360–78. Information on the hard soil near the mound is a personal communication from Tian Xingnong of the Shaanxi Committee for the Preservation of Archaeological Monuments.

25. Xu, "Zhongguo lingyuan yingyu," 522. For the evidence from Maoling, see Wang Zhijie and Zhu Jieyuan, "Han Maoling ji qi peizang fujin xin faxian de zhongyao wenwu" (Important cultural relics newly discovered near the accompanying burials of the Maoling), *Wenwu*, 1976, no. 7: 51–56.

26. On the policy of relocating powerful families, see Ch'ü T'ung-tsu [Qu Tongzu], *Han Social Structure* (Seattle: University of Washington Press, 1972), 196–99. Only two of the mausoleum towns have been confirmed by surveys, those at Changling and Anling; see Huang Zhanyue, "Zhongguo Xi'an Luoyang Han Tang lingmu de diaocha yu fajue" (Investigations and excavations at the Han and Tang imperial tombs near Xi'an and Luoyang), *Kaogu*, 1981, no. 6: 531–38.

27. Shi Xingbang et al., "Changling jianzhi ji qi youguan wenti: Han Liu Bang Changling kancha jicun" (The architectural system of the Changling and related questions: Records of investigations at Liu Bang's Changling), *Kaogu yu wenwu*, 1984, no. 2: 32–45.

28. Homer H. Dubs, trans., *The History of the Former Han Dynasty* (Baltimore: Waverly Press, 1938–55), 1: 266–67, quoting So Jian's notes to *Jin shu* (History of the Jin).

29. Xianyang Museum, "Han Anling de kancha ji qi peizang mu zhong de caihui taoyong" (Investigation of the Han Anling and the painted ceramic figures in its satellite tombs), *Kaogu*, 1981, no. 5: 422–25. Some of the earlier finds at this site, called Langjiagou, are reproduced in Terukazu Akiyama et al., *Neolithic Cultures to the T'ang Dynasty: Recent Discoveries*, vol. 1 of *Arts of China* (Tokyo: Kodansha, 1968), no. 286.

30. Dubs, *History of the Former Han Dynasty*, 1: 267–72.

31. Xu, "Zhongguo lingyuan yingyu," 522. On this type of tomb chamber, see page 26.

32. Wang Xueli and Wu Zhenfeng, "Xi'an Renjiapo Han ling congzang keng de fajue" (Excavation of the pits for funerary objects accompanying a Han mausoleum at Renjiapo, Xi'an), *Kaogu*, 1976, no. 2: 129–33, 75. Similar figures are in Japanese and American collections; see Osaka Municipal Museum, *Kandai no bijutsu* (Arts of the Han period) (Osaka: Osaka Municipal Museum, 1975), nos. 110, 113. Some trenches at this site clearly were looted before Liberation.

33. Luo, "Shaanxi Xingping xian Maoling kancha," 86.

34. Shaanxi Institute of Archaeology, "Shaanxi Xingping xian chutu de gudai qianjin tong xi zun" (An ancient bronze rhinoceros wine vessel with gold inlay unearthed in Xingping County, Shaanxi), *Wenwu*, 1965, no. 7: 12–16. The piece is best illustrated in Fong, *Great Bronze Age*, no. 93. First considered a Warring States vessel, this object could be contemporary with the site.

35. Wang and Zhu, "Han Maoling," 54–55.

36. Mou Anzhi, "Shaanxi Maoling yihao wuming zhong yihao congzang keng de fajue" (Excavation of accompanying pit 1 at anonymous burial mound 1 at the Maoling, Shaanxi), *Wenwu*, 1982, no. 9: 1–17.

37. For the lavish funeral of Huo Guang, see Burton Watson, trans., *Courtier and Commoner in Ancient China: Selections from* The History of the Former Han *by Pan Ku* (New York: Columbia University Press, 1974), 139–40.

38. Liu Qingzhu and Li Yufang, "1982–83 nian Xi Han Duling de kaogu gongzuo shouhuo" (Archaeological finds at the Western Han Duling for 1982–83), *Kaogu*, 1984, no. 10: 887–94. Compare Sekino and Tokiwa, *Shina bunka shiseki*, 9: 105–6.

39. The nude figures from this site are matched by several in museum collections. For reports of a workshop that may have produced such figures, see Yu Weichao, "Han Chang'an cheng xibei bu kancha ji" (Record of investigations at the northwest corner of Han Chang'an), *Kaogu*, 1956, no. 5: 23; and Bi Chu [sic], "Han Chang'an cheng yizhi faxian luoti tao yong" (Ceramic figures of nudes discovered at the site of Han Chang'an), *Wenwu*, 1985, no. 4: 94–96. The site, near Liucunbao Village within the ancient walls of Han Chang'an, produced many figures, including nude males and females, female heads, horses, and oxen, all of Western Han date. It is probable this was a factory attached to the Artisans of the Eastern Garden, the imperial funerary workshop.

40. Chen Chang'an, "Luoyang Mangshan Dong Han ling shitan" (Preliminary investigation of the Eastern Han imperial tombs in the Mangshan range, Luoyang), *Zhongyuan wenwu* (Cultural relics from the central plains), 1982, no. 3: 31–36.

41. Thorp, "Mortuary Art and Architecture," 240–48.

42. Yu Weichao, "Handai zhuhou wang yu liehou muzang de xingzhi fenxi" (An analysis of the plans of tombs of Han lords, princes, and marquises), *Zhongguo kaogo xuehui diyici nianhui lunwenji 1979* (Papers from the first annual meeting of the Chinese Archaeology Association, 1979) (Beijing: Wenwu Press, 1980), 332–37.

43. Institute of Archaeology, *Mancheng Han mu fajue baogao* (Excavation report of the Han tombs at Mancheng) (Beijing: Wenwu Press, 1980). Edmund Capon and William MacQuitty, *Princes of Jade* (London: Nelson, 1973) is flawed.

44. Shandong Museum, "Qufu Jiulongshan Han mu fajue jianbao" (Brief report on the excavation of the Western Han tombs on Jiulongshan, Qufu), *Wenwu*, 1972, no. 5: 39–44, 54.

45. Beijing Municipal Ancient Tomb Excavation Office, "Dabaotai Xi Han muguo mu fajue jianbao" (Brief report on the excavation of the Western Han wooden chamber tombs at Dabaotai), *Wenwu*, 1977, no. 6: 23–29; and Dabaotai Western Han Tomb Museum, *Dabaotai Han mu* (The Western Han tombs at Dabaotai) (Beijing: Wenwu Press, 1985).

46. *Xin Zhongguo*, 443–47. See also Shan Xianjin, "Xi Han 'huang chang ti zou' zangzhi chutan" (Preliminary investigation of the Western Han "huang chang ti zou" burial system), *Zhongguo kaogu xuehui disanci nianhui lunwenji 1981* (Papers from the third annual meeting of the Chinese Archaeology Association, 1981) (Beijing: Wenwu Press, 1984), 238–49.

47. Cultural Relics Work Team, Hebei Bureau of Culture, "Hebei Ding Xian Beizhuang Han mu fajue baogao" (Excavation report of the Han tomb at Beizhuang, Ding County, Hebei), *Kaogu xuebao* (Archaeology journal), 1964, no. 2: 127–94.

48. *Hou Han shu*, Treatise 6B, 3144.

49. Guangzhou Xianggang Han Tomb Excavation Team, "Xi Han Nanyue wang mu fajue chubu baogao" (Preliminary report of the excavation of the tomb of the Western Han King of Nanyue), *Kaogu*, 1984, no. 3: 222–30.

50. Thorp, "Mortuary Art and Architecture," 165–72 discusses the evidence up to 1979.

51. Ibid., 122–28.

52. Jiang Ruoshi et al., *Luoyang Shaogou Han mu* (The Han tombs at Shaogou, Luoyang) (Beijing: Kexue Press, 1959); and Thorp, "Mortuary Art and Architecture," 172–85.

53. *Xin Zhongguo*, 451–56.

54. See nn. 8 and 9 above. On this late evolution, see Yu, "Handai zhuhou wang," 337.

55. Xu, "Zhongguo lingyuan yingyu," 524.

56. Han-Wei Ancient City Work Team, Institute of Archaeology, "Xi Jin di ling kancha ji" (Record of investigations of the imperial tombs of the Western Jin), *Kaogu*, 1984, no. 12: 1096–1107.

57. Luo Zongzhen, "Liuchao lingmu maizang zhidu zongshu" (General account of the burial system of the Six Dynasties imperial tombs), *Zhongguo kaogu xuehui diyici nianhui lunwenji 1979*, 358–66.

58. Yao Qian and Gu Bing, *Nanchao lingmu shike* (Stone sculpture of the Southern Dynasties imperial tombs) (Beijing: Wenwu Press, 1981).

59. Luo Zongzhen, "Liuchao lingmu," 363–65.

60. For examples, see Yao Qian and Gu Bing, *Liuchao yishu* (Arts of the Six Dynasties) (Beijing: Wenwu Press, 1981), nos. 141–233.

61. Datong Museum and Shanxi Provincial Cultural Relics Work Team, "Datong Fangshan Bei Wei Yongguling" (The Yonggu tomb of the Northern Wei at Fangshan, Datong), *Wenwu*, 1978, no. 7: 29–35. See also A. G. Wenley, *The Grand Empress Dowager Wen Ming and the Northern Wei Necropolis at Fang Shan*, Freer Gallery of Art, Occasional Papers, vol. 1, no. 1 (Washington: Smithsonian Institution, 1947).

62. Datong Museum and Shanxi Provincial Cultural Relics Work Team, "Shanxi Datong Shijiazhai Bei Wei Sima Jinlong mu" (The Northern Wei tomb of Sima Jinlong at Shijiazhai, Datong, Shanxi), *Wenwu*, 1972, no. 3: 20–33. Many of these artifacts are illustrated in *Wenhua dageming qijian chutu wenwu, diyiji* (Cultural relics unearthed during the Cultural Revolution, first series) (Beijing: Wenwu Press, 1972).

63. Su Bai, "Bei Wei Luoyang cheng he Beimang lingmu" (Northern Wei Luoyang and the Beimang imperial tombs), *Wenwu*, 1978, no. 7: 42–52; and Huang Minglan, "Luoyang Bei Wei Jingling weizhi de queding he Jingling weizhi de tuice (A determination of the position of the Northern Wei Jingling at Luoyang and an estimate of the position of the Jingling), *Wenwu*, 1978, no. 7: 36–39.

64. Huang, "Luoyang Bei Wei," 39.

65. A good introduction to the motivations and purposes of the Tang rulers is H. J. Wechsler, *Offerings of Jade and Silk: Ritual and Symbol in the Legitimation of the T'ang Dynasty* (New Haven: Yale University Press, 1985), 142–60.

66. Zhaoling Cultural Relics Office, "Zhaoling peizang mu diaocha ji" (Record of investigations of the accompanying burials at Zhaoling), *Wenwu*, 1977, no. 10: 33–40, 49.

67. Shaanxi Provincial Museum and Tang Tomb Excavation Team of the Liquan County Cultural Education Office, "Tang Zheng Rentai mu fajue jianbao" (Brief report on the excavation of the Tang tomb of Zheng Rentai), *Wenwu*, 1972, no. 7: 33–44; and Zhaoling Cultural Relics Office, "Tang Yue wang Li Zhen mu fajue jianbao" (Brief report on the excavation of the tomb of the Tang Prince of Yue, Li Zhen), *Wenwu*, 1977, no. 10: 41–49.

68. Institute of Archaeology, *Tang Chang'an chengjiao Sui Tang mu* (Sui and Tang tombs in the suburbs of Tang Chang'an) (Beijing: Wenwu Press, 1980).

69. Shaanxi Provincial Museum and Tang Tomb Excavation Team of the Qian County Cultural Education Office, "Tang Yide taizi mu fajue jianbao" (Brief report on the excavation of the tomb of the Tang prince Yide), *Wenwu*, 1972, no. 7: 26–32. For a brief introduction, see Jan Fontein and Wu Tung, *Han and T'ang Murals* (Boston: Museum of Fine Arts, 1976), 104–20.

70. Wang Renbo, "Yide taizi mu so biaoxian de Tangdai huangshi maizang zhidu" (The Tang imperial burial system as represented in the tomb of heir Yide), *Zhongguo kaogu xuehui diyici nianhui lunwenji 1979*, 400–406. For the wall paintings, see Fontein and Wu, *Han and T'ang Murals*, 104–20; and *Tang Li Chongrun mu bihua* (The wall paintings in the tomb of Li Chongrun of the Tang) (Beijing: Wenwu Press, 1974).

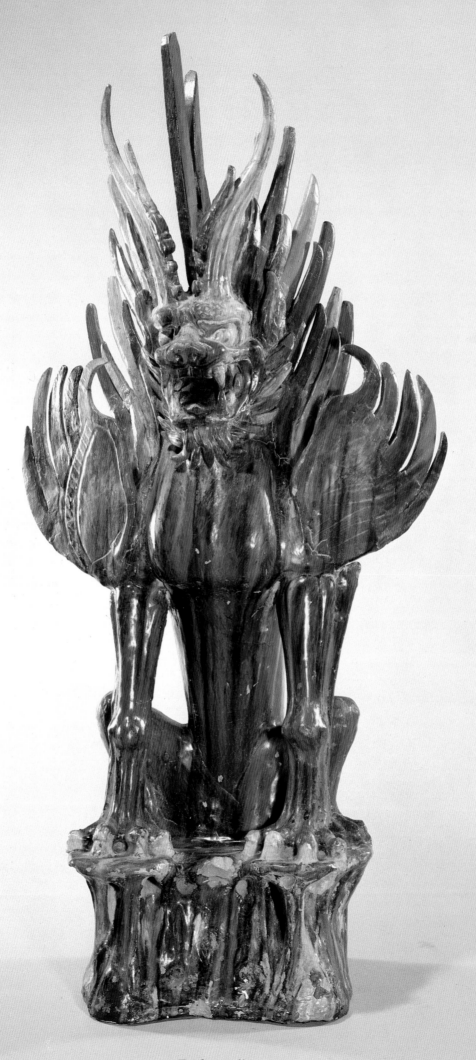

Tomb guardian
Tang dynasty, cat. no. 64

GENERAL COMMENTS ON CHINESE FUNERARY SCULPTURE

Wang Renbo
Shaanxi Provincial Museum

Translator's note

Historians in the People's Republic of China usually follow in their analyses the classical stages of socioeconomic development as defined by Karl Marx. Premodern Chinese history is thus divided into several stages: primitive society in prehistoric times, slave society in the Shang and early Zhou periods (c. 2000–400 B.C.), and feudal society in the late Zhou and subsequent dynasties. Such a periodization, as well as a concern for changing methods of production, underlies this essay.

The sculpture of ancient China is an important element of Chinese culture. Ceramic funerary figures, gems from the treasury of ancient sculpture, comprise a significant chapter in the long history of Chinese art.

The origin of the art of sculpture must be sought in the practical matters of daily life. In the Neolithic age (c. 8000–2000 B.C.) the invention of baked clay vessels not only improved life but also contributed to the development of agriculture and animal husbandry. As the ancient Chinese made earthenware bowls, jars, tripods, and cauldrons, they improved their grasp of the nature and potential of clay. The practical skills they gained through such utilitarian production substantially improved their sculptural capabilities.

Early pottery was decorated both by painting and by manipulation of the clay itself with stamped, scratched, carved, and appliquéd ornament. The motifs included relief images of human beings and animals, especially birds and human faces and heads. A jar discovered in 1953 in Luonan County, Shaanxi Province (cat. no. 1), decorated with the image of a human head, and the sculpture of a human head found in Huangling, Shaanxi (cat. no. 2), are of this type. Recent archaeological evidence makes it clear that the ceramic tomb sculptures that appeared after the Shang and Zhou periods must have had their roots in Neolithic black and polychrome pottery vessels.

During the Shang and Zhou periods it was the custom to inter live human beings and animals, including horses, dogs, and chickens, in the graves of their masters. Excavations of the large tombs of slave-owners at Yinxu, near Anyang, site of the late Shang dynasty capital, revealed that every tomb contained between several dozen and three or four hundred slaves who had been buried alive. Although complete statistics are not available, more than five thousand victims of live burial or sacrifice have been discovered. This proves the accuracy of a passage from *Mozi* that reads, "In human sacrifices for an imperial burial, a large number of victims signified several hundred, while a 'small number' was several dozen; in sacrifices for generals or high officials, several dozen people would be killed for a large burial and a few people for a small one."[1]

During the same period ceramic, stone, and jade figures of human beings and animals were also used as tomb offerings. For example, three earthenware figures of slaves wearing shackles were discovered at Xiaodun, near Anyang, in a pit of the early Yinxu culture. In an early Shang ash pit and exploratory trench at Erligang, Zhengzhou, Henan Province, ceramic replicas of kneeling human figures, tigers, goats' heads, turtles, and fish were found. A late Shang ash pit, also at Xiaodun, yielded ceramic ox heads and owls. These objects are the earliest ceramic tomb figures that have been excavated to date in China. On the basis of current archaeological evidence, then, one can say that the Shang and Zhou dynasties were the periods during which Chinese funerary sculpture first came into being.

The occurrence of ceramic tomb figures at these sites was probably not so much a result of the compassion of the slave-owners as of their desire to create the impression that they possessed even more slaves and wealth than they actually did. Tomb 1 at Langjiazhuang, Linzi, Shandong Province, which dates to the Spring and Autumn period (722–481 B.C.), contained both human sacrifices and a large assemblage of ceramic burial attendants. This is the earliest known tomb in which the burial of funerary figures plays an important role.

The fifth century B.C. was the prelude to the transition from slave society to feudal society, as well as the infancy of the great development of Chinese tomb sculptures. The burial of these figures to replace human sacrifices was an important sign of a social transformation that affected funerary rites. Tombs of the Warring States period (475–221 B.C.) did contain human beings buried alive, as demonstrated by those found before 1949 in Shanbiao, Ji County, Henan. However, during this period the custom of burying sacrificial victims alive, which had traditionally been considered ritually correct, had already begun to be considered improper and was

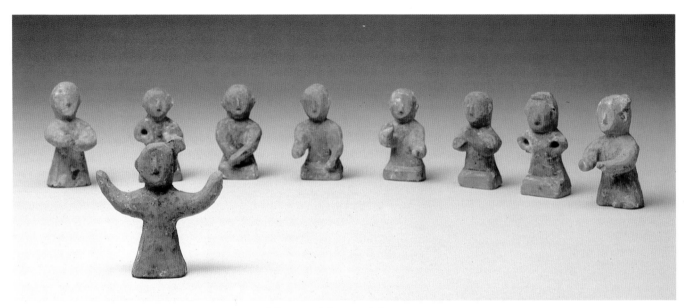

Nine musicians and dancers
Warring States period, cat. no. 5

Duck
Warring States period, cat. no. 4

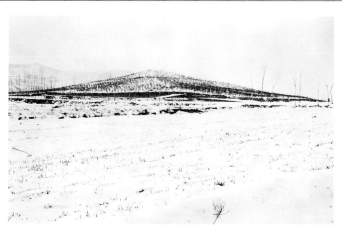

Fig. 1. Site of the Lishan necropolis of the First Emperor of Qin, Lintong, Shaanxi Province. Photo courtesy Julia F. Andrews.

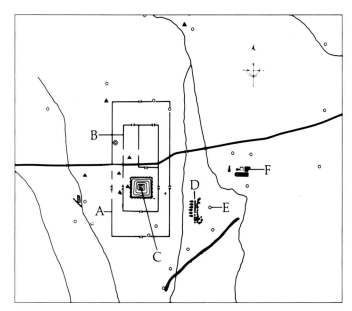

Fig. 2. Map of the Lishan necropolis. *A,* outer wall of tomb precinct; *B,* inner wall of tomb precinct; *C,* tumulus; *D,* stable pit area; *E,* Shangjiao Village; *F,* trenches containing terra-cotta figures. Photo courtesy Overseas Archaeological Exhibition Corporation.

resisted and opposed. Of the more than three thousand Warring States tombs discovered between 1949 and 1979, only thirty contained human sacrifices (the publication of relatively complete data makes about seventeen of these accessible).

Builders of many large and medium-sized tombs of the Warring States period — such as those of Fenshuiling in Changzhi, Shanxi Province; Pingshan in Hebei Province; Changtaiguan in Xinyang, Henan; Xigongduan in Luoyang, Henan; Jiangling in Hubei Province; and Changsha in Hunan Province — abandoned human sacrifice altogether in favor of figure burials. One example was tomb 14 at Fenshuiling,

Changzhi, Shanxi, excavated in 1954 and 1955, enormous in scale and rich in contents, with grave goods totaling 1,005 items. Three bronze funerary sculptures and eighteen of earthenware were found. The ceramic figures, mounted on flat bases with hollow centers, are extremely varied in pose (cat. no. 5). They bear traces of red pigment and incised decoration.

The practice of sacrificing slaves was completely done away with by 384 B.C., the first year of the reign of Qin emperor Xiangong.[2] The complete substitution of funerary figures for human and animal sacrifices was an innovative measure that liberated the productive capacity of the society and raised the level of the culture. The transformation of society prompted the evolution of funerary rituals and provided the social conditions necessary for the continuing development of the art of ceramic tomb figures.

The unification of China during the Qin period (221–207 B.C.), the development of a feudal economy and culture, and the opening of relations between China and other lands established a solid foundation for the evolution of ceramic sculpture. The results appeared one hundred years later in the powerful and majestic horses and warriors of Qin, completely lifelike in their gallant battle array (cat. nos. 6–9). During the last few years, surveys and excavations of the pits that lie 1.5 kilometers to the east of the tomb of the First Emperor of Qin, at the foot of Lishan (Mount Li) in Lintong, Shaanxi (figs. 1–2), have revealed several thousand terra-cotta sculptures of horses and warriors assembled in Qin dynasty battle formation.

The war chariots and foot soldiers in pit 1 probably represent the Right Army of the Imperial Guard in the Qin capital of Xianyang (fig. 3). The formation is very orderly, headed by a vanguard of three rows of seventy soldiers each, facing east, away from the emperor's tomb (fig. 4). Behind them are eleven trenches running east to west, containing a total of thirty-eight single-file columns of horses and warriors, also facing east (fig. 5). To the southwest and northwest are single rows containing companies that protect the flanks of the main body. From the density of distribution of the figures already unearthed, we may hypothesize that there are more than six thousand ceramic horses and warriors in pit 1.

The formation in pit 2, mainly composed of war chariots and mounted cavalry, would seem to be the Left Army of the Qin Imperial Guard. The pit is roughly L-shaped and is occupied by four units (fig. 6): a square group of kneeling archers on the eastern side, a square group of war chariots in the southern half, a rectangular

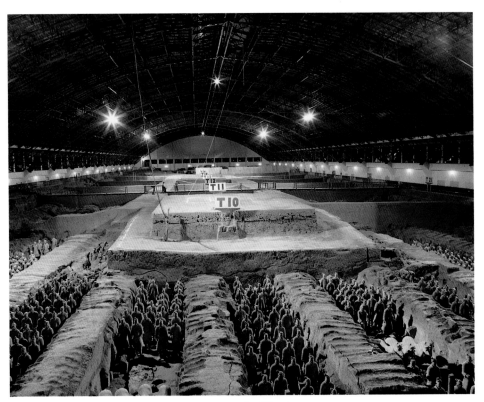

Fig. 3. Partial view of pit 1 at the Lishan necropolis. Photo courtesy Overseas Archaeological Exhibition Corporation.

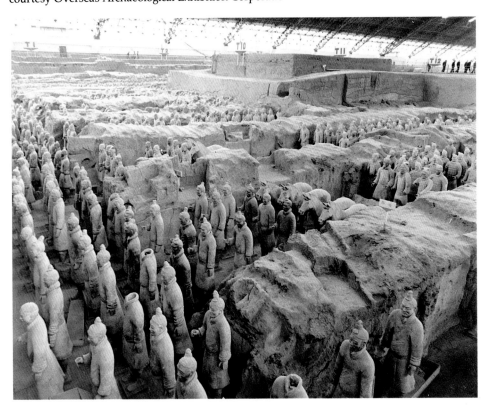

Fig. 4. Partial view of pit 1 at the Lishan necropolis; the vanguard troops are at the left. Photo courtesy Overseas Archaeological Exhibition Corporation.

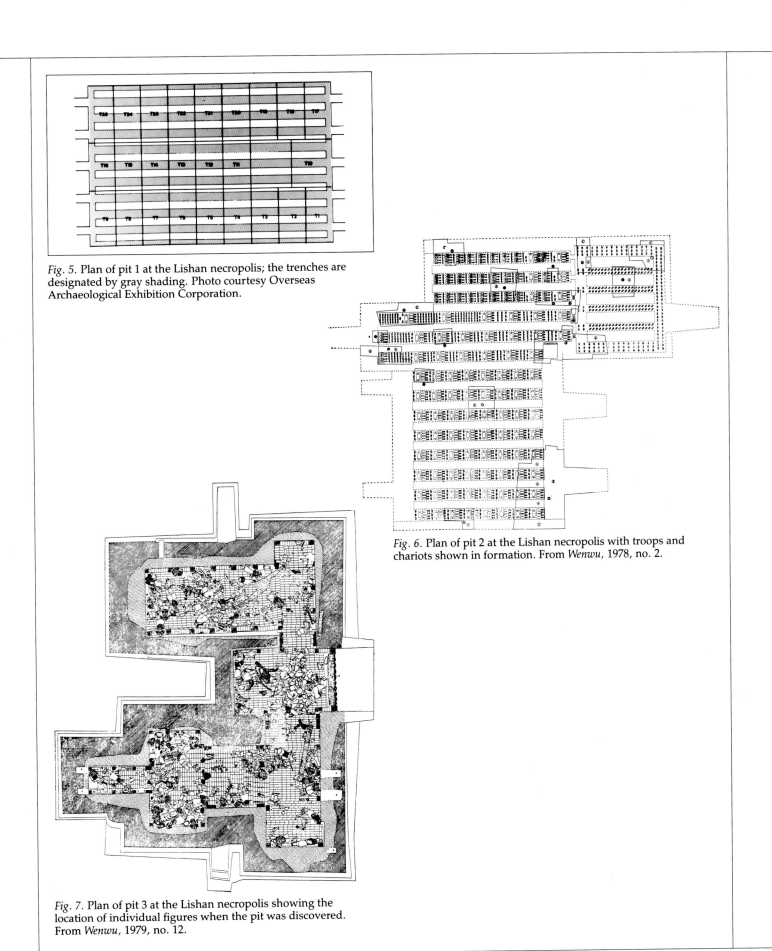

Fig. 5. Plan of pit 1 at the Lishan necropolis; the trenches are designated by gray shading. Photo courtesy Overseas Archaeological Exhibition Corporation.

Fig. 6. Plan of pit 2 at the Lishan necropolis with troops and chariots shown in formation. From *Wenwu*, 1978, no. 2.

Fig. 7. Plan of pit 3 at the Lishan necropolis showing the location of individual figures when the pit was discovered. From *Wenwu*, 1979, no. 12.

Fig. 8. Cross sections of excavated stable pits at the Lishan necropolis. From *Kaogu yu wenwu,* 1980, no. 4.

group of chariots and foot soldiers at center, and a rectangle composed of mounted cavalry in the northern half. An additional pit, incomplete and abandoned, may have been intended for the Central Army (see fig. 2).

Pit 3 is divided into a main area for chariots and horses and subsidiary areas to the north and south (fig. 7). Within the main area was discovered a wooden war chariot to which were yoked four terra-cotta horses; behind the chariot were four warriors. Excavation of the southern subsidiary area produced forty-two armored warriors, and the northern area yielded twenty-two. Since most of the figures in the third pit are officers, this pit may represent the general headquarters of the armies.

Also to the east of the emperor's tomb, near Shangjiao Village (see fig. 2), a group of nearly one hundred stable pits was discovered in which were found kneeling figures representing the administrators of the stables, both masters and stable boys (fig. 8; cat. no. 10). In still other subsidiary pits were figures representing keepers of war horses, exotic birds, and livestock.

The handsome horses of Qin remind us that this dynasty had a tradition of horse breeding. Beautiful stanzas from Qin folk songs describe the lively air of the horses and praise the flourishing breeding industry, which became an important factor in the military strength of the Qin regime. The ceramic horses from the First Emperor's tomb complex are similar to the modern Hequ horses of Shanxi Province in many of their phys-

ical characteristics: they are tall and long, with similar girths to body and neck, making them equally suitable for riding and yoking in teams.

As early as the Warring States period, sculpture had begun to exist as an art form independent of the production of ceramic vessels. It had also cast off the impenetrable quality that characterized Shang and Zhou art for a naturalistic and lively style. The successful production of the Qin horse and warrior figures was an epoch-making event in the history of Chinese sculpture. The artists applied their technical skills to create realistic figures based on the actual soldiers of Qin, using their tools to capture subtly the characters, spirits, and states of mind of soldiers of all ages, all types, and from all parts of the empire, including the ethnic minorities. The faces may be beautiful, ugly, fat, or thin; the expressions include pleasure, anger, sorrow, and joy. Men and horses alike are well proportioned and have a strong sense of substance. This is evidence of careful observation and a certain knowledge of anatomy.

Great care was taken with all aspects of the execution of the Qin figures. The artists achieved a balance between realism and exaggeration. They paid considerable attention to the interaction of body and spirit in each figure and to the relationship between the group and the individual in the overall formation.

The basic techniques of execution combined modeled and mold-made elements. The major components of each Qin figure — head, feet, legs, trunk, platform, the

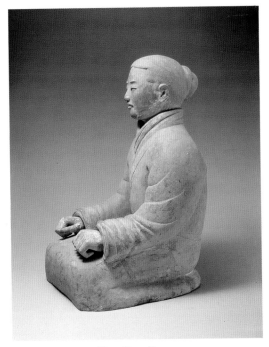

Kneeling figure
Qin dynasty, cat. no. 10

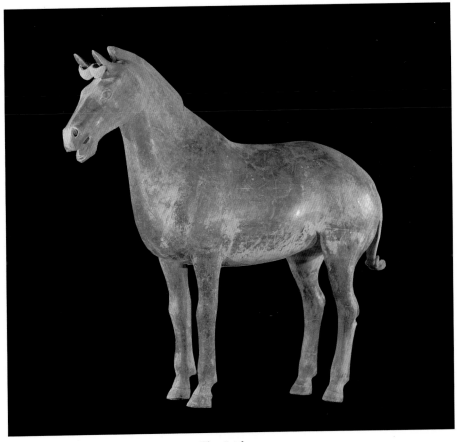

Chariot horse
Qin dynasty, cat. no. 9

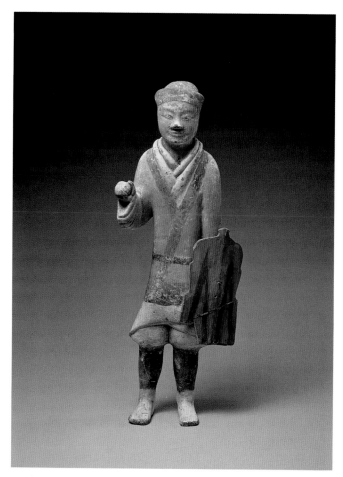

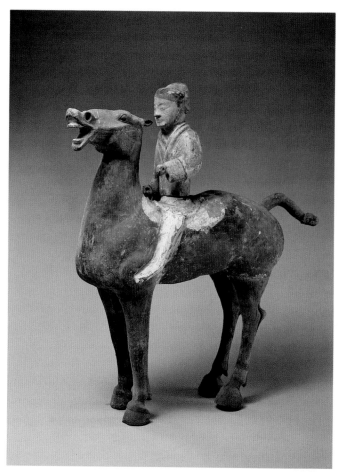

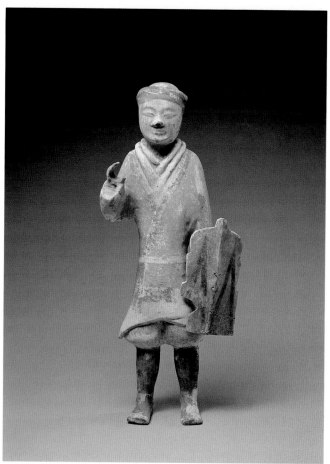

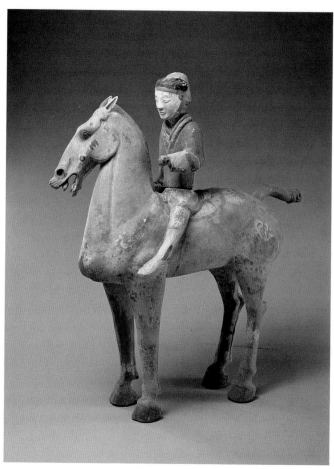

Warriors with shields
Western Han dynasty, cat. no. 12

Horsemen
Western Han dynasty, cat. no. 15

hands and arms of the warrior, the tail of the horse — were made separately of a sandy, rather coarse clay and then assembled to create a rough general form. When the figure had dried slightly, several layers of finer clay were applied, in which were carved the details of hair, beards, eyes, mouths and chins, muscles and tendons, collars, pleats, leg bindings, and armor plates. Next, molded elements such as ears, noses, and the rivets and straps of the armor were added. A thin layer of clay was then applied to the legs and feet of the warriors and the bodies of the horses and rubbed smooth. The chest of each horse was pierced with openings that served as exhaust holes during firing and allowed the artists to smooth the interior walls during the joining of sections. After the form was dry, it was fired in a kiln and painted. The Qin horse and warrior figures illustrate the techniques — modeling, coiling, carving, appliqué, pinching, and painting — that are the foundation of the art of sculpture from Han through Tang.

The huge complex of horse and soldier figures functions like a memorial stele or a history painting as it captures the glorious image of the thousands of chariots, ten thousands of mounted warriors, and millions of armored soldiers with whom the First Emperor subdued the feudal lords and united the six kingdoms of the Warring States. The enormous scale of this monument also reminds later observers that Qin Shihuang's oppression of the populace, as exemplified by his conscription of the work force necessary to produce the terra-cotta army, was the root cause of the crises that buried the regime, which only endured for fifteen years. This achievement thus records for posterity the funeral dirge of not only Qin Shihuang himself, but of the Qin empire.

The Han period (206 B.C.–A.D. 220) saw the greatest development of the feudal era in centralization of power, agricultural production, animal husbandry, and artistic craftsmanship. In early Western Han the country was pacified domestically and the invasions of the Xiongnu peoples from the north were resisted. The advancement of the military might of the empire and the opening of the silk route, with the attendant cultural exchange between China and other countries, were factors in artistic development, providing the sculptor with new stylistic influences and subject matter.

The Western Han dynasty (202 B.C.–A.D. 8) continued and developed the funerary practice of providing large numbers of figures as burial attendants. Written sources record that "they made images as attendants of the coffin."[3] Figures of warriors, cavalrymen, horses, chariots, male and female servants, dancers, musicians, and storytellers were buried in the tomb itself or in subsidiary pits. The elaborate Han burials were remarked upon in their own time: "Today the relatives of the aristocracy in the capital and the wealthy in the provinces are not extravagant when living, but in death are honored and mourned, and there is much burying of gems, human images, and chariots."[4]

The builders of the large tomb complexes exerted every effort to imitate earthly estates and mansions. Figures of all sorts of domestic animals and fowl, including horses, oxen, goats, dogs, pigs, chickens, ducks, and geese, were buried in the tombs, along with various types of ceramic architectural and agricultural models, such as single- and multistoried houses, small pavilions, towers, detached kitchens, wells, pigpens, privies, winnows, storehouses, wooden boats, ponds, and rice paddies. According to the *Yan tie lun*, the interiors of the tombs also contained a generous supply of the utensils that would have served a living person.[5]

Typical of an important Han burial are the tombs at Yangjiawan in the northeastern suburbs of Xianyang, Shaanxi, dating to the reigns of the emperors Wendi (r. 180–157 B.C. and Jingdi (r. 157–141 B.C.) of the Western Han dynasty. The *Shui jing zhu* states that the prime minister Zhou Bo and his son Zhou Yafu were buried in this region along the Gaogan Canal,[6] and it is therefore hypothesized that tombs 4 and 5 at Yangjiawan are theirs. Near the tomb mounds were discovered eleven subsidiary pits, six of cavalrymen, four of foot soldiers, and one of war chariots. In all, 1,965 figures of infantrymen and 583 mounted cavalrymen were unearthed (cat. nos. 11–15), a total certainly consistent with the high rank of Zhou Bo. The resolute Yangjiawan cavalrymen are especially lively, detailed images of Western Han troops; the war horses are very lifelike.

The arrangement of the eleven subsidiary pits at Yangjiawan placed the foot soldiers in the vanguard, with the mounted cavalry as a rear guard, a reflection of Western Han military formations. This battle array is invaluable for the military historian: it reflects the development of cavalry under the emperors Wendi and Jingdi. The Western Han rulers realized from practical military experience that those who had chariots and horsemen had a completely equipped national military force. According to the *Han shu*, in the third year of the reign of Emperor Wendi (177 B.C.), Prime Minister Guan Ying led eighty-five thousand cavalrymen against the northern Xiongnu, and, in the fourteenth year (166 B.C.), commanders Zhou She and Zhang Wu sent out a thousand chariots and a hundred thousand cavalrymen

Two oxen
Western Han dynasty, cat. no. 22

Four goats
Western Han dynasty, cat. no. 23

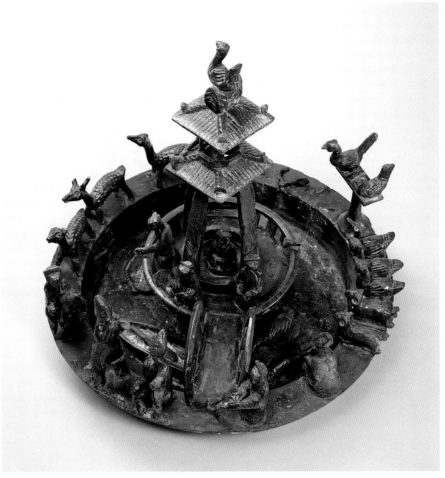

Waterside pavilion
Eastern Han dynasty, cat. no. 29

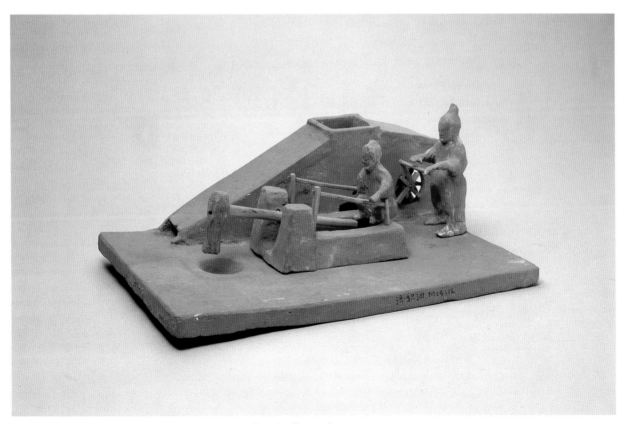

Rice huller and winnow
Western Han dynasty, cat. no. 25

to repel a Xiongnu attack near the capital of Chang'an (modern Xi'an).[7] To utilize that many cavalry soldiers in one movement of troops was completely unprecedented in the annals of military history.

The development of horse breeding in the Han period had great significance for a strong national defense, particularly against the invasions and harassments of the more socially primitive Xiongnu. The *Han shu* records that in the time of Emperor Jingdi, there was in the northwestern border prefecture a horse park comprised of thirty-six buildings, with a staff of grooms who were called "supervisors of the park." Thirty thousand male and female slaves took care of three hundred thousand horses. During the reign of Emperor Wudi (r. 141–87 B.C.), the central government controlled more than four hundred thousand war horses.[8] The ceramic horses found in Han tombs have small heads, large eyes and nostrils, thin ears, moderately long, arched necks, short, wide bodies, very strong limbs, and sturdy hooves. They are of the same excellent Central Asian stock represented in the stone carving of a horse trampling a Xiongnu enemy from the tomb of Huo Qubing at Maoling near Xi'an (fig. 9) and the bronze sculpture of a galloping horse from Leitai, Wuwei, Gansu Province.

Many animals other than horses were replicated for burial purposes. To the east of Anling, the tomb of the Han emperor Huidi (r. 195–188 B.C.), near Xianyang, is a scattered group of satellite graves. Sixteen mounds of pounded earth are extant. At tomb 11, surrounding the tomb chamber on all sides, is a square auxiliary trench of brick for the burial of objects to accompany the deceased. In the central part of the southern trench were found ceramic figures of warriors and animals, including 46 oxen, 125 sheep, and 23 pigs (cat. nos. 21–23). In auxiliary pits of the Han tombs at White Deer Plain (Bailuyuan) in the eastern suburbs of Xi'an the finds included polychromed ceramic figures of animals and family servants (cat. nos. 16–18), pottery jars, grain, and the skeletons of actual horses, goats, pigs, dogs, chickens, geese, and cranes. The animal remains and ceramic figures found in these trenches reveal an unprecedented development of animal husbandry in the Western Han period.

Ceramic figures and funerary utensils from tombs of the middle of the Western Han era to the Eastern Han period (A.D. 25–220) in all parts of China are richly varied in subject matter and reflect many aspects of daily life. The red earthenware model of two workers operating a rice winnow and huller is a lively depiction of the exhausting lives of servants who began work when the

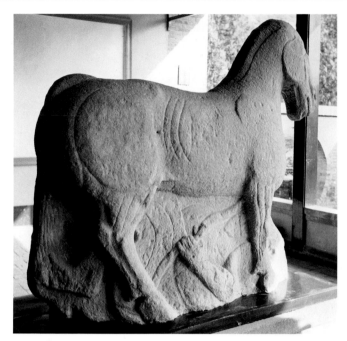

Fig. 9. Stone carving of a horse trampling a Xiongnu warrior, from the tomb of Huo Qubing at the Maoling necropolis, Shaanxi Province. Photo courtesy Julia F. Andrews.

cock crowed (cat. no. 25). In a late Eastern Han tomb at Zhechuan County, Henan, was found a ceramic model of a waterside pavilion, comprised of a pond and high pavilion (cat. no. 29). The master is seated cross-legged in the lower level of the pavilion, surrounded by attendants, animals, birds, and water creatures. This image of a typical garden pavilion clearly manifests the Eastern Han aristocracy's life of extravagance.

In Sijian'gou, in Jiyuan County, Henan, a late Western Han tomb yielded a representation of a new subject in Han sculpture, a glazed earthenware image identified as the mythical tree on Mount Peach Capital (cat. no. 28). Among the creatures on the tree or at its base are the Celestial Cock and other birds, monkeys, cicadas, running horses, and male nudes.

The sculptural level of Han ceramic figures is quite high. The human images in early Western Han are simple, lively, and precise, but the artists did not make fine distinctions in the variation of human form. Rather, in terms of gesture and basic proportion, they first exaggerated and distorted and then invested the figures with variations in emotion. For example, in the male and female attendant figures found in a tomb at Hongqing, Xi'an, Shaanxi, the upper part of the bodies are particularly flat and stiff and the skirts form simple trumpet shapes (cat. nos. 19–20). However, the faces of the fig-

Standing woman
Western Han dynasty, cat. no. 19

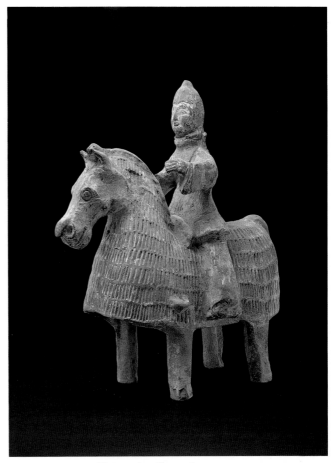

Equestrian figure in armor
Northern Wei dynasty, cat. no. 41

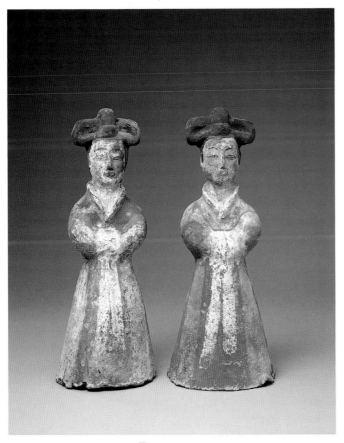

Two women
Northern Wei dynasty, cat. no. 42

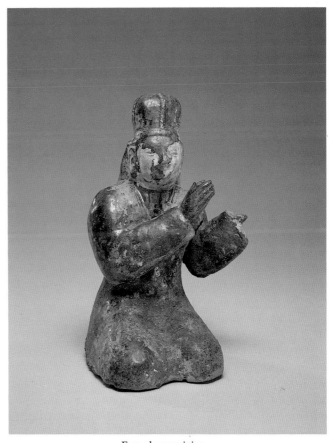

Female musician
Northern Wei dynasty, cat. no. 50

ures brim with feeling. Similarly, the entertainers excavated from an Eastern Han tomb at Xindu, Sichuan Province, are not very accurate from the point of view of proportion and anatomy, but the master sculptor who made them endowed them with unique features. Using concise and simple sculptural techniques he expressed in the most energetic fashion the rapturous performance of a drummer (cat. no. 38).

From the last years of the Eastern Han to the period of the Northern and Southern Dynasties (317–589) the economy advanced to the extent that many landlords could afford to maintain private troops. Tomb 1 at Caochangpo in the southern suburbs of Xi'an is the burial place of a landlord of Han Chinese ethnic stock from the Sixteen Kingdoms era (301–439). In a small niche were discovered eighty figures as an honor guard for an ox-drawn chariot, including warriors, mounted cavalrymen, drummers, buglers, and armored horses (cat. nos. 39–41). Twenty figures of male and female servants and seated female musicians were found in the antechamber of the tomb (cat. nos. 42–45). All are lively representations of the veritable army of people who attended the deceased in his lifetime, both in battle and in domestic service.

Another Han Chinese aristocrat, Sima Jinlong, and his wife were laid to rest in 484 and 474, respectively, in their tomb in Shijiazhai Village, southeast of Datong, Shanxi. In the front chamber were 320 small male and female ceramic figures, armored cavalrymen, warriors (cat. nos. 46–48), and wooden figures. There were also thirty large ceramic horses, some with packs of grain on their backs. In the side chambers were found three figures of female musicians (cat. no. 50). The majority of the figures in this tomb are not people of Han nationality, nor do they resemble the non-Chinese figures found in tombs of central China. We may hypothesize that they are images of the Toba people, the Turkic ethnic group to which the Northern Wei (386–534) rulers belonged. Sima Jinlong was a descendant of the Han Chinese Jin royal house that had surrendered to the Northern Wei. Texts record that he and his son served as officials for several decades; each was given honorary royal titles after he died.

Discoveries of Japanese terra-cotta funerary sculptures called *haniwa*, found in conjunction with Chinese-style chambered tombs, document the cultural exchange between China and Japan during this period. Near an ancient tumulus in Gumma Prefecture in central Japan was discovered a female haniwa figure with a long skirt and horizontal coiffure similar to those of Chinese sculptures excavated at Mufushan in Nanjing. A site in nearby Saitama Prefecture yielded a male haniwa wearing military gear similar to that represented on tile murals in a tomb at Dengxian in China. Japanese historical documents such as the *Nihon shoki* and *Kojiki* record that potters, tailors, and other craftsmen traveled to Japan from southern China during the Northern and Southern Dynasties era.[9] The production of haniwa and the building of tumuli ceased in Japan after the seventh century as funerary customs changed with the adoption of Buddhism.

More than seventy figures were found in a Western Wei tomb at Cuijiaying near Hanzhong, Shaanxi (cat. nos. 53–57), including an honor guard of sixty-six. Flowers ornamenting the heads and the hairstyles of the figures are typical of the people of Shu (modern Sichuan), and the warriors and those holding seals are dressed in robes of the Northern and Southern Dynasties. The bodies are gracefully elongated, with typical Wei-Jin elegance of form.

In the Sui (581–618) and Tang (618–907) periods the sculptural art of China burst into blossom. The Tang capital of Chang'an (modern Xi'an) was a cosmopolitan city of more than one million residents. It and Constantinople, capital of the Byzantine Empire, were the two ends of the silk route, like two stars in the heavens illuminating east and west. This international center attracted many Chinese and foreign visitors. Friendly emissaries of foreign countries and China's ethnic minorities, merchants, artists, and musicians met there. The colorful environment provided an inexhaustible source for sculptors, who observed life in minute detail and captured with the tools of their art the physical appearance of a wide variety of people and animals, as well as scenes of everyday life. Tang artists and artisans concentrated not only on the external forms of their subjects but also on the inner spirit. The spirit, in fact, was more important, ensuring the artistic vitality of these masterpieces. Artists became proficient at more complicated techniques for the creation of unglazed ceramic and *sancai* ("three color") glazed figures, a process that involved conceptualizing the image, making rough models, creating the form, making the mold, casting, trimming, firing the biscuit, painting, sancai glazing, glaze firing, and other special procedures.

Ceramic funerary objects of the Sui and Tang periods excavated from tombs in the Xi'an region fall into six typological groups: tomb guardians (warriors, heavenly kings, guardian beasts, and the twelve animals of the calendrical cycle), ceremonial figures and attendants (primarily ox-drawn chariots, horses, and camels, also

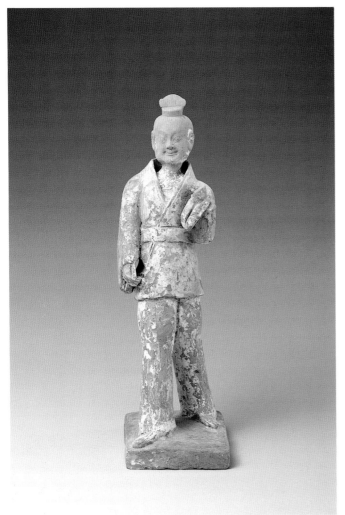

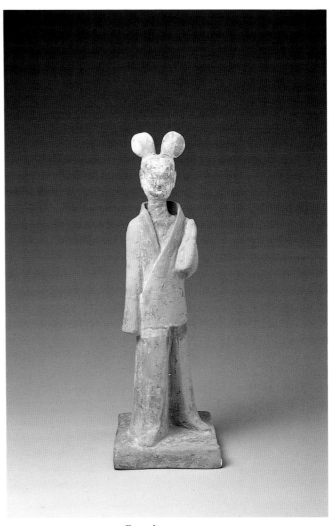

Warrior
Western Wei dynasty, cat. no. 55

Female servant
Western Wei dynasty, cat. no. 56

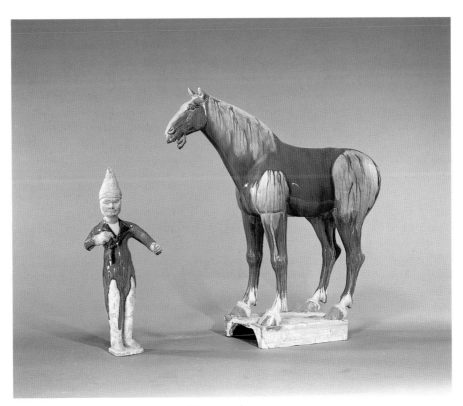

Horse and groom
Tang dynasty, cat. nos. 73–74

mounted warriors and hunters, grooms, and musicians), servants, animals, utensils for daily life, and architectural models.

Archaeological fieldwork has made it possible to divide the production of these image types into four periods. From the beginning of the Sui dynasty in 581 through the reign of the emperor Gaozong (r. 649–683) in the early Tang period, depictions of tomb guardians and ceremonial paraphernalia associated with the travels of the deceased were particularly characteristic. Figures of ox-drawn carts and ceremonial attendants were especially popular burial items (cat. nos. 58–59). Groups of ceremonial attendants remained popular during the reigns of Empress Wu Zitian and Emperor Zhongzong, which together span the years 684 to 710 and are usually referred to as the flourishing Tang period; however, horses with riders gradually replaced the ox-drawn carts. The standing horse became the focus of the groups of ceremonial attendants (cat. nos. 66–74). From the reign of Emperor Ruizong through that of Emperor Daizong, the middle Tang period (711–779), interest shifted from traveling to a less ceremonious domestic life, with figures of youthful servants and garden villas and rockeries favored as burial objects. Finally, from the reign of Emperor Dezong through the end of the Tang dynasty (779–907), there arose the custom of elaborate burials featuring gold, silver, brocade, and embroidered ornaments. After the reign of Emperor Xianzong (r. 805–820) the number of ceramic figures in most tombs decreased, while the quantity of metal sculptures increased and wooden figures also became popular.

The fascination with travel and the influence of the silk trade had a noticeable effect on the sculptors' choice of subject matter. Among the sancai figures excavated from Tang tombs in the Xi'an area, the most interesting is a group consisting of braying camels, magnificent horses, and the men who lead them (cat. nos. 73–76, 79). The pack animals, often heavily laden with silk, were symbols of the caravans that traversed the route from Chang'an to Constantinople. Within the city of Chang'an lived many Central Asian foreigners with deep-set eyes, high-bridged noses, red hair, purple robes, and jewels, who served the artists as inspiration for the large-eyed, bearded ceramic figures in high-peaked hats with upturned brims and long robes with narrow sleeves.

Horse breeding was a well-developed industry in the Tang. During the reign of Emperor Gaozong the herd directly controlled by the central government numbered 706,000 horses, and even more horses were raised in the stables of the Tang imperial household and in the villas of the bureaucrats and aristocrats near Chang'an. The famous Tang painter Han Gan based his work on the noble steeds of the imperial stable, and the foreign stock continuously shipped to Chang'an provided Tang sculptors with rich subject matter. The accurate proportions, distinct musculature, and lifelike postures of the sancai horses are renowned throughout the history of Chinese sculpture. They bring to life some of the images of Tang poetry, such as the verses of Cen Shen:

> One courier station after another,
> Express horses flowing by like stars.
> Leaving Xianyang at crack of dawn.
> By nightfall at Longshantou.

A sancai horse from the tomb of Qi Biming in the northern suburbs of Xianyang is an accomplished work capturing the beauty of the Ili horses of western Xinjiang (cat. no. 73). From the tomb of Zhang Shigui were excavated white-bodied ceramic images of prancing horses that may correspond to the dancing horses celebrated in Tang poetry (cat. no. 60).

The Tang dynasty female figures decorated with sancai glaze are extremely elegant and manifest very clearly the fashions of their time. The period of greatest production and popularity of Tang sancai corresponded closely to an era of stylistic transition in painting. In the early Tang period, ceramic figures of women had slender bodies and very tight-fitting garments, corresponding to the painting style associated with Cao Buxing, described as "draperies clinging as though dripping wet." By contrast, in the flourishing Tang period, female figures such as those excavated at Zhongbao Village (cat. nos. 77–78) and Gaolou Village (cat. nos. 83–84) in Xi'an are shown with bouffant coiffures, well-nourished bodies, and loose robes, as in the painting style of Wu Daozi, characterized as "sashes floating in the breeze." Also during the flourishing Tang period it was fashionable for women to ride horses and dress as men. Ceramic figures of ladies on horseback from the tomb of Li Zhen, Prince of Yue, illustrate this custom (cat. no. 82).

The Tang feudal rulers considered hunting to be one of the chief pleasures of life; they derived great enjoyment from chasing wild animals in mountain forests. The sancai figures of hunters on horseback from the tomb of Prince Yide (cat. nos. 70–72) successfully re-create a scene of the Tang imperial hunt. Among the figures are some with quivers, bows, or swords, some holding hawks. Several twist their bodies to look up, gazing at soaring game in the sky, hands holding cocked bows and arrows as though ready to shoot. Others carry the

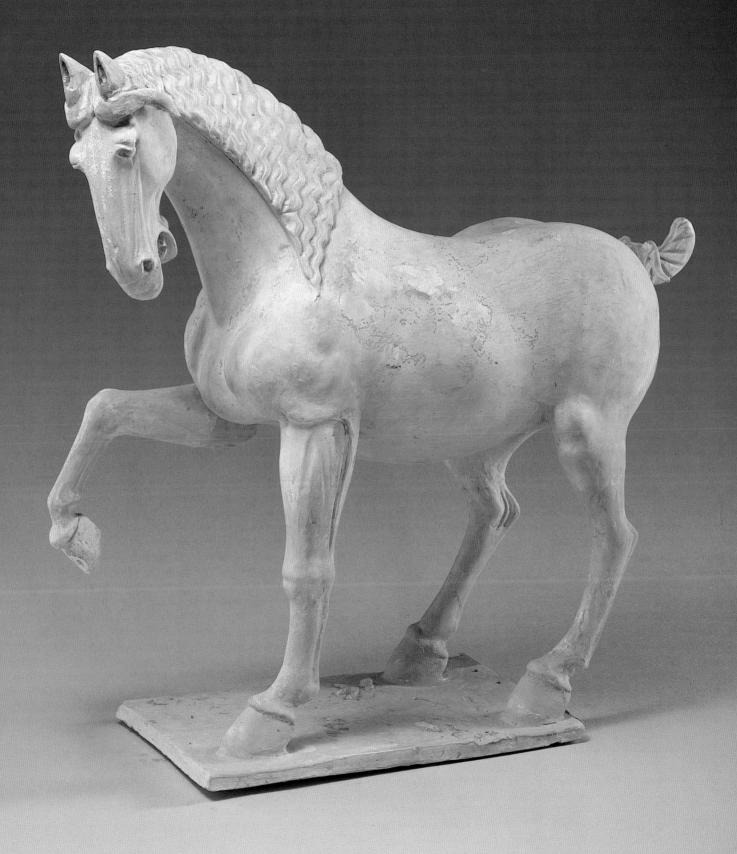

Horse
Tang dynasty, cat. no. 60

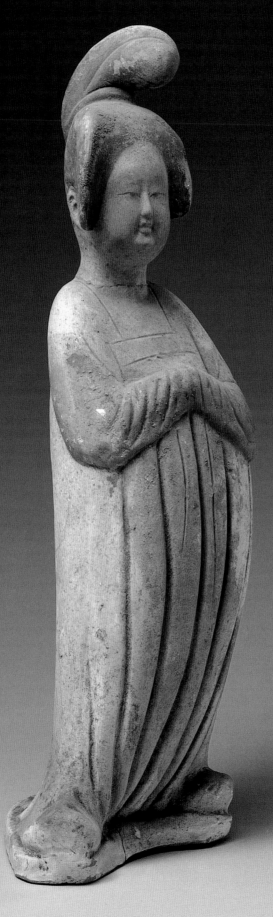

Woman with a high chignon
Tang dynasty, cat. no. 84

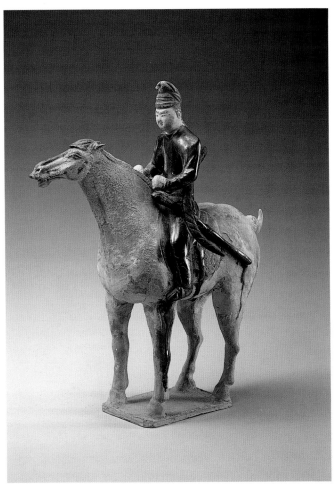

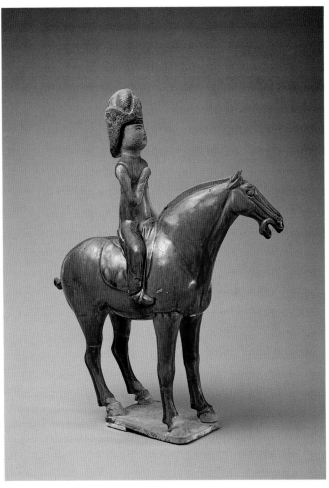

Hunter on horseback
Tang dynasty, cat. no. 72

Female equestrian
Tang dynasty, cat. no. 82

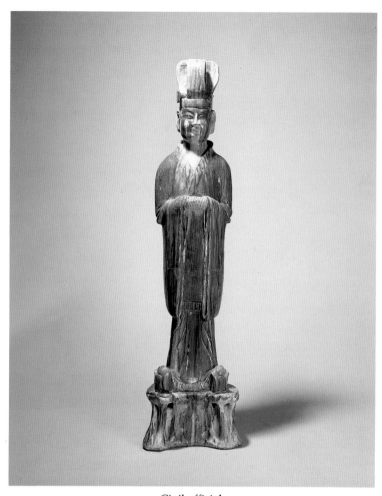

Civil official
Tang dynasty, cat. no. 62

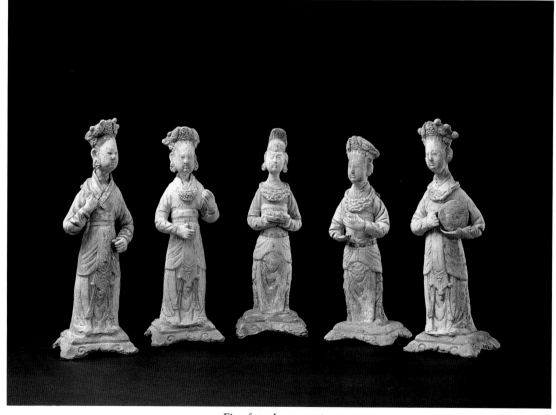

Five female servants
Song dynasty, cat. no. 88

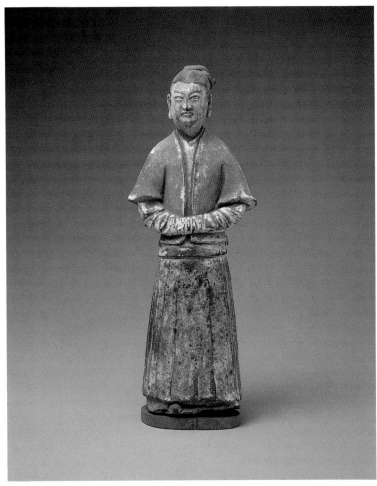

Standing woman
Yuan dynasty, cat. no. 95

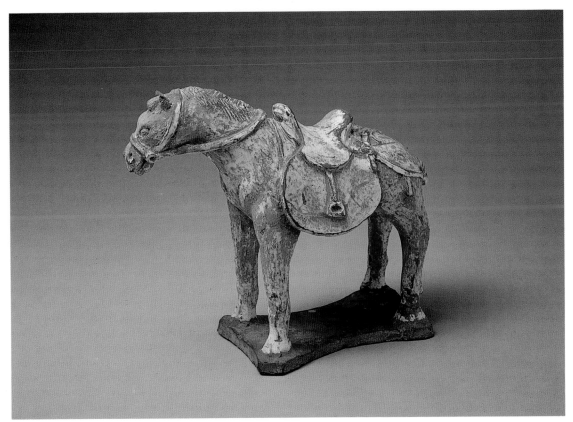

Horse
Yuan dynasty, cat. no. 96

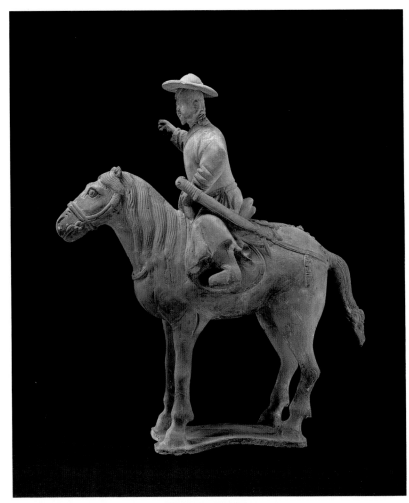

Horse and rider
Yuan dynasty, cat. no. 99

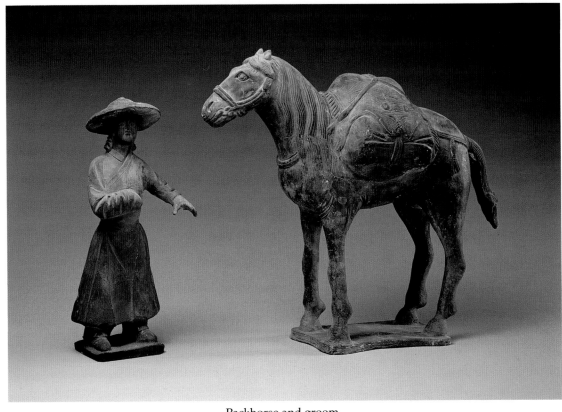

Packhorse and groom
Yuan dynasty, cat. nos. 97–98

spoil of the hunt, animals and fowl, slung across the backs of their saddles.

The tomb of Prince Yide also yielded 113 earthenware figures of horsemen decorated with paint and gold leaf (cat. nos. 67–69). This corresponds to written records and poems describing the gold and silver armor and attire worn by imperial ceremonial troops, tribute slaves, specialists in the martial arts, and performers of ritual music and other ceremonies.

The solemn and respectful civil officials (cat. nos. 58, 62) and the brave warriors excavated from Sui and Tang tombs are taken from life, while the marvelously depicted heavenly kings and guardian creatures that exorcise the evil spirits of the dark (cat. nos. 59, 63–64, 80–81) are evidence of the fertile imaginations of the sculptors and craftsmen.

The Song, Liao, Jin, Yuan, and Ming (960–1644) periods saw a decline in the quantity and quality of Chinese funerary sculpture. The golden age of figure burials in large tombs had already passed, and ceramic images were gradually replaced by paper figures and horses, some of which were transmitted into the afterworld by burning during the funeral ceremony. Paper funerary objects from the flourishing and middle Tang periods have been discovered in Astana in Turfan, Xinjiang; middle and late Tang documents record the use of funerary quilts and canopies made of paper. Paper objects became even more popular in the Song and Yuan periods; evidence may be found in official prohibitions contained in the *Yuan dian zhang* (Regulations of the Yuan) against the use of certain types of objects in funerals, including, houses made of glued paper, gold, silver, and paper figures and horses, and silken garments and canopies.

Some fine ceramic figures have nevertheless been excavated from tombs of this period. For example, the tall, slender attendant figures from a Song tomb at Xinlifeng, Jiaozuo, Henan, are executed with great refinement and delicacy (cat. nos. 87–88). The Jin period ceramic entertainers excavated from Xifengfeng Village at Jiaozuo, Henan, include figures whistling, holding clappers, playing the bamboo flute, reciting, and singing (cat. nos. 92–94). Most have long braids at the backs of their heads, while their foreheads and crowns are shaved clean; this is a custom of the Jin (Jurchen) peoples. The rendering of the figures is simple but accurate and the expressions varied. This group of lively performers is a masterpiece of carved terra-cotta sculpture.

Yuan period figures are mainly gray-bodied and unglazed. Facially some of them resemble the Semu,

non-Han people of the northwest. The polychrome standing female figures and horses from a Yuan tomb at Qujiangchi in Xi'an (cat. nos. 95–96) and the gray earthenware horses, camels, and grooms from the Yuan period tomb of the He family at Huxian, Shaanxi (cat. nos. 97–99, 103–104), achieve a certain artistic level because of their expressive skill and technical finesse. However, when compared with figures from the Qin and Han periods they are decidedly inferior. With this decline, the history of ancient Chinese sculpture entered another phase.

Notes

1. *Mozi* (Writings of Master Mo), fifth century B.C.

2. Sima Qian (c. 145–86 B.C.), *Shiji* (Annals of history), ch. 5.

3. Wang Chong (27–97), *Lunheng: Bozangbian* (Philosophical essays: Simplicity of funerals).

4. Wang Fu (85–163), *Qianfulun* (Essays of Master Qian), ch. 3.

5. Huan Kuan (active c. 23 B.C.), *Yan tie lun* (Discourses on salt and iron).

6. Zhao Yiqing (c. 1710–1764), ed., *Shui jung zhu* (Notes to the Classic of Waters).

7. Ban Gu (32–92), *Han shu* (History of the Han), ch. 4.

8. "Jingdiji" (Record of Jingdi), *Han shu*, ch. 5.

9. *Nihon shoki* (Chronicles of Japan) and *Kojiki* (Records of ancient things), both eighth century.

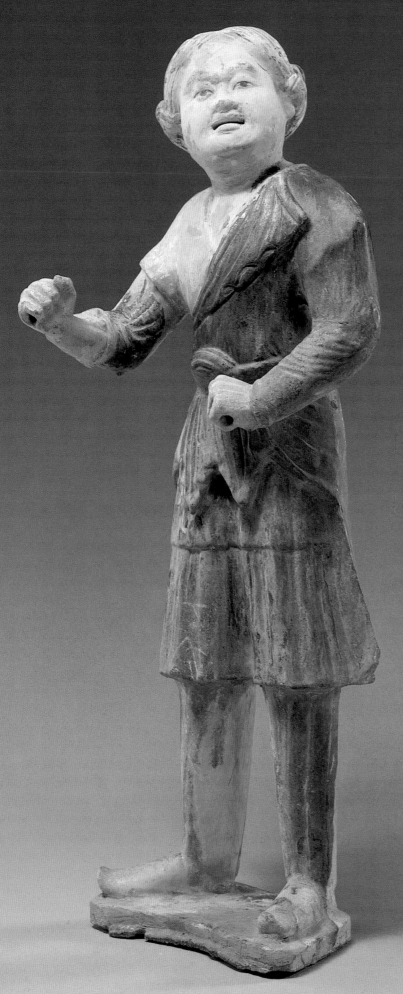

Groom
Tang dynasty, cat. no. 65

THE SCULPTURAL DEVELOPMENT OF CERAMIC FUNERARY FIGURES IN CHINA

George Kuwayama
Los Angeles County Museum of Art

The lively forms and haunting imagery of Chinese ceramic funerary sculptures have enthralled art collectors throughout the world for more than a century, but this enthusiasm was unmatched within China until modern times. Mortuary sculptures, while appreciated aesthetically by the ancient Chinese, were more highly regarded for their value in comforting and sustaining the deceased than for their form and style. They were not collected by the Chinese scholar-gentry, nor were they acquired for the great imperial collections, undoubtedly due to taboos concerning burial objects. Grave robbers stripped tombs of their more precious treasures and left funerary figures untouched.

Since the presence of tomb figures in museums and private collections outside China is the result of chance finds and the vagaries of the art market, art historical research on ceramic funerary sculpture has been inhibited by the uncertainty of provenance and a skepticism toward the dates ascribed to individual pieces. The earliest studies by Western writers emphasized the socioanthropological aspects of ceramic funerary sculptures, discussing their functions in the tomb and their revelations about Chinese life and material culture. Berthold Laufer's *Chinese Clay Figures* (1914) and Jane Gaston-Mahler's *The Westerners among the Figurines of the T'ang Dynasty of China* (1959) exemplify this approach: morphologically descriptive, they explore subject themes and their social and cultural implications.

Studies of Chinese sculpture have hitherto emphasized the evolution of Buddhist art, which had its religious and philosophical origins in India and its artistic styles and iconography rooted in India, Central Asia, and Romanized western Asia. Chinese sculptural development was largely defined as a process of gradual sinicization of foreign sculptural styles. Within the last four decades, however, this has changed radically. Frequent reports of stunning new archaeological discoveries have profoundly altered our perceptions of Chinese funerary art and, indeed, of Chinese culture in its entirety. The new archaeological discoveries provide a corpus of ceramic sculpture that reveals an ancient native Chinese tradition re-creating in three-dimensional form figures of people, animals, and objects of daily life. We are now aware of the vitality of that tradition, which extended from the Neolithic era through the

dynastic period to modern times. This exhibition of recently excavated examples encapsulates the development of style, form, and technique of Chinese ceramic funerary sculpture.

Neolithic Art (c. 8000–2000 B.C.)

Like all humankind the Chinese have sought to ameliorate the uncertainties of death. As early as the Neolithic age considerable resources were expended on the burial of the dead in order to appease the departed spirit. Finely carved jades, painted pottery, and occasional figurative forms in ceramic, stone, or more perishable materials graced these early interments. Efforts were even made to communicate with the spirit in early forms of ancestor worship.[1]

The development of ceramic funerary figures in China was a unique, indigenous phenomenon, which grew out of a penchant in Neolithic times for modeling plastic forms in clay. From this era into the Six Dynasties period these creations were governed by an aesthetic of conceptualization: solid, massive forms were created as they were remembered rather than seen. Generalization and abstraction characterize the sculptures which, nevertheless, often capture directly and succinctly an act or emotion.

The Neolithic Chinese of the early Yangshao culture (5000–3000 B.C.) made remarkable earthenware figures of humans and animals, as typified by the discoveries at Luonan (cat. no. 1) and Huangling (cat. no. 2) in Shaanxi Province. Their compact masses and simply conceived forms cry out with mute intensity. There is only the merest indication of a recognizable shape, but even elemental facial features may evoke a mood or an emotion with unencumbered directness. One of the most astonishing late Neolithic works is an earthenware bird discovered at Liuzizhen, Huaxian, Shaanxi (fig. 1).[2] Through geometric volumes simply modeled with rudimentary means, it powerfully expresses the essence of a winged creature.

Bronze Age (c. 2000–221 B.C.)

During the Bronze Age (later Xia, Shang, and Zhou dynasties) royal interments were accompanied by elaborate tomb furnishings. These *mingqi,* or "spirit objects," were made for the dead as an affirmation of an existence

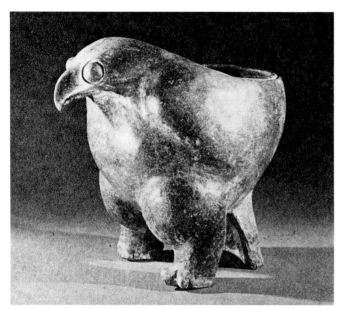

Fig. 1. Neolithic pottery bird from Huaxian, Shaanxi Province. From Institute of Archaeology, *Xin Zhongguo de kaogu faxian he yanjiu* (1984).

beyond mortal life. The earliest instances of burial substitutes occurred in the late Shang when ritual bronzes were replicated in low-fired pottery for common graves.[3] This is the beginning of a tradition that floresced into the magnificent art of ceramic sculpture in subsequent dynasties.

As early as middle Shang, human sacrifices were included in royal burials.[4] The grisly practice of immolating retainers and animals was replaced by the use of effigies during the late Zhou period. It is possible that the earliest surrogates were made of wood. The archaeological sites associated with the southern state of Chu (c. 800–223 B.C.) contained wooden funerary figures, many of which were colorfully painted or lacquered.[5] Wooden figures have also been found in tombs in other regions of China, such as a Jin dynasty site of the late Spring and Autumn period (770–475 B.C.) at Changzi, Shanxi Province.[6]

The oldest tomb so far discovered with ceramic effigies accompanying the dead was unearthed at Langjiazhuang, Linzi, Shandong Province, a site that can be dated by its archaeological context to the early fifth century B.C.[7] Other clay figures from early sites include the finds at Fenshuiling, Changzhi, Shanxi (cat. no. 5), where more than one thousand items were discovered.[8]

Advances in sculptural techniques during the Bronze Age resulted in greater clarity in the definition of mass and volume, but there was little attempt to represent movement. Shang ceramic figures have summary forms with contours outlining palpable shapes rigid in their symmetry and frontality (cat. no. 3). Although the masses lack surface definition and the appendages are without articulation, the whole is evocative of a vibrant creature of nature.

The ceramic figures from Langjiazhuang and Fenshuiling present freestanding human figures in plastic isolation. When viewed from the front, the large, smooth surfaces of the geometric masses are distinguished by an unbroken silhouette. Incidental details are suppressed, and legs and torso, arms and hands flow into each other without articulation. The disproportionately large head rests on a neckless, short body. All these features suggest a figure as it was conceived in the mind rather than seen with the eye. The compact masses and flat facial planes with protruding triangular noses imply a stylistic origin in media other than clay. The lithic rigidity of form contradicts the greater flexibility inherent in clay, while the angular treatment of surface hints at a prior source in wood carving.

By the Warring States period (475–221 B.C.), mortuary ceramics had become a tradition independent of functional pottery. Surrogate figures and objects were buried in graves of both wealthy and poor. Soft low-fired ceramics of fine quality, differing from plain, sturdy utilitarian wares, were produced especially for burial use. Particularly notable were the ceramic replicas of ritual bronze vessels, adorned with paint, lacquer, impressed or appliquéd designs, inlaid with glass paste and, in more elegant examples, with tin or copper foil.

Qin Dynasty (221–207 B.C.)

Our perceptions of the history of Chinese sculpture have been radically changed by the most spectacular archaeological discovery made in China since the founding of the People's Republic: the vast funerary army guarding the mausoleum of the First Emperor of Qin.[9] An accidental find in 1974 uncovered row upon row of life-sized terra-cotta warriors massed in military formation, eternally prepared to defend the emperor in his afterlife. Subsequent discoveries and excavations of two additional sites added to a total of more than seven thousand ceramic sculptures of soldiers and horses painted in bright colors, revealing a monumental sculptural tradition hitherto unknown.

Qin Shihuangdi, the "First Emperor of Qin," was a brilliant general equally adept at political administration who brought an end to centuries of political chaos and war by uniting China through conquest in 221 B.C. This

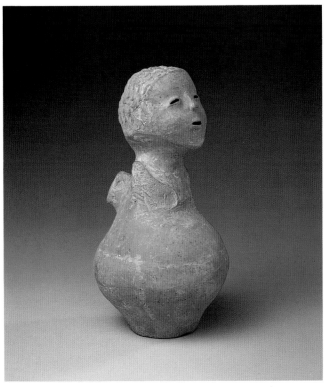

Human-headed pot
Neolithic period, cat. no. 1

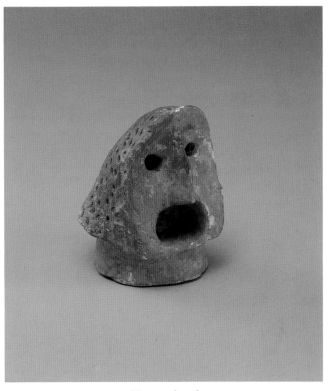

Human head
Neolithic period, cat. no. 2

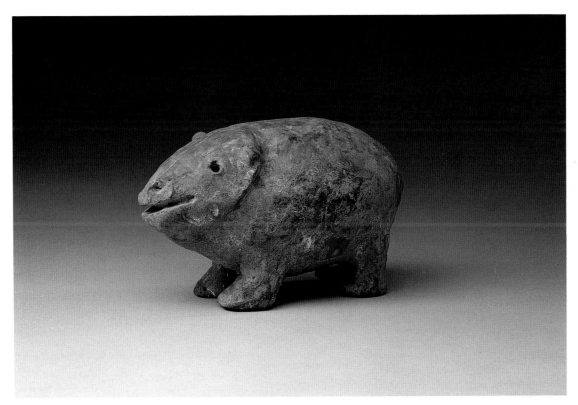

Pig
Shang dynasty, cat. no. 3

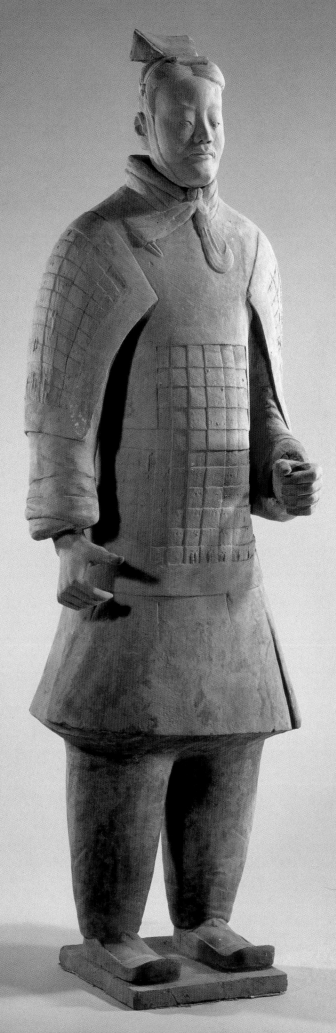

Officer
Qin dynasty, cat. no. 6

Fig. 2. Detail of the sole of a shoe from the figure of a warrior at the Lishan necropolis of the First Emperor of Qin, Lintong, Shaanxi Province. Photo courtesy Maxwell K. Hearn.

Despite the astounding number of life-sized ceramic soldiers and horses, each displays a high degree of technical accomplishment. Most of the parts were mold-made, carefully assembled, and finished with particular attention to individualization.[14] The completed figure was coated with a slip of fine clay, and details of dress and armor were appliquéd to the still pliant surface. An amazing concern for detail is displayed on the sole of a shoe (fig. 2) or in the braiding of a knot of hair. The entire figure was then mounted on a base and fired. The hands and heads of the warriors and the tails and forelocks of the horses were made separately and attached with clay. Finally, each figure was colorfully painted and fitted out with real weapons or trappings of bronze.

The style and color of uniform, armor, cap, and shoes differed with each warrior's combat speciality, as did the pose; some figures are kneeling, others leading horses, still others poised for hand-to-hand combat. The height of each figure appears to have been determined by rank or function, with important officers exceeding six feet. Although the mineral-based pigments have not survived two millennia of burial, the traces that remain attest to a brilliant palette utilizing every hue in varied combinations.

The faces conform to a general idealized type, but each shows details of a highly personalized characterization, as exemplified by a lifelike warrior's head from pit 1 (cat. no. 6). The eyeball bulges convincingly against the eyelid, the lips compress naturally without the distortion of an archaic smile, and the smooth surface transitions of the face convey a sense of volume and structure. Hair knots, mustaches, and beards in infinite variation add to the individuality of the figures.

The Qin warriors (cat. nos. 6–8) are mature examples of the conceptually conceived sculptures produced from the Neolithic age into the Six Dynasties period. They display a style that is frontal, two-dimensional, linear, and idealized. Foreshortening is avoided, and suggested movement, however dynamic, is restricted to a single plane. In contrast to Zhou figures, greater clarity is achieved in the definition of body parts, which are joined in transitions smoothly manipulated in the malleable clay. Although there is not yet an organic whole with harmoniously integrated elements, these ceramic soldiers are remarkable for accuracy of detail and a new monumentality, the culmination of incipient developments in the late Zhou. The grandiose conception and heroic execution of Qin Shihuangdi's tomb complex was not equaled before or afterward.

unification laid the foundation for an imperial China that lasted more than two thousand years. The First Emperor's prodigious construction projects, which included the Great Wall, numerous palaces, canals, and waterworks, promoted the development of the technology and the specialized division of labor necessary to manufacture his ceramic army. The facilities, resources, and technicians previously employed to produce ceramic water conduits and tiles for wells and buildings were sequestered for a nobler purpose.[10]

At a site about 1,225 meters east of the outer mausoleum wall an army of warriors and horses was buried in elaborate subterranean chambers. Six thousand ceramic horses, fully equipped chariots, and warriors armed with actual bronze swords, spears, and bows were uncovered in pit 1.[11] A second pit contained a force of chariots and cavalry, about fourteen hundred warriors and horses.[12] A third, smaller pit containing only sixty-eight figures appeared from the large proportion of officers to be a command post.[13]

Han Dynasty (206 B.C.–A.D. 220)

The national unification initiated by the short-lived Qin empire was firmly established by the Han dynasty. Internal peace fostered economic development and extensive commercial and cultural contacts with foreign countries as far away as ancient Rome. The Han era was a time of consolidation of cultural values, formalizing the ideas extant for centuries, and of promulgation of a Chinese cultural identity.

During Han there was a surge of interest in filial piety, which, as a metaphor for loyalty to the emperor, also became a political virtue. Popular belief in the ability of descendants to ease their parents' way in the afterlife, not to mention a fear of vengeful ghosts, encouraged elaborate funerary preparations. In order to placate the spirit (*po*) of the deceased, mingqi in a wide variety of forms were interred in the tomb, together with many of the dead person's prized possessions, indicating his status and style of life for the netherworld.[15]

The Han period was also an age of experimentation and innovation in tomb architecture and furnishings. The Qin had set an ostentatious precedent for Han royal tombs, which evolved from simple vertical shafts to multichambered mausolea. The late Western Han tomb had several brick-lined chambers linked by passageways. Joint burials of husband and wife and new ritual requirements resulted in larger tomb chambers, which could accommodate even more grave goods.[16] Literary sources mention, the number and types of mingqi prescribed for a proper burial.[17]

Ceramic figures were commonly used in interments, and officially sponsored factories arose to produce them. The areas around the Han capitals of Xi'an and Luoyang were the major centers of production. Nevertheless, other regions produced excellent funerary sculpture, meeting local needs in Gansu and Sichuan in the west, Hunan in central China, and Shandong, Jiangxi, and Guangdong in the east.

The subjects rendered in Han tomb sculpture encompass virtually every aspect of life and provide visual documents of the nature of Han civilization. The declining economy of Eastern Han changed the character of the tomb from a treasure chest to a model dwelling. Reinforcing a firm conviction to "treat death as life," burial chambers imitated actual homes, complete with furnishings, provisions, and ceramic reproductions of household items. The agricultural basis of the economy was graphically indicated by the inclusion of imposing model farm structures and an amazing variety of domesticated animals. These barnyard creatures were especially well rendered during Han, an achievement unsurpassed until the Tang dynasty. Figures representing every station in life — officials, court ladies, warriors, servants, acrobats, dancers — filled the tombs with a re-creation of the mortal world.

The supernatural powers of wild or mythical animals such as fabulous three-horned rhinoceroses, dragons, and unicorns were enlisted to protect the grave. During late Eastern Han, as cosmological concepts began to influence burial practices, ceramic warriors, guardians, and shamans wearing suits of armor and brandishing spears or swords began to appear in tombs. These had their origins in a belief in exorcism, and they were modeled after practicing sorcerers.

The funerary figures of the Han dynasty provide the ultimate achievement of conceptual sculpture, that is, an art of cognitive interpretation rather than realistic description. There is an imposing monumentality in the figures despite their small size, but their unique quality is a sense of vigorous movement, conveyed through pose and gesture, most admirably captured in the renderings of acrobats and dancers. Simplified and schematized volumes with smooth surfaces are coherently related, with strong contours as the primary unifying elements. There is little underlying organic structure, but the gently rounded masses are inscribed with details.

Han tomb sculptures were produced by impressing clay between two facing molds; they were characterized by hollow centers and unfinished seams down the sides (although the finest pieces are carefully trimmed and finished). In architectural models and other large-scale objects, individually molded parts were joined before firing. The gray earthenware that was produced by firing at a low temperature was then covered with a white slip and colorfully painted. The technical excellence, precision, and refinement of detail of Han funerary sculpture may be seen in the figures unearthed at Renjiapo, Xi'an, Shaanxi (cat. nos. 16–18).

Lead-glazed ceramic mingqi first occur in late Western Han. Iron oxide impurities in the lead silicate caused the glazes to turn brown during firing. Tomb 8 in Sijian'gou, Jiyuan, Henan Province, yielded a large number of such pieces (cat. nos. 27 and 28), demonstrating a technological development that was to endure. A little later, lead silicate glazes with copper oxide were used to produce a bright green color and a fine luster that replicated the patina of bronze (cat. nos. 29, 33, and 34). These lead glazes were used exclusively for mingqi. During Eastern Han they grew in popularity for figures and replicas of

ritual bronzes, lamps, storehouses, towering pavilions, and Taoist sacred mountains. The official kilns near the capitals in Shaanxi and Henan provinces were the principal centers for the production of lead-glazed funerary vessels.[18] There were, however, other regions that produced lead-glazed mingqi, as revealed by the contents of tombs in Changsha, Hunan,[19] in Nanchang, Jiangxi,[20] and in Haizhou, Jiangsu.[21]

In the south, the development of the dragon kiln for high-temperature firing resulted in green-glazed stoneware of feldspathic type; examples were produced as early as late Eastern Han at Shaoxing and Shangyu in Zhejiang Province. This stoneware underwent major advances during the following Three Kingdoms and Six Dynasties period.

Fig. 3. Earthenware tableau of performers and spectators from an early Western Han tomb at Jinan, Shandong Province. From Institute of Archaeology, *Xin Zhongguo de kaogu faxian he yanjiu* (1984).

The archaeological discoveries of the last several decades have revealed a diversity of regional sculptural styles during Han, a legacy of the political subdivisions and regionalism of the Warring States period. One stylistic current can be seen in discoveries in an early Western Han tomb in the northeast at Jinan, Shandong, which yielded a remarkable tableau of ceramic figures arranged on a rectangular platform (fig. 3).[22] An orchestra provides musical accompaniment for a singer, dancers, and a troupe of acrobats performing for an audience of proud dignitaries arranged formally in rows on either side. Like many Han figures they are monumental in conception, despite their small size. The style is also traditional in its schematization and preference for abstract geometric volumes. The most characteristic pose for each figure is selected, the simplified forms

defined by compact spheres or cylinders. Bodies are barely described below the neck, yet they are capable of expressive animation in a striking pose or a facial expression.

Another archaeological excavation, at Yangjiawan near Xianyang, Shaanxi (cat. nos. 11–15), uncovered a Western Han funerary site of spectacular scope, dating to the middle of the second century B.C.[23] With about two thousand infantrymen and more than five hundred mounted warriors, it approached the grand precedent established by the First Emperor of Qin. In addition, replicas of dancers, musicians, acrobats, animals, buildings, farms, and common utilitarian objects provide visual documentation of the culture. The figures are rendered frontally, with large heads and body masses only suggested by long tunics. Layers of clothing are clearly indicated, and details are executed by incising or painting the clay in red or black over a white slip. In contrast to the Jinan figures there is a sense of proportions, a clear definition of body parts, and an accurate functioning of anatomical joints. These figures are generic types, universal in their characterization, rather than individuals captured at a specific instant in time. Analogous to the Yangjiawan figures are the ceramic warriors from the Anling Mausoleum, Xianyang, dating to the early second century B.C.,[24] and those from the Western Han tombs at Langjiagou, Xianyang, all attesting to a regional Shaanxi style.

A remarkable group of standing and seated servant figures, which may be dated to around 135 B.C., was uncovered at Renjiapo, Xi'an, Shaanxi (cat. nos. 16–18).[25] They are carefully modeled, their sensitively rendered surfaces displaying a degree of naturalism not found in any other region. The effect of gravity is seen in the pull of the robe at the shoulders and in the hang of the lower sleeves. The gentle undulation of the robe suggests the hips and the protruding roundness of the calves. Incredibly subtle surface modulations in the face achieve the tangible softness of flesh.

One of the most important late Western Han discoveries in central China is tomb 24 at Sijian'gou, Jiyuan, Henan, which yielded models of a bevy of animals and farm implements (cat. no. 25), confirming an advanced agricultural industry during the Han period.[26] Perhaps the most remarkable contents of this tomb are a group of acrobats and dancers with animated poses and a sense of movement. Arms and bodies extend dramatically into space, imparting to the performers a vivid sense of rhythmic motion. The dynamic acrobats of Sijian'gou exemplify a continuing tradition, as can be seen in the

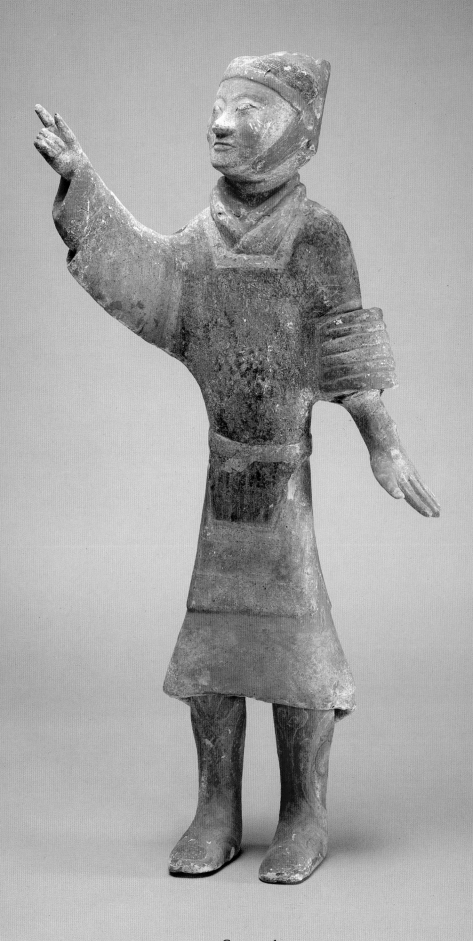

Commander
Western Han dynasty, cat. no. 11

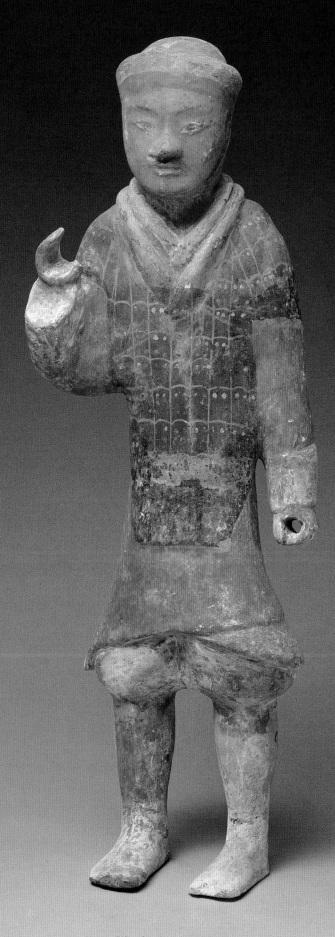

Warrior in armor
Western Han dynasty, cat. no. 14

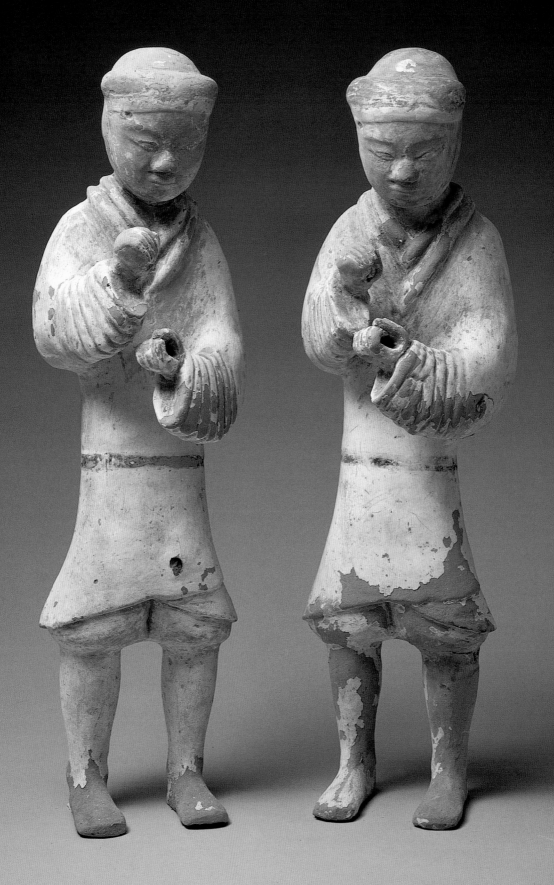

Two musicians
Western Han dynasty, cat. no. 13

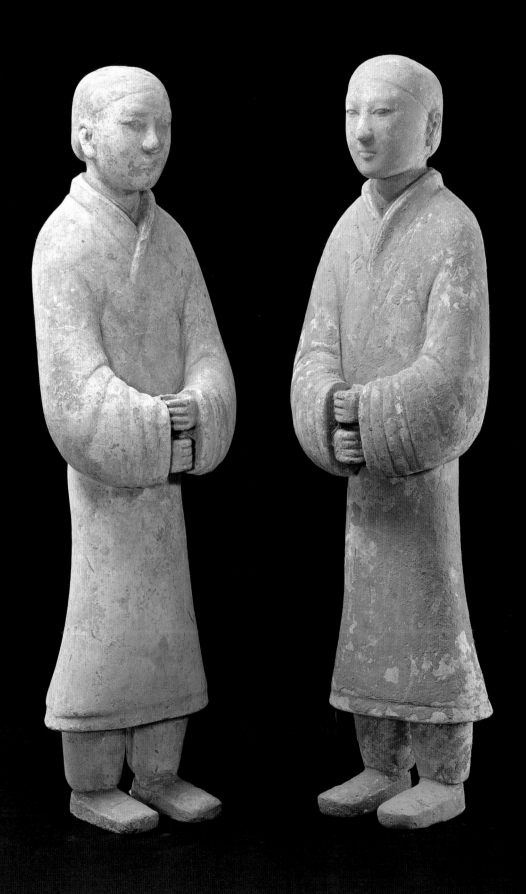

Two standing women
Western Han dynasty, cat. no. 18

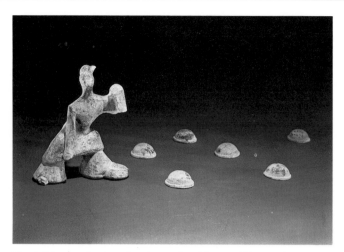

Fig. 4. Figure of an acrobat from a late Eastern Han tomb at Jilihe, Jianxi, Luoyang, Henan Province. Photo courtesy Lu Shaochen.

appealing performers from a late Eastern Han tomb at Jilihe, Jianxi, Luoyang, Henan (fig. 4).[27]

Han dynasty tombs excavated in Guangzhou have provided vital information about the culture of this southernmost province. Carved wooden figures were produced here in the Eastern Han period, attesting to the continuity of a vital tradition descending from the ancient kingdom of Chu. This tradition exerted its influence on the developing form and decoration of ceramic figures. Each body is defined by simple geometric shapes with crudely indicated arms and a head formed by intersecting planes and embellished with incised features. A more complex, and profoundly graceful, figure is a late Eastern Han dancer from a central Guangzhou tomb (fig. 5).[28] Boldly contoured sheets of clay representing long, trailing sleeves encircle the body, and an elaborate headdress is created with projecting and appliquéd forms. Colorful accents are added here and there with touches of paint.

Perhaps the finest rendering of expressive movement during the Han era is a superbly executed drummer from the southwestern province of Sichuan (cat. no. 38). This late Eastern Han piece unearthed at Xindu reveals amazing advances in the sculptor's descriptive capability. The energetic thrust of limbs into space and the implied potential action of arms and legs create a plastic composition of dynamic rhythmic movement. The parts of the body are still simplified, defined by essentially spherical or cylindrical volumes, but their surfaces are manipulated to reflect an acute awareness of natural forms. The sculptor's observations are distilled and translated into an arresting interplay of kinetic energy.

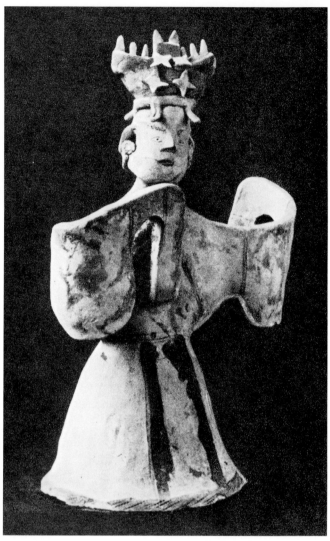

Fig. 5. Figure of a dancer from a late Eastern Han tomb at Guangzhou. From Cultural Relics Preservation Council, *Guangzhou Han mu* (1981).

The Three Kingdoms (220–265) and Six Dynasties (265–581)

The powerful, flourishing Han dynasty was succeeded by a time of political division, economic decline, and barbarian incursion. Nevertheless it was a creative period during which new foreign influences were assimilated, particularly the Buddhist religion and aspects of Indian and Central Asian cultures that accompanied it. Experimentation in the arts resulted in seminal developments in monumental stone sculpture, calligraphy, figure painting, and high-fired stoneware with celadon glazes.[29]

In the late second and third centuries, marked changes in burial practices occurred with the exercise of

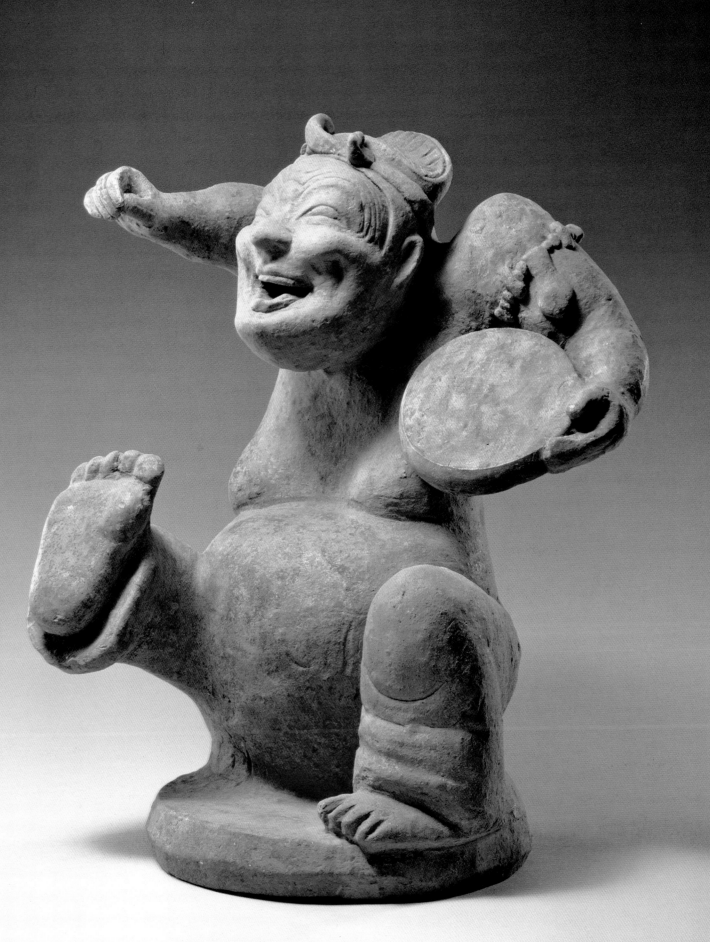

Balladeer
Eastern Han dynasty, cat. no. 38

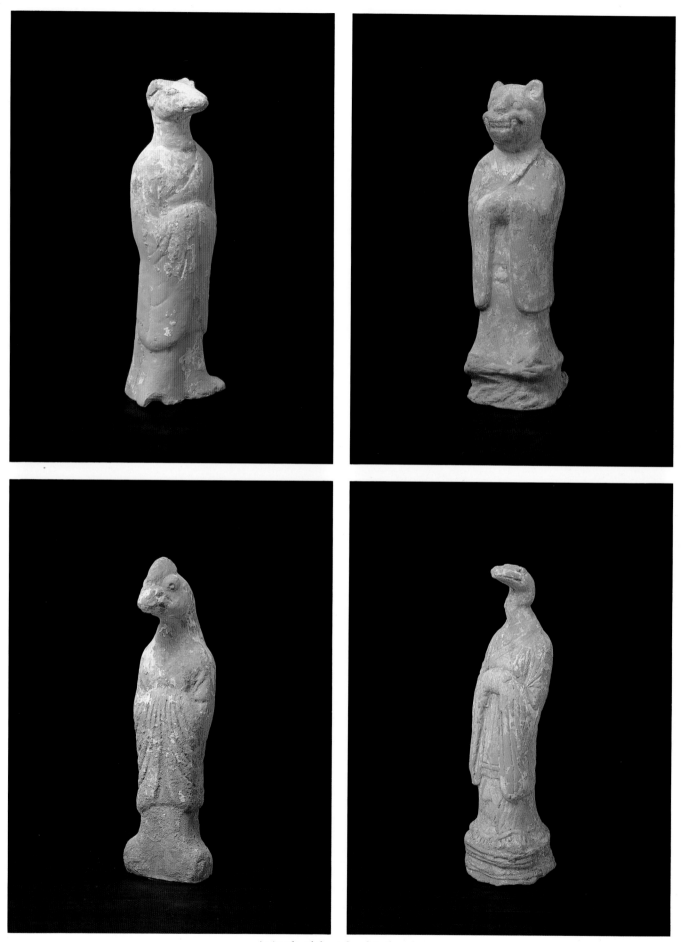

Animals of the calendrical cycle
Tang dynasty, cat. no. 86

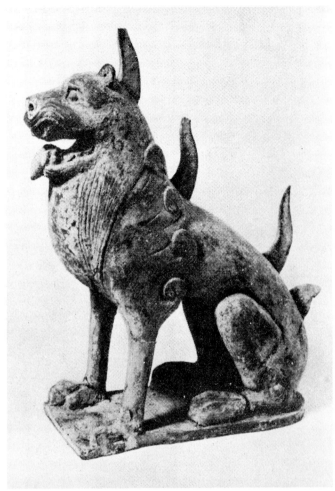

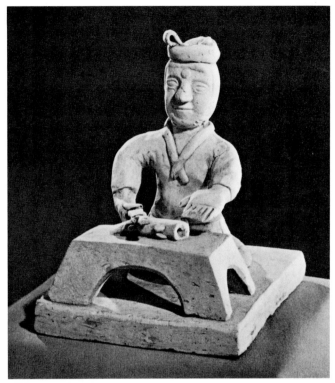

Fig. 7. Figure from a Western Jin tomb at Changsha. From *Historical Relics Unearthed in New China* (1972).

Fig. 6. Figure of a guardian beast from the tomb of Yuan Shao, Luoyang, Henan Province. From *Kaogu*, 1973, no. 4.

Taoist beliefs and the introduction of Buddhism. Graves now assumed an additional function as a place of meeting and sacrifice for the descendants of the deceased. The growth of Buddhism during the Six Dynasties also led to some reduction in the scale of burials. Tombs of the Three Kingdoms and the Six Dynasties reverted to a simpler form and contained more modest mingqi, reflecting unstable economic conditions.

The cosmological concepts prevalent in late Han continued during the Three Kingdoms and the Western Jin (265–316) periods and resulted in more frequent appearances of fabulous animals and winged dragons. During the Six Dynasties, artists conjured up fantastic creatures from the spirit world in an unfettered expression of artistic imagination. These guardian beasts included the apotropaic half-human and half-animal *qitou* and the fierce chimera with flamelike horns, bulging eyes, and menacing maw (fig. 6). Sorcerers who

guarded the tombs of Han were, in succeeding eras, closely associated with the tomb and temple guardians of the four directions (*fang xiang*).

The excavated materials from a late Eastern Wu (222–280) tomb[30] and a Jin (265–420) tomb excavated in Changsha, Hunan (fig. 7),[31] attest to a retardataire continuance of Han styles and themes in ceramic tomb figures. But the treatment of the compact geometric masses is more summary, with a decline in execution and finish, resulting in ill-defined forms. The balanced proportions characteristic of so much Han sculpture were gone.

Techniques of glazing were practiced intermittently during the Six Dynasties era. In the north during the Western Jin period, artists produced ash-glazed and green lead-glazed ceramic mingqi in the manner of the Han period.[32] In the south, with the spectacular development of Yue wares, celadon-glazed figures appeared, particularly during Eastern Jin (317–420). Ceramic sculptures of the Northern Wei (386–534), usually solid and rarely glazed, were made from iron-rich clays pressed into a single shallow mold. After firing, the dark biscuit was covered with slip and painted with a variety of colors.

In the Six Dynasties period wealth and political power were increasingly concentrated in the hands of regional warlords with large landholdings and private armies, a fact accounting for the prevalence of ceramic figures of warriors and mounted cavalrymen in the graves of this era. The fourth-century tomb of one of these powerful lords, discovered in a suburb of Xi'an, at Caochangpo (cat. nos. 39–45), yielded exceptional contents: a funeral cortege of eighty figures with an ox cart as the principal vehicle. A ceramic army of infantry and cavalry wearing belted tunics and baggy trousers reflected the continuing political dominance of the military classes. To serve the personal needs of the deceased, replicas of servants and an orchestra of lady musicians graced the subterranean chambers.

By the fourth century, China was divided into northern and southern regions. The north was under barbarian control with the Toba Tatars gradually ascending to dominance. The Toba, who produced the magnificent stone sculptures at Yungang and Longmen, were fervent Buddhists and apt students of Chinese culture. The variety of foreign influences on Chinese artistic traditions stimulated stylistic innovation toward the end of the fifth century and into the sixth century. In funerary sculpture, in contrast to the Han schematic rendering of a figure as a head and a robe, a body can be perceived beneath the garments, legs are clearly defined, and facial features are fully indicated.

Material excavated from the tomb of Sima Jinlong (d. 484) at Datong, Shanxi, demonstrates a technical renaissance (cat. nos. 46–52).[33] Of about four hundred ceramic figures discovered in this tomb, most are covered with green or brown lead glazes. Such wide use of lead glazes was unprecedented; this was a harbinger of the spectacular revival and development of polychrome glazing that was to come in subsequent centuries.

The Luoyang period (494–534) of Northern Wei ushered in a period of cultural florescence. The sinicization of the Central Asian Buddhist style manifest in the monumental cave sculptures at Longmen influenced contemporary funerary figures. Chinese aesthetic sensibilities found expression in elongation, linear rhythms, angularity, and low-relief modeling. Stylistically the faces of the sculptures became long and square, enhanced by a delicate archaic smile and arched brows. This can be confirmed by the finds in the princely tomb of Yuan Shao (d. 528) and his wife, Yuan Guai (d. 520), uncovered at Luoyang, Henan,[34] and by another Northern Wei grave, discovered at Quyang, Hebei Province, that may be dated around 524.[35]

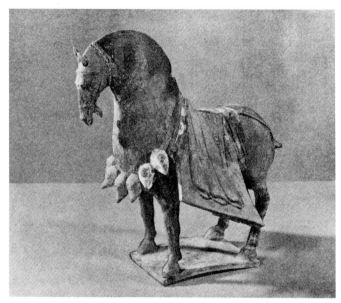

Fig. 8. Figure of a horse from a Northern Wei tomb at Quyang. From *Kaogu,* 1972, no. 5.

In a transitional style that is mannered in its bold attenuation and exaggerated forms, beguiling funerary horses and human figures were created. Elaborately caparisoned horses with long, narrow heads, broad-chested bodies, and spindly legs attached to a supporting base were typical equine representations of the period (fig. 8).[36] The tall tomb figures of courtiers and officers have proportionally small heads on long cylindrical necks. They are essentially two-dimensional, modeled on the frontal plane with their backs often unfinished (fig. 9).[37] Engraved details of facial features and dress bring descriptive clarity. The ethereal grace of these slender, elongated forms is combined with balanced tension between an insistent silhouette and a denial of bodily form beneath and between distorted proportions and the continuity of surface planes. The refined execution often achieves an evocation of tenderness, a subtle characterization of emotion that is consonant with the development of secular figure painting in the Six Dynasties period and the rise of artists like Gu Kaizhi (344–406).

In the south a succession of Chinese courts flourished at Nanjing, making impressive contributions to the arts. Here the Han tradition lingered, as is evident in the ceramic sculptures unearthed from Southern Dynasties tombs in the Nanjing region.[38] The two-dimensionality and elegant slenderness of northern figures are nowhere to be seen; instead, the traditional Han emphasis on mass and geometric volumes is apparent. The

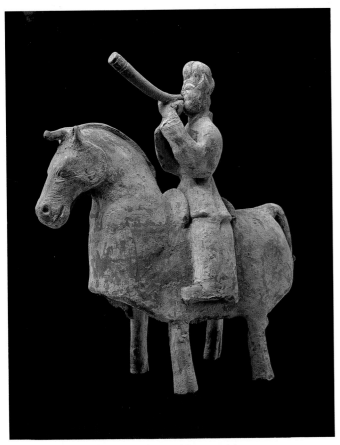

Equestrian figure blowing a horn
Northern Wei dynasty, cat. no. 40

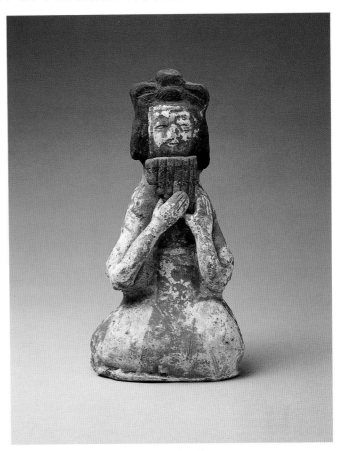

Woman playing bamboo pipes
Northern Wei dynasty, cat. no. 43

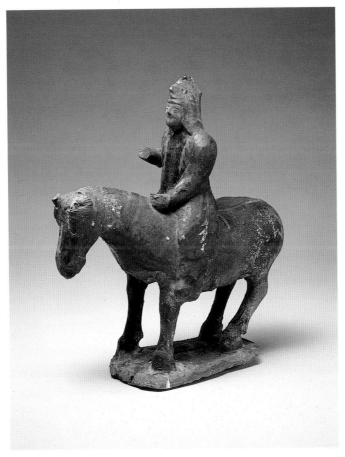

Equestrian figure
Northern Wei dynasty, cat. no. 46

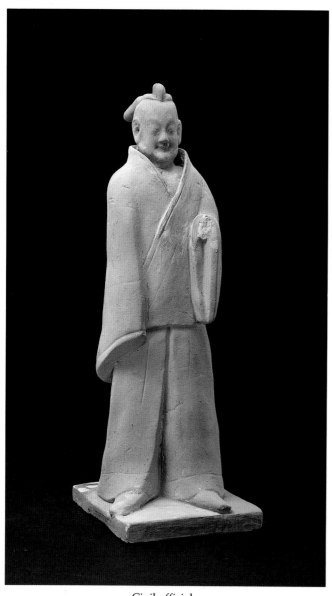

Civil official
Western Wei dynasty, cat. no. 53

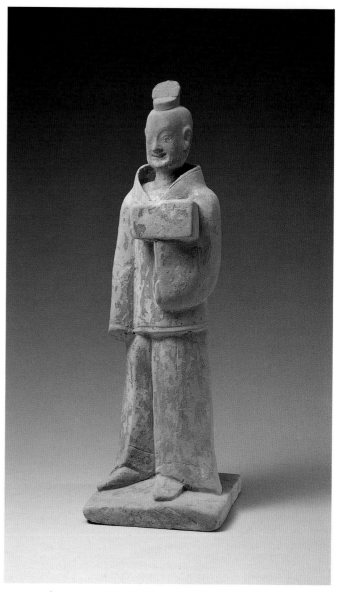

Man holding a seal box
Western Wei dynasty, cat. no. 54

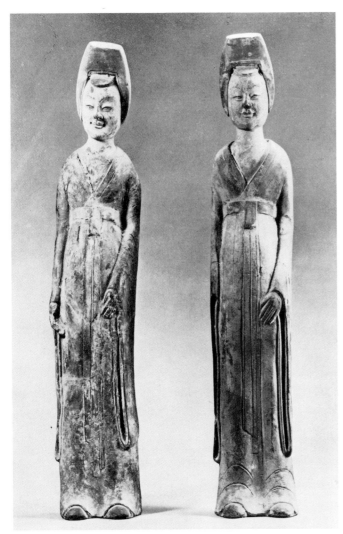

Fig. 9. Two figures of ladies from the Northern Wei period. From *Sekai toji zenshu* (1961).

artistic styles developed during Han endured here throughout the Six Dynasties, but regional variations arose in Nanjing, Guangzhou, and Changsha, and in Sichuan Province.

In the Eastern (534–550) and Western Wei (535–556) periods, the attenuated style of late Northern Wei evolved toward the greater solidity of columnar forms. The patterns and rhythms of the cascading drapery so characteristic of Buddhist sculpture of the early sixth century are not found in ceramic funerary figures, which maintain a tactile quality independent of the linear emphasis in much of Northern Wei art of the Luoyang period. By the end of the Six Dynasties, sculptural forms were being integrated into harmonious solid masses. Two Eastern Wei tombs have yielded splendid examples of this mid-sixth-century style: one excavated in

Zanhuang, Hebei, identified as the grave of Li Xizong (501–540);[39] the other, located at Dongchen, Cuxian, Hebei, of a man buried in 547.[40] For the Western Wei period, a tomb excavated at Cuijiaying, Hanzhong, Shaanxi, provided a rich find of funerary sculpture (cat. nos. 53–57). The outer contour of these figures has been simplified and the power of the plastic mass reasserted. Stiff frontality has yielded to a three-quarter pose, one leg ahead of the other, freeing the body from its previous rigidity. There is also the beginning of an identification of body and garment as separate entities. These freestanding sculptural works show more worldly facial expressions replacing the archaic smile typical earlier in the century.

During the Six Dynasties period the development of conceptual sculpture that began in the Neolithic era came to an end. It was succeeded by a representational phase, lasting from the sixth century through the Tang dynasty, characterized by an objective visual apprehension of reality paralleling a surge of creativity in Chinese figure painting and monumental Buddhist sculpture.

Northern Qi (550–577) and Sui (581–618) Dynasties

By a coincidence of history, Yang Jian, in a seeming reincarnation of the First Emperor of Qin, unified China through conquest and established the Sui Empire. He too had imperial ambitions and embarked on magnificent construction projects. Ironically, Sui hegemony was similarly brief and superseded by a prosperous and enduring dynasty.

The period from the middle of the sixth century to the early seventh was a time of rapid stylistic development in ceramic sculpture. The two-dimensionality of the early sixth century was succeeded by a static but emphatic three-dimensionality with an organic relationship between component parts. Bodily forms became solid and columnar, with massive proportions exuding a powerful presence. Details were sculpted in high relief rather than indicated by incised lines.

Northern Qi and Sui were also periods of technical transition from the Yue olive celadon glazes that graced so many southern Six Dynasties ceramics to the white-bodied wares of Tang. Green and brown lead glazes, once popular on Han mingqi and seen again on the figures in Sima Jinlong's tomb, were used on many funerary ceramics made during Northern Qi and Sui. This is in contrast to their rarity during Northern Wei. Experimentation resulted in the production of new polychrome glazes; the beginnings may be seen in the use of

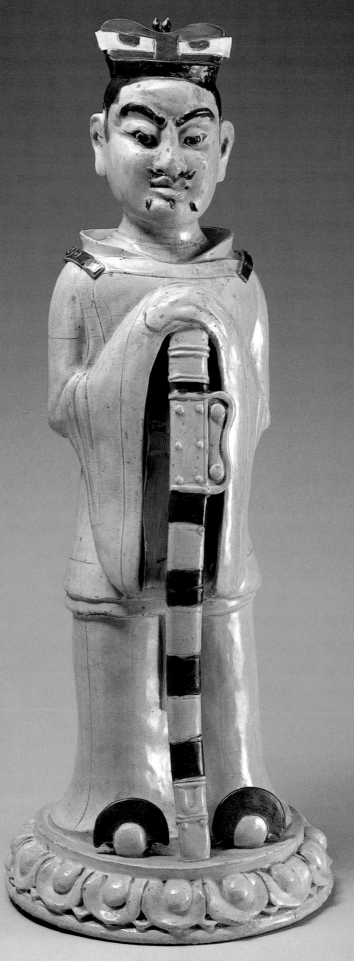

Court attendant
Sui dynasty, cat. no. 58

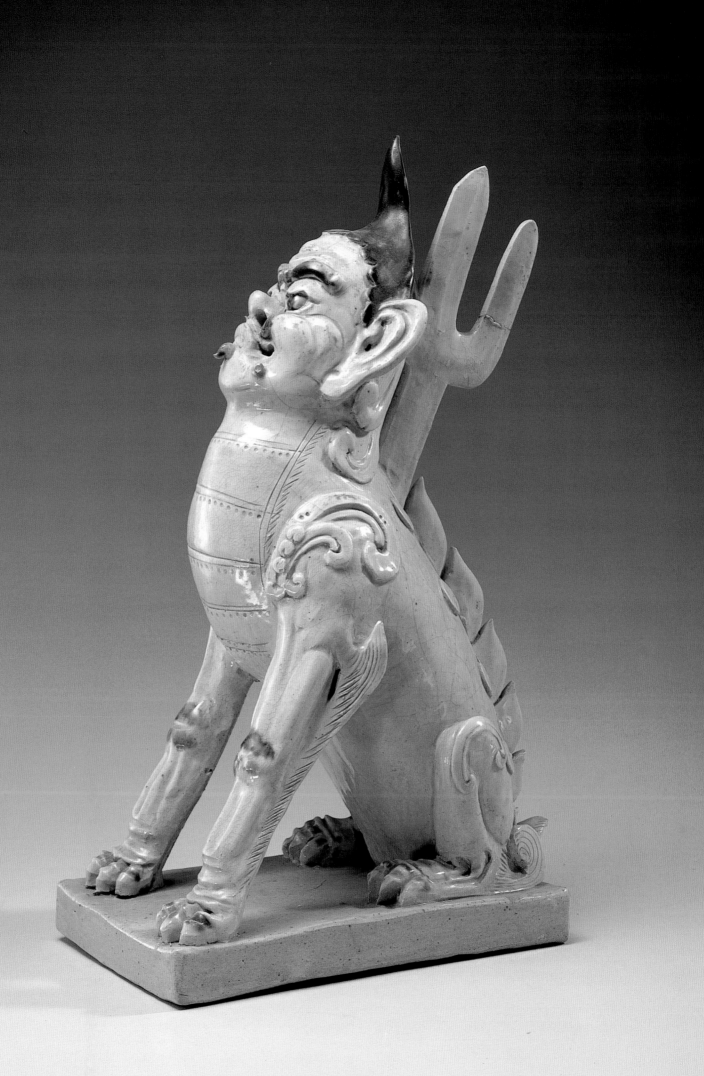

Tomb guardian with a human face
Sui dynasty, cat. no. 59

a green glaze under a light yellow one on objects among the finds from Li Yun's tomb, dated 576, at Puyang, Henan.[41]

The discovery of Northern Qi and Sui tombs that can be clearly dated provides a stylistic sequence of funerary sculptures for this period. Ceramic figures from Han Yi's tomb, dated 567, at Baigui, Qixian, Shaanxi,[42] and Fan Cui's tomb, dated 575, near Anyang, Henan,[43] display the new sense of three-dimensional mass with modeled contours integrating the various parts of the body. Fan Cui's tomb also yielded white ceramic vessels made from refined kaolin clays fired at stoneware temperatures, producing a soft translucent body texture. A finely crackled transparent glaze containing virtually no iron covered the surface. This innovative use of a white clay body provided an ideal ground for the brilliant polychrome lead glazes that became prevalent a century later.[44]

The Sui tombs near Hefei, Anhui, dated 586,[45] and those of Zhang Sheng at Anyang, Henan, dated 595,[46] and Luo Da in the eastern suburbs of Xi'an[47] yielded funerary figures with a pronounced sense of plasticity. The figures' sturdy legs are firmly planted and unequivocally support the weight of the body. There is a greater attention to the details of anatomy, facial features, and dress (cat. nos. 58–59). In the latter half of Sui, high-fired porcelaneous mingqi occurred with great frequency; such white-bodied figures were among the ceramics unearthed from Zhang Sheng's tomb. Artists painted features and designs on these pieces in iron black and applied a cream glaze.

Tang Dynasty (618–907)

The political unification initiated during Sui was maintained for three centuries by the succeeding Tang empire. The reunited China was productive and prosperous, cosmopolitan in its tastes, and culturally creative. Despite repeated restrictive edicts, the practice of sumptuous burials persisted, leaving a rich legacy of Tang funerary sculpture. Enormous quantities of mingqi were made for the royal tombs surrounding the capital of Chang'an. Other regional centers such as Luoyang were also active in this production, and handsome glazed pieces could be found as far away as Xinjiang[48] and Liaoning.[49]

One of the unique ceramic developments of the Tang period was sancai, the three-color lead glaze admired for its baroque splendor. Green, brown, yellow, and white (actually the white clay body visible beneath a transparent glaze) were combined in ensembles of two or three

hues. Occasionally a brilliant cobalt blue was also used. Its earliest known occurrences are on objects from tombs in Shaanxi Province, both datable to 664: a lid knob discovered in Zheng Rentai's grave in Liquan,[50] and a blue-splashed tray from the tomb of Li Feng, the fifteenth son of the founder of the Tang dynasty, Li Yuan.[51] Sancai colors were applied by dripping, spotting, brushing, or wax resist. The colored glazes would run while being fired, blurring and commingling to create a fantastic interplay of suffused colors.

The kilns around Chang'an and Luoyang were major producers of Tang sancai, along with those at Gongxian, Henan, which were famous for pure white clay wares. A variant type of sancai with a pinkish white body coated with white slip was made at another center, as yet unidentified. The frequent use of molded ornamentation, cast separately and then applied, reflects the influence of Persian metalwork with its striking repoussé designs which deeply impressed the Chinese.

Large, multichambered Tang tombs, a type first developed in the Sui period, retained many similarities to those of Han, but differed in their vertical shafts and long, paved entrance tunnels decorated with murals.[52] Symmetrically placed niches were filled with ceramic figures of people and animals who served as retainers and guardians to the deceased. The cortege led by an ox cart, a common funeral custom during the Six Dynasties, continued in Tang, but by the end of the seventh century ceramic models of ox carts were replaced by figures on horseback as the main element of the procession.[53] These mounted warriors represent a new type of light cavalry which contrasts with the heavily armored riders of the Six Dynasties, reflecting changing tactics as well as the reduced military requirements of a unified China.[54] In the early eighth century there was a shift in preference away from the funerary cortege in favor of depictions of domestic life. Servants, attendants, houses, and gardens became the popular subjects for ceramic tomb sculpture.

The Tang imperial necropolises of Xianling and Zhaoling near Chang'an, as well as several princely mausolea, yielded sculptural works that can be firmly attributed to the early and middle seventh century. The tomb of Li Shou at Sanyuan, Shaanxi, dated 630, provided a rich find of early Tang funerary figures.[55] The pronounced sense of volume seen in Sui figures is now softened in Tang by an increased attention to proportion, a sensitive definition of body parts, and a suggestion of movement. The rigid columnar form has become more lithe and flexible and is relieved by a freer pose and

the use of contrapposto. The component elements are no longer divided for reasons of structural clarity; there is a more harmonious relationship of parts to the whole and an understanding of their interdependence. Drapery conforms to the structure beneath, helping to define a bodily form. High-fired white-bodied ceramic figures gradually disappear during the seventh century while those covered with low-fired lead glazes, occasionally embellished with painting, increase in number.

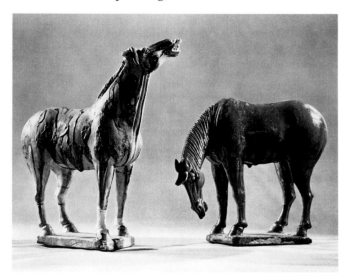

Fig. 10. Glazed figures of horses from the tomb of Princess Yongtai in Qian County, Shaanxi Province. From *Historical Relics Unearthed in New China* (1972).

The ultimate achievement of Tang funerary art was reached in the late seventh and early eighth centuries. The royal tombs of Princess Yongtai[56], her brother Prince Yide[57], and Prince Zhanghuai[58] contained a wealth of early eighth-century material, covering an enormous repertory of subjects. Ceramic warriors and guardian spirits, princes and grooms, horses and camels, and the utensils of daily life were all modeled in clay. Among the most appealing subjects are the graceful court ladies portrayed dancing or playing musical instruments. The sensitively rendered horses from Yongtai's tomb are unsurpassed, revealing the technical accomplishment and stylistic maturity of Chinese sculpture at its apogee (fig. 10).[59]

Few civilizations have left such a rich sartorial legacy of dress and hair styles, hats and accessories as is revealed in Tang figures. In an insatiable quest to be chic, people often adopted fashions inspired by those of Persia, Turfan, Kucha, southern Asia, and Manchuria. The cosmopolitan nature of Tang life is reflected in the bewildering array of foreigners from every country and

culture portrayed in ceramic sculpture. A taste for the bizarre is reflected in replicas of dwarfs and exotic beauties. For sheer panache there are the spirited, prancing horses from Ferghana. An even greater diversity of themes and forms occurred as ceramic facsimiles replaced more precious objects made of lacquer, silver, or jade.

Middle Tang was the culmination of a cycle of sculptural developments that had begun in the middle of the sixth century. All the artistic problems inherent in presenting the human or animal form as a coherent organism had been solved. Mass, structure, and surface harmonize, as suave modeling and linear contours animate the figures, capturing the essence of *sheng dong* (living movement). Freestanding figures are totally at ease, every motion balanced by another. There is clarity in the treatment of drapery, the garment assisting in defining the structure of the body beneath it. A keen interest in the natural world is expressed in faithful renderings and accurate details. Surfaces are embellished with colorful and luminous lead glazes. All these are considerable accomplishments, but the supreme achievements of the Tang potter were to harmonize the conflicting demands of naturalistic rendering and the traditional Chinese aesthetic of abstract generalization, and of a desire for monumentality with a love of realistic detail.

Although the sheer quantity of sancai tomb figures and other works in Western collections would seem to indicate a long period of production, archaeological evidence so far reveals only a short span of manufacture. This is given credence by a marked uniformity of style. The earliest dated tombs containing sancai figures are those of Prince Yide and Princess Yongtai from the year 706, but the technical sophistication of these pieces presupposes a prior stage of development, a supposition verified by the sancai tray discovered in the 664 tomb of Li Feng, located in Lücun, Fuping County, Shaanxi. Sancai mingqi were found in princely tombs near Chang'an and Luoyang during the most flourishing era of Tang. The affluent strata of society, accustomed to everyday utensils of gold, silver, jade, and white porcelain, found sancai funerary wares appropriate to an aristocratic afterlife. But by the middle of the eighth century, sancai mortuary figures were no longer made; the rebellion of An Lushan in 756 marked the end not only of high Tang but of the lavish patronage that encouraged the artistic sophistication encompassing the creation of sancai.[60]

The second quarter of the eighth century is notable for a novel figure style of baroque plumpness. It is said that

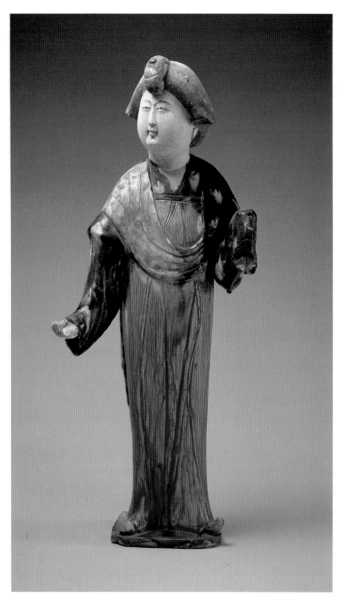 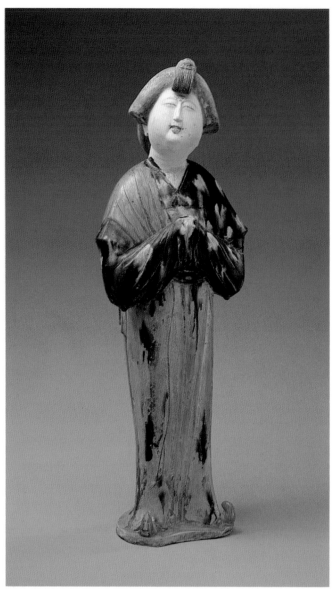

Standing women
Tang dynasty, cat. nos. 77–78

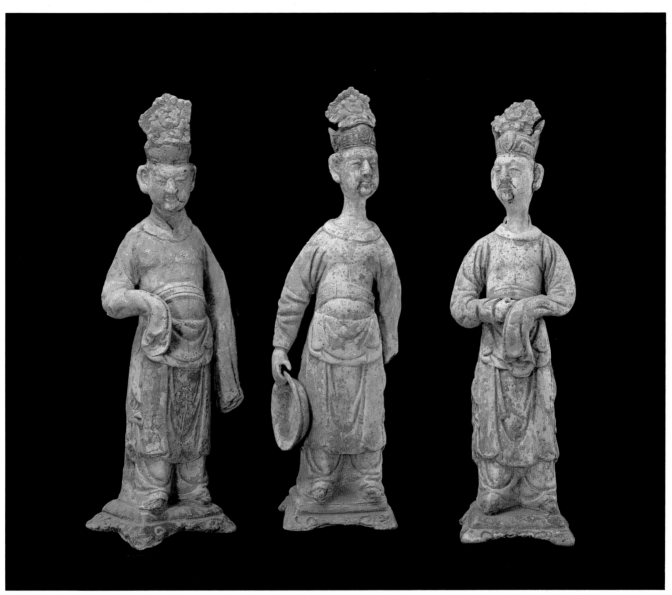

Three male attendants
Song dynasty, cat. no. 87

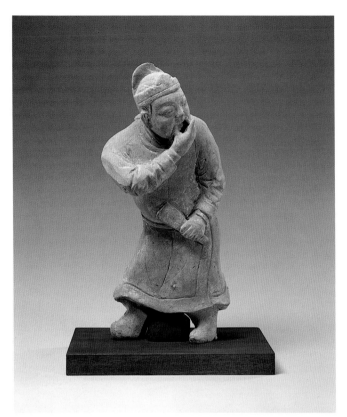
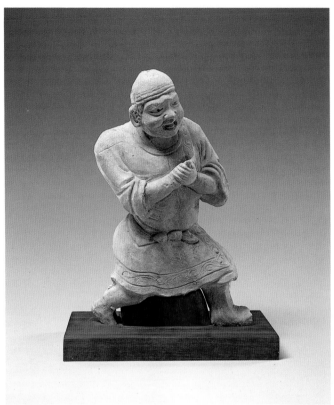

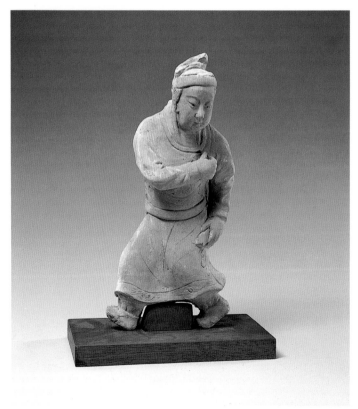

Performers
Jin dynasty, cat. nos. 92–94

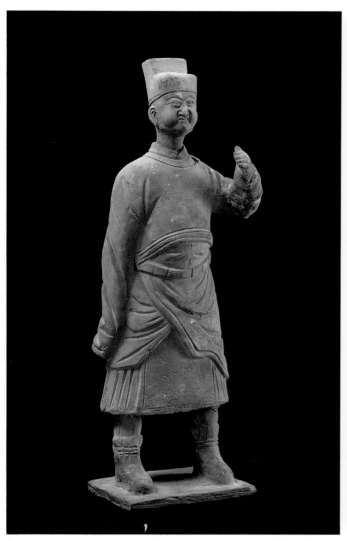

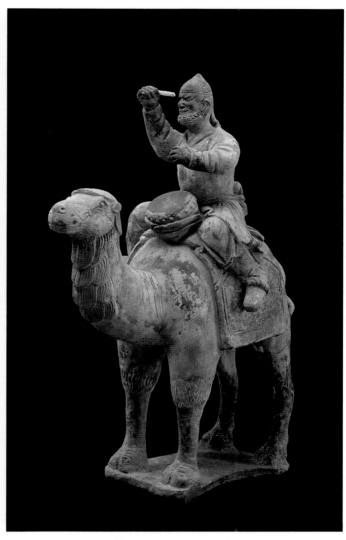

Military official
Yuan dynasty, cat. no. 102

Drummer on a camel
Yuan dynasty, cat. no. 103

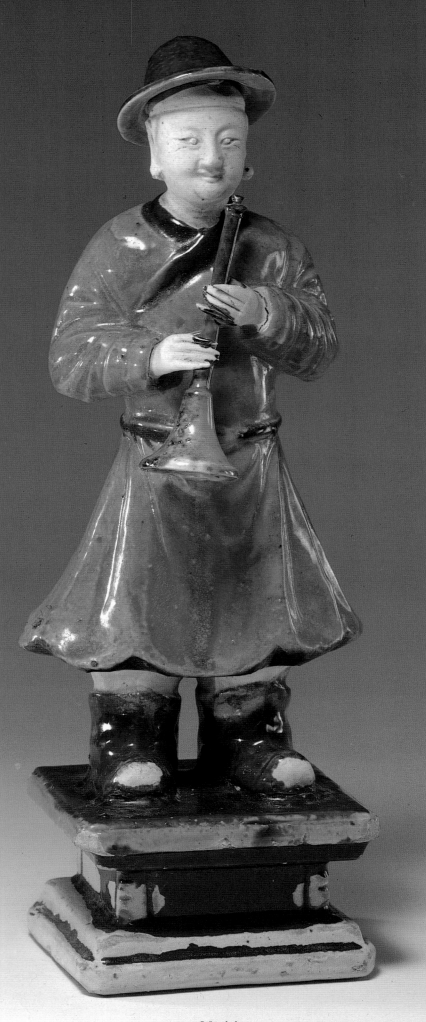

Musician
Ming dynasty, cat. no. 105d

Yang Guifei, the consort of Emperor Xuanzong (r. 712–756), set the fashion for ladies of ample form. Seven Chang'an tombs at Hanlinzhai, dated 745,[61] and others at Gaolou Village, dated 748,[62] contained a number of these Rubensesque ladies. Modeled with full, rounded volumes and flowing contours, their surfaces melt into each other without organic separation. Summary definition and generalization of form replace the clarity typical of sculpture a few decades earlier.

Political decline after the rebellion of An Lushan was accompanied by a gradual deterioration of artistic vigor. By the early ninth century the production of ceramic sculpture had decreased markedly due to a change in preference for metallic and especially wooden figures. Increasing economic impoverishment and changing customs further encouraged the use of wooden or paper mingqi.[63]

Later Dynasties (907–1644)

Until the archaeological discoveries of the last few decades it was assumed by many that the use of ceramic tomb figures ended with Tang. However, in recent years funerary sites of the Song, Liao, Jin, Yuan, Ming, and Qing periods have yielded ceramic sculptures created in a variety of techniques, with some examples in plain biscuit, others painted, and still others glazed. Generally, later ceramic mingqi from the north were low-fired and embellished with paint or occasionally with lead glazes, while those from the south had high-fired bodies that were often glazed or painted. Sculptural developments after Tang were essentially neoclassical, attempting to re-create past greatness in a nostalgic adaptation of ancient traditions, a notion called *fugu*.

The Song period is historically viewed as an era of classic maturity during which the art of ceramics achieved a new degree of excellence in high-fired monochrome wares. This was not the case with funerary figures. Due to changes in patronage, large quantities of ceramic sculptures no longer filled the tombs. Paper mingqi became common during Song, Yuan, and subsequent dynasties; even ceramic figures were reproduced in paper. Nevertheless, a number of Song period tombs excavated in Henan, Shaanxi, and Zhejiang provinces, have yielded figures of attendants in a naturalistic style (cat. nos. 87–88). Excavations at Xinlifeng, Jiaozuo, Henan, produced tall, somewhat portly figures with full jowls and a slight paunch reflecting a middle-aged maturity that contrasts with the spirit of youthful vigor common to Tang sculptures. The weight and texture of cloth is admirably captured in the Xinlifeng male atten-

dants (cat. no. 87), whose garments often hide, rather than define, the body beneath. The middle Tang interest in depicting the human form as a coherent organism has been replaced by a preoccupation with surface rhythms and textures.

Northern China was conquered by the Jin, who established a new dynasty, forcing the Song to reestablish their capital south of the Yangzi River. The most appealing group of post-Tang mortuary sculpture is the troupe of ebullient *zaju* minstrels from a Jin dynasty tomb at Xifengfeng, Jiaozuo, Henan (cat. nos. 92–94). Captured as they whistle, sing, or dance, these figures are remarkable for their animated vitality, dramatic gesture, and expressive movement. The zigzag of the body's axis lends a sense of dynamism even though it is restricted to a single plane. Summary execution and lack of finish does not detract from each figure's spontaneity and directness.

In 1280 the Mongols conquered China and established the Yuan dynasty. The elegant culture of Song was replaced by the more robust but less refined one of this vigorous nomadic people. In contrast to the light-colored bodies of Song funerary figures, those of the Yuan period are invariably gray-black; like the Northern Wei figures of the Six Dynasties they too are unglazed. The Yuan figures in this exhibition (cat. nos. 95–104), excavated in Shaanxi Province, reveal a high level of artistic skill and an attempt to suggest movement through gesture or the forward cant of a body or a horse's head. The sense of sculptural purpose is subverted, however, by a weakened awareness of proportion and a lack of finesse in handling volumes and integrating component elements.

After a century of Mongol rule, the succeeding Ming dynasty restored traditional Chinese values. They looked to the halcyon age of the Tang for cultural inspiration and attempted to revive the sculptural achievements of the Tang and Song periods. The style they developed was one of compact plastic masses, symmetrical and formal, with minimal surface treatment, typified by ceramic sculptures from Baimasi, Chengdu, Sichuan (cat. no. 105). These high-fired figures glazed dark and light blue, yellow, and turquoise were obviously influenced by Tang sancai.

The main artistic currents during Yuan, Ming, and Qing were determined by the culturally dominant literati whose aesthetic values were ideal and subjective and therefore antithetical to a plastic art rooted in natural images. Because of the strong popular tradition of belief in an afterlife, mingqi were still produced, but they

became a genre of folk art. The ceramic figures from these periods are thus endowed with the earthy vitality that is often characteristic of a popular art form.

Notes

1. Kwang-chih Chang, *The Archaeology of Ancient China*, 3rd rev. ed. (New Haven: Yale University Press, 1977), 3: 105–11.

2. Institute of Archaeology, *Xin Zhongguo de kaogu faxian he yanjiu* (Archaeological discoveries and research in New China) (Beijing: Wenwu Press, 1984), 43, pl. 4 no. 1.

3. Robert L. Thorp, "Burial Practices of Bronze Age China," in *The Great Bronze Age of China*, ed. Wen Fong (New York: The Metropolitan Museum of Art, 1980), 62.

4. Ibid., 52; see tomb 2 at Lijiazui. Hubei Provincial Museum et al., "Panlongcheng yijiuqisi niandu tianye kaogu jiyao" (Summary of field work at Panlongcheng for 1974), *Wenwu* (Cultural relics), 1976, no. 2: 5–15.

5. Chang, *The Archaeology of Ancient China*, 438–42, fig. 206. Xia Nai et al., *Changsha fajue baogao* (Report on the excavations at Changsha) (Beijing: Institute of Archaeology, 1957), pls. 28–29.

6. A wooden figure of a man was found in tomb 7; see "Shanxi Changzi xian Dong Zhou mu" (The Eastern Zhou tombs at Changzi County, Shanxi), *Kaogu xuebao* (Archaeology journal), 1984, no. 4: 514, fig. 10 no. 1, pl. 3 no. 2.

7. Wang Renbo, "Chugoku rekidai no totsu ni tsuite" (Ceramic figures in Chinese history), in *Chugoku toyo no bi* (The beauty of Chinese ceramic figures) (Tokyo: Asahi Shimbun, 1984), 7.

8. Chang Wenzhai, "Shanxi Changzhi Fenshuiling gumu de qingli" (Investigation of the ancient tombs in Fenshuiling, Changzhi, Shanxi), *Kaogu xuebao*, 1957, no. 1: pl. 12 nos. 1–2.

9. Maxwell K. Hearn, "The Terracotta Army of the First Emperor of Qin (221–206 B.C.)," in *Great Bronze Age*, 353–73.

10. Technology developed in the iron-casting industry during the Warring States period enabled the Chinese to create a model and mass-produce it. Michele Pirazzoli-t'Serstevens, *The Han Dynasty* (New York: Rizzoli, 1982), 71.

11. Archaeological Excavation Team for the Qin Funerary Figures Pit at the First Emperor's Tomb, "Lintongxian Qin yong keng shijue diyihao jianbao" (Brief report on the exploratory excavation of Qin funerary figures pit 1 in Lintong County), *Wenwu*, 1975, no. 11: 1–18, pls. 1–10.

12. Archaeological Excavation Team for the Qin Funerary Figures Pit at the First Emperor's Tomb, "Qin Shihuang ling dongce dierhao bing ma yong keng zuantan shijue jianbao" (Brief report on core samples and exploratory excavations of warrior and horse figures pit 2 on the east side of the tomb of the First Emperor of Qin), *Wenwu*, 1978, no. 5: 1–19, pls. 1–4.

13. Archaeological Team for Qin Funerary Figures, "Qin Shihuang ling dongce disanhao bing ma yong keng qingli jianbao" (Brief report on the inspection of warrior and horse figures pit 3 on the east side of the tomb of the First Emperor of Qin), *Wenwu*, 1979, no. 12: 1–12.

14. Gakuji Hasebe, "Chugoku no toyo to toji shi" (Chinese pottery figures and ceramic history), in *Chugoku toyo no bi*, 16.

15. Michael Loewe, *Chinese Ideas of Life and Death* (London: George Allen and Unwin, 1982), 26, 114–26.

16. Wang Zhongshu, *Han Civilization* (New Haven: Yale University Press, 1982), 175–79.

17. Ezekiel Schloss, *Ancient Chinese Ceramic Sculpture* (Stamford: Castle Publishing, 1977), 1: 6.

18. Wang Zhongshu, *Han Civilization*, 143–44.

19. Xia, *Changsha fajue baogao*, 107–9, 137, pl. 61 no. 5, pl. 96 no. 3, pl. 97 no. 5, pl. 98 no. 3.

20. Jiangxi Provincial Museum, "Jiangxi Nanchang Dong Han Dong Wu mu" (Eastern Han tombs and an Eastern Wu Kingdom tomb at Nanchang, Jiangxi), *Kaogu* (Archaeology), 1978, no. 3: 158–63.

21. Nanjing Museum et al., "Haizhou Xi Han Huohe mu qingli jianbao" (Brief report on the inspection of the Western Han Huohe tombs in Haizhou), *Kaogu*, 1974, no. 3: 185, pl. 5.

22. Jinan Municipal Museum, "Shitan Jinan Wuyingshan chudu de Xi Han yuewu, zaji, yanyin taoyong" (Ceramic figures of musicians, dancers, acrobats, and banqueters unearthed from a Western Han [tomb] at Wuyingshan, Jinan, Shitan), *Wenwu*, 1972, no. 5: 19–23.

23. Shaanxi Provincial Committee for Administration of Cultural Relics, Shaanxi Provincial Museum, and Yangjiawan Han Tomb Excavation Group of the Xianyang Municipal Museum, "Xianyang Yangjiawan Han mu fajue jianbao" (Brief report on the excavation of the Han tomb at Yangjiawan, Xianyang), *Wenwu*, 1977, no. 10: 10–21, pls. 1–3.

24. Xianyang Museum, "Han Anling de kancha ji qi peizang mu zhong de caihui taoyong" (Investigation of the Han Anling and the painted ceramic figures in its satellite tombs), *Kaogu*, 1981, no. 5: 422–25, pl. 9.

25. Wang Xueli and Wu Zhenfeng, "Xi'an Renjiapo Han ling congzang keng de fajue" (Excavation of the pits for funerary objects accompanying a Han mausoleum at Renjiapo, Xi'an), *Kaogu*, 1976, no. 2: 129–33, 75, pls. 7–9.

26. Henan Provincial Museum, "Jiyuan Sijian'gou sanzuo Han mu de fajue" (Excavation of three Han tombs at Sijian'gou, Jiyuan), *Wenwu*, 1973, no. 2: 46–53, 50 fig. 7.

27. Luoyang Museum, "Luoyang Jianxi Jilihe Dong Han mu fajue jianbao" (Brief report on the excavation of an Eastern Han tomb at Jilihe, Jianxi, Luoyang), *Kaogu*, 1975, no. 2: 116–23, 134, pl. 11 nos. 1–3.

28. The Cultural Relics Preservation Council of Guangzhou and the Municipal Museum of Guangzhou, *Guangzhou Han mu* (Han tombs of Guangzhou) (Beijing: Wenwu Press, 1981), 1: 432; 2: pls. 120, 160.

29. Annette L. Juliano, *Art of the Six Dynasties* (New York: China House Gallery/China Institute in America, 1975).

30. Museum of E-cheng County, Hubei Province, "E-cheng Dong Wu Sun Jiangjun mu" (The Eastern Wu tomb of General Sun in E-cheng, Hubei), *Kaogu*, 1978, no. 3: 164–67, 163, pl. 7 no. 1.

31. Hunan Provincial Museum, "Changsha liang Jin Nan Zhao Sui mu fajue baogao" (Excavation report of Changsha tombs during the Jin dynasties, the Southern Dynasties, and Sui), *Kaogu xuebao*, 1959, no. 3: pls. 8–14.

32. Ash-glazed wares were excavated from second-century A.D. Han tombs at a number of sites including Xinyang, Henan; Changsha, Hunan; and Nanchang, Jiangxi. See Masahiko Sato, *Chinese Ceramics* (New York and Tokyo: Weatherhill/Heibonsha, 1981), 33 and n. 18.

33. Datong Museum and Shanxi Provincial Cultural Relics Work Team, "Shanxi Datong Shijiazhai Bei Wei Sima Jinlong mu" (The Northern Wei tomb of Sima Jinlong at Shijiazhai, Datong, Shanxi), *Wenwu*, 1972, no. 3: 20–33.

34. For the tomb of Yuan Shao and Yuan Guai, see Luoyang Museum, "Luoyang Bei Wei Yuan Shao mu" (The Northern Wei tomb of Yuan Shao at Luoyang), *Kaogu*, 1973, no. 4: 218–24, 243, pls. 8–12; and George Kuwayama, *The Joy of Collecting* (Los Angeles: Los Angeles County Museum of Art, 1979), 75 n. 7.

35. Hebei Provincial Museum, "Hebei Quyang faxian Bei Wei mu" (The discovery of a Northern Wei tomb at Quyang, Hebei), *Kaogu*, 1972, no. 5: 33–35, pls. 9–11.

36. Ibid., pl. 9 no. 1.

37. Mizuno Seiichi, ed., *Sekai toji zenshu* (Collection of world ceramics) (Tokyo: Zauho Press, 1961), vol. 8, *China: Ancient China to the Six Dynasties*, figs. 130, 132.

38. Wang Zhimei, ed., *Nanjing Liuzhao Taoyong* (Six Dynasties ceramic figures from Nanjing) (Beijing: China Classic Arts Publishing Company, 1958).

39. Archaeological Team of the Bureau of Culture, Revolutionary Committee of the Shijiazhuang Prefecture, "Hebei Zanhuang Dong Wei Li Xizong mu" (Excavation of the Eastern Wei tomb of Li Xizong in Zanhuang, Hebei), *Kaogu*, 1977, no. 6: 382–90, 372, pl. 7.

40. Cultural Center, Ci County, Hebei Province, "Hebei Cixian Dongchencun Dong Wei mu" (Excavation of an Eastern Wei tomb at Dongchen Village in Ci County, Hebei), *Kaogu*, 1977, no. 6: 391–400, 428, pls. 8–9.

41. Sato, *Chinese Ceramics*, 57.

42. Tao Zhenggang, "Shanxi Qixian Baigui Bei Qi Han Yi mu" (Excavation of the Northern Qi tomb of Han Yi at Baigui in Qixian, Shanxi), *Wenwu*, 1975, no. 4: 64–73, pl. 3.

43. Henan Provincial Museum, "Henan Anyang Bei Qi Fan Cui mu fajue jianbao" (Brief report on the excavation of the Northern Qi tomb of Fan Cui at Anyang, Henan), *Wenwu*, 1972, no. 1: 47–57.

44. Hasebe, "Chugoku no toyo to toji shi," 17.

45. Anhui Provincial Exhibition Museum, "Hefei xijiao Sui mu" (A Sui tomb in the western suburb of Hefei), *Kaogu*, 1976, no. 2: 134–40, 77, pls. 10–12.

46. Anyang Excavation Team of the Institute of Archaeology, "Anyang Sui Zhang Sheng mu fajue ji" (Record of the excavation of the Sui tomb of Zhang Sheng at Anyang), *Kaogu*, 1959, no. 10: 541–45, pls. 9-13. See also *The Chinese Exhibition: The Exhibition of Archaeological Finds of the People's Republic of China* (Kansas City, Missouri: Nelson Gallery–Atkins Museum, 1975), cat. nos. 264–73.

47. Li Yuzheng and Guan Shuangxi, "Sui Luo Da mu qingli jianbao" (Excavation report on the Sui tomb of Luo Da), *Kaogu yu wenwu* (Archaeology and cultural relics), 1984, no. 5: 28–31, 45, pls. 4–5.

48. Museum of the Xinjiang Uighur Autonomous Region and Archaeology Section of the History Department, Northwestern University, "1973 nian Tulufan Asitana gu mu qun fajue jianbao" (Brief report on the excavation of ancient tombs at Astana in Turfan, Xinjiang, in autumn of 1973), *Wenwu*, 1975, no. 7: 8–26, pls. 1–8.

49. Zhaoyang District Cultural Office, "Liaoning Zhaoyang Tang Han Zhen mu" (Tang tomb of Han Zhen at Zhaoyang), *Kaogu*, 1973, no. 6: pl. 12 no. 1.

50. Sato, *Chinese Ceramics*, 61.

51. Cultural Center of Fuping County, Shaanxi Province, "Tang Li Feng mu jianbao" (Excavation of the Tang tomb of Li Feng), *Kaogu*, 1977, no. 5: 313–26, pls. 8–9.

52. Mary H. Fong, "Four Chinese Royal Tombs of the Early Eighth Century," *Artibus Asiae* 35 (1973): 307–34.

53. Wang Renbo, "Chugoku rekidai no totsu ni tsuite," 13.

54. Albert E. Dien, "A Study of Early Chinese Armor," *Artibus Asiae* 43 (1982): 5–66.

55. Shaanxi Provincial Museum and Cultural Relics Preservation Council, Shaanxi Province, "Tang Li Shou mu fajue jianbao" (Brief report on the excavation of the Tang tomb of Li Shou), *Wenwu*, 1974, no. 9: 71–88, 61, figs. 10–13. Li Shou, Prince Huai-an, died in the year 631 and was buried in 632; see Jan Fontein and Wu Tung, *Han and T'ang Murals* (Boston: Museum of Fine Arts, 1976), 78.

56. Cultural Relics Preservation Council, Shaanxi Province, "Tang Yongtai gongzhu mu fajue jianbao" (Brief report on the excavation of the Tang tomb of Princess Yongtai), *Wenwu*, 1964, no. 1: 7–33, figs. 1–25.

57. Shaanxi Provincial Museum and Tang Tomb Excavation Team of the Qian County Cultural Education Office, "Tang Yide taizi mu fajue jianbao" (Brief report on the excavation of the tomb of the Tang prince Yide), *Wenwu*, 1972, no. 7: 26–32, pls. 4 no. 2, 8.

58. Shaanxi Provincial Museum, "Tang Zhanghuai taitou mu fajue jianbao" (Brief report of the excavation of the Tang tomb of Prince Zhanghuai), *Wenwu*, 1972, no. 7: 13–25, pls. 6–7. The prince was buried in 706.

59. *The Chinese Exhibition*, cat. nos. 296–97.

60. Sato, *Chinese Ceramics*, 70.

61. Zhang Zhengling, "Xi'an Hanlinzhai Tang mu jingliji" (Brief report on a Tang tomb at Hanlinzhai, Xi'an), *Kaogu dong xun* (Archaeological reports), 1957, no. 5: 57–62, pls. 1–13.

62. Hang Dezhou et al., "Xi'an Gaoloucun Tang dai mu zang qingli jianbao" (Brief report on the inspection of the Tang tombs at Gaolou Village, Xi'an), *Wenwu cankao ziliao* (Cultural relics reference materials), 1955, no. 7: 103–9.

63. Wang Renbo, "Chugoku rekidai no totsu ni tsuite," 15.

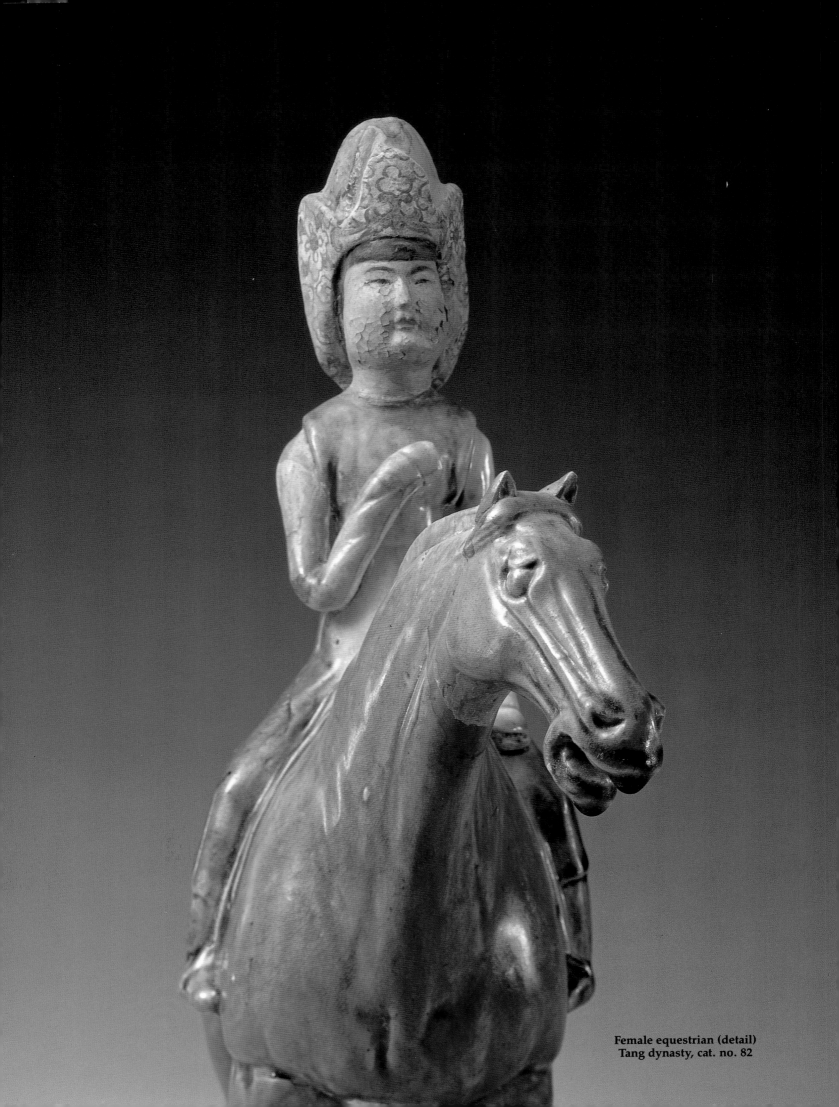

Female equestrian (detail)
Tang dynasty, cat. no. 82

Entries by
Lei Congyun, Lu Shaochen, Shi Yazhu
Overseas Archaeological Exhibition Corporation
and
Wei Yonge
Shaanxi Provincial Museum

Translated and with additions by
Julia F. Andrews
Los Angeles County Museum of Art

○

NEOLITHIC THROUGH WARRING STATES PERIODS C. 8000 – 221 B.C.

Mankind developed a relatively high level of aesthetic consciousness during the Neolithic era (c. 8000–2000 B.C.), even though social organization was still at a primitive stage. The Neolithic Chinese not only produced a wide variety of ceramic vessels but also made earthenware sculptures of men and beasts, unsophisticated yet exuberant images embodying the conceptions and sculptural skill of this ancient people.

During the Shang (c. 1600–1000 B.C.) and Zhou (c. 1000–256 B.C.) dynasties, the Chinese achieved great material wealth and cultural activity. Among the many arts that flourished in this period, the most magnificent were bronze casting, the carving of jade, stone, and ivory, architecture, and ceramic sculpture. Discoveries in the Shang ruins at Zhengzhou of such earthenware images as tigers, turtles, goats, fish, pigs, and kneeling human figures clearly attest that sculpture was produced in conjunction with pottery vessels. At this stage of development the earthenware figures were small in size and relatively few in number, but extant pieces are extremely significant as early examples of sculpture in the round. Furthermore, they prove that by the Shang period ceramic images of animals and humans were being made for burial with the dead.

In the Warring States era (475–221 B.C.) of the late Zhou dynasty, a feudal system superseded the slave-based society of the Shang and earlier Zhou periods.* Burial practices underwent profound changes, and funerary figures eventually replaced the live humans and animals interred in the graves of the deceased, a custom that developed during the Shang era. The use of surrogate figures opened a vast new territory for the sculptor; figures made of materials as varied as bronze, lead, silver, jade, stone, and wood have been found in all parts of China. Excavated images include musicians, dancers, retainers, and warriors, evidence that the primary motive in burying them with the deceased was to provide service, protection, and amusement for the departed soul. The figures' close relationship with the everyday activities of society, as well as their vital, realistic style, had a great influence on the establishment of Chinese sculptural traditions.

*For discussions of the Marxist periodization used by modern Chinese historians, see Kwang-chih Chang, *Shang Civilization* (New Haven: Yale University Press, 1980), 62–63; and Albert Feuerwerker, ed., *History in Communist China* (Cambridge: MIT Press, 1968).

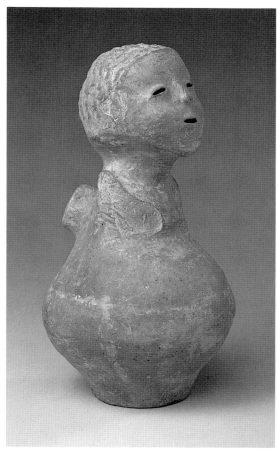

1
Human-headed pot
Red earthenware
Height 23 cm (9 ⅛ in.), greatest diameter 13.5 cm (5 ⅜ in.)
Neolithic period
Excavated in 1953 in Luonan County, Shaanxi Province
Banpo Museum, Xi'an
Color plate on p. 65

The first examples of this type of red earthenware were found at the site of Yangshao Village in Henan Province; as a result, the millet-growing Neolithic culture associated with such ceramic production has been labeled the Yangshao culture. The earliest known Neolithic culture in northern China, it extended along the middle reaches of the Yellow River basin. A large number of Yangshao sites have been found in the area of Xi'an.

This gourd-shaped jar has a smiling human face on one side and a spout on the other. The figure's arms are now broken off, but it is probable that they once reached up to the ears to form handles for the vessel. Clearly intended for daily use, the pot is characterized by a primitive form and simple sculptural techniques, but at the same time it has great visual appeal as a work of art.

Literature
Zou Shuping, ''Xi'an Banpo bowuguan shoucang de rentou hu'' (The human-headed pot in the collection of the Banpo Museum, Xi'an), *Shiqian yanjiu* (History research), 1984, no. 4: 103.

2
Human head
Red earthenware
Height 7.8 cm (3 ⅛ in.)
Neolithic period
Excavated in 1973 at the site of Huangling, Shaanxi Province
Banpo Museum, Xi'an
Color plate on p. 65

This artifact of the Yangshao culture is a valuable piece of evidence for the history of the development of Chinese ceramic sculpture. Most early earthenware images are objects of use or relief decorations for such objects. This, however, is a powerful work of sculpture modeled completely in the round and without functional purpose. In spite of its relatively crude form, the concave face, deeply carved eyes, and gaping mouth convincingly convey the image of a human head.

Literature
Gong Qiming, *Zhongguo yuanshi shehui* (Chinese primitive society) (Beijing: Xinhua Press, 1977), 71–72.

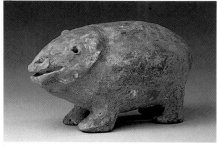

3
Pig
Gray earthenware
Height 6.5 cm (2 ½ in.), length 12 cm (4 ¾ in.)
Shang dynasty
Excavated in 1954 at Erligang, Zhengzhou, Henan Province
Henan Provincial Museum
Color plate on p. 65

The Shang dynasty remains at Erligang, Zhengzhou, were first discovered in 1950. Because the site clearly dates to the first half of the dynastic period and is of considerable size, there has been speculation that it should be identified as one of the early Shang capitals, predating the late Shang capital of Yin at Anyang.

Ritual bronzes and a large number of utilitarian gray-bodied pots have been excavated in Zhengzhou. This gray earthenware pig, with its small ears, protruding mouth, and intently gazing eyes, is typical of the Erligang site. The indented eyes and nose have been made with an awllike instrument, and the hint of a bristly muzzle can be seen in the scratches down the center of its face. The smooth, rounded body and short, sturdy legs suggest the awkward immobility of a young pig.

Ceramic images of the heads of pigs and piglets made about seven thousand years ago have been found in a Neolithic site at Peiligang in Xinzheng, Henan, south of Zhengzhou. These are evidence of a long history of raising pigs (and eating pork) in China.

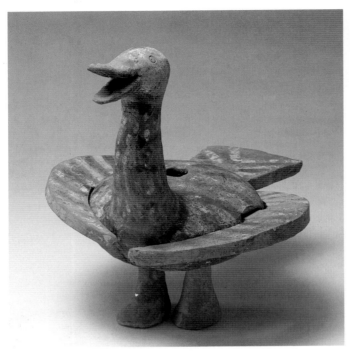

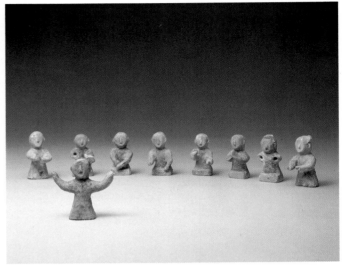

4
Duck
Painted earthenware
Height 29.5 cm (11 ⅝ in.), length 35.7 cm (14 in.), width 26 cm (10 ¼ in.)
Warring States period
Excavated in 1954 at Erligang, Zhengzhou, Henan Province
Henan Provincial Museum
Color plate on p. 40

During the extensive excavations at Erligang that produced the gray earthenware pig (cat. no. 3), more than two hundred relatively well-preserved tombs of the Warring States period were also investigated. One of the most interesting artifacts discovered was this lively earthenware duck with traces of polychrome decoration. The duck is constructed of six separate pieces — the body, two wings that encircle it, feet, and a tail — which can be disassembled.

Literature
Cultural Relics Work Team of the Henan Provincial Bureau of Culture, *Zhengzhou Erligang*, pl. 25, no. 3.

5
Nine musicians and dancers
Painted earthenware
Range of heights 4.6 to 5.1 cm (1 ¾ to 2 in.)
Warring States period
Excavated in 1956 from a tomb at Fenshuiling, Changzhi, Shanxi Province
Shanxi Provincial Museum
Color plate on p. 40

In the course of the eighth and seventh centuries B.C., local feudal lords became prosperous and independent. Rich assemblages of grave goods were buried in lavishly furnished tombs in all parts of China. Fenshuiling, in the ancient state of Han (now Shanxi and Henan provinces), is an archaeologically important tomb complex from this period.

This group of painted ceramic figures of dancers and musicians was excavated from tomb 14, a large rectangular tomb found with its chamber filled with charcoal, a material employed for the preservation of wooden objects and structures. The inner and outer coffins were lacquered and were originally decorated with brilliantly colored paintings. The rich horde of burial objects consisted of 1,005 bronze and ceramic objects. Among them were sacrificial bronze vessels, stone and bronze musical instruments, chariot accessories, jewelry, bronze weapons, and everyday utensils.

The nine musicians and dancers are part of a group of eighteen earthenware tomb figures excavated from this grave. These figures, male and female, are depicted in a range of poses, translating into sculptural form the colorful arts of music and dance during the Warring States period. Although the techniques used to create these images are rather rudimentary and most of the original polychrome decoration has been lost, the group possesses enormous vitality.

Literature
Chang Wenzhai, "Shanxi Changzhi Fenshuiling gumu de qingli" (Investigation of the ancient tombs at Fenshuiling, Changzhi, Shanxi), *Kaogu xuebao* (Archaeology journal), 1957, no. 1: 103–18.

QIN PERIOD
2 2 1 – 2 0 7 B. C.

A unified China was brought into being by a man who called himself Qin Shihuang, or the First Emperor of Qin. He accomplished this by pacifying the contending kingdoms within China and then went on to lead expeditions to the north against the Xiongnu nomads of Mongolia. In addition to the considerable political and military feat of creating the first feudal empire in Chinese history, the First Emperor and his dynasty fostered significant cultural achievements.

Since the early 1970s archaeologists have been excavating thousands of brilliantly modeled life-sized terra-cotta images of horses and warriors from the eastern side of the First Emperor's tomb complex in Lintong, Shaanxi Province. They are the major surviving masterpieces of Qin art. The anonymous craftsmen of the horse and warrior sculptures brought to life the heroic poses of the Qin generals and troops and the sturdy forms of their war horses, recreating a powerful image of the First Emperor's military conquests. This evidence of such mastery of both the representational ability and the ceramic technology required to make this group of remarkable figures has radically changed our ideas about the level of development of early Chinese art.

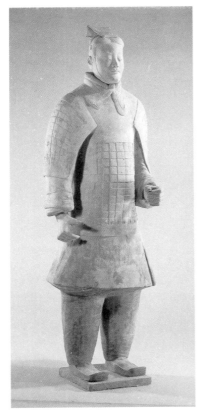

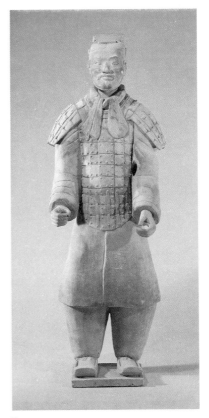

6
Officer
Painted earthenware
Height 192 cm (75 ⅝ in.)
Color plate on p. 66

7
Officer
Painted earthenware
Height 186 cm (73 ¼ in.)
Color plate on p. 4

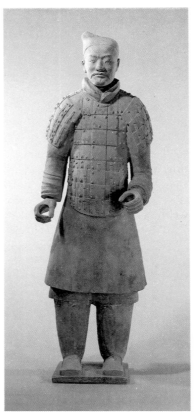

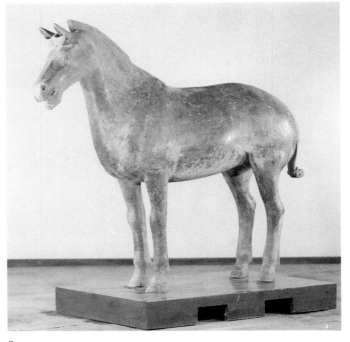

9
Chariot horse
Earthenware
Height 179 cm (70 ½ in.), length 205 cm (80 ¾ in.)
Color plate on p. 45

8
Warrior
Painted earthenware
Height 183 cm (72 in.)

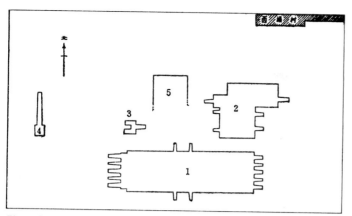

Fig. 1. Diagram of the subsidiary pits at the Lishan necropolis of the First Emperor of Qin; terra-cotta warriors and horses were found in pits 1, 2, and 3. Photo courtesy Overseas Archaeological Exhibition Corporation.

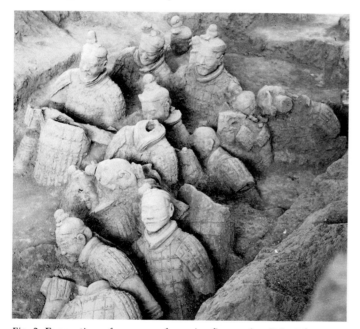

Fig. 2. Excavation of a group of warrior figures in pit 1 at the Lishan necropolis of the First Emperor of Qin. Photo courtesy Overseas Archaeological Exhibition Corporation.

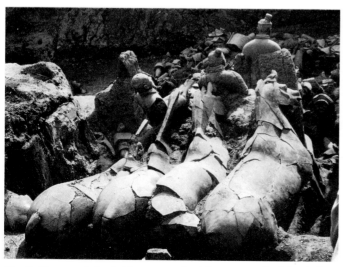

Fig. 3. Figures of chariot horses and soldiers unearthed in pit 1 at the Lishan necropolis. Photo courtesy Overseas Archaeological Exhibition Corporation.

6–9
Qin dynasty
Excavated in 1974 from pit 1 near the tomb of the First Emperor of Qin, Lintong, Shaanxi Province
Archaeological Team for Qin Terra-cotta Figures, Shaanxi

The first Qin horse and warrior sculptures were found in 1974 when local peasants were sinking a well. Three separate pits were found (fig. 1; see also pages 41–43, figs. 1–7). The largest excavation, pit 1, measures 210 meters from east to west and 60 meters from north to south. It contains approximately six thousand figures of horses and warriors arranged in an orderly and densely organized military formation of rectangular shape. The arrangement consists of eleven trenches running east to west with a broad aisle running north to south at either end. The vanguard occupies the eastern aisle and contains 210 bowmen and crossbowmen in three rows; among them are three figures who appear to be officers. The two outermost east-west trenches each contain two rows of bowmen, the outer row facing outward while the inner one faces forward, to the east. These archers, with their long-range weapons, protect the infantry in the nine central trenches: there are thirty-six files of foot soldiers, all facing east and armed with spears, knives, or swords (fig. 2). Six of the trenches have a chariot group at the eastern end, each consisting of four horses and fourteen soldiers (fig. 3).

Pit 2, about 6,000 square meters in area, is irregular in shape and represents four connecting formations comprised of cavalry, war chariots, and foot soldiers, including archers. It contains more than one thousand earthenware warriors and horses. Pit 3, about 500 square meters in area, is U-shaped and contains sixty-eight elite guardsmen and one war chariot. It seems to be the headquarters unit for pits 1 and 2. Pit 2 and 3 were filled in after exploratory excavations.

The figures were modeled in clay, assembled, fired, and then painted in contrasting hues of red, black, blue, white, and yellow. The quality, realism, variety, and technical complexity of these sculptures clearly illustrate that with the Qin period Chinese sculpture entered a new era.

The soldiers, with their handsome, resolute faces, represent warriors who had been rigorously selected and carefully trained. Figures include foot soldiers in battle array, cavalrymen leading their horses, archers bending their bows, charioteers driving their chariots and brandishing weapons, as well as steadfast and self-possessed generals and officers standing at attention, sword in hand.

Included in the exhibition are two officers and a warrior (cat. nos. 6–8). All wear armor of scalelike plates riveted together over knee-length tunics, puttees, and square-toed shoes. Their hands are all formed as if to hold objects; indeed, other finds indicate that these life-sized figures were originally equipped with real bronze weapons. Traces of their bright polychrome decoration can still be seen. One officer (cat. no. 6) was found standing to the right of a general; this position and his costume and elongated headdress suggest that he is of middle rank. His fellow officer (cat. no. 7), probably of a lower rank, wears a sturdier armor of thick plates laced and riveted together, which completely covers his chest and back as well as his shoulders and upper arms. He has a particularly finely rendered face, its strong struc-

ture and determined expression imparting to him a dignified martial air. Most of the infantrymen found in pit 1 wear no protective clothing; only the higher-ranking warriors are garbed in armor. Another figure (cat. no. 8) wears the same armor as the lower-ranking officer and a soft cloth cap over hair that has been arranged in a rounded knot to the right side of his head.

Twenty-four terra-cotta horses were found in pit 1, arranged as four-horse teams for six chariots. This example (cat. no. 9), roughly life-sized, represents an animal that is strong and well-nourished, his mane neatly clipped and tail knotted. His mouth is open as if to accommodate a bit. When this horse was excavated, bronze and stone trappings with which it had apparently been outfitted were found scattered in the mud nearby, in the vicinity of the other horses and chariots. His stance exhibits alertness, sensitivity, and vigor.

Literature
Archaeological Excavation Team for the Qin Funerary Figures Pit at the First Emperor's Tomb, "Lintongxian Qin yong keng shijue diyihao jianbao" (Brief report on the exploratory excavation of Qin funerary figures pit 1 in Lintong County), *Wenwu* (Cultural relics), 1975, no. 11: 1–18.
Qin Ming, "Qin yong keng bing ma yong junzhen neirong ji bingqi shitan" (Tentative exploration of the military formations and weapons of the warrior and horse figures from the Qin funerary figures pits), *Wenwu*, 1975, no. 11: 19–23.
Archaeological Excavation Team for the Qin Funerary Figures Pit at the First Emperor's Tomb, "Qin Shihuang ling dongce dierhao bing ma yong keng zuantan shijue jianbao" (Brief report on core samples and exploratory excavations of warrior and horse figures pit 2 on the east side of the tomb of the First Emperor of Qin), *Wenwu*, 1978, no. 5: 1–19.
Archaeological Team for Qin Funerary Figures, "Qin Shihuang ling dier tongchema qingli jianbao" (Brief report on the inspection of bronze chariot and horse figures pit 2 at the tomb of the First Emperor of Qin), *Wenwu*, 1983, no. 7: 1–16.
Archaeological Team for Qin Funerary Figures, "Qin Shihuang ling dongce disanhao bing ma yong keng qingli jianbao" (Brief report on the inspection of warrior and horse pit 3 on the east side of the tomb of the First Emperor of Qin), *Wenwu*, 1979, no. 12: 1–12.

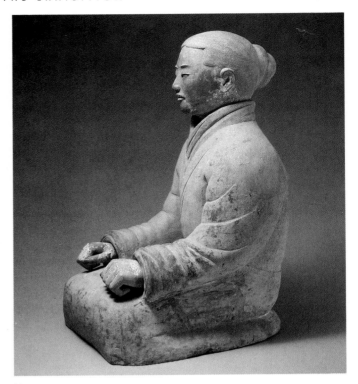

10
Kneeling figure
Painted earthenware
Height 65 cm (25 ⅝ in.)
Qin dynasty
Excavated in 1973 near the tomb of the First Emperor of Qin, Lintong, Shaanxi Province
Shaanxi Provincial Museum
Color plate on p. 45

This image, because of its serenity and elegance, and especially because of the simple bun into which its hair has been arranged, gives the impression of being a female figure. However, the excavation in 1977 of the stable pits on the east side of the First Emperor's tomb yielded similar kneeling figures along with other figures in the company of horses (fig. 4; see also page 44, fig. 8). Since some of the figures are bearded, it is clear that they are actually male stable managers and attendants.

This harmonious sculpture, rendered in accurate human proportions, is extremely lifelike and very beautiful. The head and hands were modeled separately and can be removed. Surviving traces of red and green paint are still very brilliant in hue.

Literature
Archaeological Team for Qin Funerary Figures, "Qin Shihuang ling dongce majiu keng zuantan qingli jianbao" (Brief report on the core samples and inspections of the stable pits on the east side of the tomb of the First Emperor of Qin), *Kaogu yu wenwu* (Archaeology and cultural relics), 1980, no 4: 31–41.
Zhao Kangmin, "Qin Shihuang ling dongce faxian majiu keng" (The discovery of five stable pits on the east side of the tomb of the First Emperor of Qin), *Kaogu yu wenwu*, 1983, no. 5: 23–25.

Fig. 4. Section of a stable pit at the Lishan necropolis seen from above, showing the figure of a kneeling stable attendant beside the skeleton of a horse. From *Kaogu yu wenwu*, 1983, no. 5.

Uprisings ended the Qin regime after only fourteen years. In 202 B.C. a commoner, Liu Bang, succeeded in reunifying the empire and ascended the throne as Emperor Gaozu of the Han dynasty, making his capital at Chang'an, in the suburbs of modern Xi'an. The Han period brought the nation unprecedented economic development and international prestige. These four hundred years of political unification saw the flowering of cultural, philosophical, and religious activity and many innovations in agricultural technology and military organization.

In the early part of the dynasty, the Han often found themselves at odds with the nomadic kingdoms on their borders. The Xiongnu, thought to be the ancestors of the Huns, occupied China's northern and western frontiers, disrupting caravan trade across Central Asia and occasionally capturing a Han official or general. A number of successful campaigns were conducted against them by Emperor Wudi (141–87 B.C.), whose rule ultimately incorporated most of modern China, northern Vietnam, Inner Mongolia, and part of Korea. These conquests assured the Chinese of control of the Central Asian silk routes and enabled them to conduct trade as far west as the Mediterranean basin.

A series of natural and man-made disasters forced the removal of the Han capital farther east to Luoyang in Henan Province in 25 A.D. The second half of the dynastic period is thus known as Eastern Han. During the first century of the Eastern Han period, China's international influence and economic status remained high. The upper classes enjoyed great affluence and access to exotic imported luxury objects. Elaborate funerary arrangements, once the preserve of emperors and their relatives, became widespread among families of the landowning class. This had a profound influence on the art of funerary sculpture during the Han dynasty. Early in the period magnificent military assemblages were buried in the tombs of the imperial court; a wider variety of objects and figures reflecting the rich diversity of Han culture were placed in slightly later tombs probably built by wealthy commoners.

All aspects of life, from the most serious to the most frivolous, were preserved in sculptural form, providing the modern viewer with a remarkable overview of the material culture of the Han Chinese. Images of human beings range from military figures to servants and entertainers. Everyday life was depicted in the figures of animals and fowl, both domestic and wild, and examples of architecture and engineering, including models of dwellings, garden pavilions and gazebos, fields and ponds, agricultural machines and buildings, boats and carts, and even pigsties and outhouses.

The growing demand for elaborate burial goods led to the use of molds for producing large quantities of identical figures. Despite mass production, standardized types, and very simple sculptural techniques, the artistic level attained in some of the figures is quite remarkable, displaying great descriptive or expressive power and a sense of vitality in the human form.

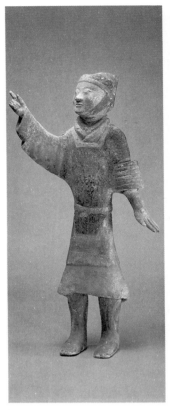

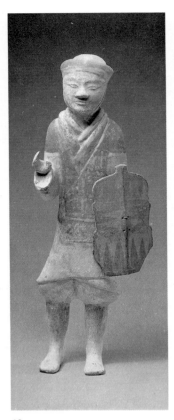

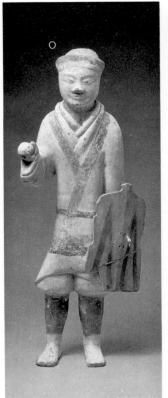

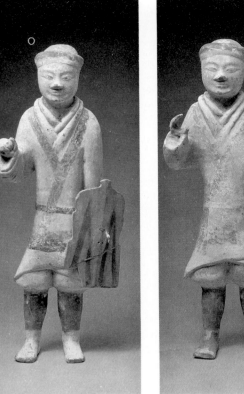

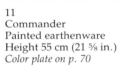

11
Commander
Painted earthenware
Height 55 cm (21 ⅝ in.)
Color plate on p. 70

12
Three warriors with shields
Painted earthenware
Range of heights 48 to 49.5 cm (18 ⅞ to 19 ½ in.)
Color plate on p. 46

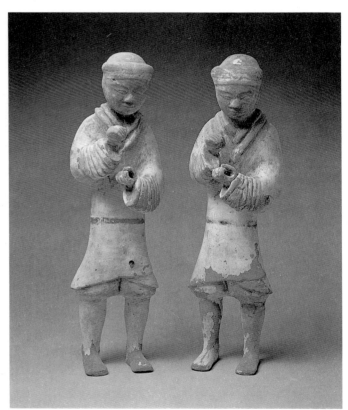

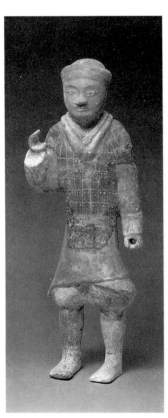

13
Two musicians
Painted earthenware
Height 48 cm (18 ⅞ in.)
Color plate on p. 72

14
Warrior in armor
Painted earthenware
Height 49.5 cm (19 ½ in.)
Color plate on p. 71

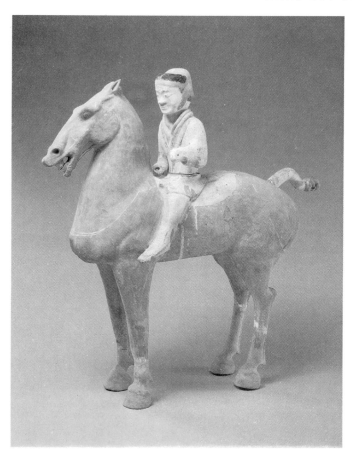

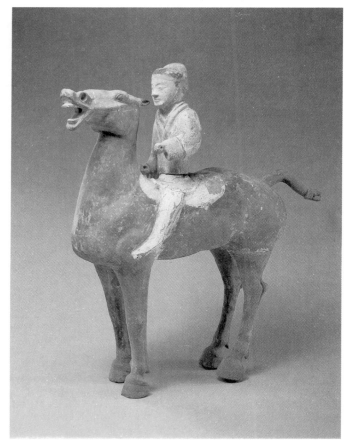

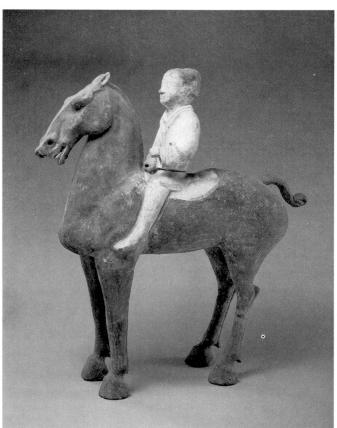

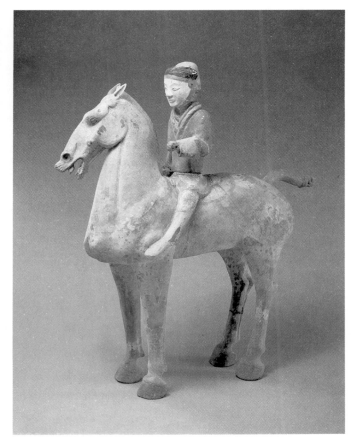

15
Four horsemen
Painted earthenware
Height 66 cm (26 in.), length 65 cm (25 ⅝ in.)
Color plate on p. 46

11–15
Western Han dynasty
c. 180–140 B.C.
Excavated in 1965 from a tomb at Yangjiawan, Xianyang, Shaanxi
Province
Xianyang Museum, Shaanxi

The imperial tombs of the Western Han were constructed on the high ground northwest of Xi'an and north of the Weishui River and were surrounded by accompanying burials of imperial relatives and officials. The two Han tomb mounds at Yangjiawan are satellite graves of the Changling, the mausoleum of Emperor Gaozu (r. 206–195 B.C.). On the basis of the finds of earthenware, jades, lacquers, horse and chariot trappings, and coins from the reigns of Empress Lü (d. 180 B.C.) and Emperor Wendi (r. 180–157 B.C.), this tomb can be dated to the middle of the second century B.C..

It is probable that these are the tombs of the famous Western Han minister Zhou Bo and his son, Zhou Yafu. According to ancient records, a canal flowed to the south of the tomb mounds of Gaozu and Zhou Bo, and, indeed, the Gaogan Canal still flows to the south of the two Yangjiawan mounds (fig. 5).

In 1965, when the ground was being leveled for farming, many polychromed earthenware figures were discovered in a group of eleven subsidiary pits 70 meters to the south of the grave mounds. Among them were 583 mounted cavalrymen and 1,965 standing figures, arranged in a formation of five rows (fig. 6). The first three rows, contained in six pits, were mounted cavalry, the rear two rows, in four pits, were civil and military officials and a complete range of musicians, dancers, and attendants. The great detail in the depiction of costumes, armor, headgear, and hairstyles provides extremely useful information about daily and military life during Western Han, an important period of development in the history of Chinese equestrian warfare. The number of figures, the completeness of the assemblage, the novelty and variety of figure types, and the precision of the military formation at Yangjiawan are rarely seen in Han excavations.

The posture and costume of one of the warriors (cat. no. 11) are unique among the Yangjiawan figures and are clear evidence he is a commander. His military garb consists of several overlapping tunics, black armor belted at the waist, and a cap with a chin strap. The elaborately ornamented boots, painted in patterns of green, red, purple, and black, are unusually colorful. His stance and gestures suggest a signal to his troops. The three dignified warriors with shields (cat. no. 12) wear uniforms that are similar to but less complicated than that of their commander, consisting of several layers of military tunics worn over puttees and caps held on by chin straps. Only one wears armor. They probably held weapons in their upraised right hands; during the excavation other such figures were found holding fragmentary iron clubs. Another warrior (cat. no. 14) is distinguished from his shield-bearing comrades primarily by his elaborate black armor, with its plates and rivets indicated in red and white paint. His original weapons are now lost, although he still has a quiver for arrows on his back.

Although their instruments have been lost, the two musicians (cat. no. 13) still convey intense concentration on the motions of their empty hands and attention to the music they are making. The costumes of the musicians are similar to those of the warriors from the same tomb.

The horses and riders (cat. no. 15) were part of the magnificent cavalry formation discovered in the subsidiary pits of the Yangjiawan tomb. Like the infantrymen and musicians, the riders have half-closed hands, which probably held reins or weapons. The figures are distinguished by variety in the color of the costumes, the saddles and bridles, and the horses themselves. Three of these steeds, which display great elegance of form and refinement of execution, stand still, their energy tightly controlled, while the fourth lifts his head to whinny.

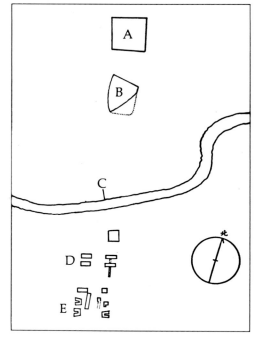

Fig. 5. Map of the excavations at Yangjiawan, Xianyang, Shaanxi Province. *A, B,* tombs of Zhou Bo and Zhou Yafu; *C,* Gaogan Canal; *D, E,* subsidiary pits containing ceramic figures. From *Wenwu,* 1966, no. 3.

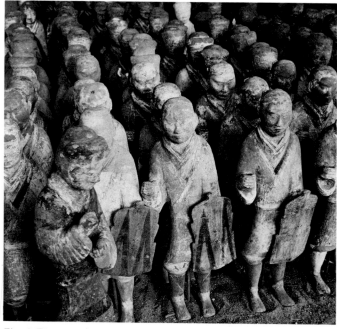

Fig. 6. Figures of warriors from a subsidiary pit at Yangjiawan. Photo courtesy Overseas Archaeological Exhibition Corporation.

Literature
Shaanxi Provincial Committee for Administration of Cultural Relics and Xianyang Municipal Museum, "Shaanxi sheng Xianyangshi Yangjiawan chutu dapi Xi Han caihui taoyong" (A large quantity of Western Han painted earthenware funerary sculptures excavated at Yangjiawan, Xianyang Municipality, Shaanxi Province), *Wenwu* (Cultural relics), 1966, no. 3: 1–5.
Shaanxi Provincial Committee for Administration of Cultural Relics, Shaanxi Provincial Museum, and Yangjiawan Han Tomb Excavation Group of the Xianyang Municipal Museum, "Xianyang Yangjiawan Han mu fajue jianbao" (Brief report on the excavation of the Han tomb at Yangjiawan, Xianyang), *Wenwu,* 1977, no. 10: 10–21.
Wang Zhongshu, *Han Civilization* (New Haven: Yale University Press, 1982), 208, 211.

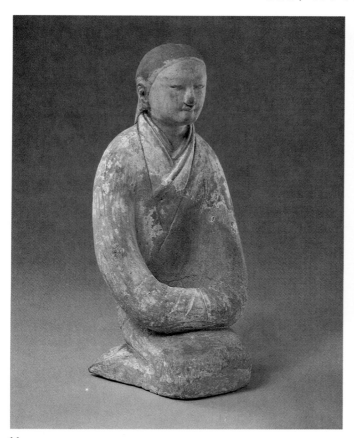

16
Kneeling woman
Painted earthenware
Height 33 cm (13 in.)
Color plate on p. 24

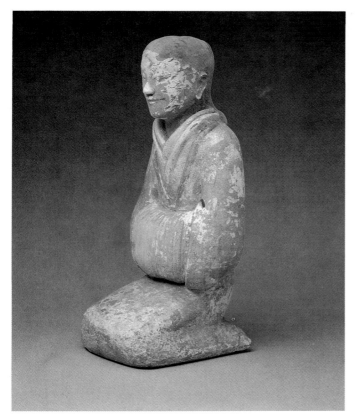

17
Kneeling woman
Painted ea. thenware
Height 35 cm (13 ¾ in.)
Color plate on p. 24

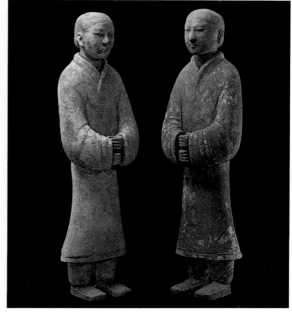

18
Two standing women
Painted earthenware
Height 53 cm (20 ⅞ in.)
Color plate on p. 73

16–18
Western Han dynasty
Excavated in 1966 from a tomb at Renjiapo, eastern suburb of Xi'an,
Shaanxi Province
Shaanxi Provincial Museum

The tomb at Renjiapo, located on White Deer Plain (Bailuyuan)
in the eastern suburbs of Xi'an, yielded forty-two earthenware
sculptures, which were scattered over thirty-seven different
pits constructed to contain funerary objects. The pits are
believed to be associated with the tomb of Empress Dou (d. 135
B.C.), wife of Wendi (r. 180–157 B.C.).

Thirty-eight relatively complete ceramic figures were found,
twenty-nine seated and nine standing females, along with
grain and the skeletons of horses, goats, pigs, and other live-
stock. The ceramic bodies, of relatively high-fired clay, are
dense in composition and dark in color, and make a ringing
sound when tapped. All the sculptures bear traces of what
must have been brilliant polychromy. Their dress and demea-
nor identify them as court attendants.

The kneeling attendants (cat. nos 16–17), two of six similar
figures found at the site, are presented in a formal posture ex-
pressing respect. Both wear three layers of robes, the inner two
with high, thick rolled collars. The inner robe of one woman
(cat. no. 16) was once bright red; the long, narrow sleeves of
her outer robe cover her clasped hands. Her hair hangs down
her back and is knotted loosely at the bottom. The other atten-
dant (cat. no. 17) wears a white inner robe with graceful
pleated sleeves that hide her hands, and her hair is caught at
the nape of her neck in a long hanging loop. Both figures are
possessed of dignity and calm, their faces modeled with simple
clarity; the features of the second woman are particularly
elegant.

The two standing figures (cat. no. 18) are virtually identical
in appearance and costume and differ only slightly in construc-
tion, one having holes in the soles of her feet. Their half-closed
hands, one aligned above the other, must have held vertical
objects required for their attendance on the deceased.

Literature
Wang Xueli and Wu Zhenfeng, "Xi'an Renjiapo Han ling congzang
keng de fajue" (Excavation of the pits for funerary objects accompany-
ing a Han mausoleum at Renjiapo, Xi'an), *Kaogu* (Archaeology), 1976,
no. 2: 129–33, 75.

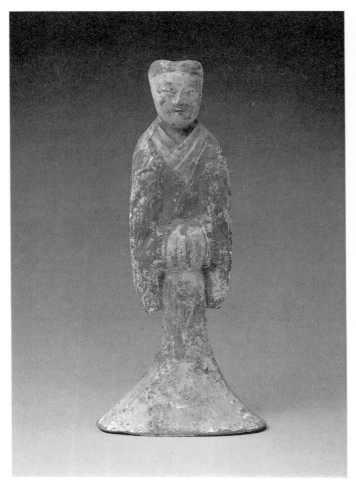

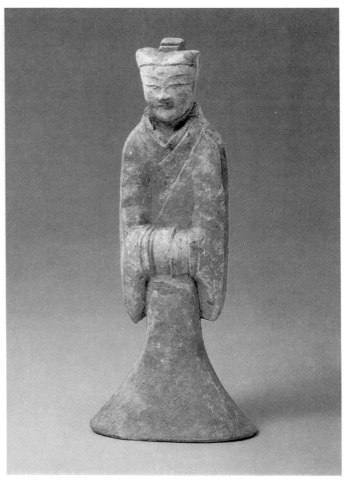

19
Standing woman
Painted earthenware
Height 27.3 cm (10 ¾ in.)
Color plate on p. 51

20
Standing man
Painted earthenware
Height 29.4 cm (11 ⅝ in.)

19–20
Western Han dynasty
Excavated in 1953 from a tomb at Hongqing Village, Xi'an, Shaanxi Province
Shaanxi Provincial Museum

Hongqing Village is 15 kilometers from Xi'an, on the way to the tomb of the First Emperor of Qin at Lintong. On the east is Lishan, on the west the Ba River, and in the distance can be seen the Baling mountain range. Between 1953 and 1955, exploration of the large group of Han tombs in this area yielded artifacts in abundance. They included glazed earthenware wine vessels of square cross-section, tripods, stoves, lamps, and jars, as well as a number of bronze mirrors and V-shaped bronze gear wheels. Only nine earthenware sculptures were found, five representing humans and the remainder depicting pigs, dogs, and chickens.

The figures in the exhibition (cat. nos. 19–20), two of the three female and two male images found in this cluster of tombs, wear similar three-layered robes that flare out in a trumpet shape at the bottom. In both figures, long inner sleeves cover their clasped hands. The woman (cat. no. 19) is distinguished by her brilliant vermilion robe and loose hair which hangs down her back and is knotted at the bottom. On the man's head is a tall cap (cat. no. 20). The flat, attenuated forms of the figures are typical of the ceramic sculpture from this site.

Literature
Shaanxi Provincial Committee for Administration of Cultural Relics, "Shaanxi Chang'an Hongqingcun Qin Han mu dier ci fajue jianji" (Brief report of the second excavation of the Qin and Han tombs at Hongqing Village, Chang'an, Shaanxi), *Kaogu* (Archaeology), 1959, no. 12: 662–67.

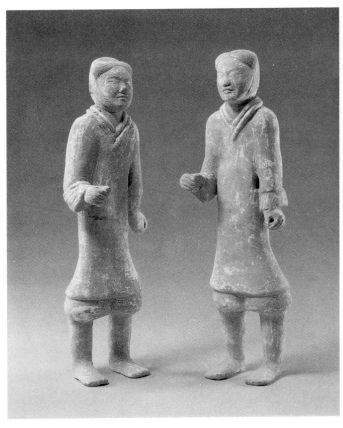

21
Two warriors
Painted earthenware
Height 44 cm (17 ⅜ in.)
Color plate on p. 23

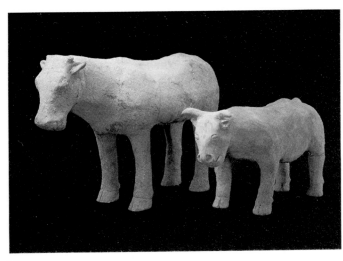

22
Two oxen
Earthenware
a) height 19 cm (7 ½ in.), length 24 cm (9 ½ in.); b) height 28 cm (11 in.),
length 43 cm (16 ⅞ in.)
Color plate on p. 48

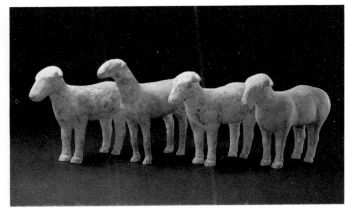

23
Four goats
Earthenware
Range of heights 23 to 28 cm (9 to 11 in.), range of lengths 25 to 28 cm
(9 ⅞ to 11 in.)
Color plate on p. 48

21–23
Western Han dynasty
Excavated in 1980 from Han tomb 11 at Langjiagou, Xianyang, Shaanxi
Province
Xianyang Museum, Shaanxi

Located about 17.5 kilometers northeast of Xianyang, Han tomb 11 at Langjiagou lies between two imperial burials (fig. 7): it is 2 kilometers to the east of the Anling, tomb of Emperor Huidi (Li Ying, r. 195–188 B.C.), to which it is a satellite, and 1.5 kilometers to the west of the Changling, tomb of Emperor Gaozu (r. 206–195 B.C.). Part of the pounded earth mound of tomb 11 has collapsed, but on the basis of similar excavations in the area it can be determined that the tomb figures were buried under the mound in a rectangular trench encircling the tomb chamber. The trench, which is 54 centimeters wide, extends 19 meters from north to south and 21 meters from east to west; its sides are constructed of seven rows of bricks. The tomb sculptures were placed on the dirt floor.

Figures of hunters were excavated from the northwest corner of the trench in 1950. In 1980 the central section of the southern trench, which had already been exposed, was investigated. In a 9-meter-long section, six rows of systematically arranged sculptures, all facing east, were found (fig. 8). There were eighty-four figures in all, providing valuable evidence for both Western Han burial practices and agriculture. Against the northern wall was a row of warriors. The elongated images of the soldiers (cat. no. 21) are very similar in dress, appearance, and pose, not only to each other but to other Western Han military figures (cat. nos. 12, 14). These, however, wear a different

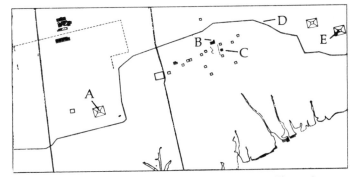

Fig. 7. Map of the burials at Langjiagou, Xianyang, Shaanxi Province. *A*, Anling; *B*, Langjiagou; *C*, tomb 11; *D*, Gaogan Canal; *E*, Changling. From *Kaogu*, 1981, no. 5.

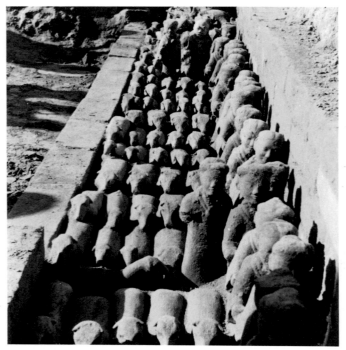

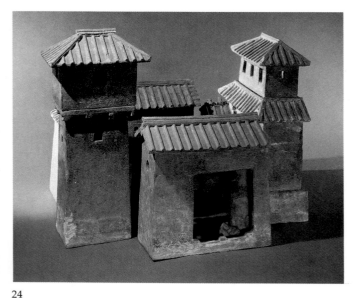

24
House with a courtyard
Earthenware
Height 76 cm (29 ⅞ in.), width 93 cm (36 ⅝ in.), depth 85 cm (33 ½ in.)
Western Han dynasty
Excavated in 1959 from tomb 159 at Nanguan, Zhengzhou, Henan
Province
Henan Provincial Museum
Color plate on p. 12

Fig. 8. Middle section of the southern trench at tomb 11,
Langjiagou, showing figures of warriors and goats. Photo
courtesy Overseas Archaeological Exhibition Corporation.

type of cap with chin strap, and on their feet are traces of straw
sandals. They are particularly distinguished by their
straightforward, determined gaze. Like many Western Han
figures, their hands are clasped to hold weapons, now lost.

The other five rows in the southern trench contained
herdlike groups of domestic animals, oxen to the west, pigs to
the east, and goats in the center. From their large bodies, high
shoulders, and sturdy hooves, the oxen (cat. no. 22) appear to
represent the typical northern Chinese yellow ox, which was
used as a beast of burden. This ox has great strength and
endurance; those qualities and its gentle disposition and
steady pace made it a valuable source of power in traditional
Chinese agriculture. The goats (cat. no. 23), with their long
heads, relatively short necks and tails, long, thin bodies, and
triangular horns, are realistic depictions of early Western Han
domestic goats and reflect the flourishing livestock industry of
the period.

Literature
Xianyang Museum, "Han Anling de kancha ji qi peizang mu zhong de
caihui taoyong" (Investigation of the Han Anling and the painted ce-
ramic figures in its satellite tombs), *Kaogu* (Archaeology), 1981, no. 5:
422–25.

This tomb was discovered in the course of a construction
project. It was essentially rectangular in shape and consisted of
four sections. An entrance corridor on the east opened into a
rectangular earthen chamber, within which was a burial vault
constructed of seventy-two large hollow ceramic tiles ornately
decorated with impressed images of buildings, people, birds,
trees, or abstract patterns. The vault itself consisted of a rectan-
gular room to which a smaller chamber was added; it was this
subsidiary chamber that contained most of the twenty-two
burial objects, seventeen of which were made of earthenware
(fig. 9). The discovery of such a completely preserved vault is
very rare. From the scale of the tomb and the types of objects
found in it, it is probable that the tomb is that of a minor land-
owner of the late Western Han period.

This earthenware model of a dwelling complex is an accurate
portrait of a Western Han household, as well as an illustration
of the architecture of the period. It is made of very fine-bodied
gray clay and has six component parts — gatehouse, main
house, watchtower, storehouse, kitchen, and latrine — which
combine to create a rectangular structure with a courtyard in
the center. The complex was placed in the tomb with the
gatehouse and main house aligned to the north. Inside the
gatehouse lies a dog, his eyes staring and his ears erect (fig.
10). The main house (fig. 11) has a gabled roof and is raised on
a platform; the entrance is reached by a staircase. To the east of
the main house is the kitchen, within which were piled three
bronze vessels: a cauldron, basin, and rice steamer. To the west
is the pigsty, in which an earthenware pig reclines (fig. 10). The
latrine (fig. 12) is situated above the pigsty; three chickens and
five chicks are perched on the ridge of its roof. At the north-
eastern corner of the complex, beside the gatehouse, is a hip-
roofed watchtower. On the western side is a hip-roofed gra-
nary built on a platform; it is reached by a double staircase (fig.
13), while another pair of staircases ascends the facade of the
building itself.

Literature
Cultural Relics Work Team of the Henan Provincial Cultural Bureau,
"Zhengzhou Nanguan 159 hao Han mu de fajue" (Excavation of Han
tomb 159 at Nanguan, Zhengzhou), *Wenwu* (Cultural relics), 1960, nos.
8–9: 19–24.

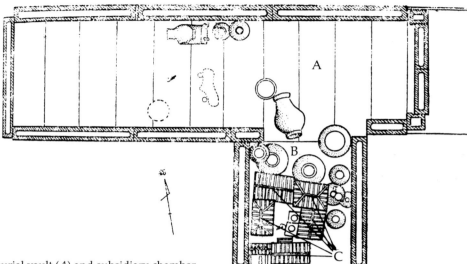

Fig. 9. Diagram of the burial vault (*A*) and subsidiary chamber (*B*) of tomb 159 at Nanguan, Zhengzhou, Henan Province. *C*, house with a courtyard (cat. no. 24). From *Wenwu*, 1960, nos. 8–9.

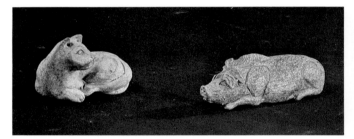

Fig. 10. Watchdog and pig.

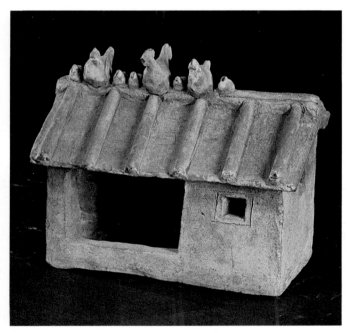

Fig. 12. Latrine with chickens on the roof.

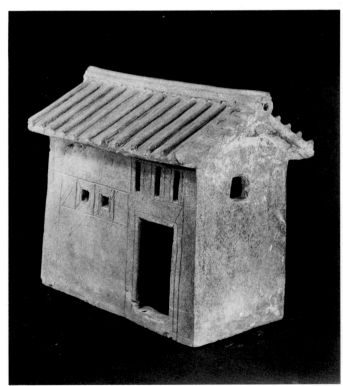

Fig. 11. Main house.

Fig. 13. Granary platform with double staircase.

Figs. 10–13. Details of the earthenware house (cat. no. 24) from tomb 159 at Nanguan. Photos courtesy Overseas Archaeological Exhibition Corporation.

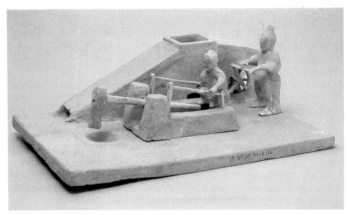

25
Rice huller and winnow
Red earthenware
Height 11.5 cm (4 ½ in.), length 35 cm (13 ¾ in.), width 9.5 cm (3 ¾ in.)
Color plate on p. 49

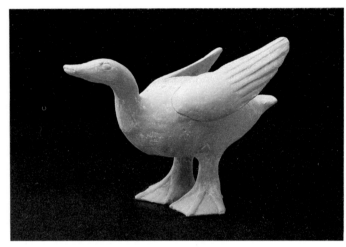

26
Goose
Red earthenware
Height 17.5 cm (6 ⅞ in.), length 25 cm (9 ⅞ in.)

25–26
Western Han dynasty
Excavated in 1969 from tomb 24 at Sijian'gou, Jiyuan County, Henan Province
Henan Provincial Museum

A group of three brick tombs of the Han dynasty were unearthed in late 1969 during a construction project at Sijian'gou, Jiyuan, Henan. Tomb 24 is a rectangular single-chambered tomb 5.3 meters in length and 2.2 meters in width (fig. 14). The tomb contained seventy different types of objects, including earthenware geese, chickens, oxen, goats, pigs, horses, and models of storehouses; green-glazed ceramic lamps, plates, jars, tripods, stoves, and other models of cooking utensils; red-and-black glazed earthenware plates, ritual bronze vessels and urns; iron swords; and copper coins inscribed with the unit of currency fifty *daquan*.

The earthenware model of a rice huller and winnow on a rectangular base (cat. no. 25) was found near the rear of the tomb, between the coffins. These are the earliest known models of an operating winnow and of a rice huller with a treadle-operated tilt-hammer; this model is an invaluable document for the history of ancient Chinese agricultural equipment, providing evidence that these processing devices were probably in use before the Western Han. A squatting figure grasps the frame of the huller with both hands as his feet work the hammer. At the top of the winnow is a funnel-shaped opening for unprocessed rice and in the lower section is a square opening from which the cleaned rice emerges. At the back of the winnow is a circular air hole in which a crank-operated fan is mounted. The figure of the operator extends his hands toward the fan handle as if to turn the crank.

The very lifelike sculpture of a plump goose (cat. no. 26) represents the bird with its neck stretched, wings extended, and tail raised as though preparing to take flight.

Literature
Henan Provincial Museum, "Jiyuan Sijian'gou sanzuo Han mu de fajue" (Excavation of three Han tombs at Sijian'gou, Jiyuan), *Wenwu* (Cultural relics), 1973, no. 2: 46–53.

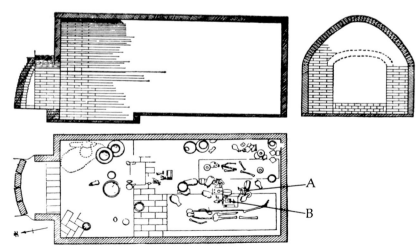

Fig. 14. Plan and cross sections of tomb 24 at Sijian'gou, Jiyuan, Henan Province. *A*, goose (cat. no. 26); *B*, rice huller and winnow (cat. no. 25). From *Wenwu*, 1973, no. 2.

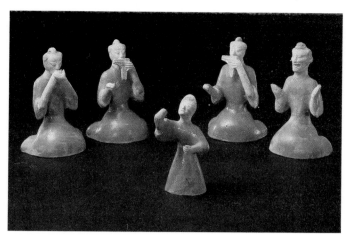

27
Four musicians and a dancer
Glazed and painted earthenware
Height ranges 17.5 to 21.5 cm (6 ⅞ to 8 ½ in.)

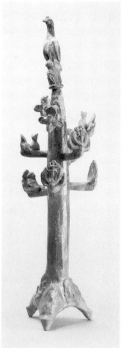

28
Peach Capital Tree
Glazed earthenware
Height 63 cm (24 ¾ in.)

27–28
Western Han dynasty
Excavated in 1969 from tomb 8 at Sijian'gou, Jiyuan County, Henan Province
Henan Provincial Museum

Tomb 8, the second of three Han tombs found at Sijian'gou, is a two-chamber type, consisting of an entrance, antechamber, and rear chamber (fig. 15). The tomb is 5.84 meters in total length and 3.35 meters in width. Most of the funerary objects were found in the antechamber. They included earthenware models of more than forty kinds of household utensils, including lamps and stoves; sculptures of domestic fowl and animals, including a mother pig and her piglets in a sty; and bronze crossbow parts.

A band of eight entertainers discovered in the center of the tomb consisted of a conductor, three dancers, and four musicians, modeled in reddish clay and decorated with both glaze and paint. Their faces were originally painted in flesh tones. Each figure has his hair braided into a bun and wears a long, narrow-waisted gown. The four musicians and one dancer are represented in this exhibition (cat. no. 27). The central figure

postures and gestures expressively as he performs his dramatic dance. One musician plays a wind instrument that is not identifiable; two others play the *xiao*, a set of bamboo pipes. The fourth musician provides vocal accompaniment and claps his hands in rhythm. The dancer may also have held a musical instrument, now lost.

The precise subject of this unusual representation of a tree (cat. no. 28) was identified in 1973 on the basis of a passage in several post-Han classical texts recording the following myth:

In the southeast is Mount Peach Capital (Taodushan). On top of the mountain is a large tree, the branches of which extend over three thousand *li*. At the top of the tree is the Celestial Cock. When the sun rises and shines on this tree, the Celestial Cock crows, whereupon all the roosters crow along with him.

In this image of the Peach Capital Tree, the green-glazed Celestial Cock stands on the head of a snarling animal. The cone-shaped trunk, giving an impression of great height, bears three tiers of three branches each, the trifoliate leaves of the top tier seeming to represent peach blossoms. Three of the branches accommodate red-glazed monkeys reclining against the leaves, three support perching birds, and the remaining three are empty. Of the nine terminal leaves, five have sap-sucking cicadas attached to them, and the others have flowers at their centers. All the leaves and flowers were made in molds and attached. The pyramidal base, which may symbolize Mount Peach Capital itself, is decorated with four relief figures of nudes interspersed with flying cicadas, running river deer, mountains, and trees. The discovery of this object is evidence that the myth of the Peach Capital Tree and the Celestial Cock had already arisen by the Han period.

Literature
Henan Provincial Museum, "Jiyuan Sijian'gou sanzuo Han mu de fajue" (Excavation of three Han tombs at Sijian'gou, Jiyuan), *Wenwu* (Cultural relics), 1973, no. 2: 46–53.
Guo Moruo, "Taodushu, Nuwa, Jialing" (The Peach Capital Tree, Nuwa, and Jialing), *Wenwu*, 1973, no. 1: 2–3. The subject matter of this sculpture was perceived by Guo as relating to an optimistic phrase in a Tang poem, "As soon as the cock crows the whole earth is bright." This phrase was quoted by Mao Zedong and Guo in their own poetry. The myth thus assumed a metaphoric meaning relating to the enlightenment of modern society. — *Trans.*

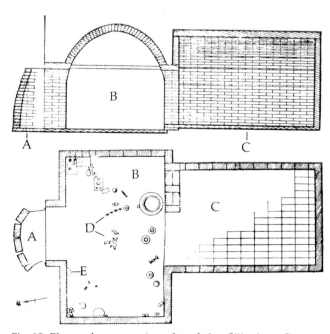

Fig. 15. Plan and cross section of tomb 8 at Sijian'gou, Jiyuan, Henan Province. *A*, entrance; *B*, antechamber; *C*, rear chamber; *D*, musicians and dancers (cat. no. 27); *E*, Peach Capital Tree (cat. no. 28). From *Wenwu*, 1973, no. 2.

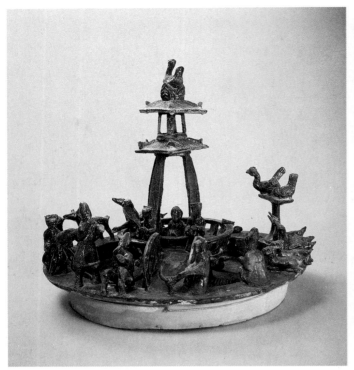

29
Waterside pavilion
Glazed earthenware
Height 45 cm (17 ¾ in.), diameter 50 cm (19 ⅝ in.)
Eastern Han dynasty
Excavated in 1964 at Zhechuan, Henan Province
Henan Provincial Museum
Color plate on p. 49

This carefully constructed model of a waterside pavilion is made of fine red clay covered with a green glaze above the rim and unglazed below. From the middle of a circular pool rises the towerlike pavilion, a bridge linking it to the bank, represented by the rim of the basin. The two levels of the pavilion are capped by hipped roofs with precisely delineated tiles and ridgepoles. Humans, animals, and birds are everywhere; a bird even perches on the bulky ridge ornament at the very top of the highest roof. The man kneeling in the center of the pavilion is probably the owner of the tomb, depicted as he gazes at the pleasant scene around him. He is attended by two servants carrying brooms.

Perched on the rim of the pool are a number of figures, including an archer poised to shoot, two men — one standing, one sitting — in animated conversation, a horse and rider, and a man with his feet in the pool. They are joined by three deer, three geese, two ducks, and a pair of birds on a T-shaped perch. On the rim behind the deer are traces of additional figures that have broken off. A small boat with a pointed bow and flat stern, and containing a paddle and a pole, drifts under the bridge. There are three holes, one in the bow for a mast and two in the stern for rudders. In the water beneath the bridge are a tortoise, a soft-shelled turtle, two mandarin ducks, geese, and fish.

This ensemble reflects the luxurious lives of landlords of the Eastern Han period. It is also an important source of information on the architectural practices of the time and the development of the early Chinese pavilion.

Literature
Sun Chuanxian and Zhang Jing'an, "Jieshao yijian Dong Han wanqi de taoshuixie" (Introducing a late Eastern Han earthenware waterside pavilion), *Wenwu* (Cultural relics), 1966: 59–60.

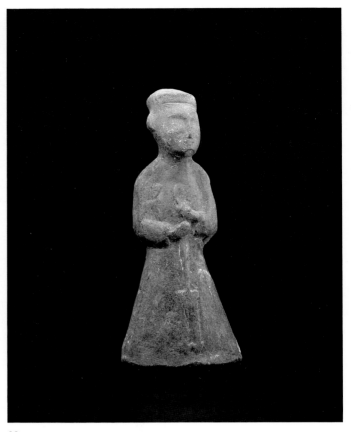

30
Farmer with spade
Painted earthenware
Height 21 cm (8 ¼ in.)
Color plate on p. 16

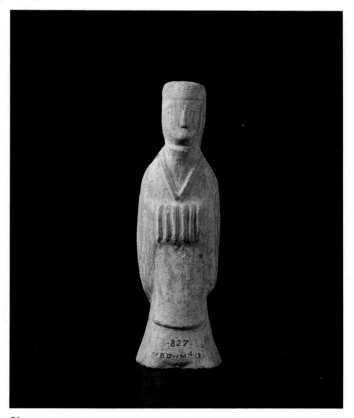

31
Attendant
Painted earthenware
Height 21 cm (8 ¼ in.)
Color plate on p. 19

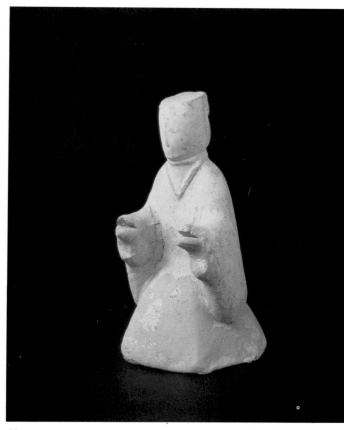

32
Kneeling attendant
Painted earthenware
Height 21 cm (8 ¼ in.)
Color plate on p. 19

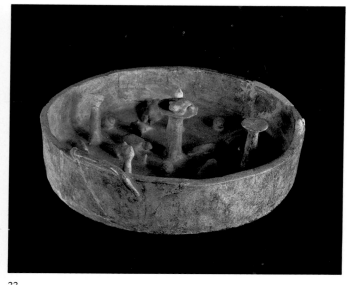

33
Circular pond
Green-glazed earthenware
Height 9 cm (3 ½ in.), diameter 36 cm (14 ⅛ in.)

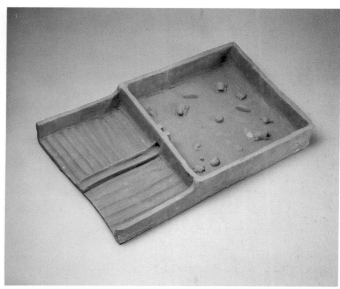

35
Farmland and pond
Earthenware
Height 6.2 cm (2 ½ in.), length 52 cm (20 ½ in.)

34
Winter rice paddy
Green-glazed earthenware
Height 5 cm (2 in.), length 31.3 cm (12 ⅜ in.)

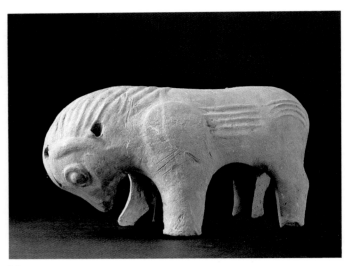

36
Ram
Earthenware
Height 17 cm (6 ¾ in.), length 32 cm (12 ⅝ in.)
Color plate on p. 27

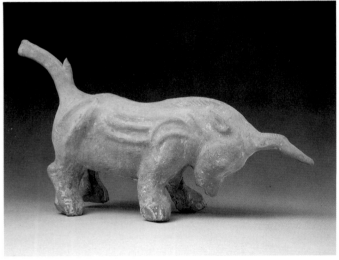

37
Unicorn
Earthenware
Height 19 cm (7 ½ in.), length 45 cm (17 ¾ in.)
Color plate on p. 27

30–37
Eastern Han dynasty
Excavated in 1978 from a tomb in Mian County, Shaanxi Province
Administrative Office for Cultural Relics, Mian County, Shaanxi

In 1978 the Administrative Office for Cultural Relics of Mian County, Shaanxi, conducted excavations of four tombs found in the course of agricultural improvements. Coins from the reign of Wang Mang (r. A.D. 9–23) and the Eastern Han period establish the date of the burials. Among the more than two hundred artifacts excavated were earthenware representations of rice paddies, ponds with dams, and hillside pools, infrequently found among Han grave goods. The finds in these tombs add to the evidence that agricultural production was already well developed in Hanzhong by the Han. They also confirm that water was a valued resource in this "region of rice and fish." Until recently, Hanzhong preserved more than seventy dams and canals dating back to the Han dynasty.

Tomb 4 produced a large number of earthenware figures as well as architectural models. The figure of a farmer carrying a spade (cat. no. 30) is the image of a peasant of the Eastern Han, a contrast to the warriors, musicians, and domestic servants usually found in Western Han tombs near the capital. His round hat and round-collared flaring robe are similar to the dress of a second figure (cat. no. 31); the latter, however, also wears a more elaborate outer robe, with pleated inner sleeves covering his clasped hands. He appears to have been an attendant to the deceased. Another attendant (cat. no. 32), similarly dressed, reaches up with hands that are notched to hold an object that is now lost.

Ancient descriptions of waterworks refer to the construction of dikes along the edge of mountain slopes for water storage and irrigation. These reservoirs were often circular because they took advantage of local topography. Although they were not large and therefore held a relatively small amount of water, they were very convenient, and many people used this type of dammed pool to cultivate water plants and raise fish. The model of one such pool (cat. no. 33) depicts a reservoir filled with lotus, water caltrops, frogs, carp, and ducks.

Winter rice paddies (cat. no. 34) tend to be found in regions with low mountains or foothills, and because of the land on which they are constructed, they are irregular in shape. They rely on rainfall for their water and therefore can only support one crop per year, hence their name "one-season fields." Because the land is flooded for long periods as part of rice cultivation, such paddies are also used for raising water plants. This piece represents a field divided into six parcels of varying sizes and shapes. Five of the six are inhabited by frogs, snails, eels, or soft-shelled turtles.

Small reservoir tanks were built in mountainous areas. Since they derived their supply from rain and diverted springs, they were effective both in times of drought and in times of excessive rain. This rectangular earthenware model (cat. no. 35) represents a tank, its dam, and two fields separated by a channel. Inside the reservoir are snails, frogs, soft-shelled turtles, and crucian carp. The dike, along which pedestrians could walk, has a hole in the center flanked by pillars into which a sluice gate could be inserted to control the flow of water. Such tank and dam constructions were examples of creative engineering on the part of the peasants; the models are physical evidence of the techniques used to develop land for agriculture.

The plump ram (cat. no. 36) with his spiraling horns can be identified as one of a sturdy breed that endures thirst well and survives in both hot and cold climates. It has thin flexible lips that facilitate cropping on short grass. The head lowered as if to butt suggests that the ram served as a tomb guardian. The unicorn (cat. no. 37) must certainly have functioned to protect the deceased from demons. It too lowers its head to attack, its tail is raised like that of an angry fighting bull. The powerful impression of invincibility relates it to the *zhenmu shou* ("grave-quelling beasts") of later periods (see cat. nos. 52, 57, 59, 64, and 81).

Literature
Guo Qinghua, "Shaanxi Mianxian Laodaosi sihao Han mu fajue jianbao" (Brief report on the excavation of Han tomb 4 at Laodaosi, Mian County, Shaanxi), *Kaogu yu wenwu* (Archaeology and cultural relics), 1982, no. 2.
———, "Qiantan Shaanxi Mianxian chutu Han dai tangku" (General comments on the Han dammed pond excavated at Mian County, Shaanxi), *Nongye kaogu* (Agricultural archaeology), 1983, no. 1.

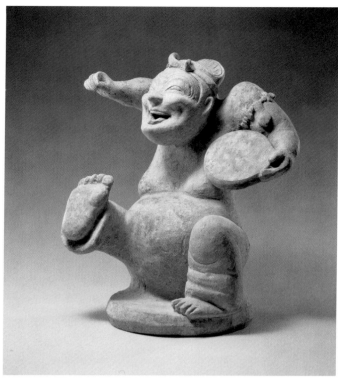

38
Balladeer
Painted earthenware
Height 50 cm (19 ⅝ in.)
Eastern Han dynasty
Excavated in 1982 from a cliffside tomb in Xindu County, Sichuan
Province
Administrative Office for Cultural Relics, Xindu County, Sichuan
Color plate on p. 75

This engaging figure is captured in mid-perfomance of an art
form called *shuochang*, ''talking and singing,'' a type of musical
storytelling. He wears a ceremonial hat and a scarf tied above
his forehead, which is wrinkled with the energy of his singing.
On his left arm, in which he cradles a drum, is a tasseled and
beaded bracelet. His corpulence does not hinder him from
lively movements and gestures, as he kicks out one bare foot
and raises his right hand high to beat the drum. The artist has
effectively concentrated vitality and animation in this figure to
evoke an enthralling entertainment.

Literature
Similar finds are discussed by Liu Zhiyuan, ''Chengdu Tianhui shanya
mu qingli ji'' (Record of the inspection of mountain cliff tombs at
Tianhui, Chengdu), *Kaogu xuebao* (Archaeology journal), 1958, no. 1:
87–103.

A combination of inadequate rulers, court intrigue, and rebellion brought about the fall of the Han dynasty. For four centuries thereafter China was divided and in turmoil. The government broke into competing states, armed conflict was frequent, and the economy stagnated. However, during this period there was an unprecedented fusion of ethnic groups. The north was reunified under the Northern Wei dynasty (386–535), a government controlled by a proto-Turkish people called the Toba. Many Han Chinese migrated to the south, but some great landlord families became administrators for the Toba rulers, who advocated sinicization and were themselves eventually absorbed into the northern Chinese population. In 535 the Wei split into two sections, Eastern and Western Wei.

In this time of political instability, China's contacts with other countries flourished, cultural exchange increased, and fresh elements were infused into the traditional cultural legacy of the Han. The Wei period thus became an important transitional epoch in Chinese culture, during which there were substantial developments in calligraphy, painting, crafts, and sculpture. Especially striking were the monumental Buddhist cave temple complexes, including Yungang, near the Wei capital at Datong in Shanxi;

Longmen, near Luoyang in Henan; and Dunhuang, built far out along the silk route in Gansu.

Large quantities of Northern Dynasties tomb sculptures have been discovered during the past few years in Ci County in Hebei, Luoyang in Henan, Datong in Shanxi, and Xi'an and Hanzhong in Shaanxi. The exceptional numbers of military figures that have been found suggest that wealthy aristocrats maintained personal armies in this period of ceaseless warfare. Among the rich variety of figure types are also officials, musicians, dancers, attendants, horses, donkeys, camels, and other animals. In the same tomb may be discovered relics of traditional Han Chinese culture, such as images of low-level officials wearing Han costume, and non-Han representations, such as a military troop composed of members of various minority ethnic groups. This reflects the cross-influences occurring in the spheres of politics, economics, and culture.

Most of these tomb sculptures were made in molds and glazed, with the exception of a small number of painted figures. Incised lines and relief techniques were used to articulate forms that express images of everyday life with a simple beauty.

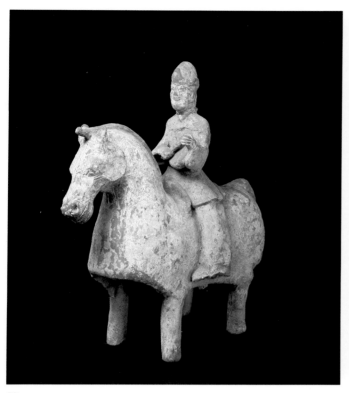

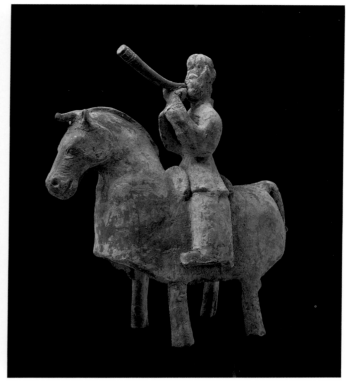

39
Equestrian drummer
Painted earthenware
Height 39.3 cm (15 ½ in.), length 38.5 cm (15 ⅛ in.)

40
Equestrian figure blowing a horn
Painted earthenware
Height 40 cm (15 ¾ in.), length 39 cm (15 ⅜ in.)
Color plate on p. 79

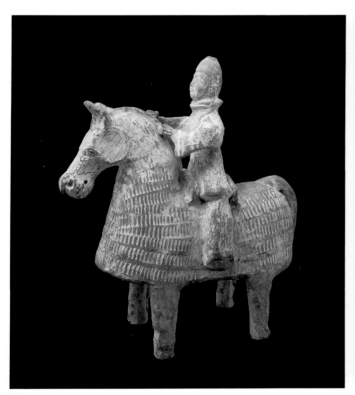

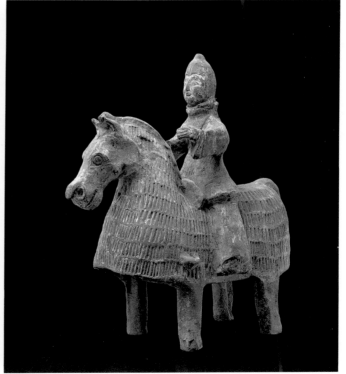

41
Two equestrian figures in armor
Painted earthenware
Height 39 cm (15 ⅜ in.), length 37 cm (14 ½ in.)
Color plate on p. 51

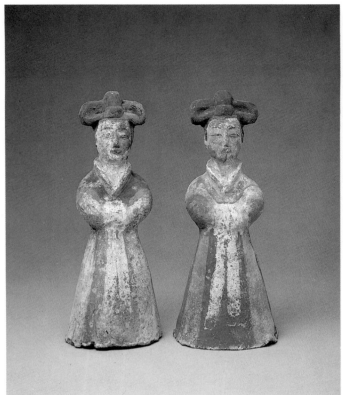

42
Two women
Painted earthenware
Height 33.5 cm (13 ¼ in.)
Color plate on p. 51

43
Woman playing bamboo pipes
Painted earthenware
Height 22.5 cm (8 ⅞ in.)
Color plate on p. 79

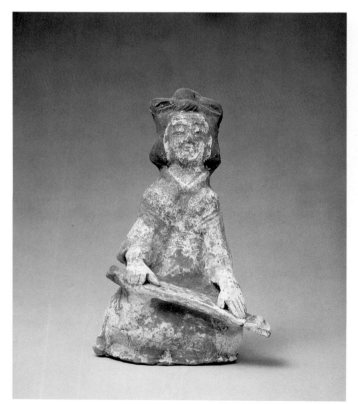

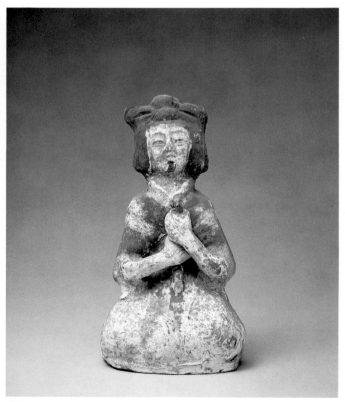

44
Woman playing a zither
Painted earthenware
Height 22.8 cm (9 in.)

45
Woman playing a musical instrument
Painted earthenware
Height 22.5 cm (8 ⅞ in.)

Fig. 16. Copy of a section of a mural painting from cave 285k at Dunhuang, Gansu Province. Photo courtesy Overseas Archaeological Exhibition Corporation.

39–45
Northern Wei dynasty
Excavated in 1953 from a tomb at Caochangpo, Xi'an, Shaanxi Province
Shaanxi Provincial Museum

This tomb was discovered in the course of routine digging by local peasants. It yielded 158 earthenware objects, the majority of them sculptures, representing many types of figures, including warriors in armor, cavalry, and ladies with elaborate hair styles. The simple forms are fresh and lively.

In the tomb, the figures on horseback (cat. nos. 39–41) were discovered surrounding a chariot. They are probably the ceremonial attendants for a procession and are a reflection of the importance of regalia during the period and the strong martial character of the ethnic groups of northern China.

The mounted musicians (cat. nos. 39–40) wear felt hats with folded brims, long-sleeved robes, and pants; the bodies of their horses are covered with armor. One man strikes his drum with a stick; the other sounds a long horn. Both groups were originally painted with bright pigments, traces of which remain. They represent one of the non-Chinese peoples of northern China. Similar lively depictions of warriors are preserved in mural paintings from the same period at the Buddhist cave temple site of Dunhuang in Gansu (fig. 16).

The other equestrian figures (cat. no. 41) wear armor and helmets, and their horses are also covered with patterned armor. The holes at the top of the figures' helmets and the horses' heads may have been pierced for the insertion of tassels. There are also brackets in the horses' armor that line up vertically with the riders' extended hands, perhaps to support lances or standards.

Two women (cat. no. 42), their hair arranged in elaborate cross-shaped coiffures, must represent the latest fashion in the Northern Dynasties period. Their long, narrow-sleeved robes are painted in dramatic contrasts of red and white. Each figure, plumper than those made during the Han dynasty, holds her hands, hidden by long sleeves, clasped over her waist. The three female musicians (cat. no. 43–45) wear more subdued versions of the same coiffure, with small combs visible behind the buns. They are dressed in high-collared garments with long striped skirts painted in the same tones of red and white. Each holds a different musical instrument: one raises a set of bamboo pipes (*paixiao*) to her lips, a second plucks a zither (*qin*) placed across her lap, while the third plays a wind instrument of some kind, most of which has broken off. Such brightly colored figures are rarely seen among Northern Dynasties images of musicians.

Literature
Shaanxi Provincial Committee for Administration of Cultural Relics, "Xi'an nanjiao Caochangpocun Beichao mu de fajue" (Excavation of a Northern Dynasties tomb at Caochangpo Village in the southern suburbs of Xi'an), *Kaogu* (Archaeology), 1959, no. 6: 285–87.

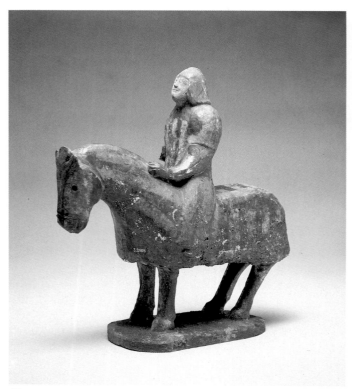

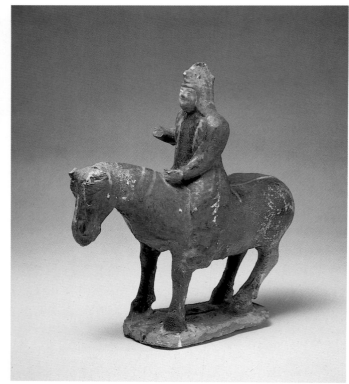

46
Three equestrian figures
Glazed and painted earthenware
Range of height 28 to 29.7 cm (11 to 11 ¾ in.), length 29.2 cm (11 ½ in.)
Color plate on p. 79

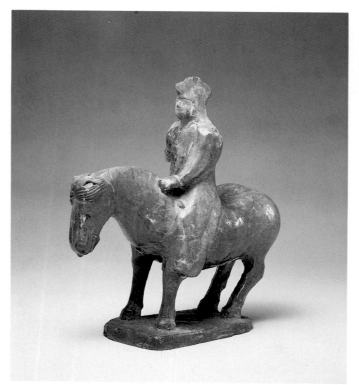

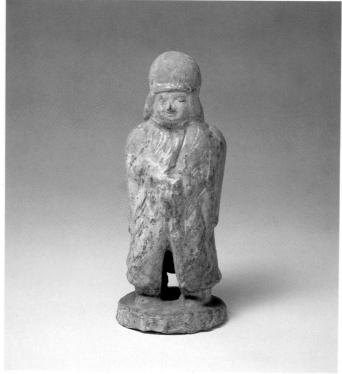

47
Man in a fur coat
Glazed and painted earthenware
Height 23 cm (9 in.)

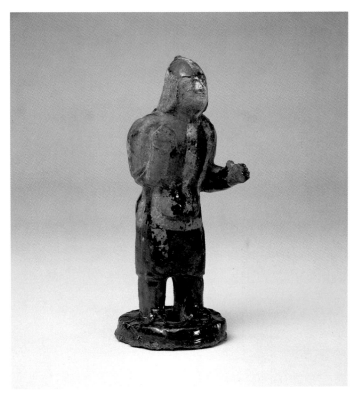

48
Warrior
Brown-glazed and painted earthenware
Height 20.6 cm (8 ⅛ in.)

49
Old man
Brown-glazed earthenware
Height 14.5 cm (5 ⅝ in.)

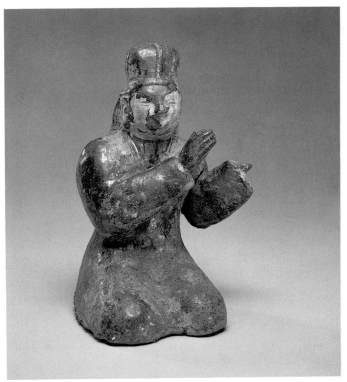

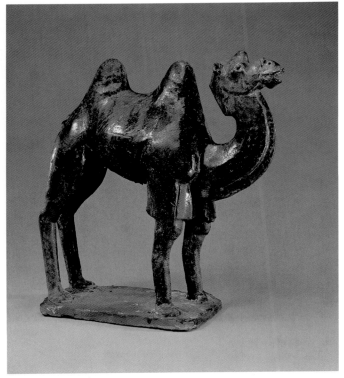

50
Female musician
Glazed earthenware
Height 21 cm (8 ¼ in.)
Color plate on p. 51

51
Bactrian camel
Black-glazed earthenware
Height 30.5 cm (12 in.), length 28 cm (11 in.)

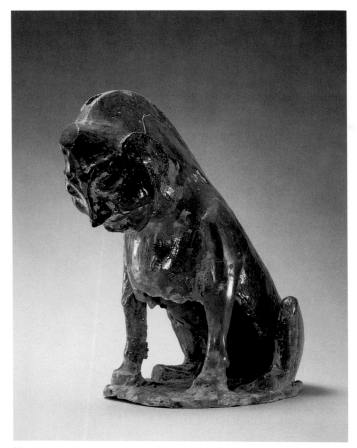

52
Tomb guardian
Glazed and painted earthenware
Height 34 cm (13 ⅜ in.)

46–52
Northern Wei dynasty
A.D. 474–484
Excavated in 1966 from the tomb of Sima Jinlong in Datong, Shanxi Province
Shanxi Provincial Museum

Sima Jinlong (d. 484), a lineal descendent of the southern imperial family, held high military and civil offices under the Northern Wei rulers. His tomb is a large, multichambered complex built of bricks specially commissioned for the purpose and impressed with his name. The tomb lies roughly on a north-south axis, and the chambers are 17.5 meters long. The layout of the tomb consists of an entrance passage leading to a door, a front corridor, antechamber, rear corridor, rear chamber, and a side chamber reached by another corridor from the antechamber (fig. 17). The coffins of Sima Jinlong and his wife (d. 474) were originally placed in the rear chamber but were disturbed by grave robbers.

Most of the funerary objects were concentrated in the antechamber. Even though the tomb had been robbed, it still yielded 454 burial objects, including funerary sculptures, lacquer paintings on wooden panels, stone sculptures, and utensils for daily life. More than four hundred of the objects were funerary figures depicting a wide variety of human and animal forms. Most of the sculptures were made from molds, then glazed and painted.

Three figures on horseback (cat. no. 46) are probably from a troop of light cavalry. White plates and red decorative borders delineate the armor of one horse and rider; the warrior also wears a tapering helmet and a full-length robe. The other two figures are not in armor; they sport coxcomb-shaped helmets. They and their horses seem alert, as if awaiting the order to

charge. All three warriors have their left hands extended to grasp the reins; their damaged right hands must have originally held weapons.

One figure, protected from winter weather in a heavy hat and coat, stands at attention (cat. no. 47). A hole piercing his clasped hands may have originally supported a weapon. The figure's face has been painted with a flesh-colored pigment, and his coat is colored in various tones to suggest the texture of the fur; the remaining glaze is almost black. His bulky clothing gives an idea of the discomforts suffered by sentries on the windswept plateaus of Shanxi.

The warrior (cat. no. 48) is dressed in high boots, a tight tunic, and a tapering helmet and white plated armor with red borders, similar to that worn by one of the equestrian figures. The figure is covered with a blackish-brown glaze, and a flesh-colored pigment has been applied to his face. His left hand is extended to grasp a spear, now missing; the right hand is clenched and raised as though he is carrying another weapon slung over his shoulder. His chin is slightly raised, which gives him an air of self-confidence.

A brown-glazed kneeling figure (cat. no. 49) can be identified as an old man wearing a high-crowned winter hat and a robe at which he tugs. His left hand rests naturally on his leg, and his right hand, now broken off, must have been in a similar position on his right leg. The man's self-possessed demeanor communicates a sense of peace and stillness. Another kneeling figure from the tomb (cat. no. 50) is a female musician dressed in a long, loose robe. Her plump face is crowned by a tall winter hat with decorative crossed bands and a flap of cloth hanging to her shoulders in back. Her arms are held out slightly to her left as though she is clapping or playing a drum in a musical performance.

Camels began to appear among funerary sculptures during the Wei-Jin period; this black-glazed example (cat. no. 51) is one of the earliest known tomb figures of the subject. It represents the two-humped variety of camel, long identified with Bactria in southwest Asia. The accuracy of rendering even extends to the thick padded feet, which make it possible for the animal to carry heavy burdens over long stretches of hot sand. The camel's spirited stance suggests its notoriously stubborn disposition.

Sima Jinlong's tomb contained this *zhenmu shou* (cat. no. 52), a guardian figure with the face of a human being and body of an animal. From its head grows a single horn, and a mane may have been inserted in five rectangular holes in its neck and back. The image, seated in a doglike posture, is covered with brown glaze over which pigment has been applied: the face is white and the body is covered with a painted scale pattern.

Literature
Datong Museum and Shanxi Provincial Cultural Relics Work Team, "Shanxi Datong Shijiazhai Bei Wei Sima Jinlong mu" (The Northern Wei tomb of Sima Jinlong at Shijiazhai, Datong, Shanxi), *Wenwu* (Cultural relics), 1972, no. 3: 20–33, 64.

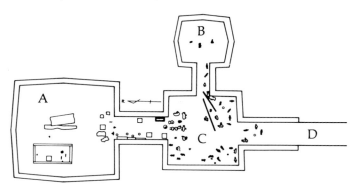

Fig. 17. Plan of the tomb of Sima Jinlong in Datong, Shanxi Province. *A*, rear chamber; *B*, side chamber; *C*, antechamber; *D*, entrance corridor. Photo courtesy Overseas Archaeological Exhibition Corporation.

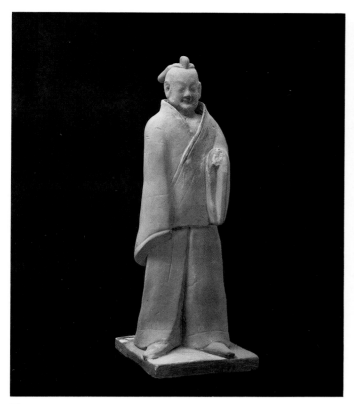

53
Civil official
Painted earthenware
Height 38 cm (15 in.)
Color plate on p. 80

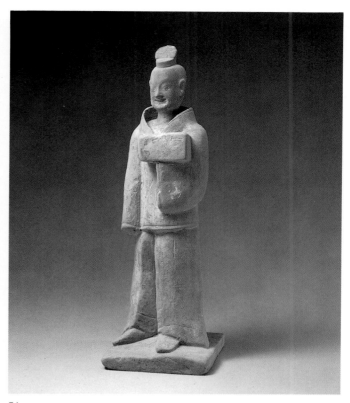

54
Man holding a seal box
Painted earthenware
Height 38 cm (15 in.)
Color plate on p. 80

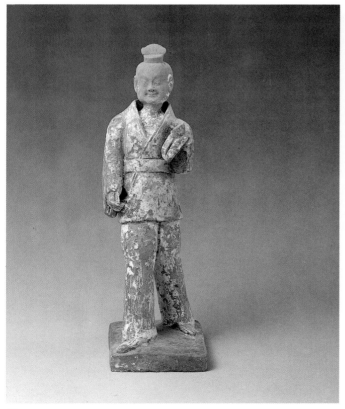

55
Warrior
Painted earthenware
Height 40 cm (15 ¾ in.)
Color plate on p. 53

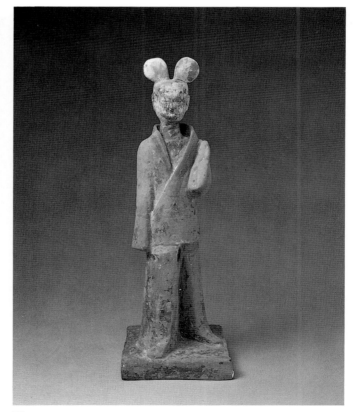

56
Female servant
Painted earthenware
Height 32 cm (12 ⅝ in.)
Color plate on p. 53

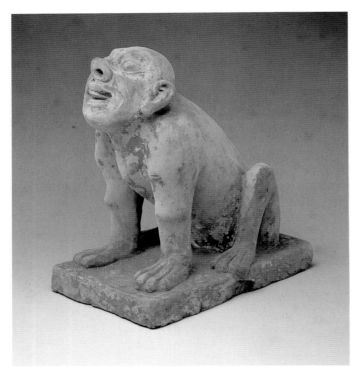

57
Tomb guardian
Painted earthenware
Height 37 cm (14 ½ in.)
Color plate on p. 13

53–57
Western Wei dynasty
Excavated in 1977 from a tomb at Cuijiaying, Hanzhong, Shaanxi Province
Hanzhong Municipal Museum, Shaanxi

The brick tomb at Cuijiaying is in the shape of the Chinese character *tu*, two parallel chambers joined by an intersecting corridor (fig. 18). It was robbed, but the ceramic figures were left in their original positions, most of them in the antechamber. Although almost all were damaged, it was possible to restore about twenty to a relatively complete state. The finds included a ceremonial arrangement of sixty-six figures, found near the east wall of the antechamber, and seventy-three informally placed figures such as civil and military officials and guardian beasts (*zhenmu shou*).

Although the objects in this tomb resemble the contents of Northern Wei tombs in central Shaanxi and along the middle reaches of the Yellow River, the figures have distinguishing features that have led to the dating of this tomb to the Western Wei period. The extremely baggy trousers worn by the human figures and the types of *zhenmu shou* are characteristic of the finds in slightly later tombs. Furthermore, the arrangement of hair into small chignons is more typical of other regions.

The image of a civil official (cat. no. 53) has such a chignon decorated with hair ornaments. The Eastern Han writer Yang Xiong in his *Shuwang benji* (Annals of Shu) described the people of Sichuan as wearing their hair in "mallet-shaped buns," and the hairstyle of this man is very similar to that of a kneeling figure depicted on a Warring States period bronze dagger from Pi County, Sichuan. Thus, he illustrates the cultural interchange in the period of the Northern and Southern Dynasties. His posture gives him the elegant and expansive air proper to an official.

The official's baggy clothing and his pose — splayed feet, right arm at his side, and left arm bent — are echoed in the figure of a man holding a seal box (cat. no. 54). He wears a small, high hat, and his clothes show many traces of their original polychrome decoration. A third man (cat. no. 55) is similarly posed and dressed, but his red belted jacket and white trousers are not as loose-fitting. His head tilts toward his sharply bent left arm, and his right arm and hand, which hang at his side, have a hole for the insertion of an object, now lost.

The figure of a female servant (cat. no. 56) has her hair arranged into two high, round chignons. She wears clothing similar to the male figures from the tomb and is portrayed in the same pose, with one foot forward and one arm raised, in her case, as if to salute someone.

The brawny guardian *zhenmu shou* (cat. no. 57) has the head of a man and the body of a beast sitting on its haunches, its tail curled behind it. Its face is very expressive as it lifts its head, its nostrils flaring, and seems to laugh. As is appropriate for the figure of a tomb guardian, it is a fierce and powerful image.

Literature
Hanzhong Municipal Museum, "Hanzhongshi Cuijiaying Xi Wei mù qingli ji" (Record of the inspection of the Western Wei tomb at Cuijiaying, Hanzhong Municipality), *Kaogu yu wenwu* (Archaeology and cultural relics), 1981, no. 2: 21–24, pls. 11–13.

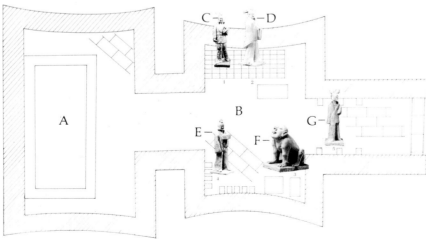

Fig. 18. Plan of a tomb at Cuijiaying, Hanzhong, Shaanxi Province. *A,* tomb chamber; *B,* antechamber. Locations in the antechamber in which the figures were discovered: *C,* warrior (cat. no. 55); *D,* civil official (cat. no. 53); *E,* man holding a seal box (cat. no. 54); *F,* tomb guardian (cat. no. 57); *G,* female servant (cat. no. 56). Photo courtesy Overseas Archaeological Exhibition Corporation.

The reunification of China during the short-lived Sui dynasty (581–618) was the prelude to three centuries of great cultural and economic development. Among the accomplishments of the Sui period was the connection of the various regions of China by canal, especially the linking of north and south by a system of waterways known today as the Grand Canal.

In 618 Li Yuan, one of the frontier generals of the Sui, established himself as Emperor Gaozu of the new Tang dynasty, which exceeded even the Han in power and prestige. Li Shimin, Gaozu's son, directed the military campaigns establishing Tang power both within China and across Central Asia. He ascended the throne in 626 as Emperor Taizong and devoted the next quarter century to completing his military conquests and to encouraging education, philosophy, and religion. The third Tang emperor, Gaozong (r. 649–683), continued the policies of his father and grandfather, but his infatuation with Wu Zitian (Wu Zhao), his father's young concubine, rendered him less effective. She was declared his legitimate empress in 655 and by 660 was actually ruling China. She moved the capital from Chang'an to Luoyang in 683, and established her own dynasty, the Zhou, in 690.

The restoration of the Tang dynasty by the emperors Zhongzong (Li Xian, r. 684, 705–710) and Ruizong (r. 684–690, 710–712) saw a host of elaborate tomb constructions, as imperial princes who had met untimely deaths during the reign of Empress Wu were reburied in grand style near Chang'an; this activity continued into the reign of Xuanzong (Li Longji, r. 712–756).

The Sui-Tang period was an era of great cultural splendor in China. The Tang capital of Chang'an, with a resident population of approximately one million, was one of the most cosmopolitan and brilliant cities in the world. The city was constantly filled with visitors from as far away as Arabia and Japan. Exotic goods from every region of China and the western world were sold in the Chang'an markets. Although the Han Chinese ethnic group was predominant, the population avidly absorbed foreign influences. The result was a new and highly developed Chinese culture. The arts of painting, calligraphy, poetry, music, and sculpture produced astonishing masterpieces to which the modern Chinese still look back with pride.

Two particularly distinguished types of ceramic tomb figures were produced in Sui and Tang times. Polychrome painting of extremely fine quality was applied to both unglazed and partially glazed earthenware sculpture, bringing these wares to a new level of excellence. Also, a new type of ware, the lavishly glazed *sancai*, or three-colored ware, appeared for the first time in the Tang period. In sancai the oxides of various metals such as iron, zinc, copper, cobalt, and manganese were used in the glazes; during firing they were transmuted into rich tones of yellow, green, brown, and blue.

Most tomb sculptures of the Sui-Tang period represent humans, animals, or spirits. In general, the human figures of the pre-Tang period have slender, elongated bodies and elegant faces. By the early Tang this aesthetic had changed, and fuller figures were considered more beautiful. Excavated examples of female images, both in brightly painted earthenware and in sancai-glazed ware include many figures of plump women of great poise and dignity. Other products of both imperial and non-imperial workshops — such as male figures, divinities, beasts, and demons — are also extremely substantial and lifelike. The serious demeanor of civil and military officials, the charm and grace of musicians and female attendants, the respectful air of servants, and the power of the fierce guardians all leave a profound impression on the viewer.

The political, economic, and cultural accomplishments of the Tang empire won great international prestige and promoted economic and cultural exchange between China and other countries. The cosmopolitan atmosphere and urban prosperity of Tang China led to an unprecedented interest in the rapidly changing fashions of dress, hairstyle, and adornment. These trends are vividly brought to life in the extremely diverse figures of beautiful ladies from different periods within the Tang era. The varied costumes and ethnic types of male figures suggest the international character of the Tang capital. Sculptures of fully laden camels symbolize the flourishing communication with countries along the silk route to the west.

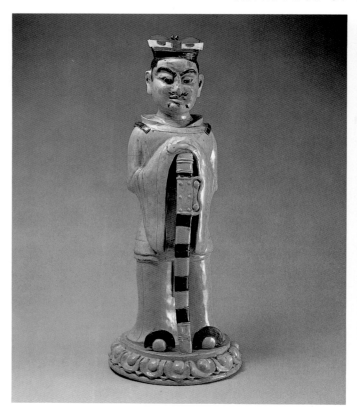

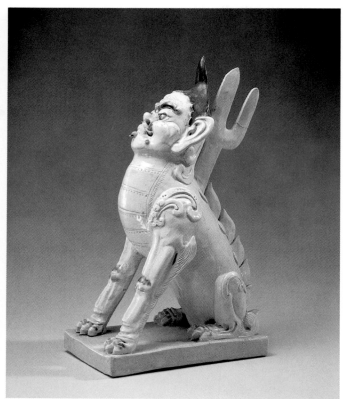

58
Court attendant
Glazed stoneware
Height 72 cm (28 ⅜ in.)
Color plate on p. 82

58–59
Sui dynasty
A.D. 595
Excavated in 1959 from the tomb of Zhang Sheng at Anyang, Henan Province
Henan Provincial Museum

There is no biography of Zhang Sheng in the official histories, but according to the carved stone epitaph in his tomb, he served as a high military official. He died in 594 at the age of 93 *sui* (approximately 92 years of age by the western calendar). The following year his wife was reburied with him.

The tomb is a single brick chamber of approximately square cross-section, 2.8 meters long and 2.9 meters wide (fig. 19). It is reached by a corridor 1.4 meters long, 0.9 meters wide, and 1.3 meters high. On either side of the corridor are tall, shallow niches. Leading to the corridor is a sloping entrance ramp 6.42 meters long and 0.9 to 1.06 meters wide.

Almost two hundred funerary objects were found in the tomb, ninety-five of which were sculptures. The most notable of the figures, which included attending officials, warriors, and guardian creatures, are stoneware with relatively high-fired, porcelaneous bodies (*ci*). The remainder are the more usual low-fired earthenware. In addition to more than fifty everyday utensils of stoneware, the tomb contained a bronze mirror and many earthenware models, including wells, stoves, shoes, and a chessboard.

The stoneware figures of a court attendant (cat. no. 58) and a tomb guardian (cat. no. 59) have dense, gray-white bodies and a clear, glossy glaze with a slightly greenish tint. They were probably made at the Jiabi kilns in Ci County near Anyang, which are known to have produced such "greenware." The discovery of this precisely dated tomb is very important for understanding the development of Chinese ceramics between the preceding period of the Northern and Southern Dynasties and the subsequent Tang dynasty.

59
Tomb guardian with a human face
Glazed stoneware
Height 48.5 cm (19 ⅛ in.)
Color plate on p. 83

The court attendant (cat. no. 58) on a lotus pedestal was originally placed in one of the shallow niches in the corridor. His armor, short coat, and long robe are typical period garb. The figure is covered with the distinctive green-tinged white glaze, while his features, hair, high hat, elaborate shoes, and long sword are indicated or decorated with black glaze. His menacing glare and demeanor suggest a military official. The similarly glazed human-headed *zhenmu shou* (cat. no. 59), has a single horn protruding from its head and a pronged spike emerging from its back; along its spine are flamelike projections. Some details are indicated in incised lines, others are applied in black glaze. The furrowed brow, wide eyes, snarling mouth, and flaring nostrils make this beast quite ferocious in appearance.

Literature
Anyang Excavation Team of the Institute for Archaeology, "Anyang Sui Zhang Sheng mu fajue ji" (Record of the excavation of the Sui tomb of Zhang Sheng at Anyang), *Kaogu* (Archaeology), 1959, no. 10: 541–45.

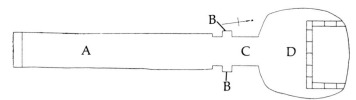

Fig. 19. Plan of the tomb of Zhang Sheng at Anyang, Henan Province. *A*, entrance ramp; *B*, niches; *C*, corridor; *D*, tomb chamber. From *Kaogu*, 1959, no. 10.

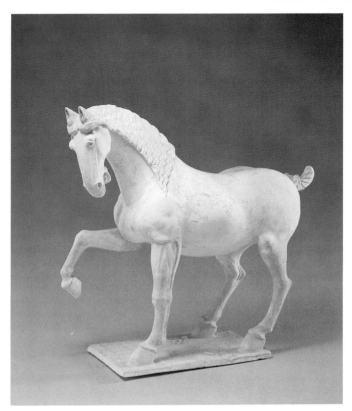

Zhang Shigui (d. 657) held high military rank under the Tang emperor Taizong (r. 626–649). Zhang's tomb, which is 57 meters long (fig. 20), was a satellite burial to the Zhaoling, Taizong's funerary mound. Although the tomb was plundered, 409 objects were found in the course of the 1972 inspection; among them were 307 polychromed and glazed ceramic sculptures of human beings and animals, important evidence for research on early Tang social relations, customs, and costumes.

This spirited image raises a front hoof to paw the air, as though it were prancing, and its carriage and grooming suggest that it is a representation of a dancing horse. The *Minghuang zalu* (Miscellaneous records of Emperor Minghuang) records that the Tang emperor Xuanzong (r. 712–756) had four hundred specially trained horses in the palace stables; on his birthday they danced in the Administrative Hall of Xingqing Palace.

Literature
Shaanxi Provincial Committee for Administration of Cultural Relics and Zhaoling Institute for Administration of Cultural Relics, "Shaanxi Liquan Zhang Shigui mu" (The tomb of Zhang Shigui at Liquan, Shaanxi), *Kaogu* (Archaeology), 1978, no. 3: 168–78.

60
Horse
White earthenware
Height 49 cm (19 ¼ in.), length 46 cm (18 ⅛ in.)
Tang dynasty
Excavated in 1972 from the tomb of Zhang Shigui at Liquan, Shaanxi Province
Shaanxi Provincial Museum
Color plate on p. 55

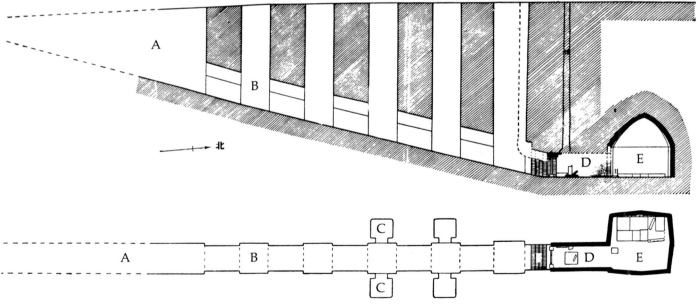

Fig. 20. Plan of the tomb of Zhang Shigui at Liquan, Shaanxi Province. *A,* entrance ramp; *B,* air shafts; *C,* alcoves; *D,* corridor; *E,* tomb chamber. From *Kaogu,* 1978, no. 3.

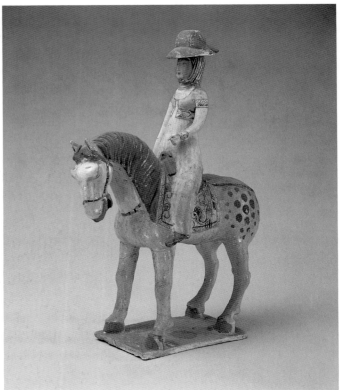

61
Female equestrian
Glazed and painted earthenware
Height 37 cm (14 ½ in.), length 29 cm (11 ⅜ in.)
Tang dynasty
A.D. 664
Excavated in 1972 from the tomb of Zheng Rentai at Liquan, Shaanxi Province
Shaanxi Provincial Museum
Color plate on p. 32

Zheng Rentai was a trusted general of the first Tang emperor. His tomb mound is a satellite grave to the Zhaoling, mausoleum of Emperor Taizong (r. 626–649). The tomb is 53 meters long; the large chamber is reached by a slanted entrance ramp decorated with mural paintings (fig. 21). The tomb contained 532 funerary objects, of which many were painted and glazed tomb figures of great artistic value. This was the first such Tang find in Shaanxi Province. The figures are particularly masterful in their combination of the arts of sculpture and painting. Moreover, they provide important information on the process by which the Tang sancai technique of three-colored glazing was developed.

Tang sancai wares did not appear until the reign of the Zhou empress Wu (r. 690–704), more than twenty-five years after the burial of Zheng Rentai in 664. However, ceramics that were both polychromed and glazed, like those found in Zheng's tomb, were probably the predecessors of sancai. The ceramic bodies of the painted figures in his tomb are the same as those of the later wares; kaolin is used in both to produce a completely white body. The artists of many sancai tomb sculptures even preserved the custom of painting rather than glazing the faces. Furthermore, a blue glaze, an important component of sancai glazes, is found on figures in Zheng's tomb.

The tomb yielded this superb polychromed earthenware sculpture of a female equestrian. Her finely modeled face features vermilion lips and thick, wide brows. On her head is a brimmed hat with an attached cowl, which was very popular in the period. Also typical is her three-piece garment: a white blouse with a short jacket, both delicately decorated, and a long striped skirt. She appears completely self-possessed on her spotted horse, whose head seems to respond to her firm grip on the reins, now missing.

Literature
Shaanxi Provincial Museum and the Tang Tomb Excavation Team of the Liquan County Cultural Education Office, "Tang Zheng Rentai mu fajue jianbao" (Brief report on the excavation of the Tang tomb of Zheng Rentai), *Wenwu* (Cultural relics), 1972, no. 7: 33–44, pls. 10–12.

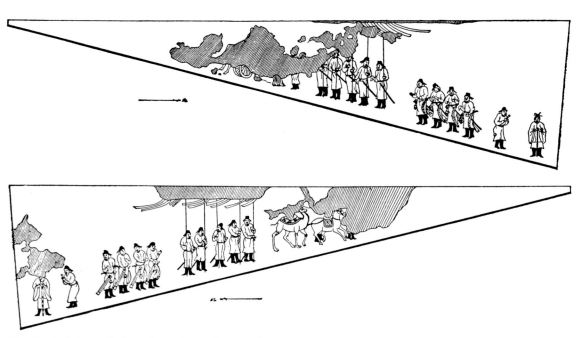

Fig. 21. Artist's rendering of mural paintings on the entrance ramp walls in the tomb of Zheng Rentai. From *Wenwu*, 1972, no. 7.

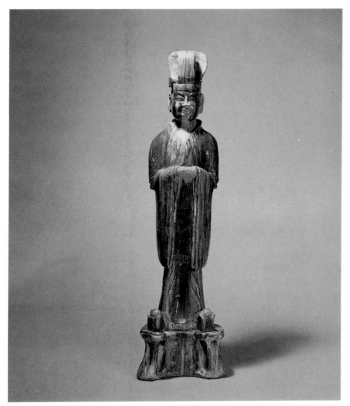

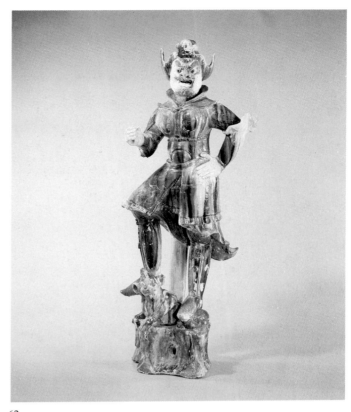

62
Civil official
Sancai-glazed earthenware
Height 120 cm (47 ¼ in.)
Color plate on p. 58

63
Guardian king
Sancai-glazed earthenware
Height 130 cm (51 ⅛ in.)
Color plate on p. 10

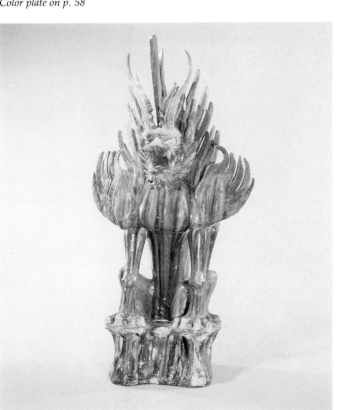

64
Tomb guardian
Sancai-glazed earthenware
Height 90 cm (35 ⅜ in.)
Color plate on p. 38

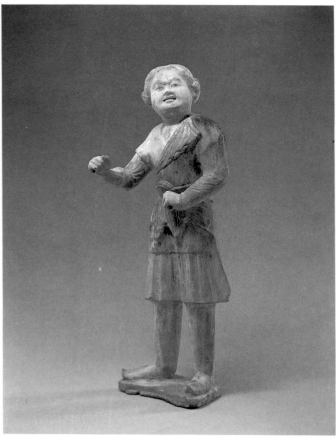

65
Groom
Sancai-glazed earthenware
Height 59.5 cm (23 ⅜ in.)
Color plate on p. 62

62–65
Tang dynasty
A.D. 706
Excavated in 1971 from the tomb of Prince Zhanghuai in Qian County,
Shaanxi Province
Qianling Museum, Shaanxi

A number of high-ranking members of the Tang imperial family met untimely deaths during the rise to power of Empress Wu (r. 690–704). Among these was Prince Zhanghuai (Li Xian), the second son of Emperor Gaozong (Li Zhi, r. 649–683). He was enfeoffed as Prince of Lu and Yong, and in 675 he was designated heir apparent. Later he was demoted and exiled to Bazhou in Sichuan where he was forced to commit suicide in 684 at the age of 30. After the Tang restoration in 705, Emperor Zhongzong reburied his relatives in the manner to which their ranks entitled them. In 706 he had Zhanghuai reinterred in a satellite grave to the Qianling, the tomb mound of his father. The prince's rich tomb had wall paintings and fluently engraved images on the stone burial vault, all extremely rare works of art, and contained more than six hundred objects, the majority of which were earthenware.

The tomb sculptures of civil and military officials (cat. no. 62) are more than one meter high, many mounted on high, contoured platforms. They are exquisitely sculpted and covered with bright glazes. Each is individualized in conception. This figure, elegant in his tall hat and long robe with flowing sleeves, wears a serious expression on his realistically modeled face and clasps his hands respectfully in front of his chest.

The Buddhist *lokapala*, or guardian king (cat. no. 63), served a similar apotropaic function in the tomb as the tomb guardian beasts. Wearing an elaborate headdress and armor, and with a fierce expression on his face, the king tramples underfoot a demon clinging desperately to the tall base. His right hand is held out, half-clenched, and perhaps once held a weapon. Even more ferocious is the fantastic *zhenmu shou* (cat. no. 64) with long horns, spiky wings and mane, and halberdlike forms protruding from behind its head. Eyes glaring, the bizarre beast bares its teeth in a furious grimace and sinks its claws into the ground.

The square-faced, lively figure of a groom (cat. no. 65) reaches out to grasp the reins of the horse he is leading. His hair is braided and coiled at his temples, and he wears a long robe, its neck turned back in lapels, tied up at the waist to reveal an underskirt. Clothes with lapels, called "foreign robes," were very popular with foreigners and Chinese alike in this period.

Literature
Shaanxi Provincial Museum and the Tang Tomb Excavation Team of the Qian County Cultural Education Office, "Tang Zhanghuai taizi mu fajue jianbao" (Brief report on the excavation of the tomb of the Tang prince Zhanghuai), *Wenwu* (Cultural relics), 1972, no. 7: 13–25.

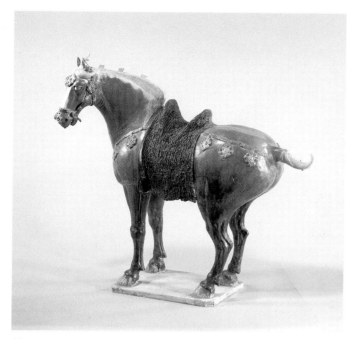

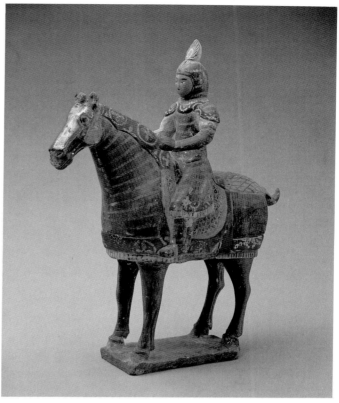

66
Horse
Sancai-glazed earthenware
Height 79.5 cm (31 ¼ in.), length 80 cm (31 ½ in.)

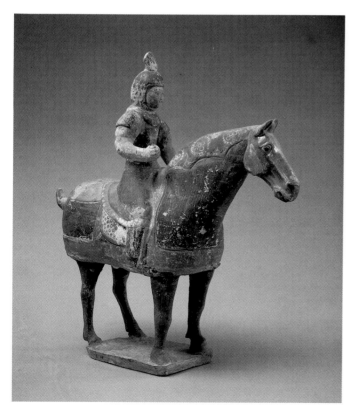

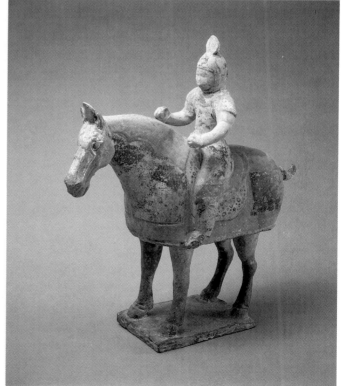

67–69
Three equestrian figures
Painted and gilded earthenware
Height 34 cm (13 ⅜ in.), length 31 cm (12 ¼ in.)
Color plate on p. 33

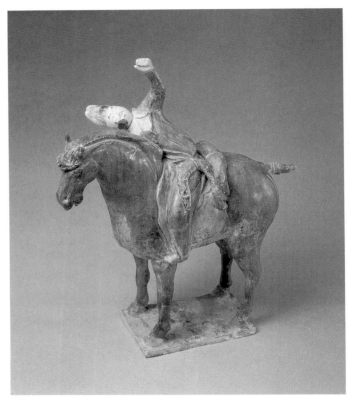

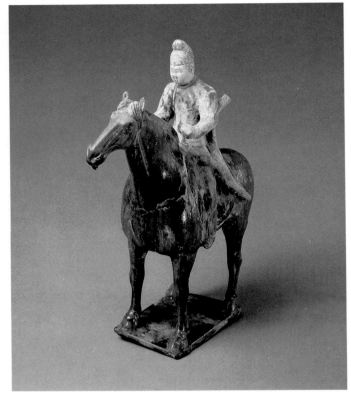

70–72
Three hunters on horseback
Sancai-glazed earthenware
Height 35.5 cm (14 in.), length 30 cm (11 ¾ in.)
Color plate on p. vi, 57

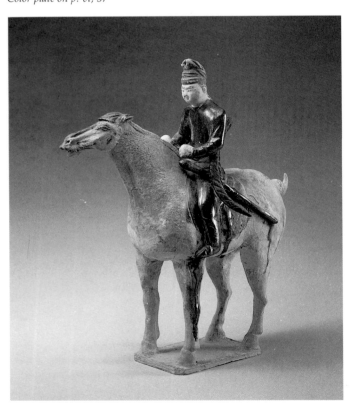

66–72
Tang dynasty
A.D. 706
Excavated in 1971 from the tomb of Prince Yide in Qian County, Shaanxi Province
Qianling Museum, Shaanxi

Prince Yide (Li Zhongrun) was the grandson of Emperor Gaozong and Wu Zitian and the eldest son of Emperor Zhongzong. He died in 701 at the age of 18. In 706, on the orders of his father, his status was elevated and his body was removed from his grave in Luoyang for reburial in a satellite grave (fig. 22) to the Qianling tomb of his grandfather near Xi'an.

His tomb is very large, over 100 meters long (see page 34, fig. 8), and its contents are rich and varied. The tomb contains forty mural paintings in a relatively complete state of preservation (fig. 23) and more than a thousand objects, including calligraphy engraved in marble and inset with gold, painted and gilded earthenware equestrian figures, and sancai sculptures of hunters and dappled horses, all very rare.

The large, exquisitely modeled sculpture of a horse (cat. no. 66) depicts the animal with its mouth open to whinny, revealing its bit. Its yellow mane and tail have been groomed, the mane trimmed into three protruding tufts. Apricot leaf–shaped ornaments hang from its trappings, and the saddle cloth has been coated with dark green glaze and incised to create a realistically rough texture.

The young Prince Yide died before he could participate in combat, and the equestrian figures in military attire (cat. nos. 67–69) who accompanied him in death were commissioned by Emperor Zhongzong as tokens of grief for the premature death of his eldest son. Horses and riders all wear armor painted in brilliant hues of red, blue, brown, green, and black, and each horse has a faceplate of gold.

The Tang court and aristocracy considered hunting one of the greatest pleasures in life. They often pursued game in the wild mountain forests or in park preserves. The group of sancai hunters from Prince Yide's tomb (cat. no. 70–72) re-creates such a hunting scene. The figures wear wrapped cloth caps, and two of them carry long swords and quivers. The same two gaze straight ahead, their hands firmly grasping the reins; the third, dressed in a long, fashionable lapelled robe, twists his whole upper body as though shooting an arrow into the air. On the back of his saddle is an animal he has already killed. This lively image recalls a couplet in a poem by the Tang writer Du Fu, "turning his body toward the sky to gaze at the speeding cloud, and with one arrow tumbles down a pair of soaring wings."

Literature
Shaanxi Provincial Museum and the Tang Tomb Excavation Group of the Qian County Cultural Education Office, "Tang Yide taizi mu fajue jianbao" (Brief report on the excavation of the tomb of the Tang prince Yide), *Wenwu* (Cultural relics), 1972, no. 7: 26–32.

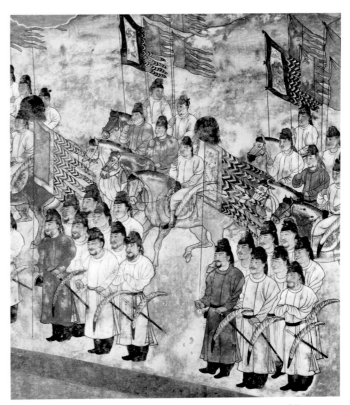

Fig. 23. Section of the mural paintings from the tomb of Prince Yide. Photo courtesy Overseas Archaeological Exhibition Corporation.

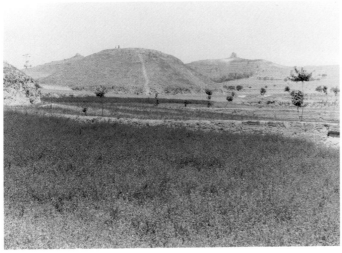

Fig. 22. Tumulus of Prince Yide in Qian County, Shaanxi Province. Photo courtesy Overseas Archaeological Exhibition Corporation.

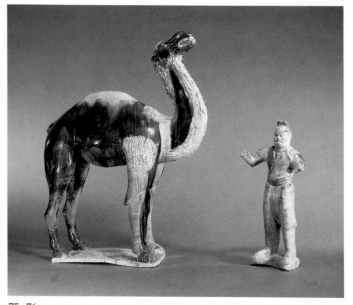

73–74
Horse and groom
Sancai-glazed earthenware
Horse: height 68 cm (26 ¾ in.), length 69 cm (27 ⅛ in.); groom: height
49 cm (19 ¼ in.)
Color plate on p. 53

75–76
Dromedary camel and groom
Sancai-glazed earthenware
Camel: height 80 cm (31 ½ in.), length 60 cm (23 ⅝ in.); groom: height
50 cm (19 ⅝ in.)

73–76
Tang dynasty
Excavated in 1970 from the tomb of Qi Biming at Xianyang, Shaanxi
Province
Xianyang Museum, Shaanxi

In Tang China horses were considered to be the "steeds of heaven" and thus suitable for the emperor, who was known as the "Son of Heaven." Due to a flourishing trade with the west, Chinese horse stock was substantially improved during this period. The sancai sculpture of a muscular horse (cat. no. 73) from the tomb of Qi Biming is a realistic portrait of this new breeding stock. A mane and tail originally attached to the sculpture have been lost; all that survives is a groove for the mane and a hole for the tail. This type of large sancai horse with a mane attached after firing is characteristic of the Wude through Jinlong periods of the Tang dynasty (618–709). The groom (cat. no. 74) leading the horse wears a tall hat and a robe with lapels. These "foreign" articles of clothing and his deep-set eyes and prominent nose suggests that he is not of Han Chinese ethnic stock.

The one-humped dromedary (cat. no. 75) of western Asia and North Africa is rarely found in Tang tombs, and an example as well-preserved as this is particularly unusual. The body is partly covered with a brown glaze, and in other areas the clay is scratched to create the texture of the camel's shaggy coat. The groom (cat. no. 76) wears a short-sleeved robe with lapels, a cloth cap, and high boots. He has deep-set eyes, a large nose, red lips, and a beard; like the other groom, he appears to be a foreigner. The entire figure was once covered with a green glaze.

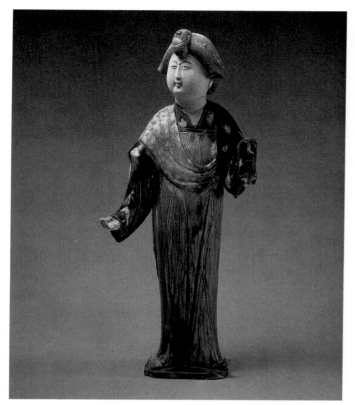

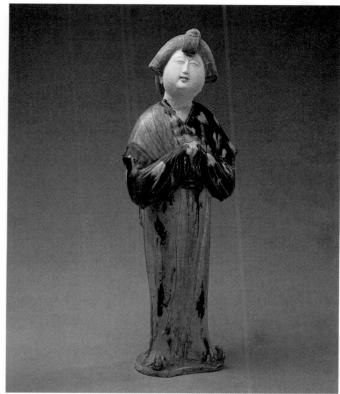

77–78
Standing women
Sancai-glazed earthenware
Height 44.5 cm (17 ½ in.)
Color plate on p. 86

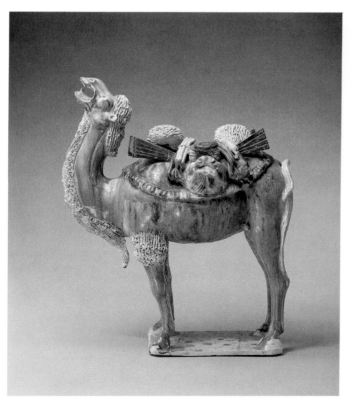

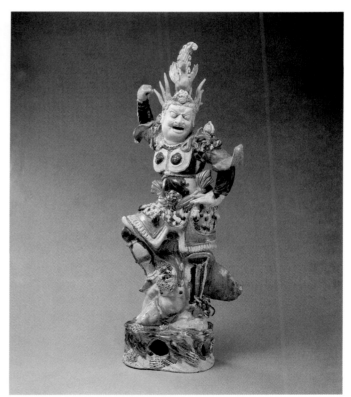

79
Bactrian camel
Sancai-glazed earthenware
Height 49 cm (19 ¼ in.), length 39.5 cm (15 ½ in.)
Color plate on p. x

80
Guardian king
Sancai-glazed earthenware
Height 65 cm (25 ⅝ in.)
Color plate on p. ii

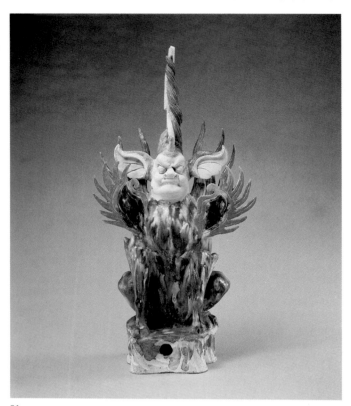

81
Tomb guardian
Sancai-glazed earthenware
Height 57.5 cm (22 ⅝ in.)
Color plate on p. xiv

77–81
Tang dynasty
First half of the eighth century
Excavated in 1959 from a tomb at Zhongbao Village, Xi'an, Shaanxi Province
Shaanxi Provincial Museum

A Tang tomb discovered at Zhongbao Village could not be associated with a particular family in the absence of an engraved epitaph, but the tomb, a rectangle 3.5 by 2.2 meters, and its contents, which included a string of coins from the Kaiyuan period (713–756), probably date to the high Tang era (fig. 24). More than seventy funerary objects were found, among them ceramic models of buildings and gardens, pigs, goats, horses, a duck, and an ox. The figures of lovely ladies, grooms, camels, and horses are particularly notable for their superb modeling, subtle and varied poses, and bright glazes. In style and quality they are similar to the exquisite figures excavated from the tomb of Xianyu Tinghai in the southern suburbs of Xi'an, which is datable to 723.

The elaborate dress and makeup and ample proportions of the elegant ladies (cat. nos. 77–78) provide information about the fashions of the Tang period. Their coiffures are upswept, with knots of hair arranged exotically over the forehead. A black dot has been applied at either corner of their vermilion mouths. Outside the dots are barely visible "plum blossom dots," a type of beauty mark applied with white powder, and one of the women has a red design between her eyebrows. They wear similar clothing: a patterned upper garment, high-waisted skirt, slippers with upturned points, and a scarf draped over the right shoulder. Their poses are different: one gestures and looks to her right, her left arm raised; the other tilts her head and extends her joined hands as if making a presentation; there is a hole in her hands for the insertion of an object, now lost. Both figures possess grace and femininity and are masterpieces of sancai sculpture.

The figure of a double-humped camel (cat. no. 79) is laden for its trek along the silk route. Over its felt blanket is a saddle-bag decorated with a tiger's face. A number of articles are tied to it, including a bolt of silk, wild fowl, and rabbits. The artist has effectively contrasted the smooth glazed areas with patches of rough, shaggy texture.

The ferocious figure of a *lokapala*, or guardian king, (cat. no. 80) wears magnificent armor and an elaborate headdress topped with a pheasantlike bird. With violent gestures, bulging eyes, and bared teeth, he tramples a squatting demon under his feet. The brilliant glazes are extremely well preserved in this rare example of sancai. Another protector of the dead, the fantastic *zhenmu shou* with a human head (cat. no. 81) has been constructed in three sections: horn, head, and body and platform. From behind the tall, twisted knot of its hair a halberdlike shape emerges, and spiked wings sprout from its shoulders. These fierce, half-human guardians are always found in pairs.

Literature
Shaanxi Provincial Committee for the Administration of Cultural Relics, "Xi'an xijiao Zhongbaocun Tang mu qingli jianbao" (Brief report on the investigation of the Tang tomb at Zhongbao Village in the western suburbs of Xi'an), *Kaogu* (Archaeology), 1960, no. 3: 34–38.
For the tomb of Xianyu Tinghai, see Institute for Archaeology, *Tang Chang'an chengjiao Sui Tang mu* (Excavation of the Sui and Tang tombs of Xi'an) (Beijing: Wenwu Press, 1980), 55–65, color pls. 2–8, pls. 73–89.

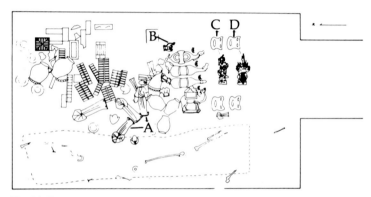

Fig. 24. Diagram of the chamber and contents of a Tang tomb at Zhongbao Village, Xi'an, Shaanxi Province. *A*, standing women (cat. nos. 77–78); *B*, Bactrian camel (cat. no. 79); *C*, guardian king (cat. no. 80); *D*, tomb guardian (cat. no. 81). Photo courtesy Overseas Archaeological Exhibition Corporation.

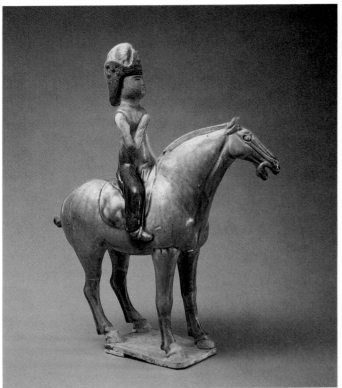

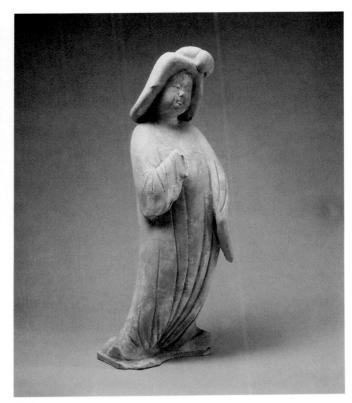

82
Female equestrian
Sancai-glazed earthenware
Height 35.2 cm (13 ⅞ in.), length 29 cm (11 ⅜ in.)
Tang dynasty
A.D. 718
Excavated in 1972 from the tomb of Li Zhen at Liquan, Shaanxi
Province
Zhaoling Museum, Shaanxi
Color plate on p. 57, 94

83
Woman with a loose chignon
Painted earthenware
Height 54 cm (21 ¼ in.)
Color plate on p. viii

Li Zhen, Prince of Yue, was the eighth son of Emperor
Gaozong (r. 649–683), and his tomb is a subsidiary burial to the
Zhaoling, his father's funerary mound. Li Zhen opposed the
imperial pretensions of Empress Wu, and after his military
defeat in 687 or 688 he committed suicide. In 718, after the
Tang dynasty had been restored, Emperor Xuanzong ordered
him reburied at the Zhaoling. The tomb, which includes a long
entrance ramp, is 46.10 meters in length. There is evidence that
it was robbed, but more than 130 funerary objects were
excavated.

This female equestrian figure is an elegant beauty with a full
face, carefully plucked brows, and gentle smile. She wears a
non-Chinese style of hat with an upturned embroidered brim,
but since her facial features seem to be Chinese, she probably
represents an aristocratic lady in foreign attire. The poet Yuan
Zhen described the fascination of the Tang Chinese with the
customs of other lands: "[Chinese] women study foreign
dances from the foreign women, [Chinese] musicians learn
foreign sounds and perform foreign music."

Literature
Zhaoling Cultural Relics Office, "Tang Yue wang Li Zhen mu fajue
jianbao" (Brief report on the excavation of the tomb of the Tang Prince
of Yue, Li Zhen), *Wenwu* (Cultural relics), 1977, no. 10: 41–49.

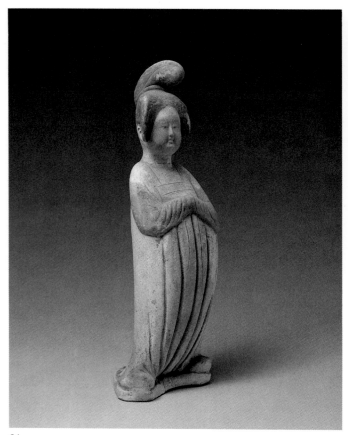

84
Woman with a high chignon
Painted earthenware
Height 47 cm (18 ½ in.)
Color plate on p. 56

83–84
Tang dynasty
A.D. 748
Excavated in 1955 from tomb 131 at Gaolou Village, Xi'an, Shaanxi
Province
Shaanxi Provincial Museum

Tomb 131 at Gaolou Village is the tomb of Wu Shouzhong (d. 748), a native of Bohai who served as a military official in the Tianbao era (742–755). There were a great many funerary objects in the tomb, most of which were ceramic figures. Among them sculptures of women wearing long robes are most characteristic of the style of the high Tang period. Contemporary literature, such as the poetry of Bo Juyi, attests to the imposing physical impression created by the ladies of the flourishing Tang period. The standards of beauty had gradually changed so that plumpness had become fashionable. Garments were long and loose-fitting, and exotic hairstyles were also popular.

These images represent the ideal woman of the time. They stand enveloped in flowing robes whose folds are fluently indicated. One has hair softly framing her face and gathered into an asymmetrical chignon (cat. no. 83), while the other wears hers piled in a precariously high arrangement (cat. no. 84). A natural beauty and charm is expressed in their graceful carriage and the delicate features of their full faces.

Literature
Hang Dezhou et al., "Xi'an Gaoloucun Tang dai mu zang qingli jianbao" (Brief report on the inspection of the Tang tombs at Gaolou Village, Xi'an), *Wenwu cankao ziliao* (Cultural relics reference materials), 1955, no. 7: 103–9.

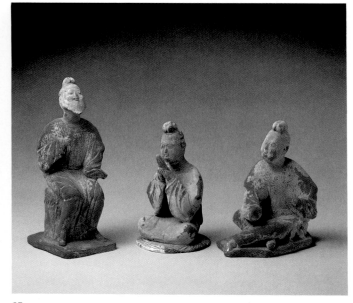

85
Three balladeers
Painted earthenware
Heights 23.2 cm (9 ⅛ in.), 18 cm (7 ⅛ in.), 17.5 cm (6 ¾ in.)
Tang dynasty
Excavated in 1966 at Hongqing Village, Xi'an, Shaanxi Province
Shaanxi Provincial Museum
Color plate on p. 10

This group of performers provides valuable evidence for the art of storytelling in the Tang period. *Shuochang*, which literally means "talking and singing," is an art form that has long been appreciated by the Chinese (see cat. no. 38). It may involve one or two performers and may include musical accompaniment as well. In this representation the narrator/singer is a long-bearded elder with elegant gestures and an enthusiastic manner. He is accompanied by two musicians sitting cross-legged on the floor, one playing a *sheng* (a bamboo mouth organ) and the other, a drum. The percussionist's instrument has been lost, but his activity is clear from the position of his arms.

A number of sets of the twelve animals have been excavated from Tang tombs since 1949; most are damaged to the point that the sets are no longer complete. They may date from as early as the late Kaiyuan period (713–741) but are more prevalent in tombs of the subsequent Tianbao period (742–756). This amusing group of animal-headed human figures was assembled from the finds in several tombs in the eastern suburbs of Xi'an: the rat, dragon, horse, goat, and dog come from one tomb; the ox, snake, monkey, and pig from another; and the tiger, rabbit, and chicken are each from a separate find.

Literature
For a similar but incomplete set, see Institute for Archaeology, *Tang Chang'an chengjiao Sui Tang mu* (Sui and Tang tombs in the suburbs of Tang Chang'an) (Beijing: Wenwu Press, 1980), pls. 103–4.

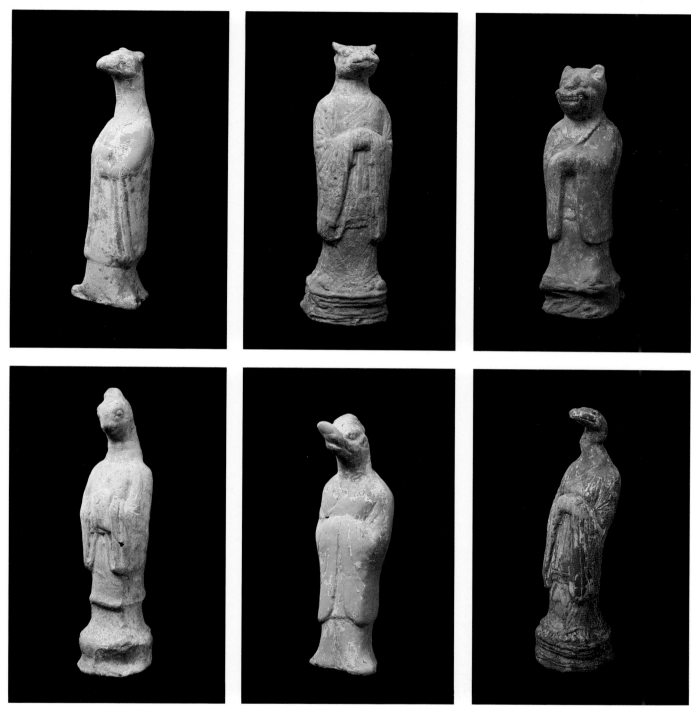

86
Twelve animals of the calendrical cycle
Painted earthenware
Range of heights 20 to 27.5 cm (7 ⅞ to 10 ⅞ in.)

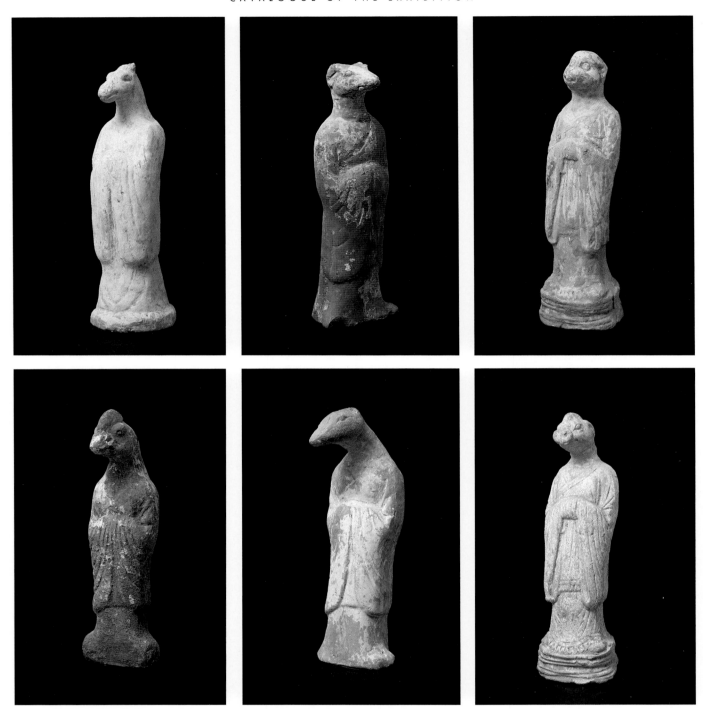

86
Twelve animals of the calendrical cycle
Painted earthenware
Range of heights 20 to 27.5 cm (7 ⅞ to 10 ⅞ in.)
Tang dynasty
Excavated in 1955–56 from tombs in the eastern suburbs of Xi'an,
Shaanxi Province
Shaanxi Provincial Museum
Color plate on p. 76

The Chinese have long associated specific animals with each of the "twelve earthly branches" of the Chinese calendar, that is, with each year in a twelve-year cycle. According to traditional sources, this concept dated from the Eastern Han period. Its origin can now be pushed back at least as far as the Warring States period on the basis of a text written on bamboo slips found in 1975 in Qin tomb 11 at Shuihudi, Yunmeng, Hubei Province. The text lists the same correspondence between animals and the twelve earthly branches as is preserved in later Chinese folklore.

People came to believe that the year of one's birth made one subject to the animal of that year, and that one's character and destiny were related to the sign, beliefs that have had a strong impact on Chinese thought up to modern times. The twelve animals selected to represent the twelve earthly branches correspond to the years in the modern calendar as follows:

zi	rat	1984	1972	1960	1948	1936	1924
niu	ox	1985	1973	1961	1949	1937	1925
xin	tiger	1986	1974	1962	1950	1938	1926
mao	rabbit	1987	1975	1963	1951	1939	1927
chen	dragon	1988	1976	1964	1952	1940	1928
ji	snake	1989	1977	1965	1953	1941	1929
wu	horse	1990	1978	1966	1954	1942	1930
wei	goat	1991	1979	1967	1955	1943	1931
shen	monkey	1992	1980	1968	1956	1944	1932
you	chicken	1993	1981	1969	1957	1945	1933
xu	dog	1994	1982	1970	1958	1946	1934
hai	pig	1995	1983	1971	1959	1947	1935

The period of disunity following the fall of the Tang dynasty concluded with the unification of China in 960 under the Northern Song dynasty. The Song rulers established their capital at Kaifeng, Henan Province, which became a large urban complex of great wealth and culture. In 1126, however, the Jurchen, a non–Han Chinese people from the northeast, conquered northern China. The Song rulers fled south and, as the Southern Song dynasty, governed their reduced territory from Hangzhou.

China was reunified by another non–Han Chinese group, the Mongols, who first subdued Mongolia, Manchuria, Korea, northern and northwestern China, Central Asia, and southern Russia, and then went on to assert their influence over the rest of China and across the Near East to Poland, Prussia, and Hungary. Their Yuan dynasty (1271–1368) was proclaimed at Peking by Kublai Khan, one of the greatest Mongol conquerors. The dynasty, whose grandeur was recorded by Marco Polo, lasted only one century. In 1368 a Han Chinese commoner proclaimed the Ming dynasty (1368–1644), which ruled China for almost three centuries.

Art and culture developed rapidly during the Song, Jin, Yuan, and Ming periods. Buddhism and Taoism permeated all levels of society, and the arts associated with them flourished. Painting and sculpture, taking subject matter from both religious and secular culture, reached new heights of quality. At the imperial level, the court sponsored official artists and painting academies, but private artistic circles and their patronage were also extremely active. As early as the tenth century, ornamental hanging scroll paintings were even used as grave goods.

During the Song period the custom of burying ceramic sculptures in the grave came to the end of its "golden age." As a result, the quantity of figures excavated from tombs of the later dynasties is considerably diminished and the images are not as spectacular as those of the Han and Tang periods. However, works have been found that are still quite dazzling in their realism and detail. Generally, figures were made of carved brick in the north and porcelain in the south. The postures and expressions of the figures are individualized, and the simple elegance and detail of their hair and dress are striking. From these images one can gain an idea of the ceremonies and costumes of the Song and Yuan periods.

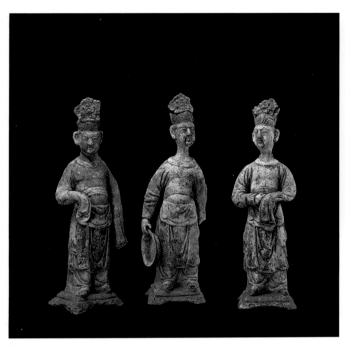

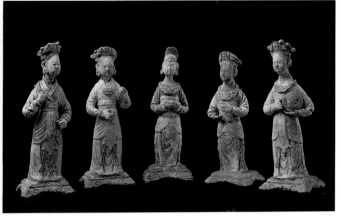

87
Three male attendants
Painted earthenware
Height 27.5 cm (10 ⅞ in.)
Color plate on p. 87

88
Five female servants
Painted earthenware
Range of heights 22 to 23.5 cm (8 ⅝ to 9 ¼ in.)
Color plate on p. 58

87–88
Song dynasty
Excavated in 1963 at Xinlifeng, Jiaozuo, Henan Province
Henan Provincial Museum

Forty-one earthenware sculptures of male and female servants were excavated from this tomb, but only thirteen were relatively intact. Traces of rich pigments demonstrate that the original colors were very bright. All aspects of the figural depiction, from the postures and gestures to the facial expressions, are minutely differentiated. The detail and realism of these images, while unusual in Song funerary sculpture, are typical of the best Song art.

The three polychromed earthenware sculptures of male servants (cat. no. 87) are dressed in the same costume. On their heads they wear black cloth hats in which have been inserted large flowers. Their garments, which include aprons, are realistically modeled to fall in soft folds. Facial features, which have been outlined in color, and poses are highly individualized. One figure holds a bronze washbasin in his right hand and turns his head, smiling slightly, as if concentrating his attention on his master's orders. A second figure stands in attendance with dignity, his hands posed to enclose a now-lost object. The third seems to wait patiently for his instructions.

Although less bulky in their general proportions than female figures of the Tang period, the five female servants (cat. no. 88) are still rather plump. Their costume, typical of the Song period, consists of a tunic, over which are worn a long, high-waisted skirt and an apronlike overskirt. On their black-painted hair, arranged in twin chignons, are elaborately detailed red and green headdresses, and each woman wears earrings and a large red necklace. They stand on ornamental bases similar to those of their male counterparts, and, like them, each one is individualized in pose and expression. Two of them seem to grasp long narrow objects, now lost; another once held a slightly larger article (on the base of this figure is inscribed the character *zhang*, a common Chinese surname). A fourth servant carries a tea tray, and a fifth, a round object that may be a mirror box. They are realistic depictions of the servants who attended wealthy Song families.

Literature
Yang Baoshun, "Jiaozuo Jin mu fajue jianbao" (Brief report on the excavation of a Jin tomb at Jiaozuo), *Henan wenbo tongshun* (Henan cultural digest), 1979, no. 1: 22–24. Yang dates this tomb to the late Jin period. — *Trans.*

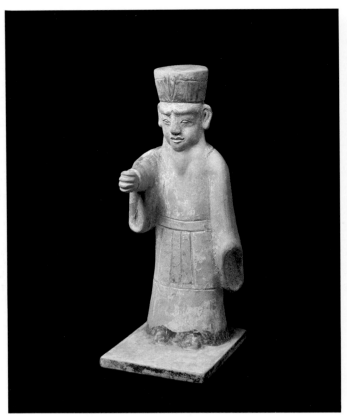

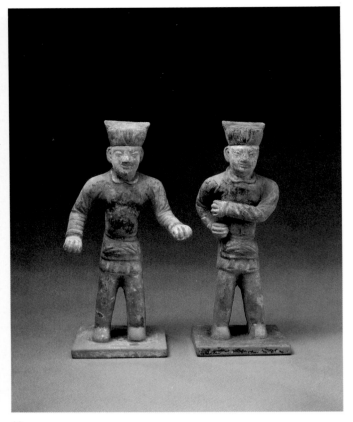

89
Standing man
Painted earthenware
Height 27 cm (10 ⅝ in.)
Color plate on p. 8

90
Two male servants
Painted earthenware
Height 22.5 cm (8 ⅞ in.)

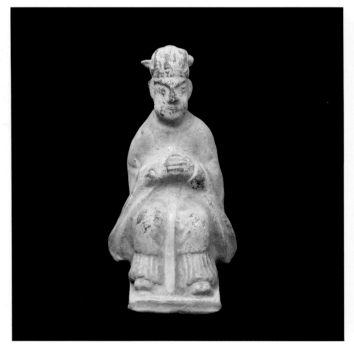

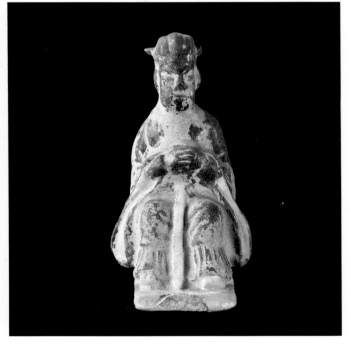

91
Two seated men
Green-glazed earthenware
Height 17.5 cm (6 ⅞ in.)
Color plate on p. 8

89–91
Northern Song dynasty
Excavated in 1956 from a tomb at Xingping, Shaanxi Province
Shaanxi Provincial Museum

The brick tomb chamber from which these figures come, a complicated structure that emulates wooden architecture, measures 3.48 by 2.70 meters and is 1.80 meters high. The tomb contained a bronze mirror, a pair of iron oxen, and a few porcelains, in addition to fifteen earthenware sculptures, which are the most significant funerary objects. Coins from the Shunhua (990–994) and Tianxi (1017–1021) periods provide evidence that the tomb dates to the Northern Song dynasty (960–1126). Since very few tomb figures of this period have been found in Shaanxi, this group is extremely valuable for research on Song dynasty earthenware sculpture.

The standing figure (cat. no. 89) wears a tall gauze hat typical of the Song period; his long white gown has an incised overskirt and a wide blue border. He has a very serious expression on his broad features and raises his right hand in an official gesture, as if to hold a staff. Two very conventionalized figures of male servants (cat. no. 90) are virtually identical in their facial features, broad shoulders, tubular legs, and costume. Both wear Song gauze hats. Only their postures differ, although both have hands pierced to hold objects that are now lost.

The green-glazed seated figures (cat. no. 91) wear the same tall, lobed hats with horizontal projections ("curled cloud" crowns) that may be seen frequently in portraits of emperors. Under their outer robes, worn with long belts, pleated garments can be seen. Their long sleeves billow out on either side as they clasp their hands sedately at their waists.

Literature
Shaanxi Provincial Committee for the Administration of Cultural Relics, "Shaanxi Xingpingxian xijiao qingli Song mu yizuo" (Inspection of a Song tomb in the western suburbs of Xingping County, Shaanxi), *Wenwu* (Cultural relics), 1959, no. 2: 39–40, 46.

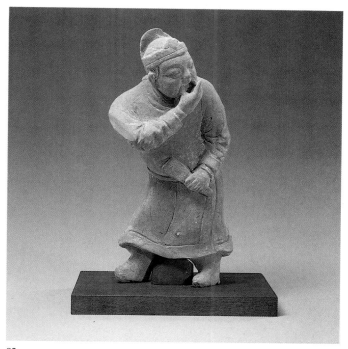

92
Whistling performer
Gray earthenware
Height 37 cm (14 ½ in.)
Color plate on p. 88

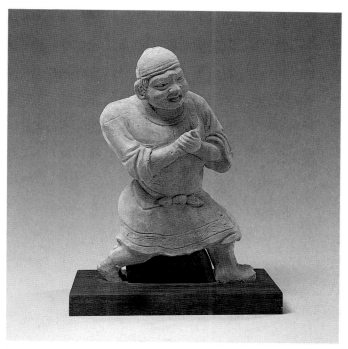

93
Clapping performer
Gray earthenware
Height 33 cm (13 in.)
Color plate on p. 88

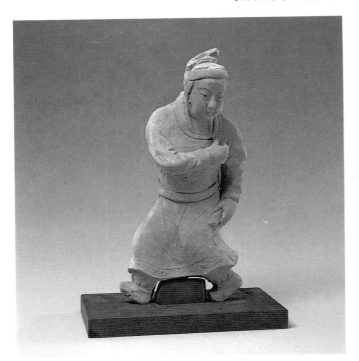

94
Performer holding a clapper
Gray earthenware
Height 37 cm (14 ½ in.)
Color plate on p. 88

92–94
Jin dynasty
Excavated in 1963 from a tomb in Xifengfeng Village, Jiaozuo, Henan Province
Henan Provincial Museum

As the sculptures in this exhibition attest, the performing arts have a long history in China. The genre called *zaju*, or "mixed drama," existed as early as the Tang dynasty. It is thought to have been rather free in structure, incorporating comedy, song, and dance. By the Yuan period zaju had evolved into a fixed form characterized by four acts with a prologue, each act consisting of arias and dialogue. Evidence of the existence of zaju and of stages built for the performance of drama has been found in the Northern Song capital of Kaifeng in Henan Province. Since 1949 many discoveries have been made in brick tombs of the Jin and Yuan periods of carved brick models of theatrical stages and earthenware images of zaju performers, vividly illustrating the theatrical tradition carried on from the earlier Song period.

The varied earthenware zaju figures in this group are very direct in sculptural conception and realistically depict new developments in the theatrical art of the Jin period. They are part of a group of seven surviving figures that were originally inset, along with elaborate carved brick lattices, in the walls of a square tomb chamber. They were made in an unusual technique still practiced in parts of China today. Instead of being modeled in unfired clay, the forms were chiseled from bricks that had already been baked. Similar groups of brick theatrical figures have been found in Henan and Shanxi provinces: in a Jin dynasty tomb datable to 1210 in Houma, Shanxi, five zaju performers were discovered in a model stage mounted on the wall of the tomb (fig. 25).

The liveliest of the group, a whistling figure (cat. no. 92), originally had plumelike ornaments inserted in the two holes in his hat. His body moves in one direction, his head in another. In his left hand he holds a clapper, and he sticks the thumb and middle finger of his right hand in his mouth to whistle. Judging from literary evidence and other excavated figures of performers, it seems that whistling was a very

important performance technique in Song and Yuan zaju. Figures of this type may represent a specialized genre of clown or comic actor.

The figure clapping his hands (cat. no. 93) also wears a hat with a hole for the insertion of a decoration; his robe is more elaborate, with incised borders and a knotted belt. The lively, comical expression on his face is emphasized by his distinctive features: bushy brows, large eyes, and puffed cheeks. As he recites and sings, his tongue protrudes from his grinning mouth.

The third performer (cat. no. 94) wears a soft hat that originally had wings and a robe with incised border decorations. Like his companions, he twists energetically as he strides in one direction and swivels his upper body in the opposite direction. He holds a clapper in his left hand, and his right hand appears poised as if to grasp another object.

Literature
Yang Baoshun, "Jiaozuo Jin mu fajue jianbao" (Brief report on the excavation of a Jin tomb at Jiaozuo), *Henan wenbo tongshun* (Henan cultural digest), 1979, no. 1: 18–24.
Wenwu kaogu gongzuo sanshinian, 1949–1979 (Thirty years of cultural relics archaeological work, 1949–1979) (Beijing: Wenwu Press, 1979), 62.
For the figures discovered at Houma, see "Shanxi Houma Jin mu fajue jianbao" (Brief report on the excavation of a Jin tomb at Houma, Shanxi), *Kaogu* (Archaeology), 1961, no. 12: 681–83.

Fig. 25. Figures of performers on a model stage in the tomb of Madame Dong at Houma, Shanxi Province. Photo courtesy Overseas Archaeological Exhibition Corporation.

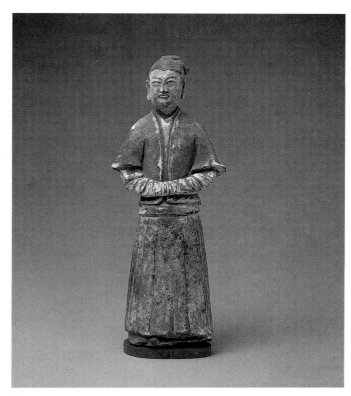

95
Standing woman
Painted earthenware
Height 29 cm (11 ⅜ in.)
Color plate on p. 59

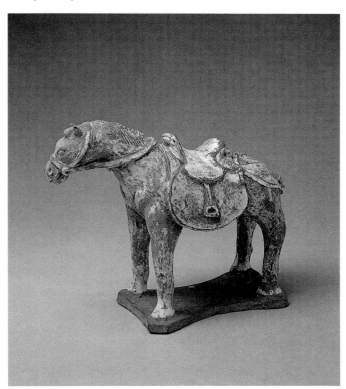

96
Horse
Painted earthenware
Height 19 cm (7 ½ in.), length 24 cm (9 ½ in.)
Color plate on p. 59

95–96
Yuan dynasty
A.D. 1251
Excavated in 1956 from the tomb of Duan Jirong at Qujiangchi, Xi'an, Shaanxi Province
Shaanxi Provincial Museum

The Yuan tomb at Qujiangchi is the grave of Duan Jirong (d. 1252) and his wife Liu Hua (d. 1265). The Duan family produced five successive generations of officials, and Duan Jirong served in both the Song and Yuan regimes. The couple was interred in a brick tomb chamber almost 3 meters square, with details, such as brackets, constructed to resemble wooden architecture.

Twenty earthenware figures of carts, horses, and male and female figures were found in the tomb, along with earthenware models of stoves, bowls, ladles, plates, vases, lamps, censers, an inkslab, and other useful objects. Items in bronze — two mirrors, a pig, and an ox — two stoneware pillows, and a stone epitaph were also discovered.

The figure of a serene, demure woman (cat. no. 95) wears her hair in an elaborate chignon with an ornament at its center, an arrangement skillfully indicated with incised lines. Her elegant attire includes a buttonless red jacket and a long black skirt with side pleating. Her garments are different from those of the Han Chinese; she thus would seem to be the member of a minority nationality.

The sturdy horse (cat. no. 96) is depicted with a complete set of tack, down to the stirrups. Details of its mane and knotted tail are incised, and the entire figure was originally painted bright red.

Literature
Shaanxi Provincial Committee for the Administration of Cultural Relics, ''Xi'an Qujiangchi xicun Yuan mu qingli jianbao'' (Brief report on the inspection of the Yuan tomb at West Village, Qujiangchi, Xi'an), *Wenwu cankao ziliao* (Cultural relics reference materials), 1958, no. 6: 57–61.

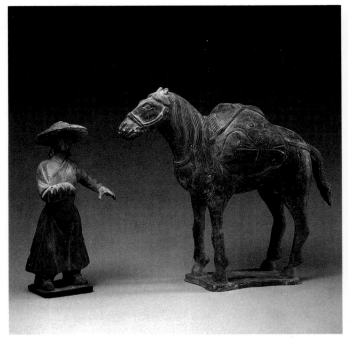

97–98
Packhorse and groom
Gray earthenware
Horse: height 34 cm (13 ⅜ in.), length 40 cm (15 ¾ in.); groom: height
27 cm (10 ⅝ in.)
Color plate on p. 60

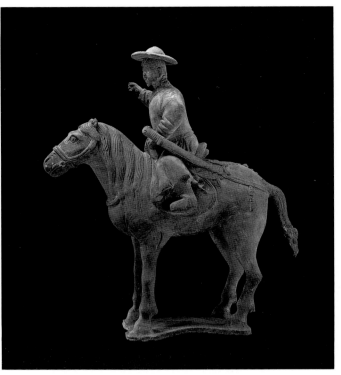

99
Horse and rider
Gray earthenware
Height 45 cm (17 ¾ in.), length 38.5 cm (15 ⅛ in.)
Color plate on p. 60

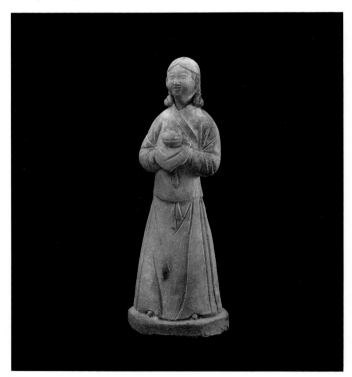

100
Female servant with a box
Gray earthenware
Height 30.5 cm (12 in.)
Color plate on p. 7

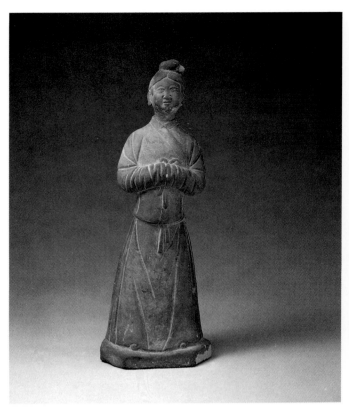

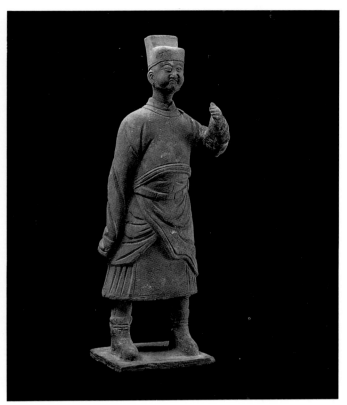

101
Female servant with folded hands
Gray earthenware
Height 30.4 cm (12 in.)
Color plate on p. 7

102
Military official
Gray earthenware
Height 33 cm (13 in.)
Color plate on p. 89

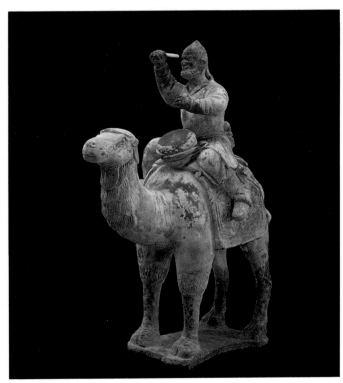

103
Drummer on a camel
Gray earthenware
Height 41.2 cm (16 ¼ in.), length 34.5 cm (13 ½ in.)
Color plate on p. 89

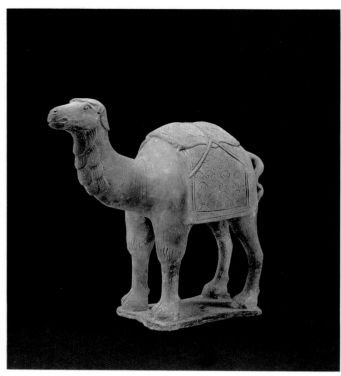

104
Camel
Gray earthenware
Height 30.5 cm (12 in.), length 33.5 cm (13 ¼ in.)
Color plate on p. 19

97–104
Yuan dynasty
Excavated in 1978 from the He family tomb in Hu County, Shaanxi Province
Cultural Center of Hu County, Shaanxi

The He tomb complex is the burial site of three generations of the family, beginning with He Ben. The tombs of his son, He Renjie (d. 1307), and his grandson, He Sheng, contained epitaphs identifying the occupants and describing their careers. All three men served as officials to the Mongol rulers of the Yuan dynasty. He Sheng was executed because of false accusations made against him, but in 1324 he was exonerated and the following year was given various posthumous titles including Lord of Qin. In 1327 his body was reburied in Hu County near the graves of his father and grandfather. The tombs are very rich in funerary objects. The objects selected for this exhibition are mainly from the tombs of He Ben and He Sheng.

The handsome earthenware horse with a long, flowing mane (cat. no. 97) has a saddle cloth on his back, over which is bound a heavy bundle covered with an animal skin. The tack and trappings used on horses during the Yuan dynasty have remained substantially unchanged up to the present day. The figure of the groom (cat. no. 98) wears a wide-brimmed military helmet and a long robe; his hair is in two braids. His left hand is extended as though to grasp the horse's lead.

The Mongols who ruled China at this time were originally nomadic herdsmen who excelled at horsemanship, archery, and forms of horseback warfare. The figures in the He tombs reflect very accurately this historical fact. The horseman (cat. no. 99) sits astride a steed very similar to the packhorse. He also wears a broad-brimmed military helmet with a tassel on top, and his hair is in two braids with a tuft left in front. With the long sword at his side and his right hand raised as though to flourish a whip, he presents a martial air.

The self-composed, smiling maids (cat. nos. 100–101) wear identical jackets and full skirts and share the same facial features. They are differentiated by their hairstyles, one wearing braids, the other a high coiled chignon. As one presents a round box, her companion folds her hands and waits in attendance. Their form and costume are typical of ladies of the Yuan dynasty.

The emphatically gesturing man (cat. no. 102) wears the cap of an official. An apronlike garment tied at the hips partially covers a pleated underskirt short enough to reveal his sturdy boots. In a particularly realistic expression, his cheeks are puffed out and his other features compressed with determination.

The drummer (cat. no. 103) wears a helmetlike skullcap over his braided hair. His non-Chinese features include deep-set eyes, a high nose, and a heavy beard. Mounted on his placid camel, he raises his arms high in a lively gesture to beat forcefully on the drum in front of him. Another camel (cat. no. 104) stands as if patiently waiting for a heavy load to be tied over the ornately decorated felt rug on its back.

Literature
Xianyang Regional Committee for the Administration of Cultural Relics, "Shaanxi Huxian Heshimu chutu daliang Yuandai yong" (A large quantity of Yuan dynasty funerary sculpture excavated from the He family tombs in Hu County, Shaanxi), *Wenwu* (Cultural relics), 1979, no. 4: 10–16.

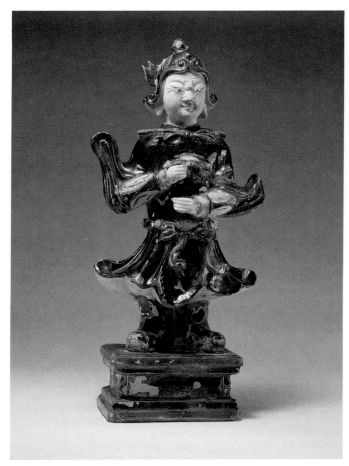

105a
Warrior
Glazed porcelain
Height 42 cm (16 ½ in.)

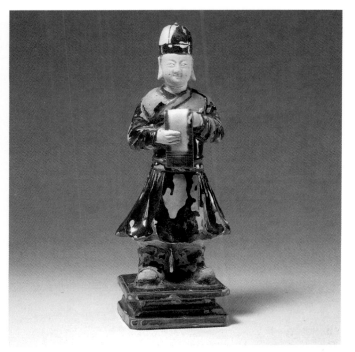

105b
Attendant
Glazed porcelain
Height 30 cm (11 ¾ in.)

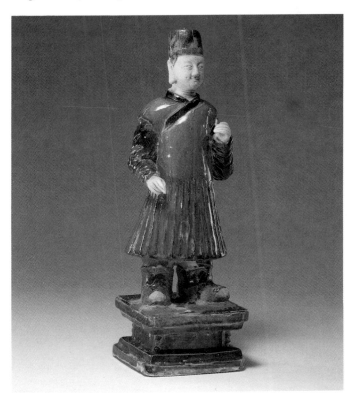

105c
Attendant
Glazed porcelain
Height 32 cm (12 ⅝ in.)

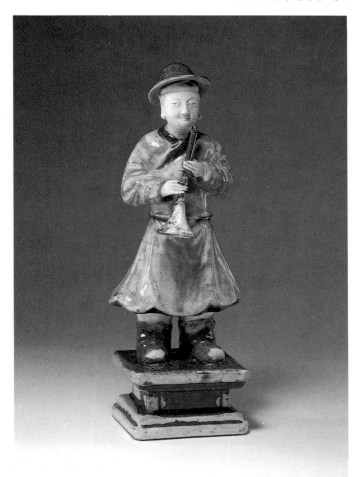

105d
Musician
Glazed porcelain
Height 31.5 cm (12 ⅜ in.)
Color plate on p. 90

105a–d
Ming dynasty
Excavated in 1955 from tomb 6, White Horse Temple, Chengdu,
Sichuan Province
Sichuan Provincial Museum

The custom of burying figures in tombs was gradually replaced by that of burning glued paper effigies of people and horses. However, there were still some high officials who commissioned earthenware or porcelain sculptures as burial objects in order to flaunt their status, wealth, and power. The glazed porcelain funerary figures in this exhibit were found in the tomb of the eunuch Wei Cunjing (1445–1510), whose family had served as trusted advisors to four generations of imperial princes in Sichuan. Wei's tomb, a typical example of the grave of a high-ranking Ming eunuch, measured 6.32 by 2.65 by 3.3 meters. It included a lavishly appointed offering table and a rear chamber with more than eighty porcelain figures to attend the deceased. Above the ornate door to the tomb was inscribed "Realm of Eternal Life."

Ming funerary figures are clearly inferior in style to the sculptures of Han and Tang, which they were meant to imitate. However, the rich texture of the bright yellow, turquoise, and blue glazes and the realism of the human forms can speak for the high technical and artistic standards of the Ming. The painted ceramic sculptures were first fired at a high temperature without glaze, and then refired at a low temperature after applying a different pigment.

All four figures plant their heavily booted feet on pedestals. The warrior (cat. no. 105a) is attired in an ornate helmet and robe in a striking combination of dark blue and turquoise glazes. His robe, belt, and sleeves fly out around him, suggesting vigorous motion, and his ferocity is expressed in his glaring eyes. Two servants (cat. nos. 105b–105c) stand smiling and respectful in wide-skirted robes and paneled hats. One prepares to offer a towel to his master; the other has lost the objects he once held. The musician (cat. no. 105d) wears a dark blue round-brimmed hat and a bright turquoise robe. His delicate hands clasp a trumpet, which he brings to his lips. He seems lost in concentration, awaiting the direction of his conductor.

Literature
Sichuan Provincial Committee for Administration of Cultural Relics, "Sichuan Baimasi diliuhao Ming mu qingli jianbao" (Brief report on the inspection of Ming tomb 6 at White Horse Temple in Chengdu, Sichuan), *Wenwu cankao ziliao* (Cultural relics reference materials), 1956, no. 10: 42–49.

GLOSSARY

ci 瓷
a ceramic fired at a high temperature that produces a ringing sound when tapped; generally, stoneware and porcelain

fang xiang 方向
guardian of the tomb chamber associated with the four directions

fugu 复古
nostalgic pursuit of the hallowed ideals of antiquity

gui 鬼
the *po* after it has returned to earth; a malevolent being

huang chang ti zou 黄肠题凑
literally, "yellow intestines aligned together"; a method of constructing tomb chambers by stacking timbers of aromatic woods

hun 魂
the part of the soul that ascends to heaven after death; the emanation of the *yang*

lokapala 天王
a king serving as a tomb guardian

mingqi 明器
literally, "numenous artifacts"; any images, models, or objects made specifically for burial in a tomb

paixiao 排箫
a musical instrument consisting of a set of bamboo pipes of graduated lengths

po 魄
the part of the soul that returns to earth after death; the emanation of the *yin*

qi 气
the breath of life

qin 琴
a seven-stringed zither

qitou 麒头
a monster that protects a tomb

sancai 三彩
literally, "three-colored"; earthenware with a pale body covered with lead glazes in combinations of green, brown, yellow, and blue; characteristic of Tang funerary wares of the early eighth century

shen 神
the *hun* after it has ascended to heaven; an apotheosized mortal

sheng 笙
a cylindrical mouth organ made of bamboo

shuochang 说唱
literally, "speaking and singing"; a form of entertainment or storytelling

sui 岁
age by the Chinese calendar; approximately one year older than Western reckoning

tao 陶
a somewhat porous ceramic that has been fired at a low temperature; pottery or earthenware

tudishen 土地神
the local god of a family

xiao 箫
see *paixiao*

yang 阳
the light, heavenly principle; the male

yin 阴
the dark, earthly principle; the female

zaju 杂剧
a form of entertainment incorporating comedy, music, and dance

zhenmu shou 镇墓兽
literally, "grave-quelling beast"; fierce animallike tomb guardians

CHARACTER LIST

安禄山	An Lushan	二里岗	Erligang
安徽	Anhui	范粹	Fan Cui
安陵	Anling	汾	Fen
安阳	Anyang	凤翔	Fengxiang
阿斯塔那	Astana	分水岭	Fenshuiling
		妇好	Fu Hao
灞水	Ba River		
白圭	Baigui	甘肃	Gansu
白鹿原	Bailuyuan	高楼村	Gaoloucun
白马寺	Baimasi	高宗	Gaozong
霸陵	Baling	高祖	Gaozu
半坡	Banpo	巩县	Gongxian
巴州	Bazhou	顾恺之	Gu Kaizhi
北京	Beijing	灌婴	Guan Ying
北庄	Beizhuang	广东	Guangdong
白居易	Bo Juyi	广阳	Guangyang
渤海	Bohai	固围村	Guweicun
曹不兴	Cao Buxing	海州	Haizhou
曹操	Cao Cao	韩	Han (state)
曹丕	Cao Pi	汉	Han dynasty
草厂坡	Caochangpo	韩干	Han Gan
岑参	Cen Shen	韩裔	Han Yi
长安	Chang'an	杭州	Hangzhou
长陵	Changling	韩林寨	Hanlinzhai
长沙	Changsha	汉书	Hanshu
长台关	Changtaiguan	汉中	Hanzhong
长治	Changzhi	蒿里	Haoli
长子	Changzi	贺贲	He Ben
陈	Chen dynasty	贺仁杰	He Renjie
成都	Chengdu	贺胜	He Sheng
楚	Chu	河北	Hebei
磁县	Cixian	合肥	Hefei
崔家营	Cuijiaying	河南	Henan
滁县	Cuxian	河曲	Hequ
		洪庆村	Hongqingcun
大葆台	Dabaotai	后土	Hou Tu
轪侯	Dai, Marquis of	侯马	Houma
代宗	Daizong	黄陵	Huangling
大同	Datong	华县	Huaxian
邓县	Dengxian	湖北	Hubei
德宗	Dezong	惠帝	Huidi
定县	Dingxian	湖南	Hunan
东陈	Dongchen	霍去病	Huo Qubing
窦皇后	Dou, Empress	霍河	Huohe
窦绾	Dou Wan	鄂县	Huxian
杜甫	Du Fu		
段继荣	Duan Jirong	贾壁窑	Jiabi kilns
杜陵	Duling	江陵	Jiangling
敦煌	Dunhuang	江苏	Jiangsu

江西	Jiangxi	龙门	Longmen
焦作	Jiaozuo	陇山头	Longshantou
吉利河	Jilihe	鲁	Lu (state)
金	Jin dynasty (265–420)	鲁王	Lu, Prince of
晋	Jin dynasty (1115–1234)	吕后	Lü, Empress
济南	Jinan	吕村	Lücun
泾	Jing	洛达	Luo Da
景帝	Jingdi	雒南县	Luonanxian
景帝纪	Jingdiji	洛阳	Luoyang
景龙	Jinglong		
九龙山	Jiulongshan	满城	Mancheng
蓟县	Jixian	邙山	Mangshan
济源县	Jiyuanxian	茂陵	Maoling
女真	Jurchen	马王堆	Mawangdui
		沔县	Mianxian
开封	Kaifeng	明	Ming dynasty
开皇	Kaihuang	明皇	Minghuang
开原	Kaiyuan	幕府山	Mufushan
忽必列汗	Kublai Khan		
		南昌	Nanchang
狼家沟	Langjiagou	南关	Nanguan
郎家庄	Langjiazhuang	南京	Nanjing
琅琊王	Langye, Prince of	南越	Nanyue
雷台	Leitai		
乐浪	Lelang	裴李岗	Peiligang
李封	Li Feng	平陵	Pingling
李隆基	Li Longji	平山	Pingshan
李世民	Li Shimin	蕃县	Pixian
李守	Li Shou	濮阳	Puyang
李贤（章怀）	Li Xian (Zhanghuai)		
李显（中宗）	Li Xian (Zhongzong)	契苾明	Qi Biming
李希宗	Li Xizong	齐	Qi dynasty
李渊	Li Yuan	乾陵	Qianling
李云	Li Yun	乾县	Qianxian
李贞	Li Zhen	秦	Qin dynasty
李治	Li Zhi	秦始皇帝	Qin Shihuangdi
李重润	Li Zhongrun	曲阜	Qufu
梁	Liang dynasty	曲江池	Qujiangchi
辽	Liao dynasty	曲阳	Quyang
辽宁	Liaoning		
李家	Lijia	任家坡	Renjiapo
陵山	Lingshan	睿宗	Ruizong
临潼县	Lintongxian		
临淄	Linzi	三原	Sanyuan
醴泉县	Liquanxian	色目	Semu
骊山	Lishan	陕西	Shaanxi
刘邦	Liu Bang	山彪	Shanbiao
刘化	Liu Hua	山东	Shandong
刘胜	Liu Sheng	上帝	Shang Di
刘盈	Liu Ying	商	Shang dynasty
		上焦	Shangjiao
		上虞	Shangyu

O

SUGGESTED READING

Akiyama, Terukazu, et al. *Arts of China: Neolithic Cultures to the T'ang Dynasty, Recent Discoveries.* Coordinated by Mary Tregear. Tokyo: Kodansha International, 1968.

Bachhofer, Ludwig. *A Short History of Chinese Art.* London: B. T. Batsford, 1947.

Beurdeley, Michel. *The Chinese Collector through the Centuries: From the Han to the 20th Century.* Rutland, Vermont: Charles E. Tuttle Company, 1966.

Chang, Kwang-chih. *The Archaeology of Ancient China.* 3rd rev. ed. New Haven: Yale University Press, 1977.

_____. *Shang Civilization.* New Haven: Yale University Press, 1980.

Chen, Kenneth K. S. *Buddhism in China: A Historical Survey.* Princeton: Princeton University Press, 1964.

Chinese Studies in Archeology 1, no. 2 (fall 1979). Edited by Jeffrey K. Riegel. New York: M. E. Sharpe, 1980.

Chinese Studies in Archeology 1, no. 3 (winter 1979–80). Edited by Jeffrey K. Riegel. New York: M. E. Sharpe, 1981.

Fitzgerald, C. P. *China: A Short Cultural History.* 3rd ed. New York: Praeger, 1961.

Fong, Mary H. "Four Chinese Royal Tombs of the Early Eighth Century." *Artibus Asiae* 35, no. 4 (1973): 307–34.

Fong, Wen, ed. *The Great Bronze Age of China: An Exhibition from the People's Republic of China.* New York: The Metropolitan Museum of Art/Alfred A. Knopf, 1980.

Fontein, Jan, and Tung Wu. *Han and T'ang Murals Discovered in Tombs in the People's Republic of China and Copied by Contemporary Chinese Painters.* Boston: Museum of Fine Arts, 1976.

_____. *Unearthing China's Past.* Boston: Museum of Fine Arts, 1973.

Gaston-Mahler, Jane. *The Westerners among the Figurines of the T'ang Dynasty of China.* Rome: Istituto Italiano per il Medio ed Estremo Oriente, 1959.

The Genius of China. London: Times Newspapers, 1973.

Hucker, Charles O. *China's Imperial Past: An Introduction to Chinese History and Culture.* Stanford: Stanford University Press, 1975.

Juliano, Annette L. *Art of the Six Dynasties.* New York: China House Gallery/China Institute in America, 1975.

Keightley, David N., ed. *The Origins of Chinese Civilization.* Berkeley: University of California Press, 1983.

Kuwayama, George, ed. *The Great Bronze Age of China: A Symposium.* Los Angeles: Los Angeles County Museum of Art, 1983.

Laufer, Berthold. *Chinese Pottery of the Han Dynasty.* Rutland, Vermont: Charles E. Tuttle Company, 1962.

Lefebvre d'Argencé, René-Yvon, ed. *Treasures from the Shanghai Museum: 6,000 Years of Chinese Art.* Shanghai: Shanghai Museum/San Francisco: Asian Art Museum of San Francisco, 1983.

Medley, Margaret. *The Chinese Potter. A Practical History of Chinese Ceramics.* New York: Charles Scribner's Sons, 1976.

Needham, Joseph. *Science and Civilisation in China.* 7 vols. Cambridge: Cambridge University Press, 1954–1971.

Nelson Gallery–Atkins Museum. *The Chinese Exhibition: A Pictorial Record of the Exhibition of Archaeological Finds of the People's Republic of China.* Kansas City, Missouri: Nelson Gallery–Atkins Museum, 1975.

Pirazzoli-t'Serstevens, Michele. "Extrême-Orient, préhistoire et archéologie. Chine: paléolithique, néolithique et âge du bronze." In *Encyclopaedia Universalis,* supplement 1, 582–90. Paris: Encyclopaedia Universalis France, 1980.

_____. *The Han Dynasty.* Translated by Janet Seligman. New York: Rizzoli International Publications, 1982.

Prodan, Mario. *The Art of the T'ang Potter.* New York: Viking Press, 1961.

Rawson, Jessica. *Ancient China: Art and Archaeology.* New York: Harper & Row, 1980.

The Royal Ontario Museum, Far Eastern Department, *Chinese Art in the Royal Ontario Museum.* Ontario: The Royal Ontario Museum, 1972.

Sato, Masahiko. *Chinese Ceramics: A Short History.* New York and Tokyo: Weatherhill/Heibonsha, 1981.

Schloss, Ezekiel. *Ancient Chinese Ceramic Sculpture: From Han through T'ang.* 2 vols. Stamford, Connecticut: Castle Publishing Co., 1977.

_____. *Art of the Han.* New York: China House Gallery/China Institute in America, 1979.

Shangraw, Clarence F. *Origins of Chinese Ceramics.* New York: China House Gallery/China Institute in America, 1978.

Sickman, Laurence, and Alexander Soper. *The Art and Architecture of China.* Harmondsworth, Middlesex: Penguin Books, 1956.

Siren, Osvald. *A History of Early Chinese Art: Sculpture.* London: Ernest Benn, n.d.

Swann, Peter C. *Chinese Monumental Art.* London: Thames and Hudson, 1963.

Twitchett, Denis, and John K. Fairbank, eds. *The Cambridge History of China.* Vol. 3, *Sui and T'ang China, 589–906, Part I.* Cambridge: Cambridge University Press; Taipei: Caves Books, 1979.

Wang Zhongshu. *Han Civilization.* Translated by K. C. Chang et al. New Haven: Yale University Press, 1982.

Watson, William. *Art of Dynastic China.* New York: Harry N. Abrams, 1981.

_____. *Style in the Arts of China.* New York: Universe Books, 1975.

Willetts, William. *Chinese Art.* 2 vols. Harmondsworth, Middlesex: Penguin Books, 1958.

The Quest for Eternity

Designed by Ed Marquand Book Design

Composed by Continental Typographics
in Palatino with display lines in
Palatino and Futura

Printed and bound by Toppan Printing Company